Venetian Interiors

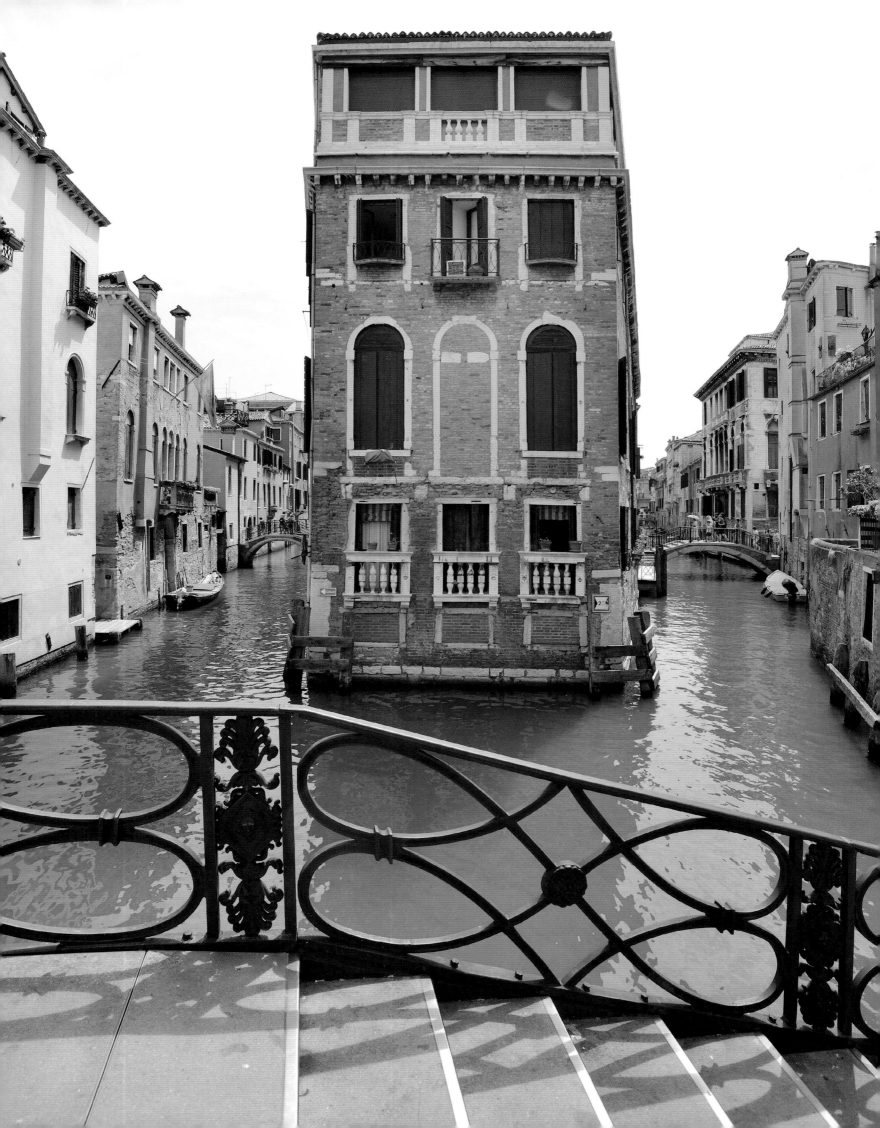

Venetian Interiors

Giuseppe Molteni and Roberta Motta

RIZZOLI
NEW YORK

New York · Paris · London · Milan

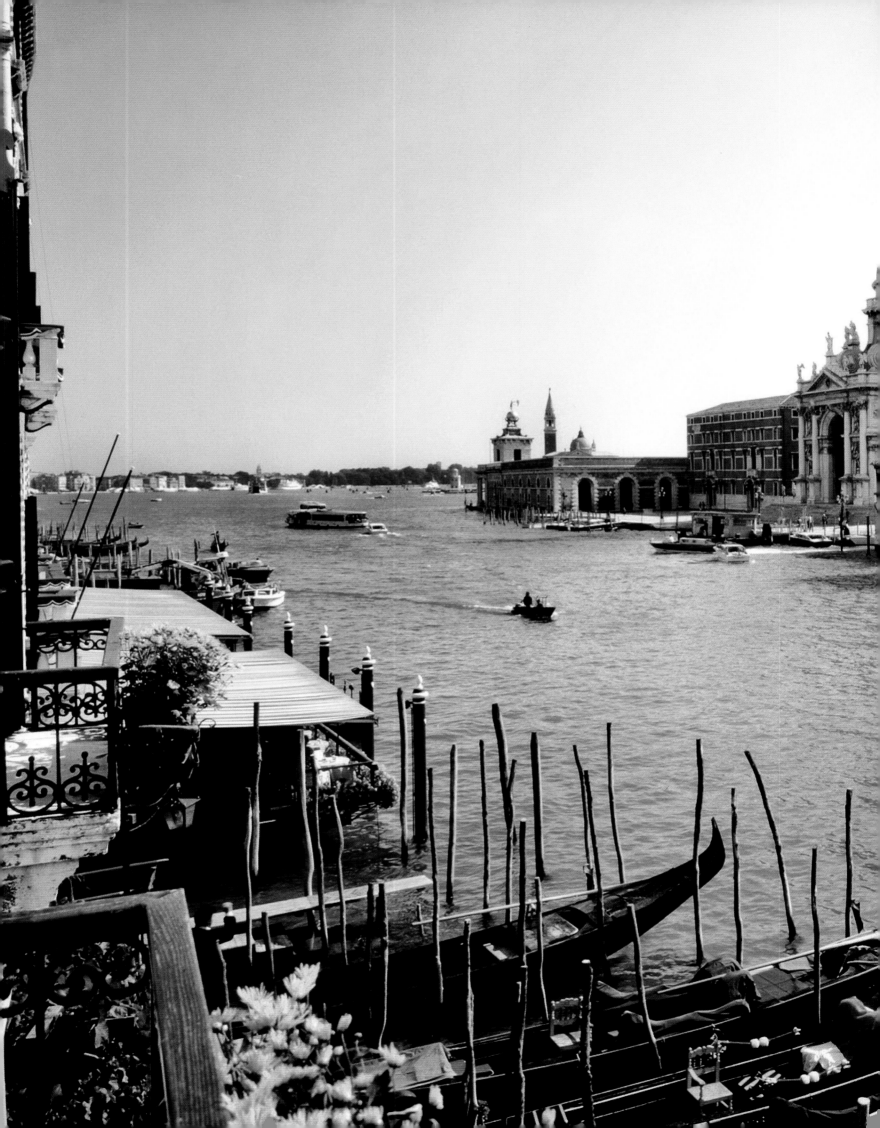

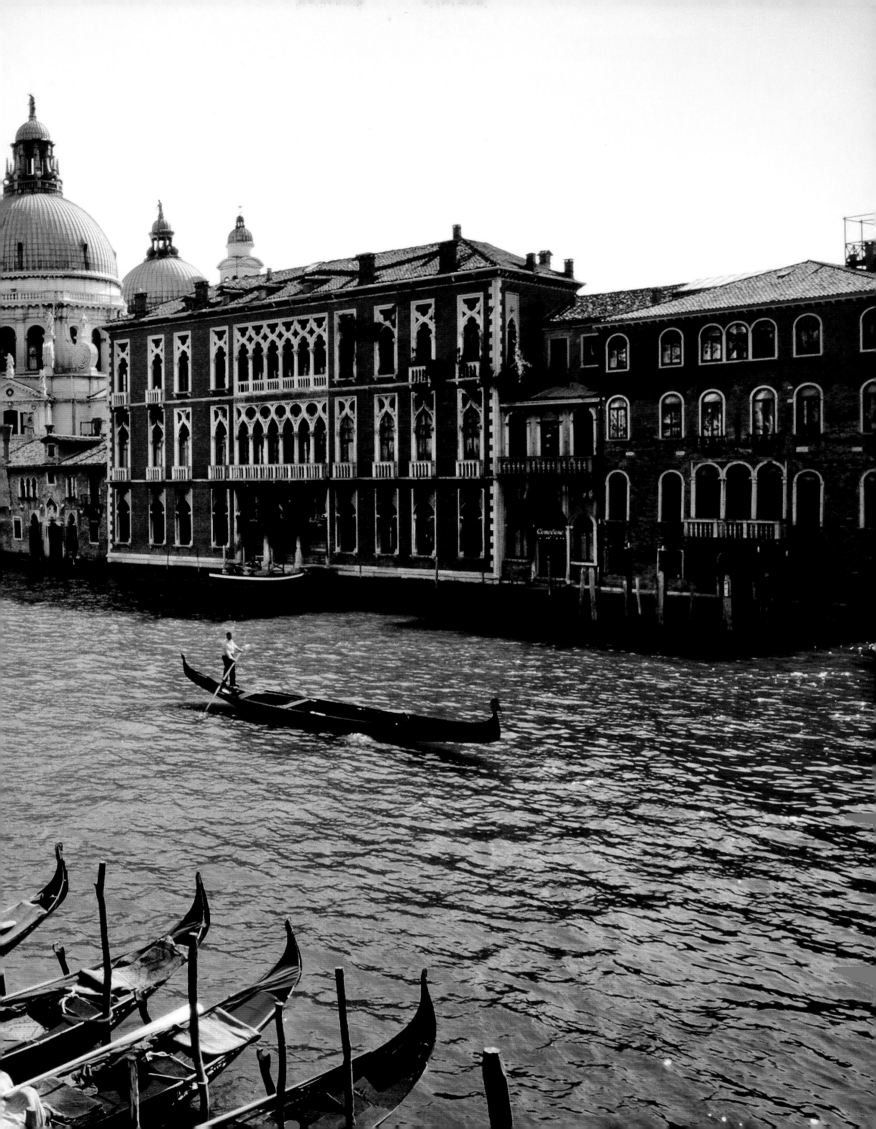

One hundred deep solitudes together constitute the city of Venice.
Therein lies its charm.
A model for the man of the future.

Friedrich Nietzsche

Contents

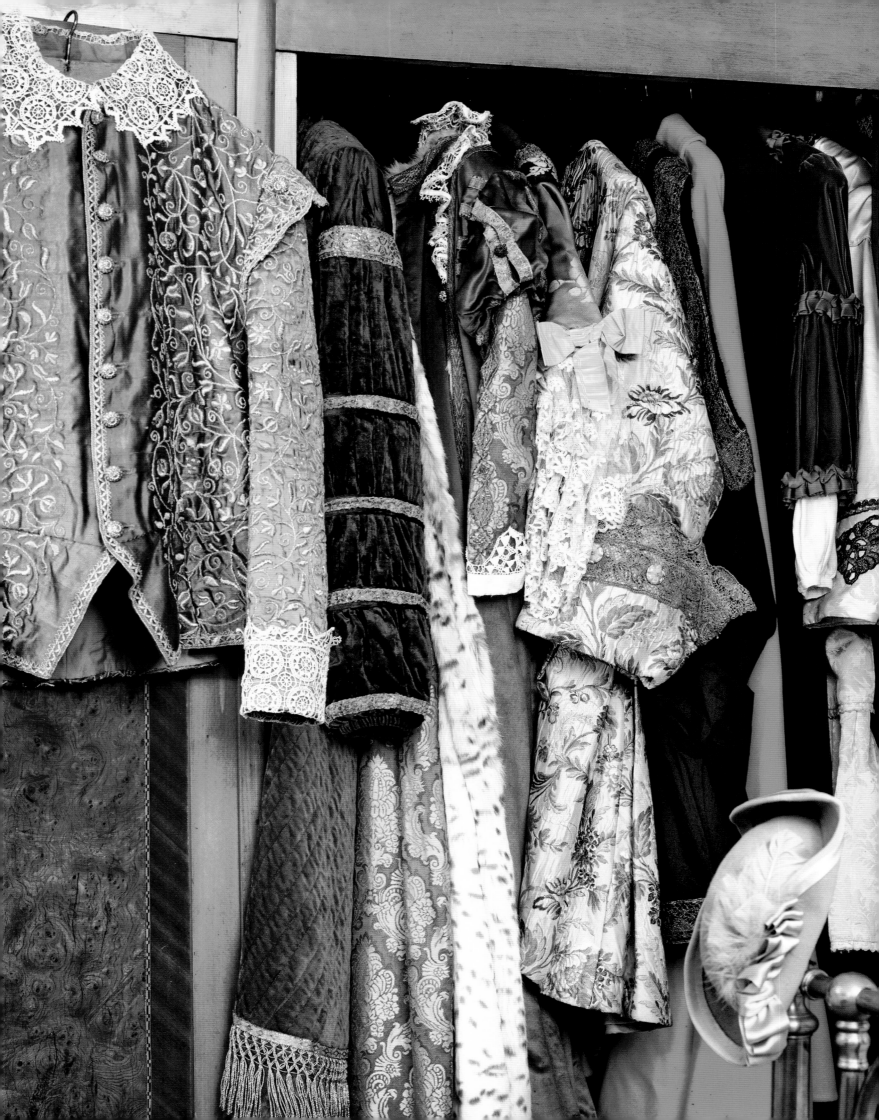

Has any city in the world more deeply touched our collective heart, mind, and soul than Venice? I don't believe so, and to test this hypothesis all you have to do is run through the endless list of famous authors who have described, recounted, sung, and even criticized this most serene city. From Ortensio Lando to Carlo Goldoni, Goethe, Byron, Stendhal, Dickens, Proust, Hermann Hesse, Filippo Tommaso Marinetti, Paul Morand, and the list goes on . . .

It is as if the *Serenissima* were an unavoidable final exam of sorts for the writer and poet. Each of these authors has added to our knowledge of the city, contributed to its mythic status, and compounded its legend. Each has given us the gift of "his" Venice, which helps us understand "our" Venice a little better. Each has turned it into a metaphor for his innermost feelings and also for his vision of the outside world. Perhaps they all had the shared goal of capturing—as Joseph Brodsky did in his book *Watermark*—the city's most intimate secret, the one capable of revealing its ineffable and incorruptible charm. Its undeniable spell remains eternal despite the decay that incessantly looms on the lagoon's horizon: as Brodsky once reflected, in Venice "water equals time and provides beauty with its double. Part water, we serve beauty in the same fashion. By rubbing water, this city improves time's looks, beautifies the future. That's what the role of this city in the universe is."

And yet, despite the vast wealth of cultural work this city has inspired, there is still a Venice that hasn't been explored: the part of the city that you don't see from the street. To quote Brodsky once again, "the upright lace of Venetian facades is the best line time-alias-water has left on terra firma anywhere." This is the Venice of houses, inhabited spaces, everyday life, and hidden interiors. This other side of the city is shrouded in its own jealously preserved mystery, with thousands upon thousands of facets and declinations. It is radically different from the side that overlooks the

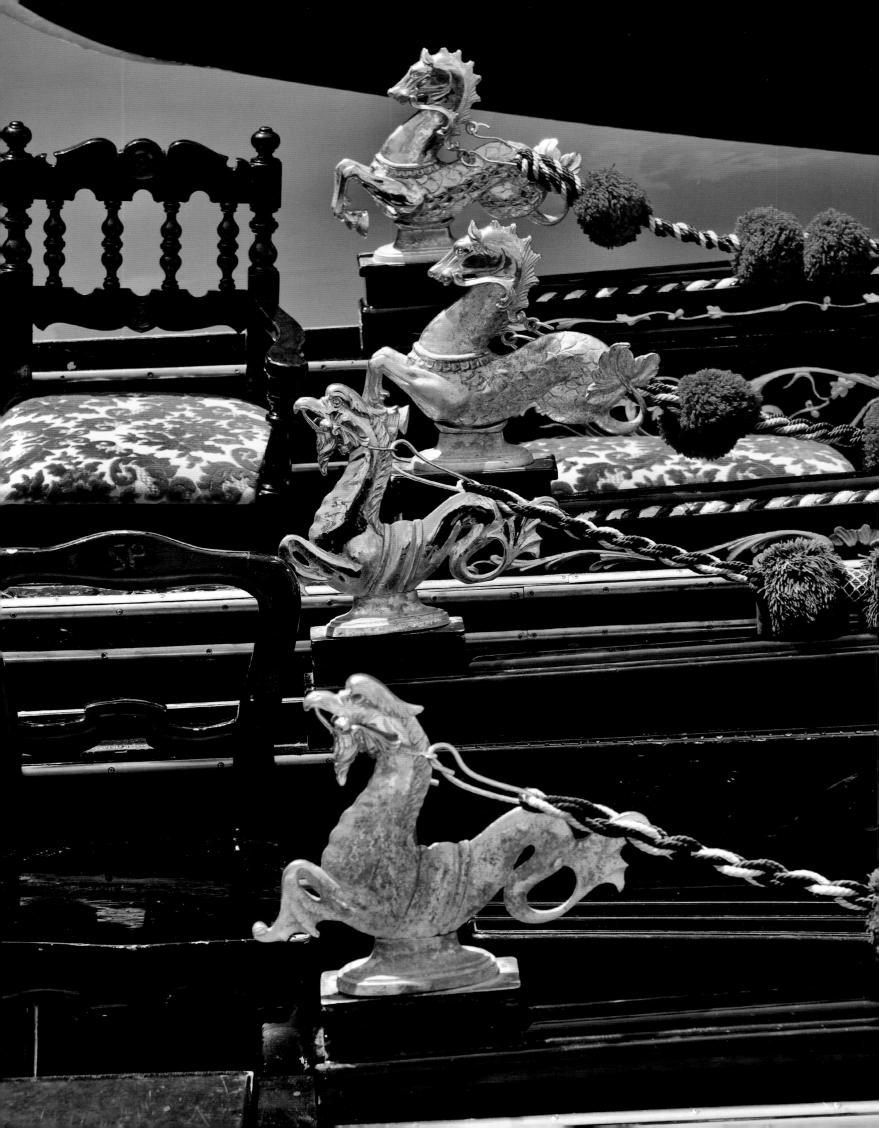

dense pattern of bridges and canals, as well as streets and town squares distinctively known as *calle*, *campi*, and *campielli*. Yet in its own way it is also the same because—like that other Venice, and perhaps even more so—it also has an endless variety of spatial shapes and sizes. It mixes and combines, in alternating harmonies and counterpoints, epochs, styles, and evocations. Here you can glimpse the legacies of tradition as well as modernity, as Gothic touches come into contact with art nouveau, Renaissance, baroque, neoclassical, and contemporary designs. This book aims to highlight a few of its most emblematic spaces as viewed by Giuseppe Molteni and Roberta Motta. Their extensive publishing experience helped them bring together the full-fledged portraits herein, which document with sharp precision the remarkable wealth of Venetian homes—intimate, artistic treasure troves containing objects from the Middle Ages and the Renaissance, as well as seventeenth-century paintings, neoclassical sculptures, furniture by some of the greatest cabinetmakers ever, books (*lots* of books), and sumptuous fabrics. Such fixtures are complemented by touches of everyday contemporary life, objects straight out of childhood memories and family trips, filled with echoes of faraway lands and exotic adventures. Many of these objects seem drawn from the pages of the unmistakably Venetian comic-book creator Hugo Pratt, whom cultural critic Oreste del Buono nicknamed "the Master of Malamocco," in reference to the neighborhood in which he grew up. These photographs document the marvelous palimpsest that is Venice, inspiring wonder and emotion and showing the unreal character of the domestic landscape that, in the words of renowned historian Fernand Braudel, "creates the enchantment and repeated mythology" of this motionless yet vibrant city, "like a world that is part seen and part dreamt of."

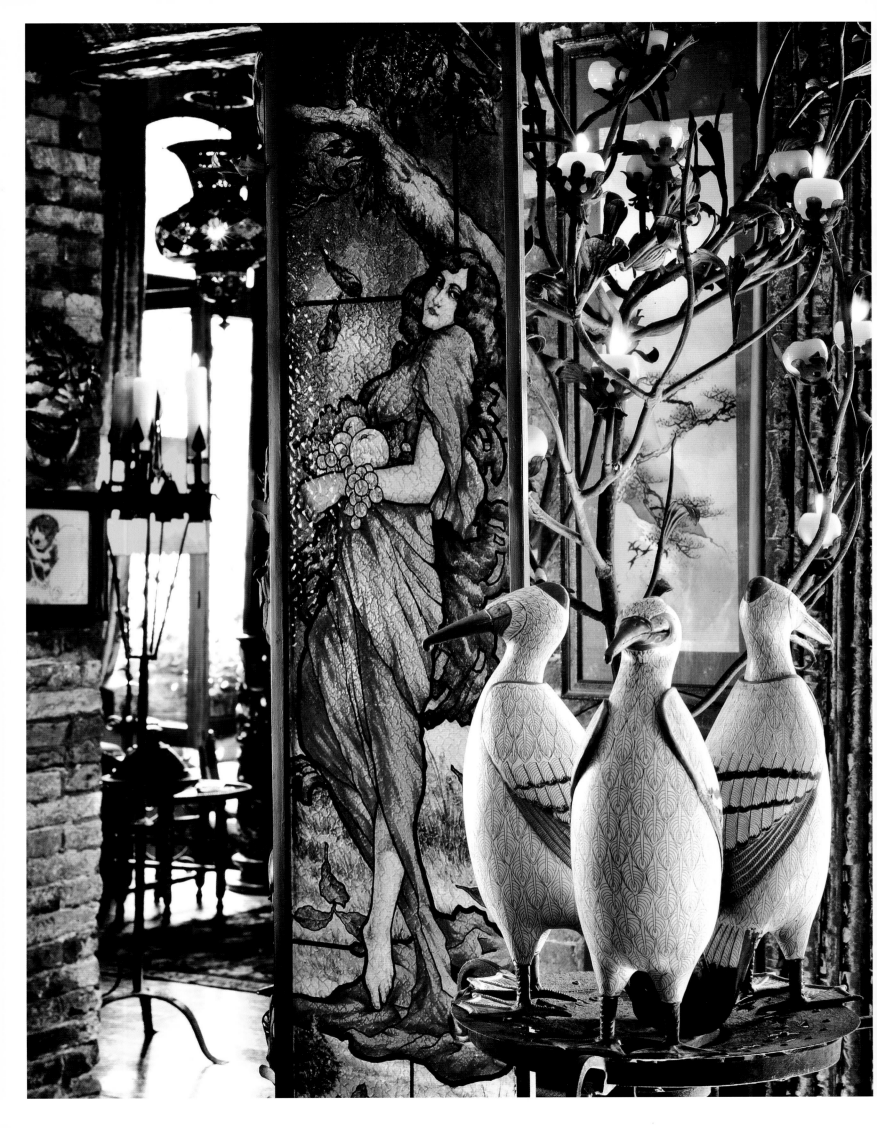

The Dwelling Place of Memory

This particular story takes place in a former lumber warehouse in the Cannaregio *sestiere*, not far from the church of the Misericordia. It's a ramshackle building with a pitched roof in need of repair—its large interior a tangle of cobwebs and its stone walls flaking—and yet the signs of its ancient majesty are still clearly legible. It was once part of the *barchessa*—as the building housing the service quarters on aristocratic properties used to be called—of the palazzo owned by the Da Lezze family. This patrician dynasty's illustrious members included Antonio Da Lezze, who defended the Turkish city of Scutari (present-day Üsküdar) in 1476; Giovanni Da Lezze, who was made Count of Croce in 1532; and another Giovanni Da Lezze, a military leader and politician.

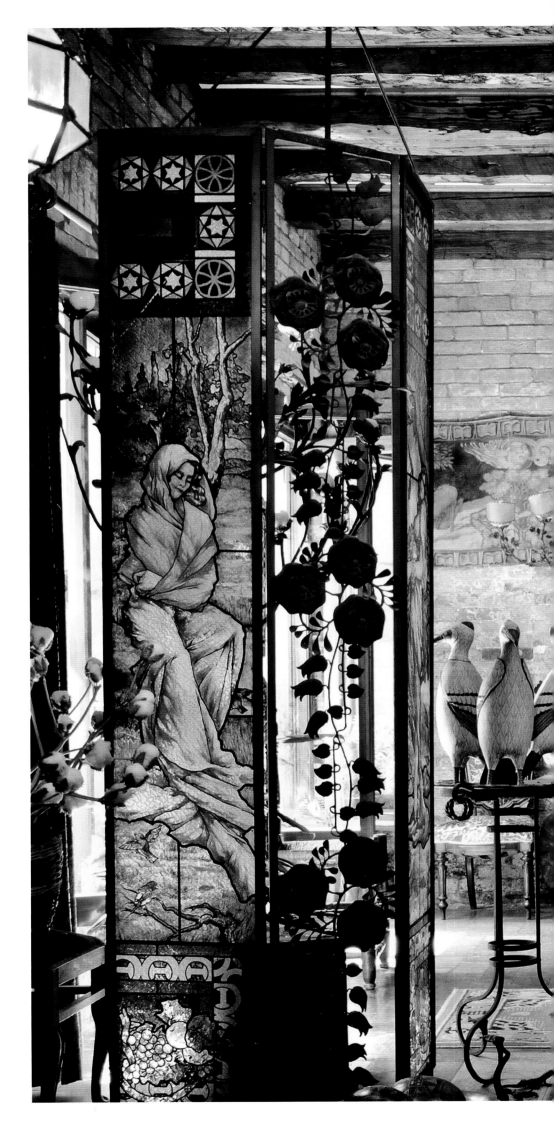

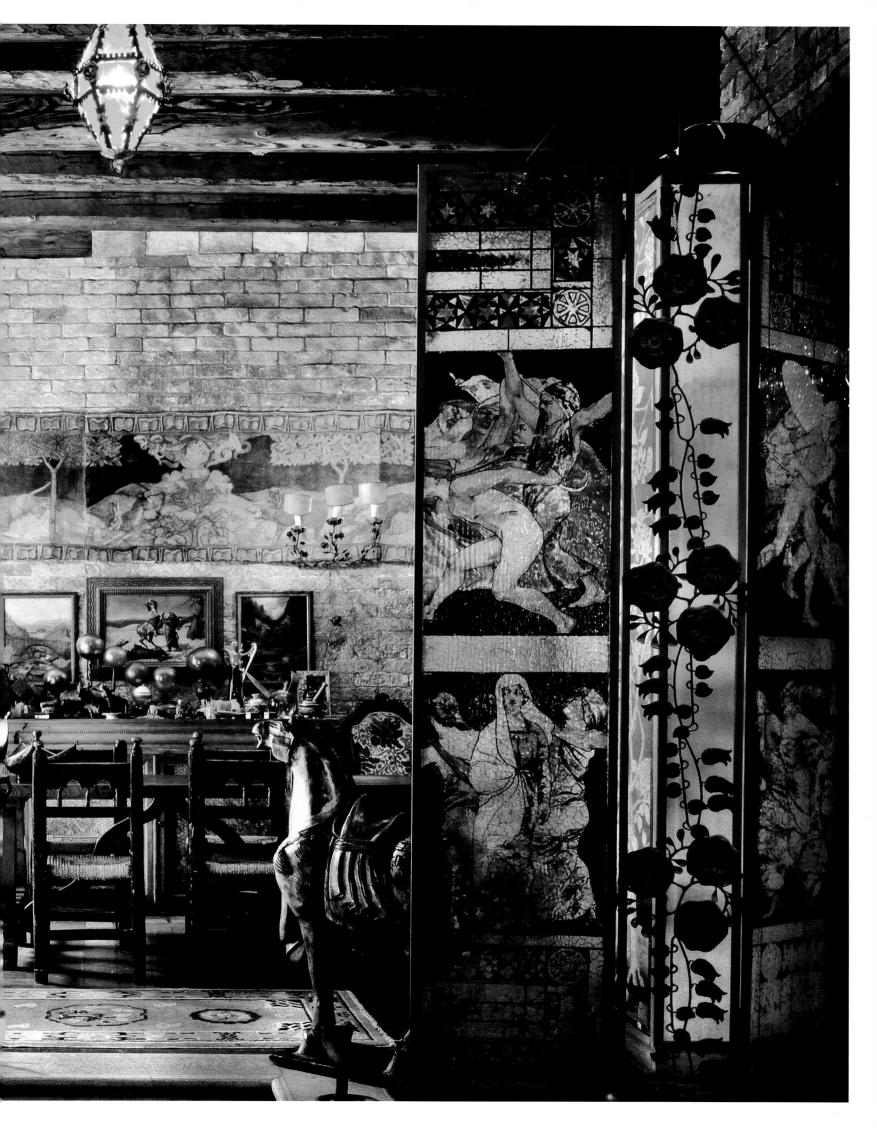

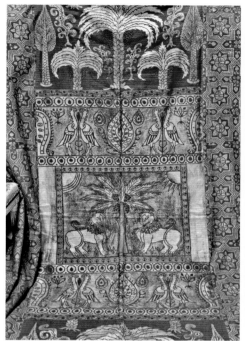

The palazzo was designed by Baldassarre Longhena and built in 1654, a product of the Venetian baroque. It was a period of glory and growth—at least until 1680, according to Braudel and the Annales school—but also of darker events. For instance, in 1607 Pope Paul V issued an interdict against the Venetian Republic because it wanted to bring two clerics to trial in a secular court. That same atmosphere could still be felt just a few years ago, when Mirella Spinella first opened the warehouse doors. Spinella has both the temperament and training of an artist: she studied mosaic in Ravenna, decoration in Padua, and set design at the Accademia di Belle Arti in Venice. She is also a professional textile artisan, and tells the story as follows: "I was looking for a house in Venice, which is really a big problem—especially if you need to work at home and can't do without a table that's at least thirty feet long. After months of fruitless searching, I had almost resigned myself to the idea that what I wanted just didn't exist. And then the unexpected happened. One day by chance I found myself standing in front of this old lumber warehouse: a building that was very run-down, yet still powerful in terms of its shapes and spaces. One of the people who was with me said that it was for sale and that the owners weren't even asking too much for it because restoring and refurbishing such an old place would still have meant spending more than building something new. Sure, I said to myself, but it's also true that once the roof has been repaired so that it doesn't rain inside I could move in and do what has to be done, little by little. Either you do something right away or you don't do it at all, I said to myself. So the very next morning I got in touch with the owners, and we wrote up and signed the deeds."

Those small jobs that were supposed to be taken care of little by little actually took years to do, but in the end the result is one of the most original dwellings in all of Venice. The renovation was carried out according to strictly conservative guidelines; the large ceiling beams were restored and cleaned, and the uneven floors were repaired with stone slabs and terra-cotta tiles from the roof of a nearby building that was being demolished. Spinella admits, "I had to clean every single piece before I could use it. Gradually their original color was restored, each one a different shade but all with the same fascinating antique look. I also wanted these floors to show something about my own experiences and my passion for travel, especially to the Far East. Even now, after all is said and done, I can't say which is more beautiful—the rugs or the humble terra-cotta tiles they are supposed to cover." The open space of the warehouse

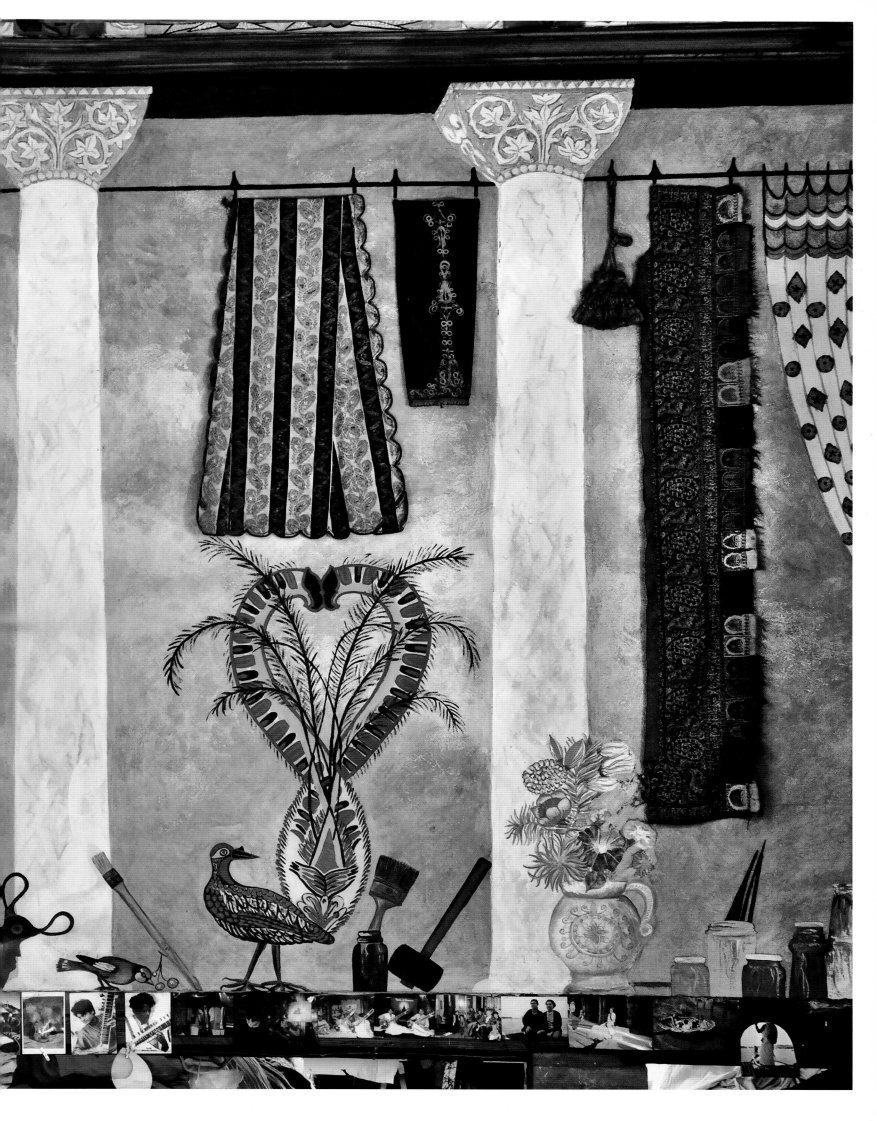

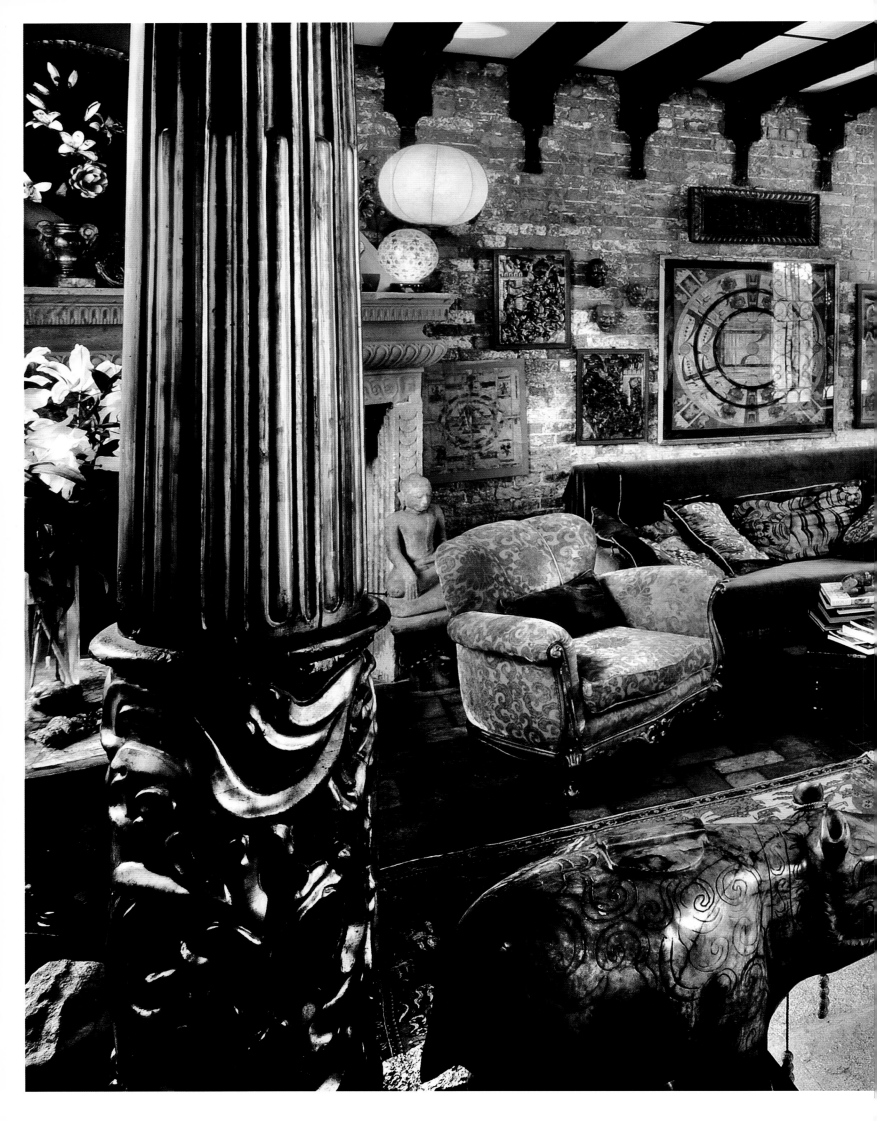

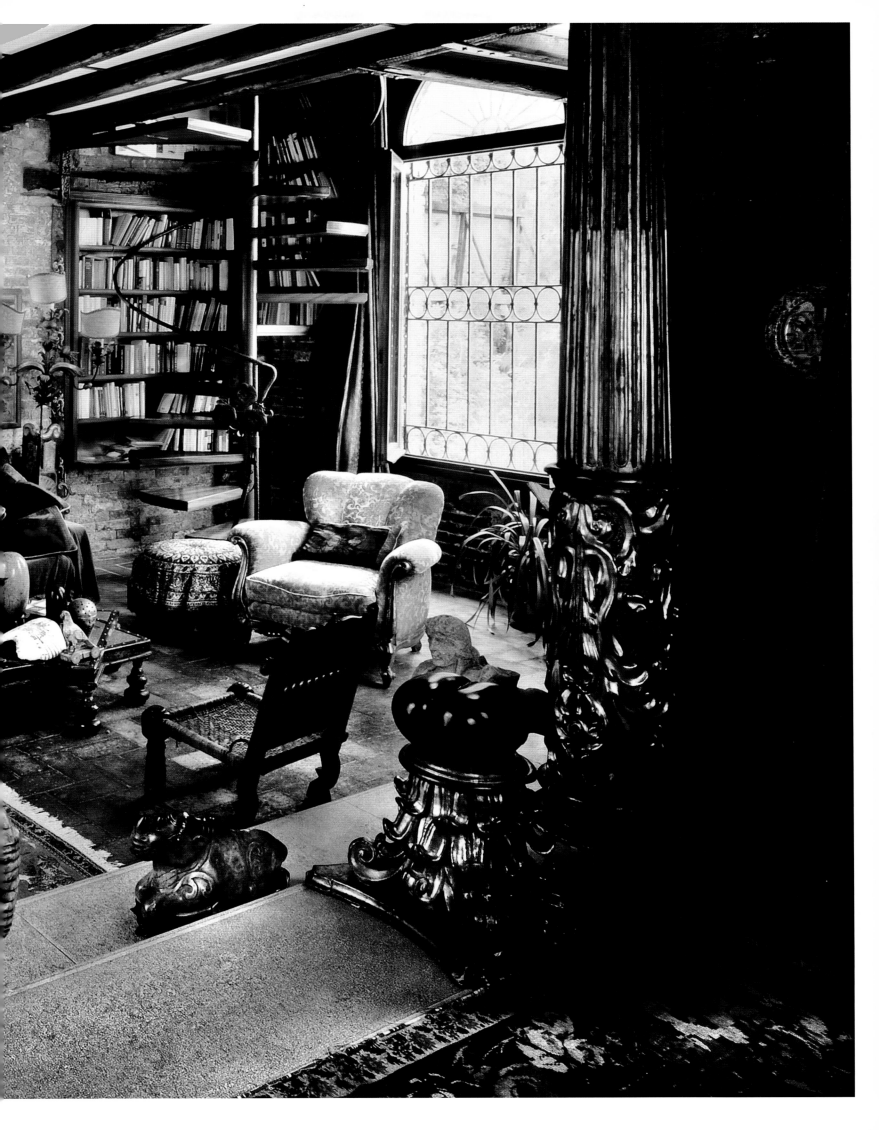

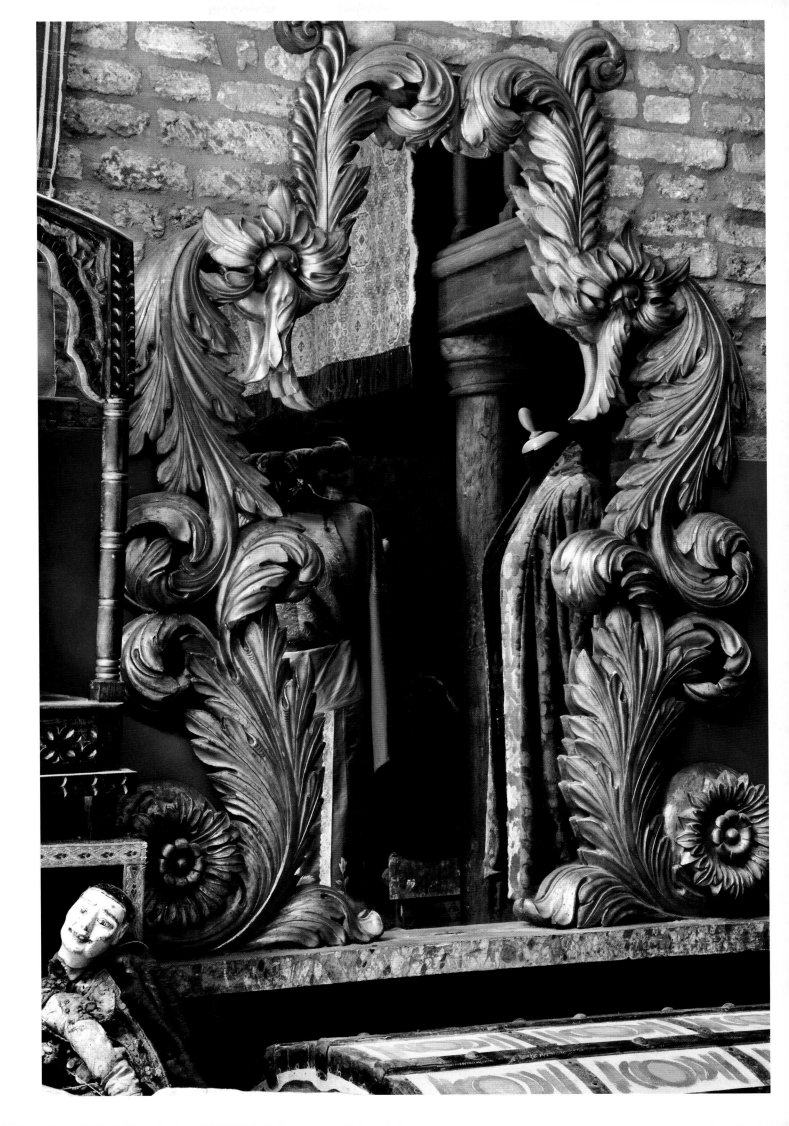

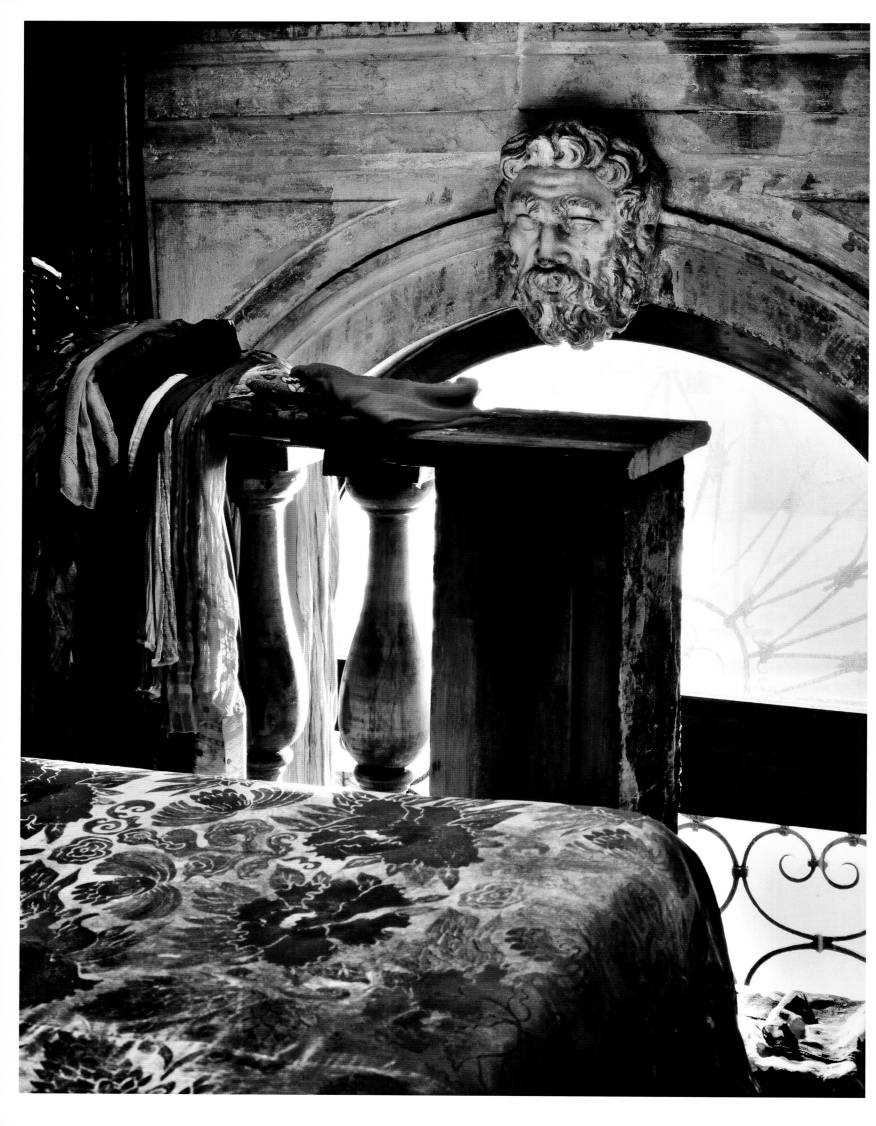

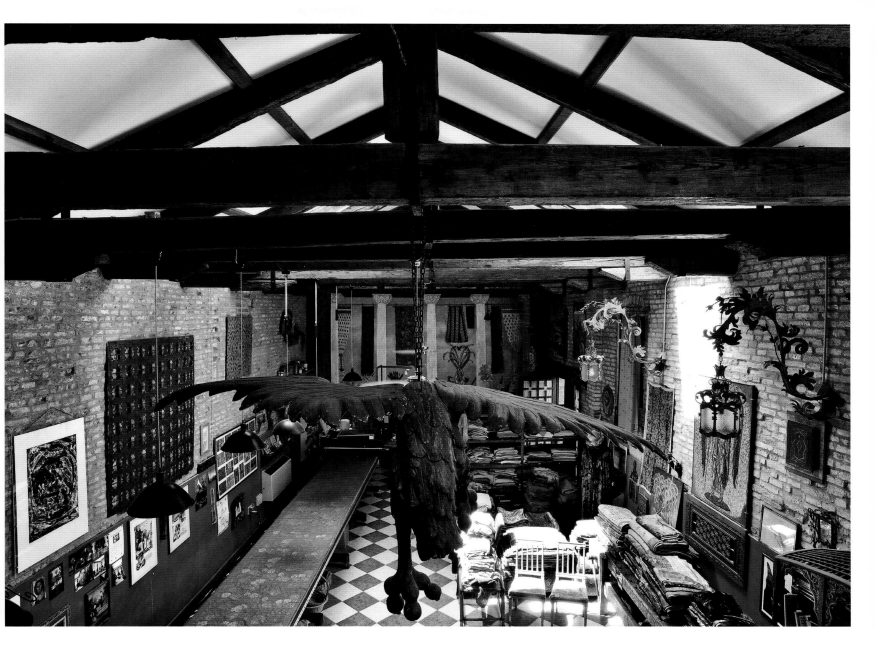

remained the same even after it was turned into a home—there are only three doors, one for the main entrance and two for the bathrooms—divided into three functional areas. The vestibule, living room, and kitchen all have arches and are set at different levels; some of the settings are original, and others were added on during the renovation. The bedroom is situated on a large mezzanine that can be reached from the living room by a spiral staircase featuring a wrought-iron railing decorated with a floral motif.

The furnishings here are like a long existential voyage reflecting Spinella's fresh, exuberant taste and her tendency to cross-pollinate periods, styles, and origins, as well as her inclination to freely mix and match different things, unencumbered by any aesthetic preconceptions. One brand-new bookcase is lit by an antique mosque lamp and has shutters featuring chivalric scenes painted on leather by an eighteenth-century Piedmontese artist. The seventeenth-century fireplace in the living room is topped by an ornate Turkish brass plate, and an eighteenth-century Italian gilt-wood table combines with the symbols of the myth of Shiva. A Tibetan Buddha imparts an atmosphere of serenity, while a grouping of symbolic animal sculptures watches over the majestic columns and art nouveau windows of a Neapolitan palazzo. The dining area features wintry hunting scenes typical of Russian romantic painting, while a nearby space showcases three nineteenth-century Chinese cloisonné birds and a large art nouveau tapestry. Everything here adheres to a vision that is as exotic as it is eclectic. "I like to mix things, put them next to each other, accumulate," Spinella explains, "and anyway, life is one continuous overlapping of objects, events, images, and emotions." Like the emotion of searching this entire house for that famous thirty-foot table and never finding it. "Oh, don't worry," Spinella says, "it's in my studio, nearby. This house is my refuge."

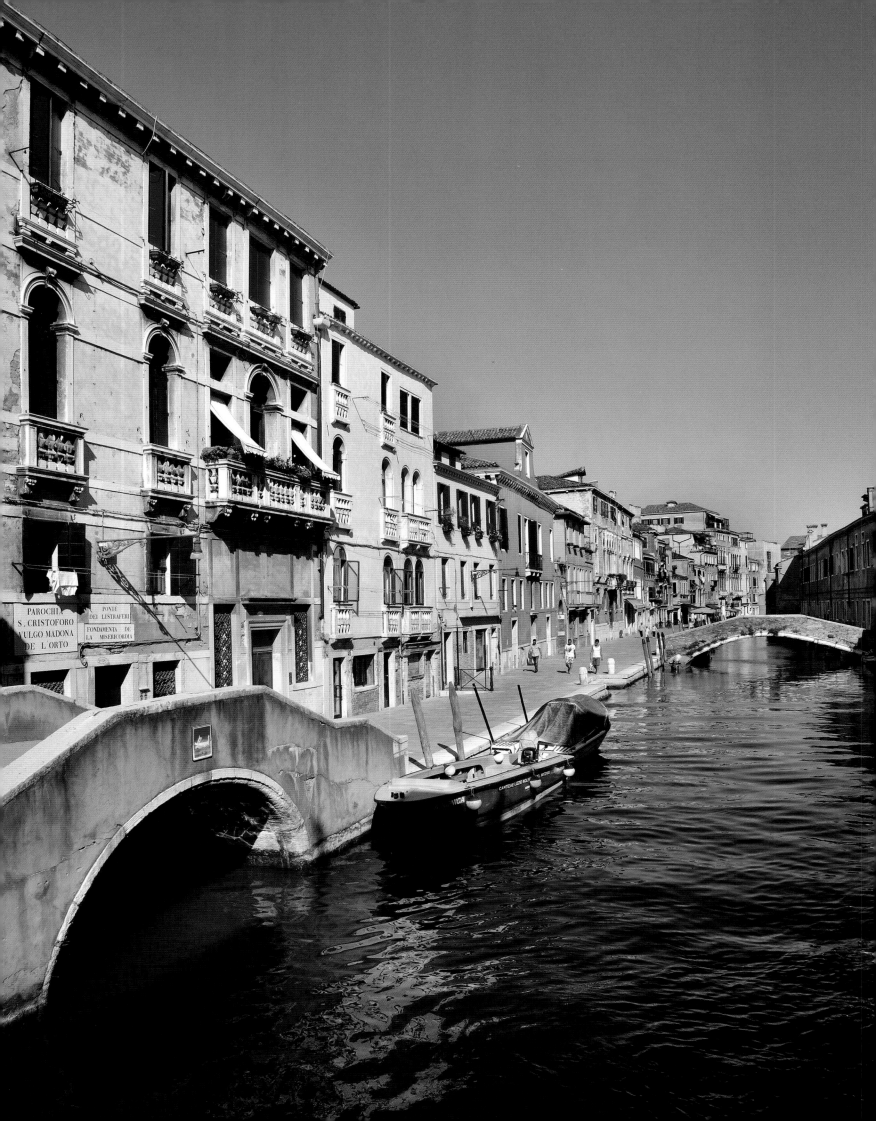

S. CRISTOFORO
VULGO MADONA
DE L'ORTO

In the Shadow of the Frari

This ancient house is arranged in reverse order. It lies in the heart of the San Polo sestiere, and begins where others usually end: from the terrace, where you can get a feeling for the spirit of the house. As the esoteric Egyptologist René-Adolphe Schwaller once said, "All houses have a spirit, and that is true in Venice more than anywhere else." Here you can perceive its emotional weave, the fact that it's a close-knit palimpsest of many interiorities and just as many exteriorities. The prime mover behind this feeling is one of the large circular windows, specifically the one in the transept of the Basilica of Santa Maria Gloriosa dei Frari, known simply as "i Frari," and which overlooks the house.

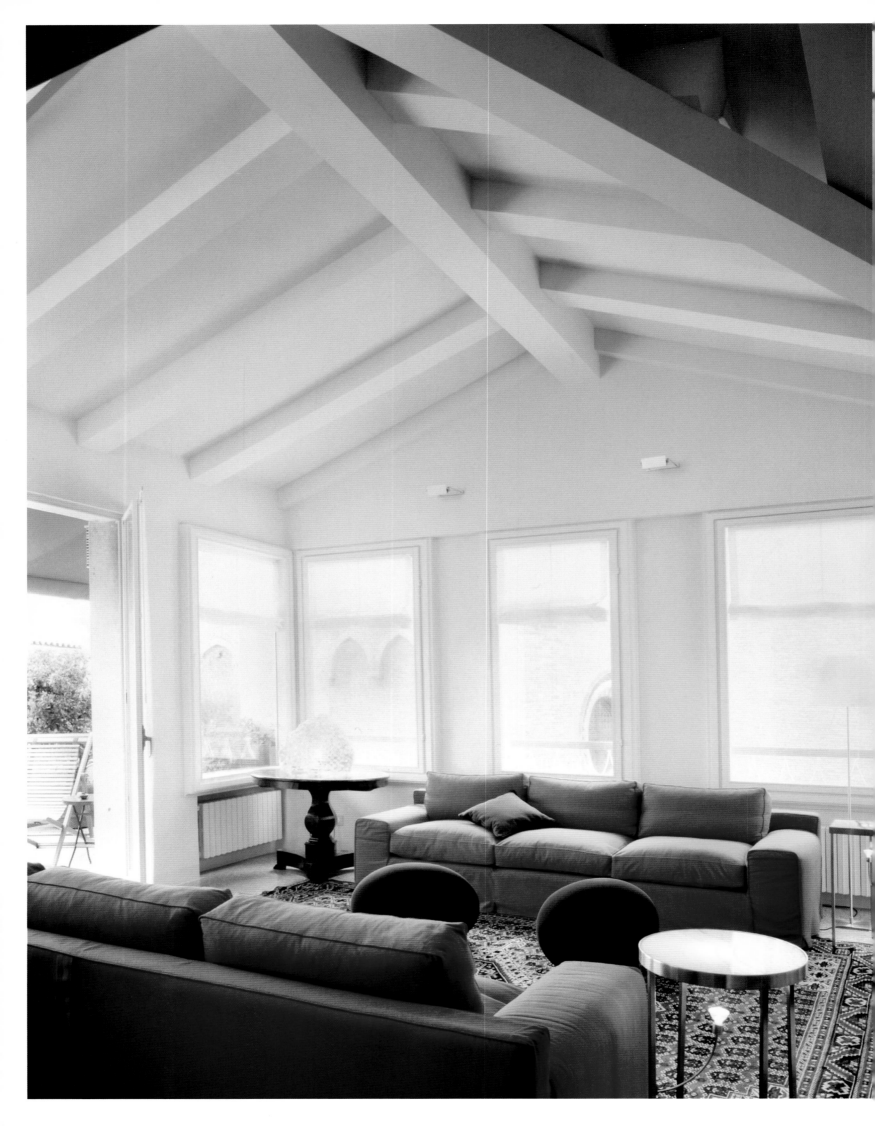

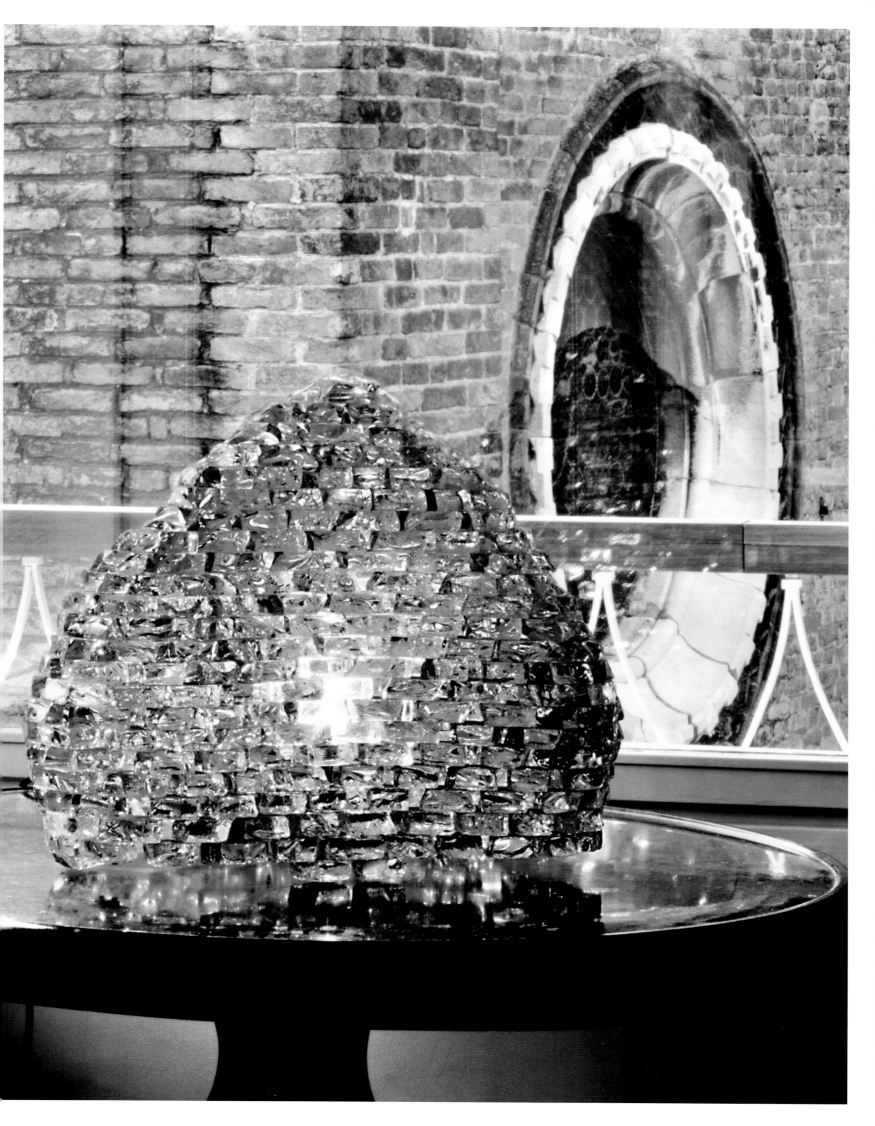

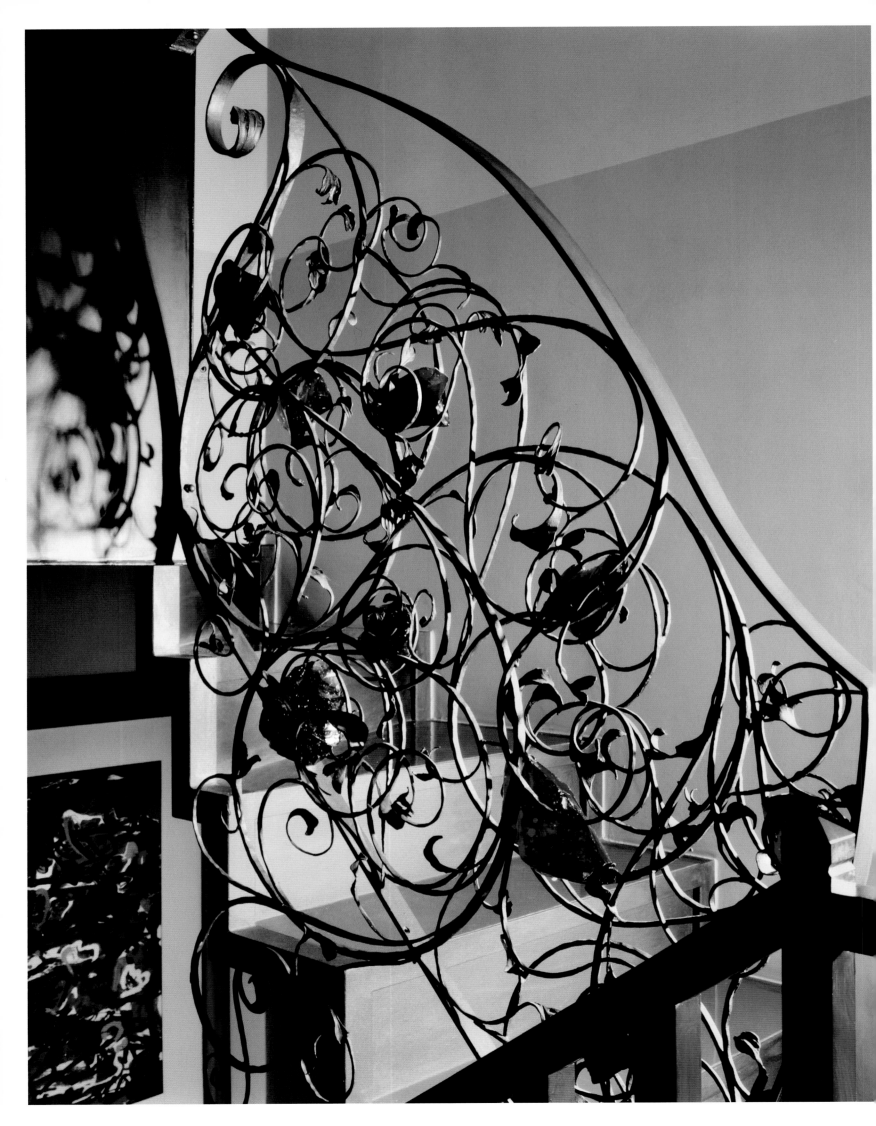

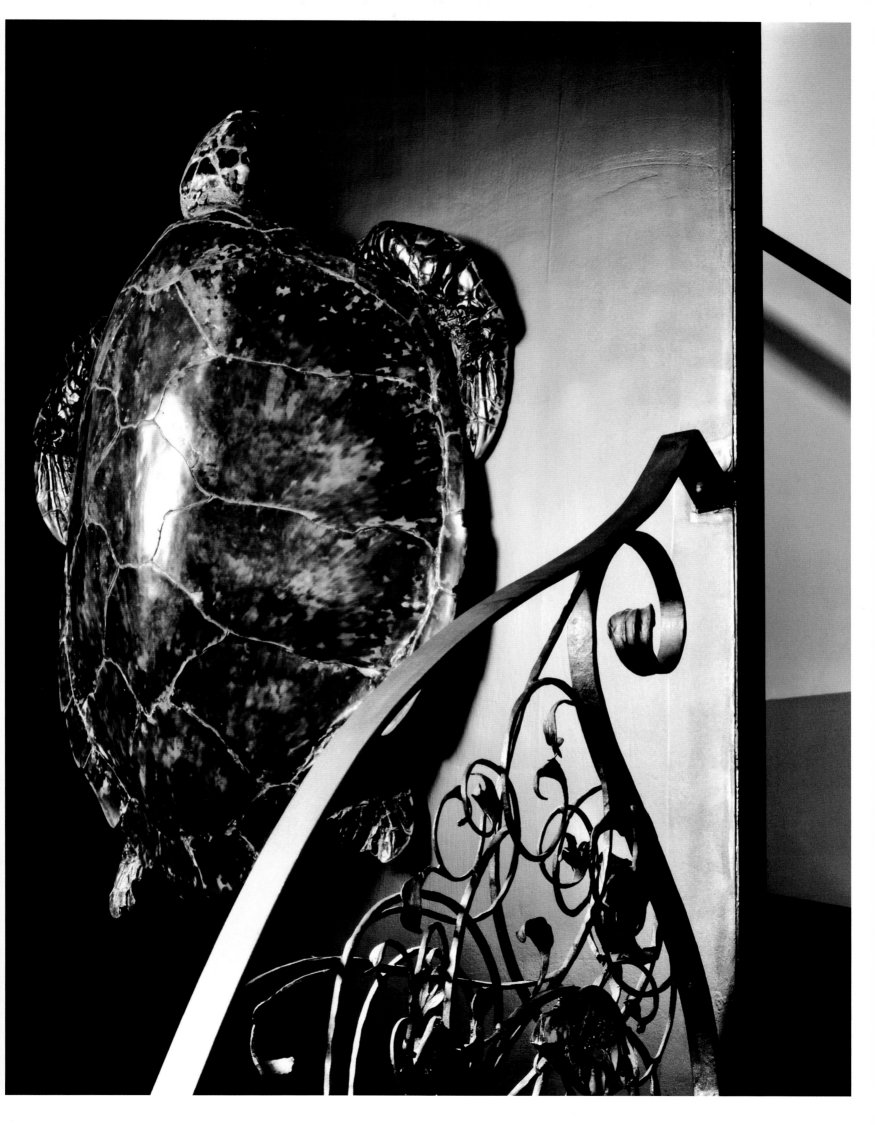

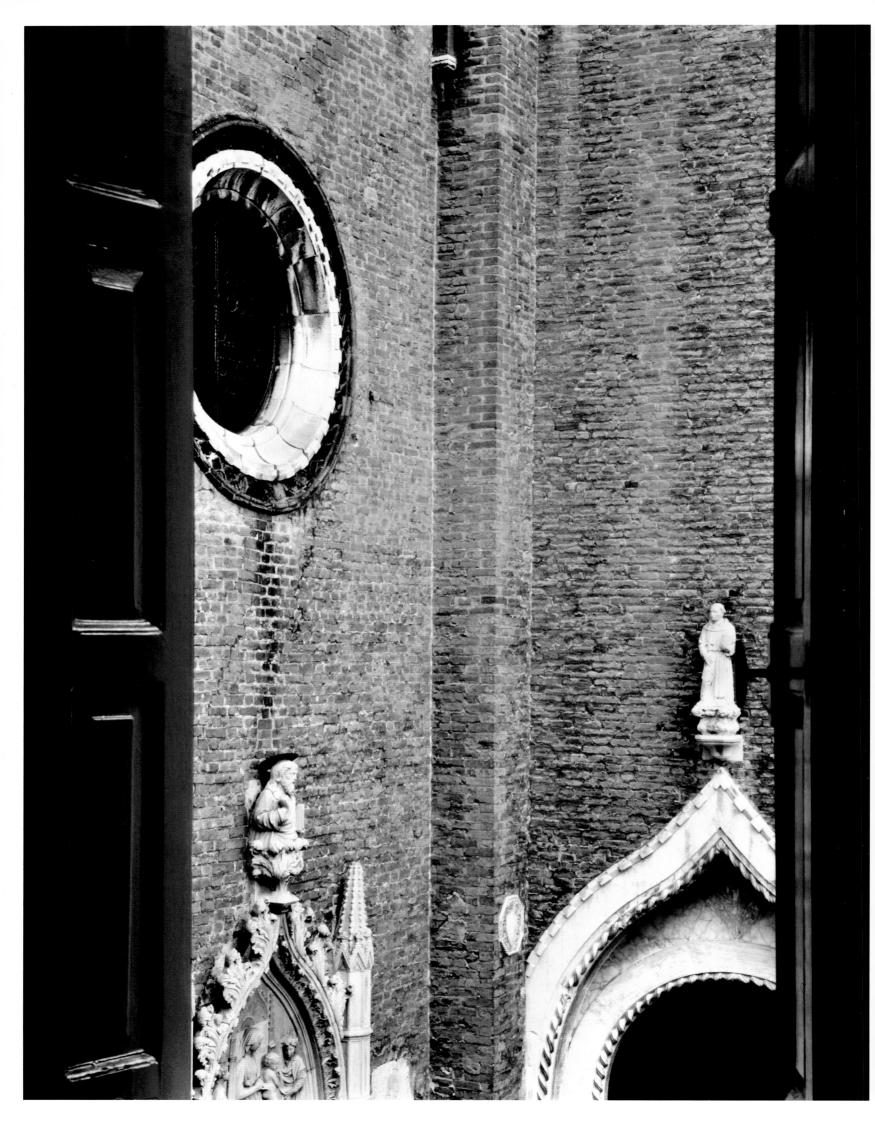

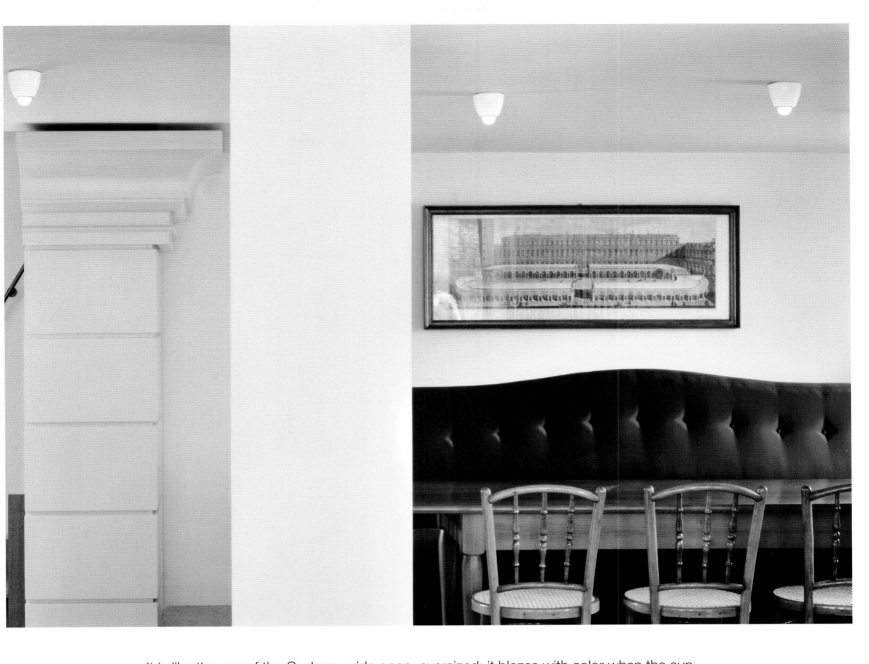

It is like the eye of the Cyclops, wide open, oversized; it blazes with color when the sun strikes it, and glimmers with the full moon. Its curious, somewhat astonished, magical gaze seems to explore this home, and asks to be looked at in turn. It creates a divide, imposing a perceptive dualism between inside and outside. In the words of Corrado Anselmi, the architect who designed and remodeled the house a few years ago, "It would seem to be one of those combinations of the unconscious that Jung talked about, but it's true: it's as if that eye had been looking at me while I was directing the work. In hindsight, I'd say that it guided me, that it suggested the thematic counterpoint for the work we had to do, and bestowed substance and credibility on my way of planning." His work combines and sheds light on "the needs of the person who has to live there—I call them signals—and my aesthetic ideas. I fuse my client's memories with my own creative emotions." The motif of the eye is a metaphor for the double gaze—one inward, one outward—and can be seen everywhere in the house. It is a continuous epiphany that suggests a journey both within ourselves and toward somewhere else yet to be discovered. It is the common thread of a decorative approach redolent of deep mystery—and, if you look closely, it's also a very Venetian motif. "This was supposed to be a real Venetian home for real Venetians, who are all great travelers," explains the architect, "but not at all a knockoff of the stereotypical 'historic' palazzo owned by a collector, much less a bohemian apartment. So I decided to build on the basic architecture, which was actually quite spartan, and designed an intervention that was supposed to convey both lightness and a degree of monumentality. I used the large window of the Frari, and more or less the entire facade of the church, to dramatize and at the same time calm the domestic landscape, to give it a deeper, more insightful, yet not necessarily rational content." A strong esoteric undercurrent can be felt

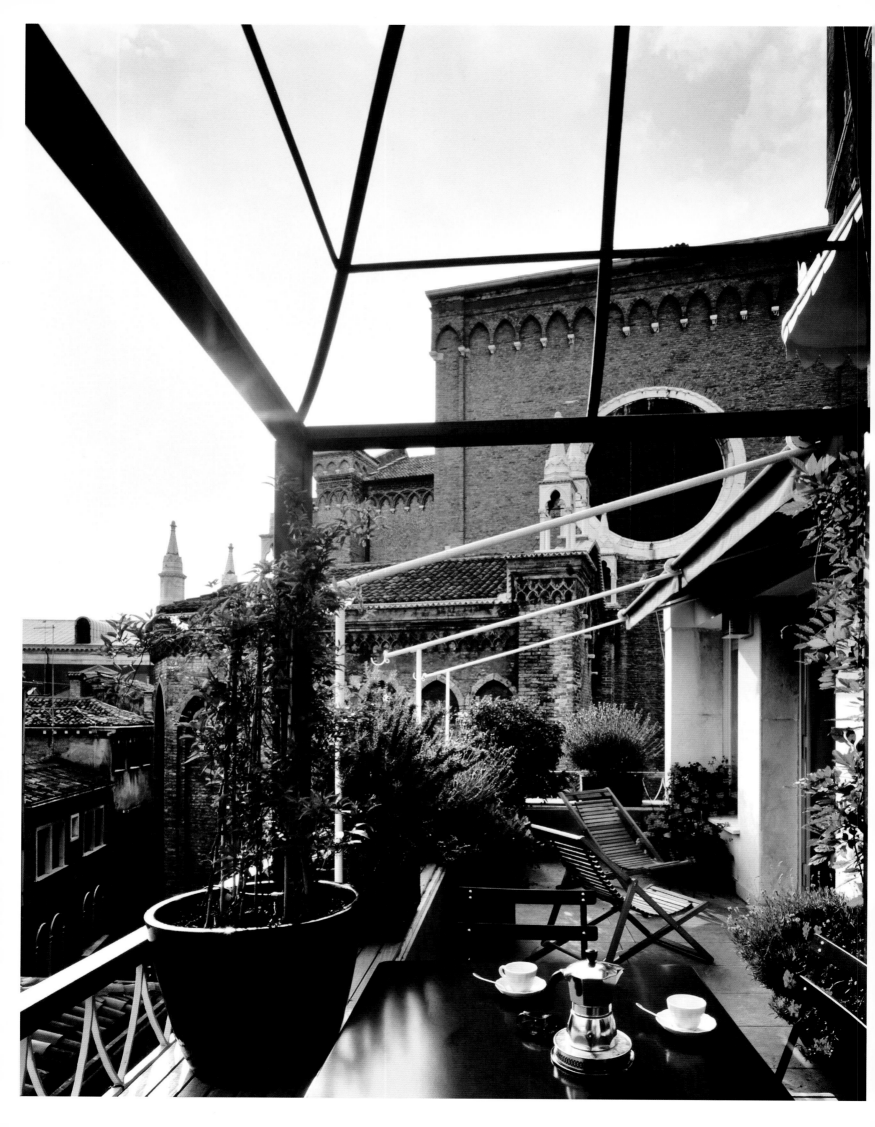

in the living room, where the porthole glints between the filigree of the curtains as if the whole building were crossing paths with Captain Nemo's *Nautilus*, or overlooking the statuary of some Asian temple. The eye scrutinizes everything here, and the designer's "signals" and fantasies are artfully combined in the way the space has been divided between sitting room, dining area, and kitchen.

A lamp made from a jumble of glass fragments—an object inspired by Indian tradition— spreads its segmented light across red sofas and side tables that in turn illuminate the space, creating a dusky effect. This creates a peaceful, proportioned ambience best inhabited by people who like to be lulled by the dancing rhythms of baroque music. The pitched roof and the bleached cathedral ceiling beams are reminiscent of old Central European architecture, but their brightness gives them a contemporary feel. The sitting-room floor is paved with used slabs of marble covered by a precious Oriental rug—perhaps the gift of a modern-day Marco Polo?— that stretches outward onto the terrace. The space is filled with echoes and subtle allusions, all the more effective because of their nuanced nature. They also fill the bedroom, where the enigmatic silence of a cathedral painted by Zoran Music—a local artist who also owns a gallery—converses with the architecture of the Frari, so that it's almost reflected inside the house, paired with an undulant neoclassical console. A Chinese incense-burner in the dining room is a nod to the owner's mother, who spent many years in the Far East. Anselmi clarifies: "I tried to envision the house as the plot of a story, each space is like a page that says something, not only *about* someone but also *to* someone. Its lines, both literal and figurative, are prolonged in the adjacent spaces. In a certain sense the spaces and their respective connotations are more scenic than functional, and have also designated the layout of the apartment."

This somewhat critical annotation brings us to the house's pièce de résistance, the staircase connecting the two levels. This detail deeply affects the house's decorative program. "Yes, within the interior design it represents a center of gravity," Anselmi explains, "but it's not the pivot around which the plan gravitates; rather, it's the effect of the plan. For this reason it has that tormented, twirling movement that gives it an expressionist touch. It doesn't have a linear, neat development; it moves in fits and starts, follows the unevenness of the spaces it encounters, and actually emphasizes it, underscoring the details according to the rationale of another great Venetian architect, Carlo Scarpa." The staircase is indeed a journey within a journey. Anselmi imagined it to be a condensation of the project, the quintessence of the unique spirit known as *venezianità* and its exoticism. The flowery wrought-iron railing is inspired by the side railing that was originally at the Peggy Guggenheim Collection, and ascending it turns into an artistic stroll studded with contemporary paintings. The steps are finished with a resin of sorts made of the leftover materials gleaned from the crucibles and kilns of Murano. Amid all that, the element that perhaps best defines this house is the large tortoise shell that motionlessly welcomes you to the upper floor. According to the architect, "Besides being a precious and fascinating object—we found it at an antiques market—it sums up the spirit of the house. It is a multifaceted symbol. For the Chinese it represents the integration between the circle and the square, hence the stability of the universe and the values underlying it. In Western esotericism, especially Freemasonry, it's an emblem of the arts and sciences. As the longest-living animal in the world, it tells us that slowness is the only way to live a long, good life, and at the same time it alludes to and prophesizes the longevity of the home. It's exotic, but in some ways also quite Venetian; it's also depicted in the mosaics of the Basilica of Aquileia, which was a major Byzantine city." In a sense, by hiding in its shell or protruding its head and legs, it manages to live both inside and outside itself, just like this house. It is a wonderful shelter to return to because inside, thanks to a few carefully placed decorative pieces and a barely perceptible arrangement of signs, the journey continues, is multiplied, and ventures into the realm of memories and dreams.

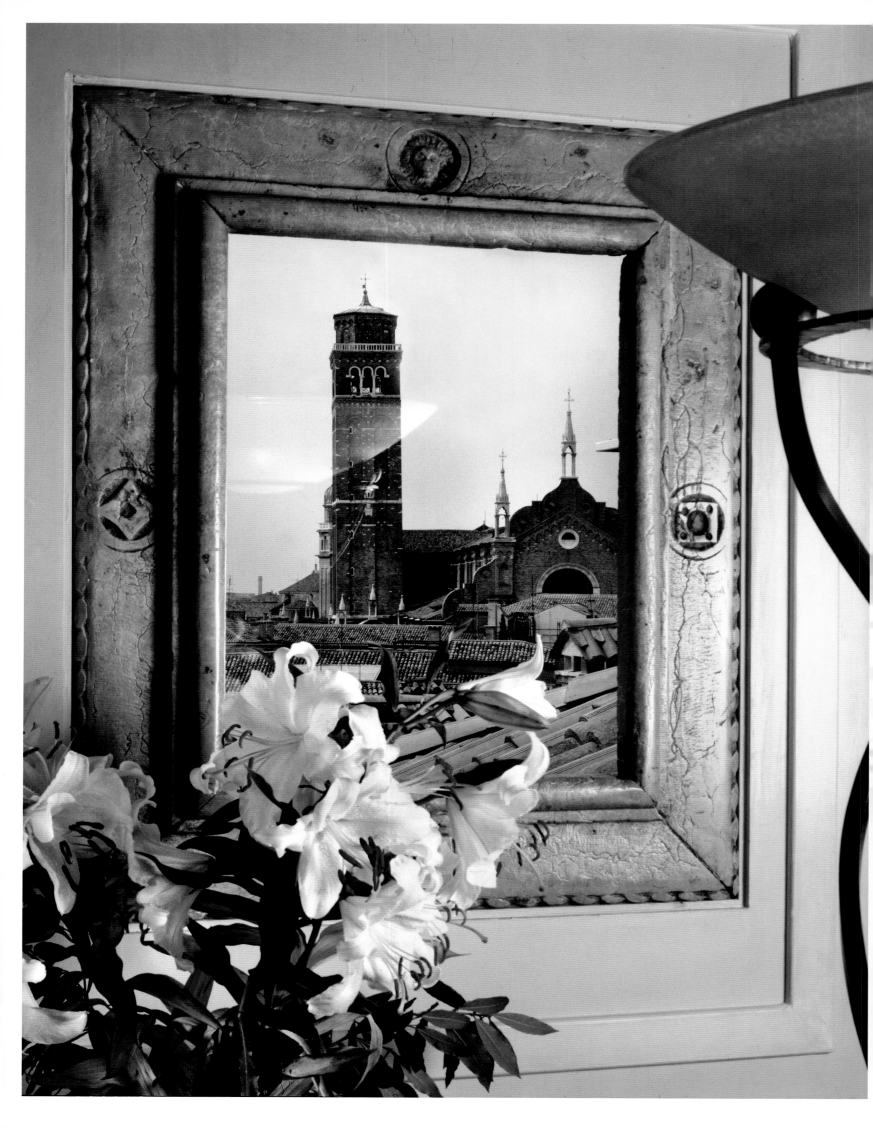

Baroque Style in the Attic

Mark Twain once said that history *is* Venice. This home, situated in the attic of a medieval Venetian palazzo, has at least three histories, and perhaps even more. The first becomes clear from its location in the San Polo sestiere, an area that can also be described as the jaws of one of the two fish biting into each other, which is what the city map actually looks like. A rapid succession of bridges, calle, campi, campielli, patrician palazzi, colorful houses, famous churches, and artistic masterpieces all revolve around Campo San Polo, the second-largest Venetian square after Saint Mark's.

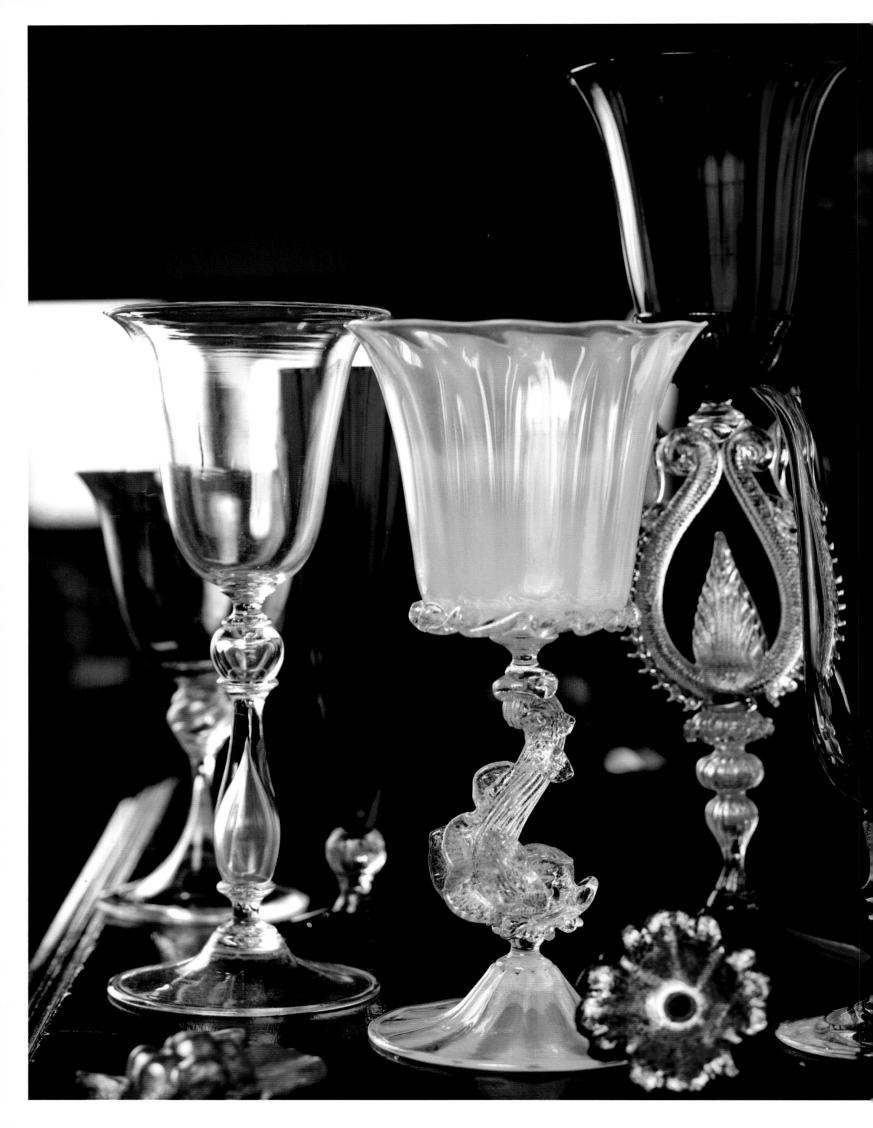

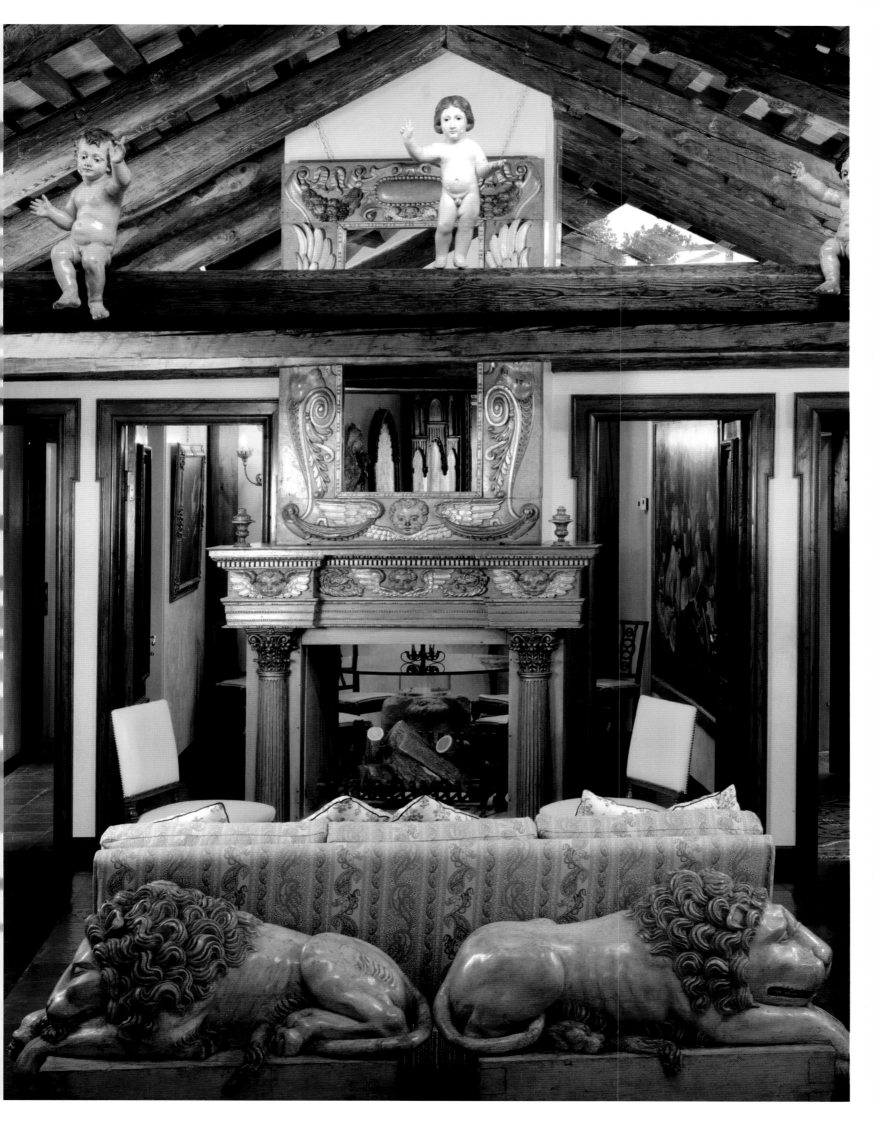

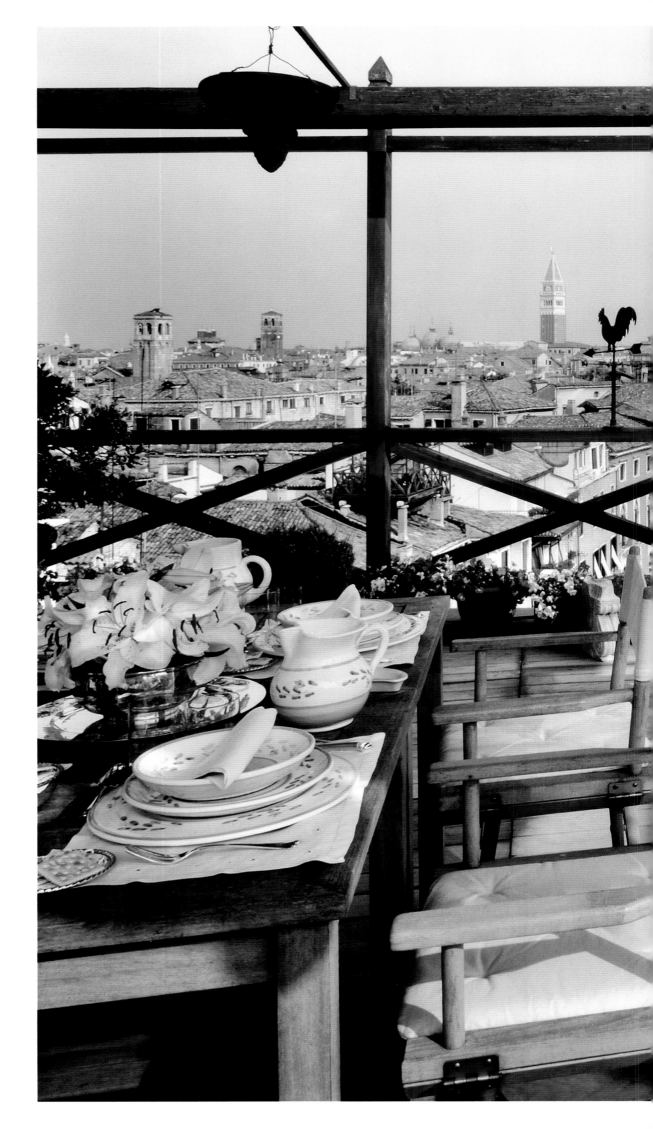

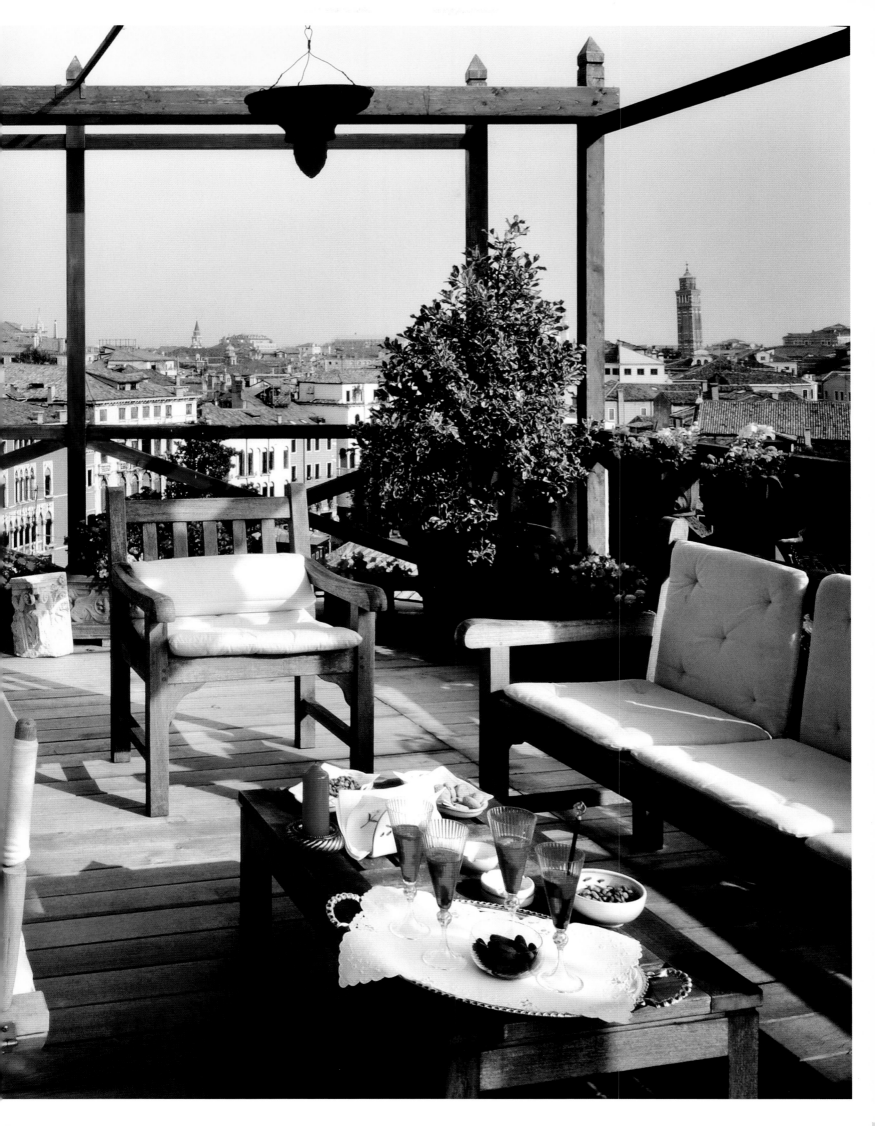

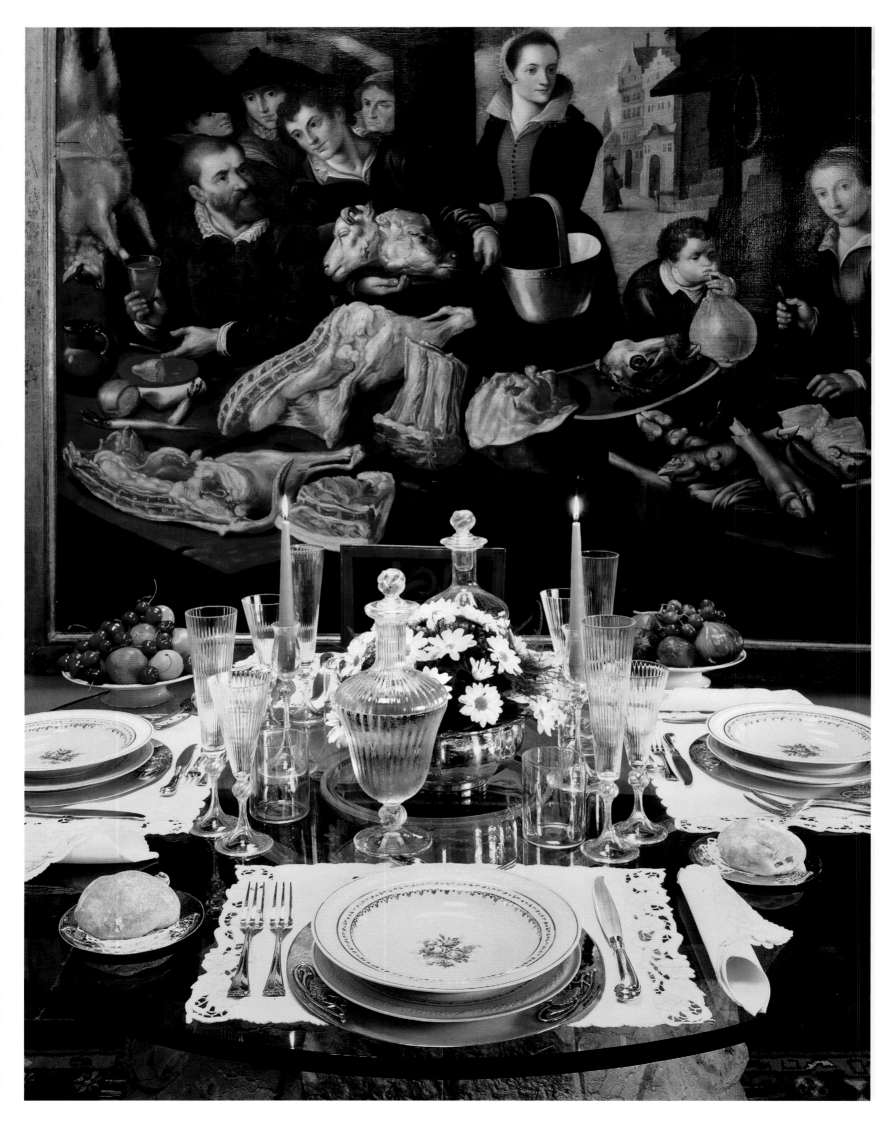

The famous Gozzi brothers—Carlo Gozzi was a writer, and Gaspare Gozzi was an inventor who also edited the forerunner of the daily newspaper *Gazzetta Veneta*—were born here, as was Carlo Goldoni. In his own words, "I was born in Venice in 1707, in a large and beautiful house located between the Nomboli and Donna Onesta bridges, on the corner of Via di Cà Cent'anni, in the parish of San Tommaso." Donna Onesta is, if not quite another history, at least a solid legend. The name means "honest woman," and refers to a character from a humble background who was the beautiful wife of a sword maker. The aristocratic Marchetto Rizzo fell in love with her and, trying to find a way to court her, had asked her husband to make him a dagger. Failing to seduce her through persuasion, he raped her. Shame drove her to suicide— with a dagger, of course. In this neighborhood countless contradictions are inextricably woven together: the sacred and the profane; asceticism and hedonism (San Polo was once the red-light district); the esoteric and the exoteric; faith and secrecy. Venice boasts both some of the most beautiful Christian temples, as well as traces of the old Freemasons' lodges Goldoni frequented. The Frari, with Titian's *Assumption of the Virgin*, stands in splendid contrast to Palazzo Fortuny, which exudes the eclectic, sensuous creativity of Mariano Fortuny. "Singularly spirited and graceful," the English aesthete John Ruskin once observed.

The second history lies in the palazzo itself, a medieval building that has been restructured several times. It was originally owned by the noble Sanudo family, which, according to tradition, was also related to the Candiano family, another line of powerful Venetians. Divided across several branches, its men were prominent crusaders, diplomats, dukes, geographers, politicians, and mathematicians. Its illustrious members included Francesco Sanudo, a governor during the fifteenth-century War of Ferrara, as well as Marin Sanudo the Younger, an erudite scholar and chronicler who published the diaries he kept between 1498 and 1533, an important record of Venetian life. This palazzo was his, and not only does it still shows traces of events from his lifetime, but it has also maintained a palpably aristocratic atmosphere.

These two histories are part and parcel of the house. You enter through the flowering terrace, and the views offered by the windows betray the substantial history lying within the walls and in the solid antiquity of the beams. These two histories lead up to yet another, and the third history is that of the house itself. Originally, it was just an attic, an empty space with powerful trusses, dim lighting, and the deteriorated memories of many centuries heaped together haphazardly in the dust. Today it is a magnificent seventeenth-century Venetian theater, thanks to fifteen years of passionate research by a Milanese antiquarian and the architectural design of Nani Prina, a longtime director of the magazine *Ville Giardini*. Together the two redesigned the large hall, distinguished by its steeply pitched roof and series of support pillars: they refurbished the antique flooring, designated the functional areas to leave ample room for the living and dining rooms, and imbued the bedrooms with an aura of cozy intimacy. They also revamped the lighting system by opening up skylights and rows of windows with a view out over a sea of rooftops and Saint Mark's totemic bell tower. From here you can also see the Frari, which looks as if it is literally cut out from the thirteenth-century stone molding, a small digression from the seventeenth-century theme underlying the narrative progression of this building.

Indeed, the home's true essence is its seventeenth-century spirit and exuberant, lush ornamentation. It begins with a two-sided open fireplace that separates the dining room from the living room without interrupting the flow. The living room is in turn divided into three areas conducive to conversation, parlor games, and a spot where one can spend time alone, warmed by the hearth's glow. This detail was originally an altar, but a hole pierced in the middle turned it into a theatrical fireplace, complete with gilt Corinthian pilasters topped by a mirror luxuriantly decorated with festoons. Watching over it all is a procession of plump baby Jesuses perched atop a console, fruit of the homeowner's many years of collecting. There

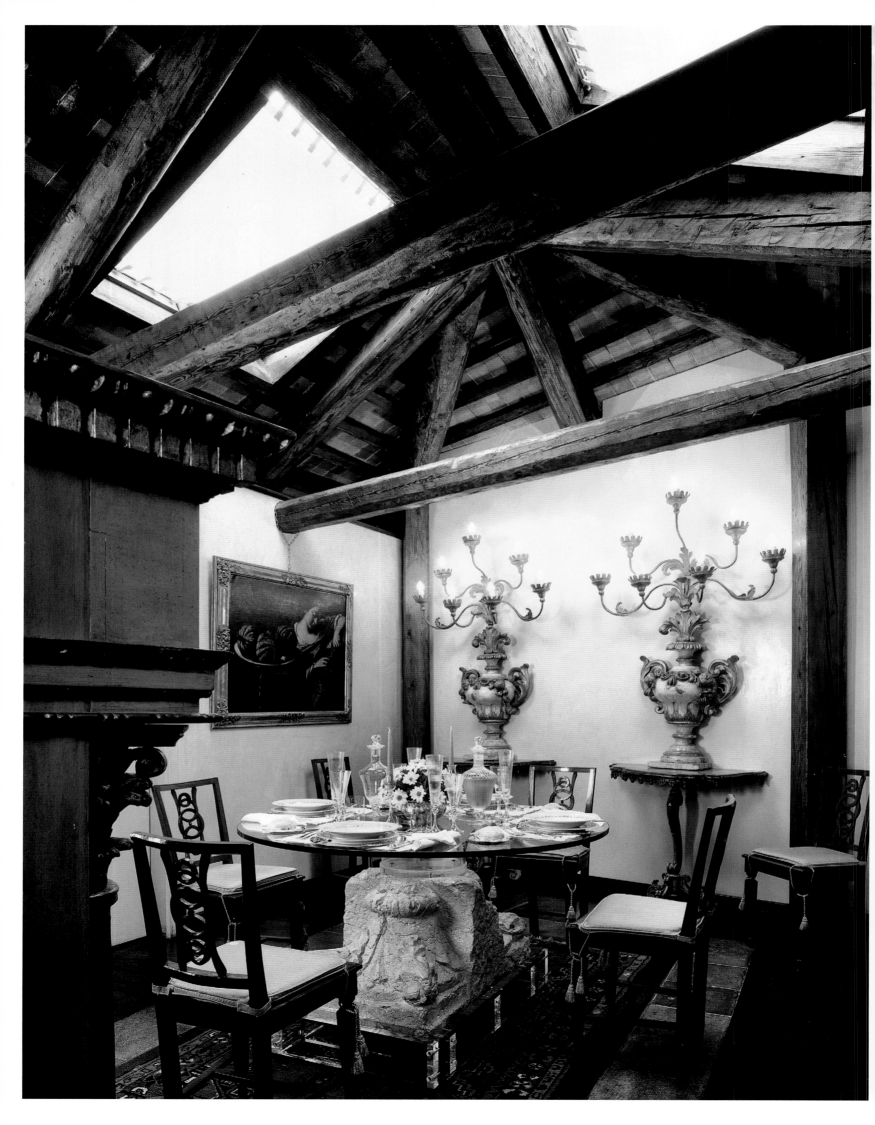

 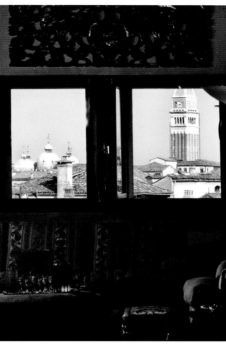 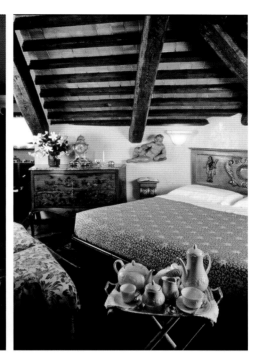

are also a number of works by Andrea Fantoni, a sculptor born near Bergamo and active throughout the late seventeenth and early eighteenth centuries, and two lacquered wooden lions crouching behind a sofa—a striking reminder of the Saint Mark's majesty.

A few modern touches can be seen here as well, but it's a retro modern, and hence looks to the past: for instance, the Terzani floor lamps roll up like the rod of Asclepius. A baroque grandiosity permeates the living room, where another spectacular fireplace and hearth are topped by an amusing collection of wine jugs—the kind used by peasants while working in the fields—as well as lyre chairs and a stunning painting of a butcher shop executed with rustic virtuosity by the Venetian school.

The scene's seventeenth-century motif is reinforced, through a pointed contrast, by the pedestal of the table with a tempered glass top: two thirteenth-century capitals have been hollowed out so that they don't weigh too heavily on the floor. Another pièce de résistance is the master bedroom, where the theme shifts from sumptuous seventeenth-century art to the much more suitable subject of love. Here that motif is transfigured into a festive seventeenth-century Venetian commode and a large wooden cupid who watches over the owners' bed . . . or is he actually spying? This was, after all, home to Sanudo, one of the Venetian Republic's greatest observers.

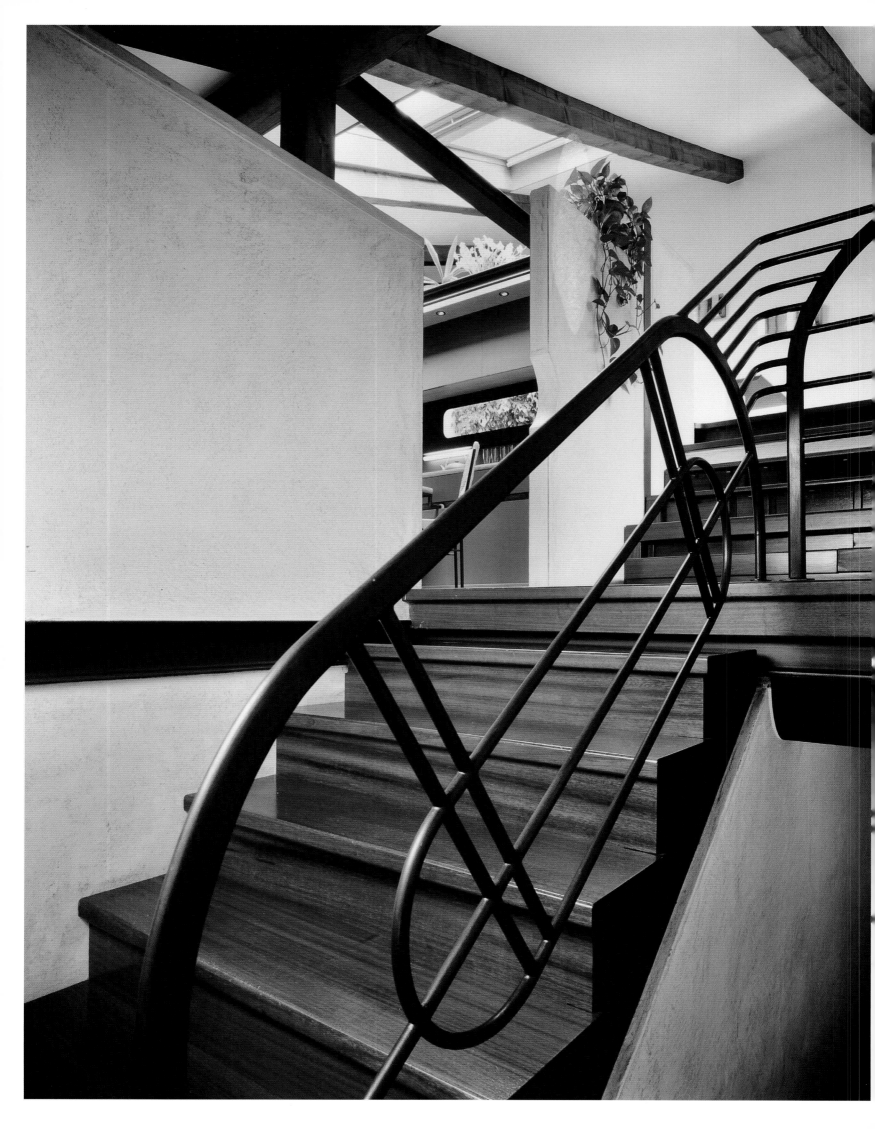

Jigsaw Rooms

In Venice much of the architectural remodeling inspired by modern ideals has taken place in attics and lofts. There is a reason for this: such storage areas have nothing beautiful about them, and therefore are not worthy of being salvaged. And yet there is a lot about them that's evocative and potentially bohemian, making them attractive to anyone who might consider reinventing them as homes. This loft is no exception, and was designed by the architect Paolo Fabris. Asked to describe the work, he takes a strong stand: "To my mind, talking about one's projects makes no sense. At best it's an exercise in rhetoric, at worst it's a futile display of narcissism, especially if the subject is a humble loft."

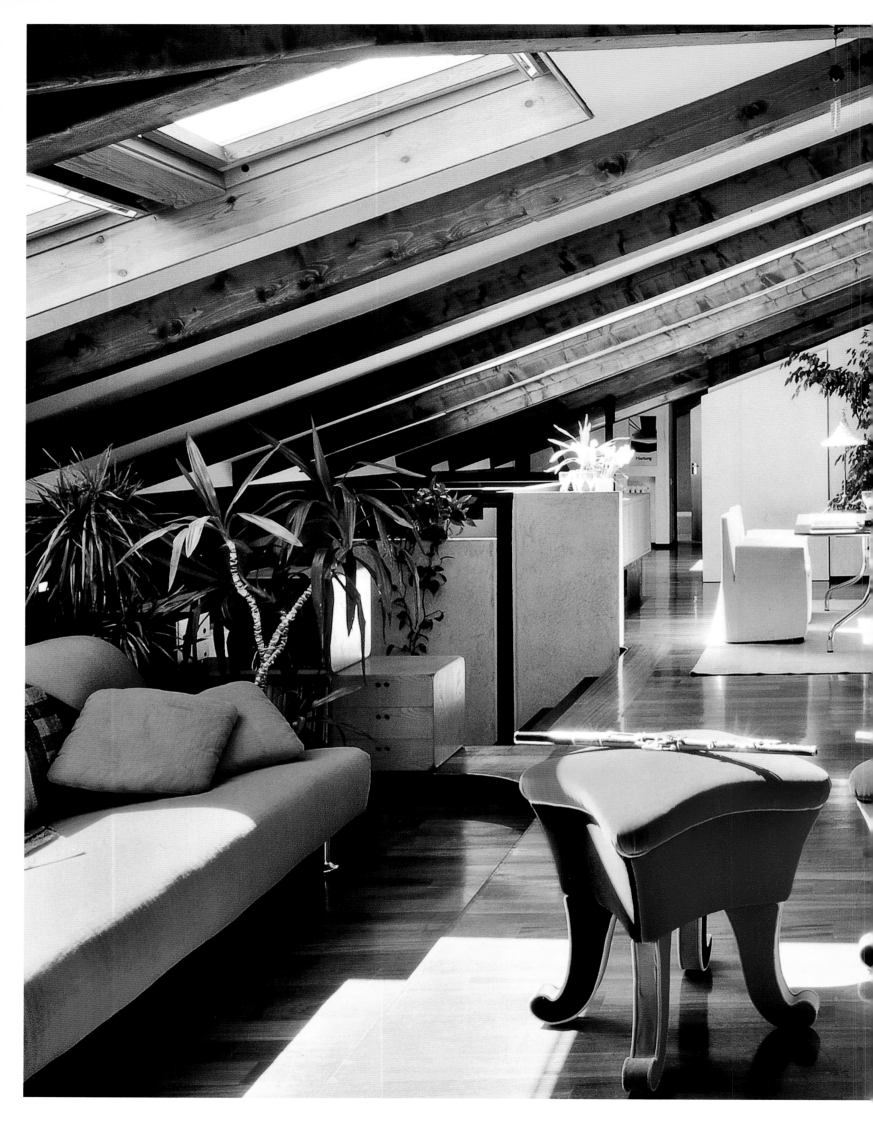

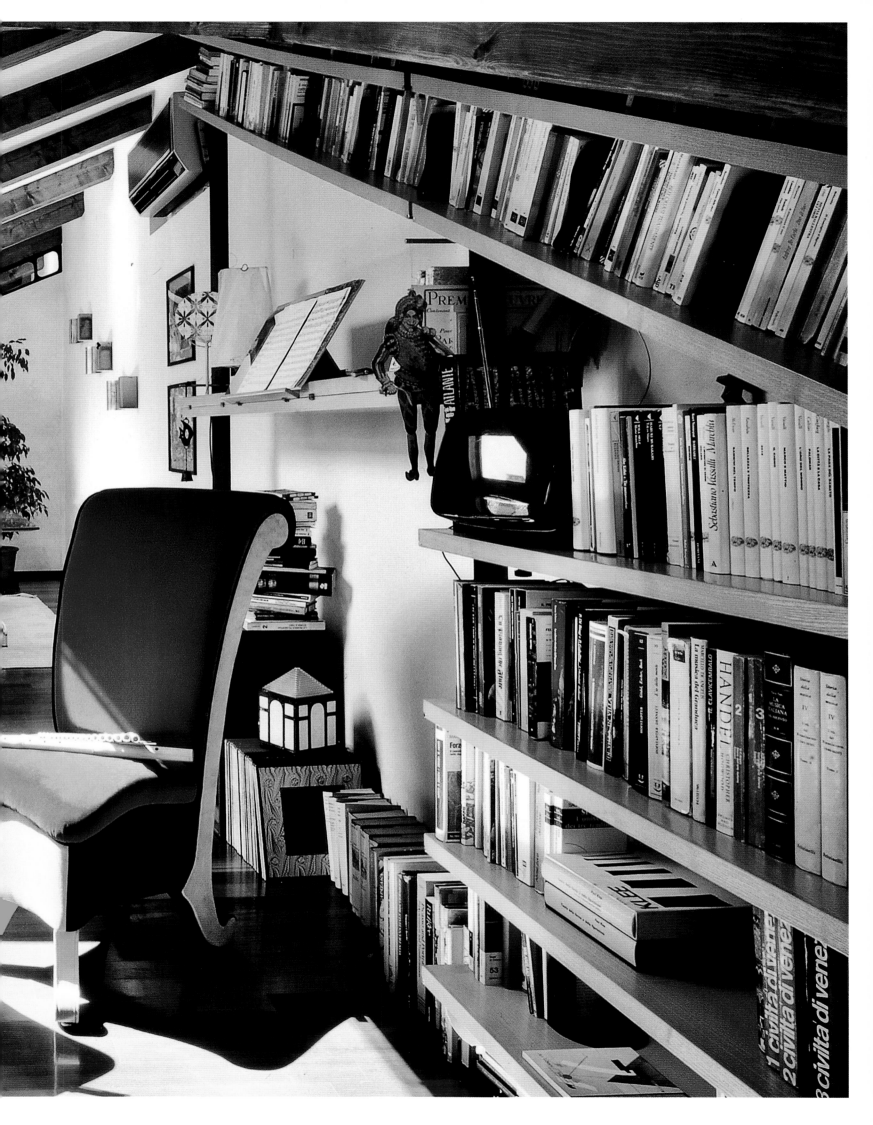

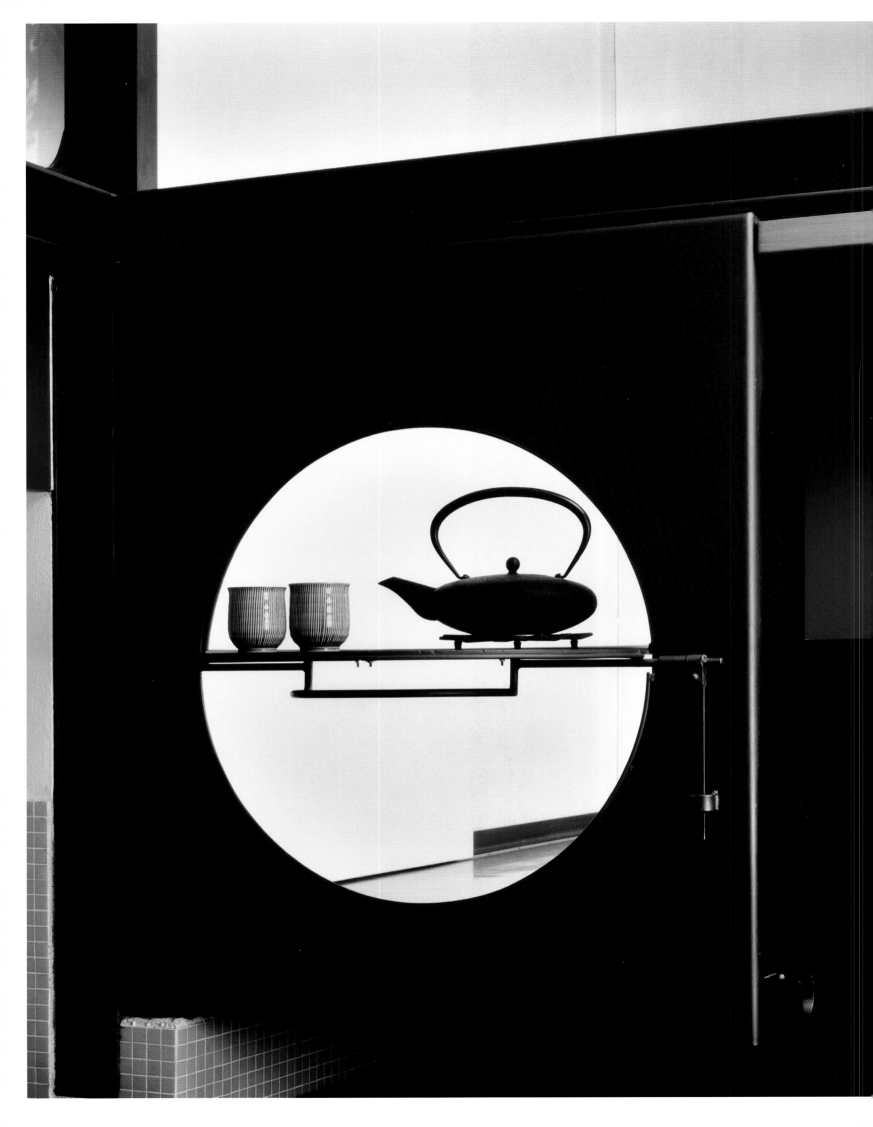

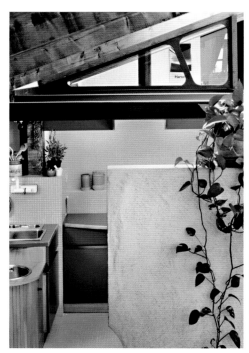
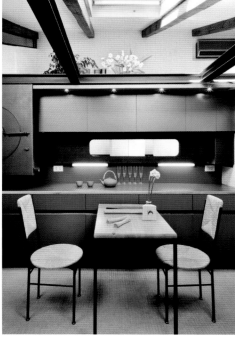

His words may have some foundation, but they certainly don't ring true in this case because this design has many interesting features, starting with the assignment itself: to transform a dark, detached, rectangular attic into a large, luminous, joyous loft suited to contemporary living. Fabris clarified, with a healthy hint of irony, that the space was "characterized by a bare minimum of not-particularly-'golden' ratios." So it was a challenge to turn it into a comfortable home suited to all its inhabitants' functional needs; it had to become a space where one could spend both time alone and evenings with friends. Both client and designer hoped to avoid arguing over every little detail, but they also had to solve the project's problems in a way that respected Venice's super-strict building restrictions—and their story deserves to be told. "To make things less complicated," the architect somewhat sarcastically notes, "we had the help of the usual bureaucratic hounds . . . All joking aside, the building authority officials actually did help: having declared the lower floors of the Gothic building unsafe because of the problem of *acqua alta,* Venice's infamous high tides, they gave us permission to transform the attic into a home, as well as build large skylights along the whole pitch of the roof. Ironic, isn't it?"

Ironic indeed, also because as soon as the attic was deemed habitable it had to be separated from the apartment beneath it, which it had been a part of for several centuries. Putting all these factors together, a project was drawn up. It called for the installation of a mechanical girder for structural reinforcement, as well as an extension of the staircase coming up from the apartment below, while the run-down, separate staircase from before was relegated to a far corner of the residence. "This change in floor plan," Fabris explains, "made it possible to create a central entrance in harmony with the plan for the loft, organizing the various living areas in a rational way. It also let us get to the lower part of the attic, to use the new yard of space discovered between the ceiling and the floor while the structural work was in progress. This layout meant we could use box stairs to connect the two levels that had previously been the living area and, next to the stairway, create a kitchen and dining area in two separate rooms connected by a swinging porthole, as well as by a door." Climbing up the sturdy wooden box stairs, you come to a living room that doubles as a study. From here, after noting the brilliant transformation of a rafter into a hanging shelf, you cross through a sliding door to reach the bedroom, where the use of magical tricks to do as much as possible in a minimal amount of

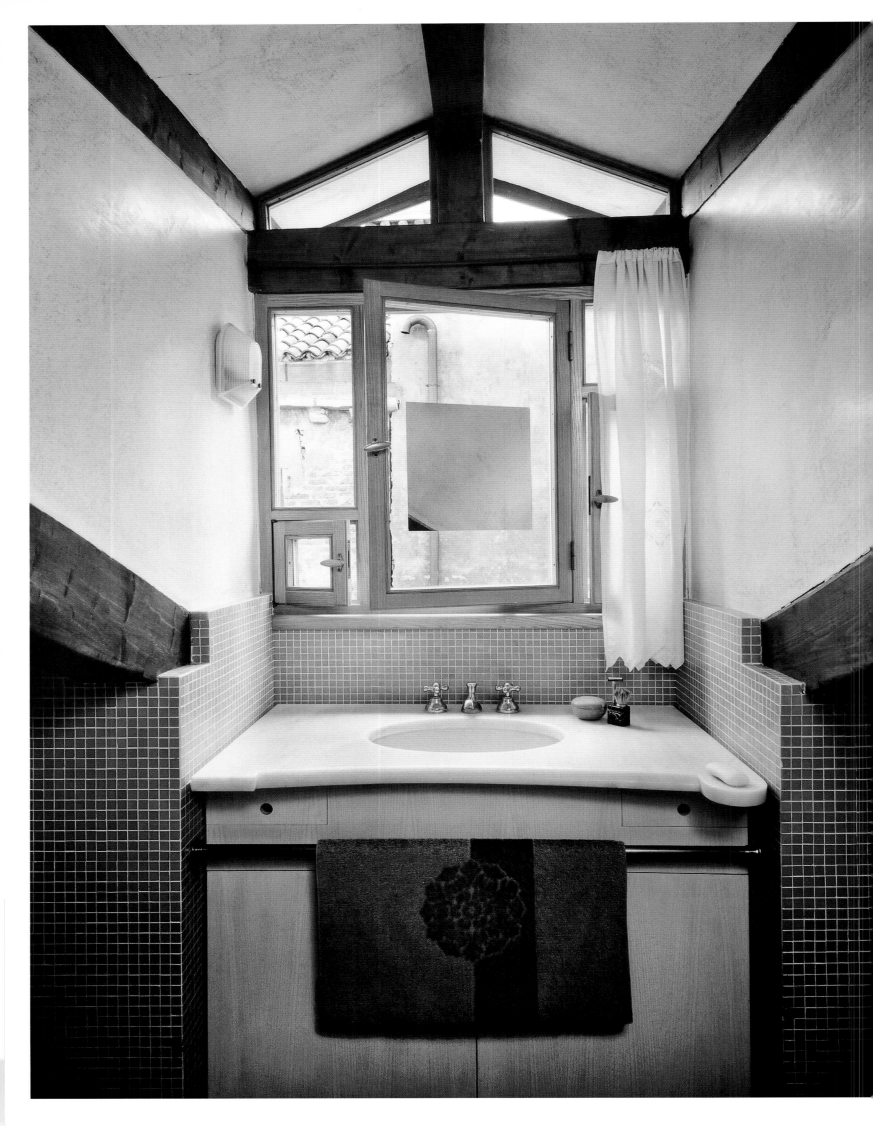

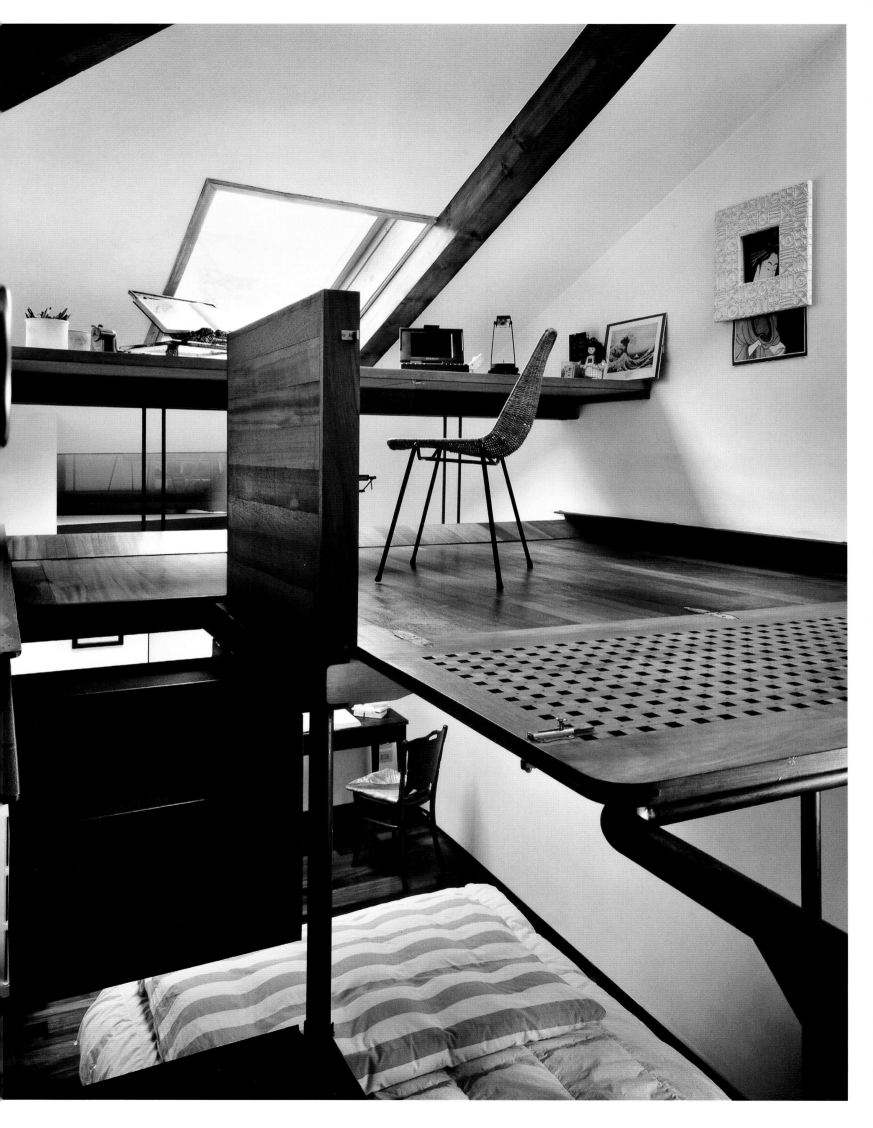

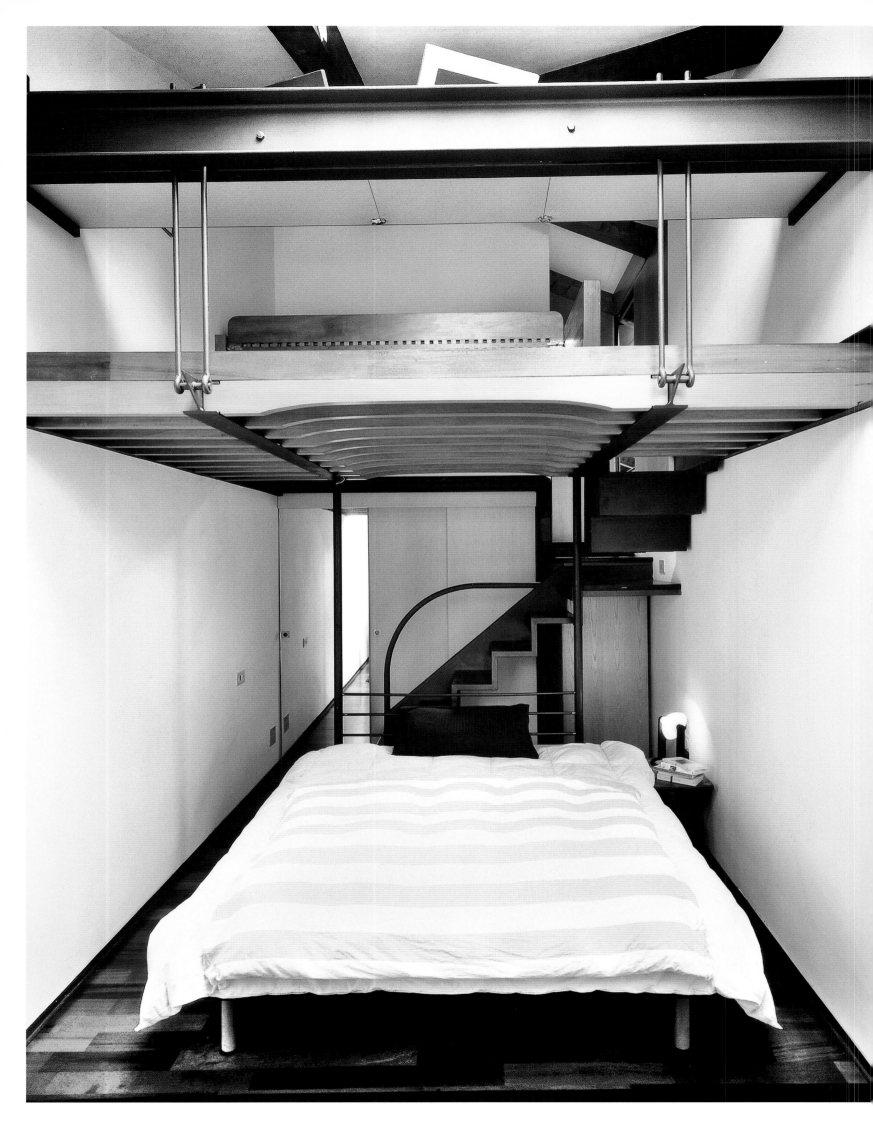

space reaches its culmination. From the first open room—part of which can be isolated thanks to a mobile furniture system—you descend to the double-height space containing the master bedroom, wardrobe, and a set of stairs leading to a mezzanine and small study. But the surprises don't end there: at the top of the stair is a sort of wooden drawbridge that, when lowered, considerably increases the mezzanine's surface area, making it possible to reach the bookcase on the other side of the stairs.

The whole house is an extraordinary puzzle of unique parts that all fit together, revealing the architect's exceptional skill at generating more space precisely where there seems to be no more room, and then linking these parts to a logical and functional plan. And there's yet another important aspect to Fabris's work: the aesthetic quality is immediately evident, and manifested in a number of ways, especially the way he pairs materials such as wood and metal. His impassioned and ingenious attention to detail is visible in all the decorative *and* functional features: when not in use, the closed porthole pass-through becomes an ornamental element; the credenza can act as a wall between the dining and kitchen areas; even the stairway railing and staffs suspending the ceiling have both beauty and utility. This array of inventions has a creativity and an essential, eloquent form reminiscent of the work of Carlo Scarpa, whose legacy is the secret ingredient in the fascinating style seen throughout this rediscovered loft.

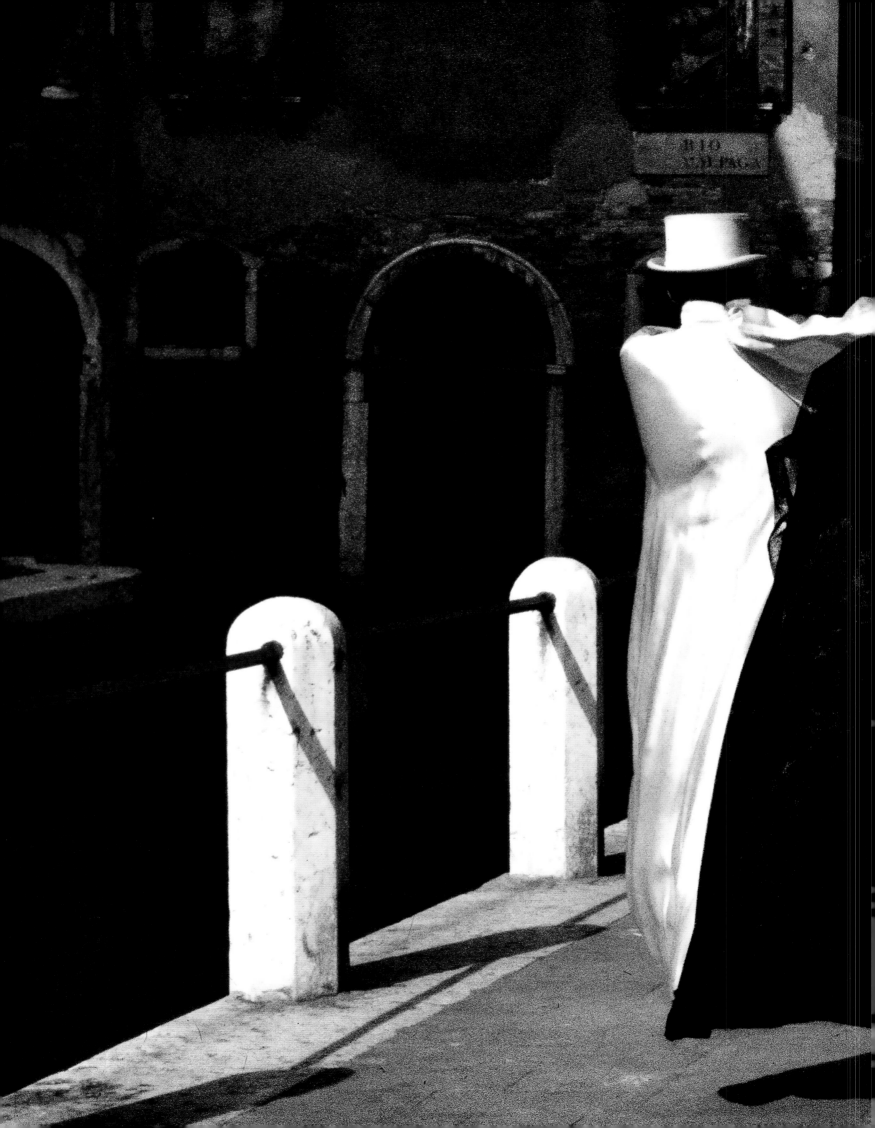

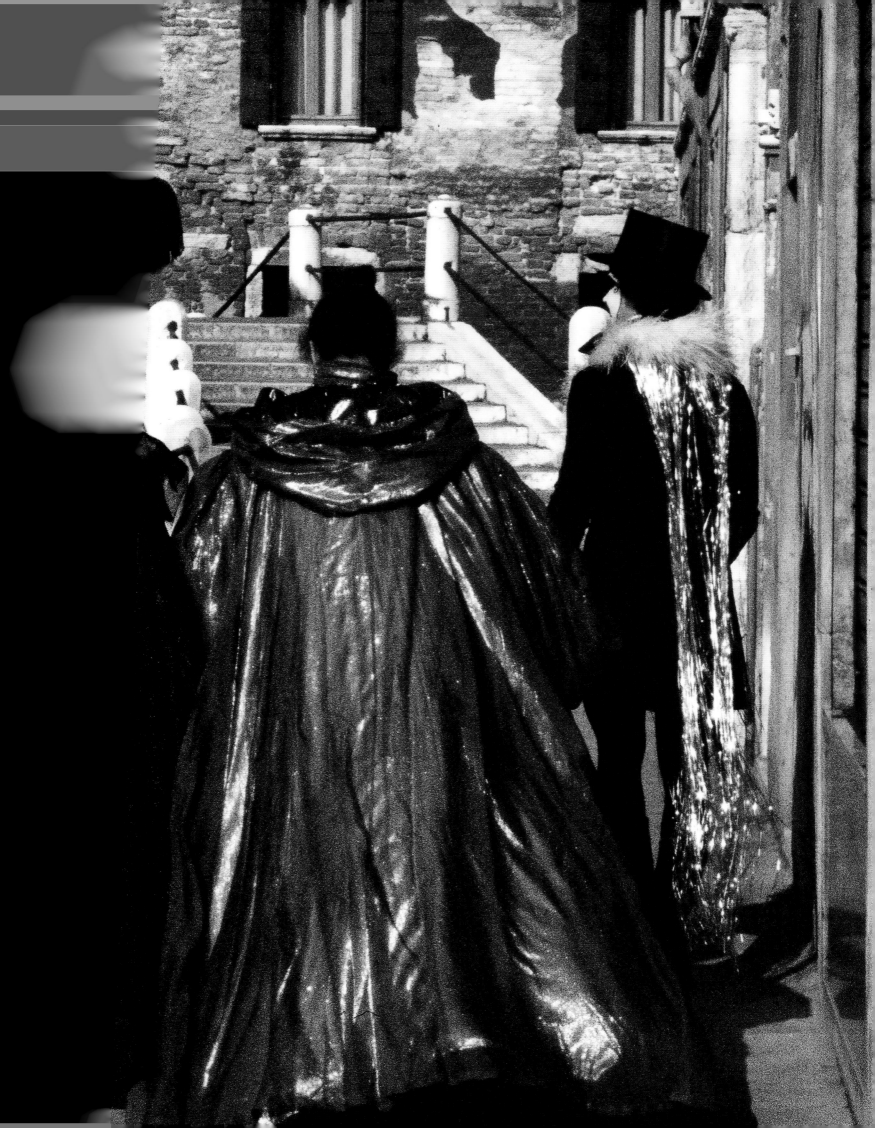

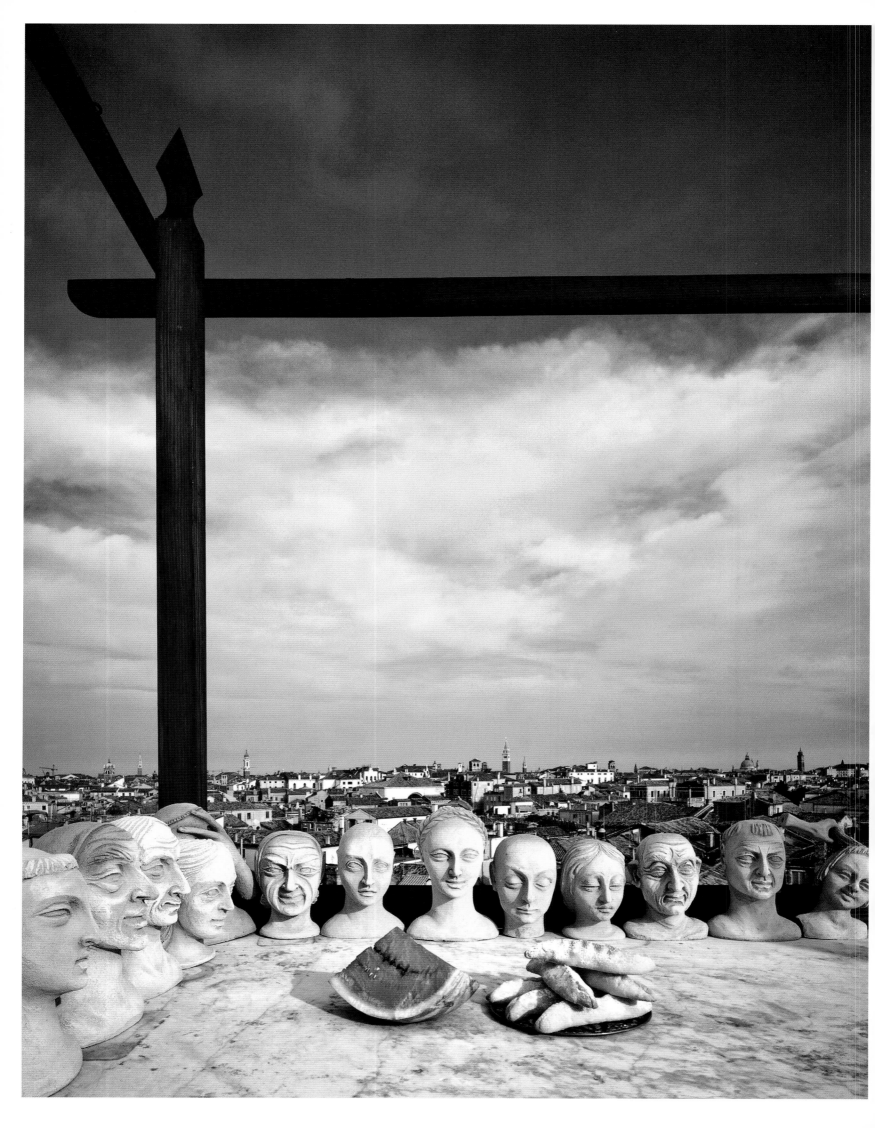

Carnival Scene

Guerrino Lovato is a multifaceted artist who sculpts papier-mâché masks; creates extraordinary contraptions for theater, opera, film, and public spaces; and is also the cofounder of Mondonovo-Le Maschere, a studio that makes masks as well as set designs and sculptures. For several years he was the Grand Prior of the Compagnia De Calza "I Antichi," the traditional confraternity founded in 1541 that was long responsible for organizing the Venetian carnival. He has painted the ceilings of the Givenchy house in Paris, designed the masks for *Eyes Wide Shut*, Stanley Kubrik's last film, and created costumes for the members of the Compagnia De Calza.

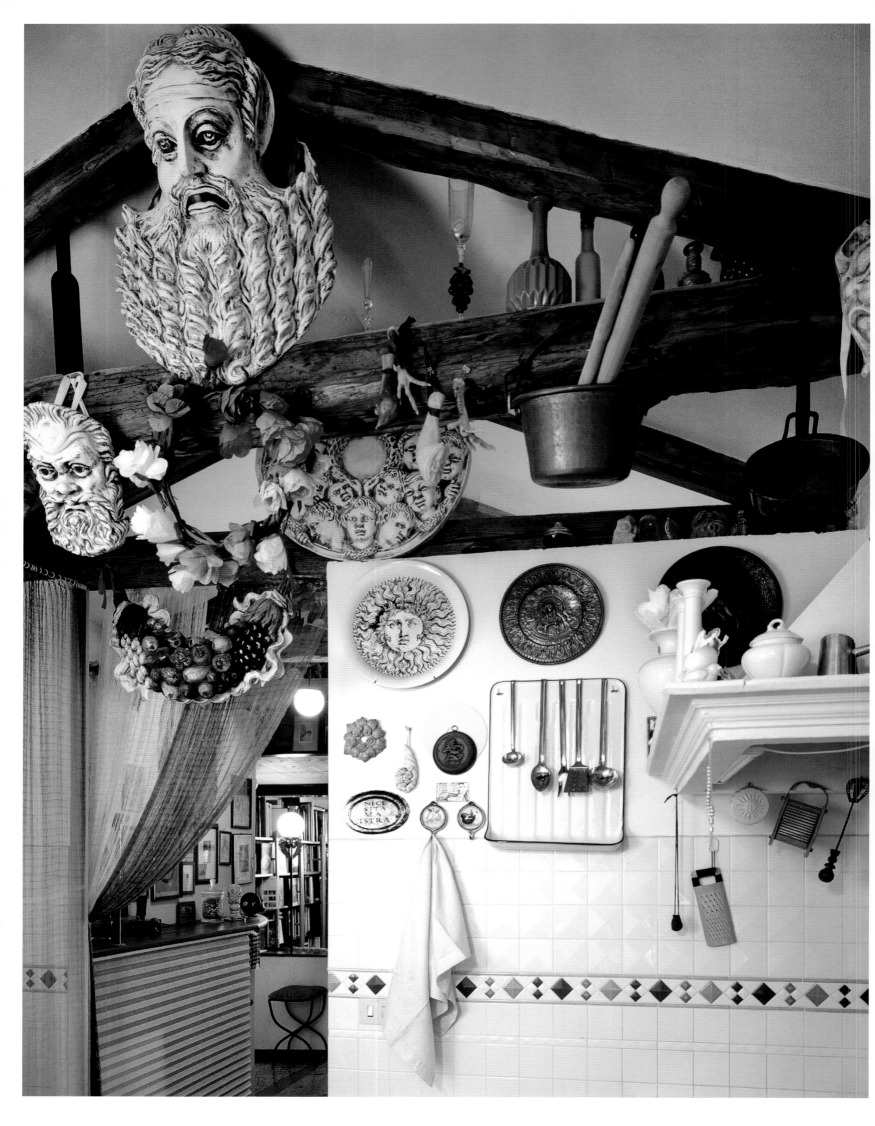

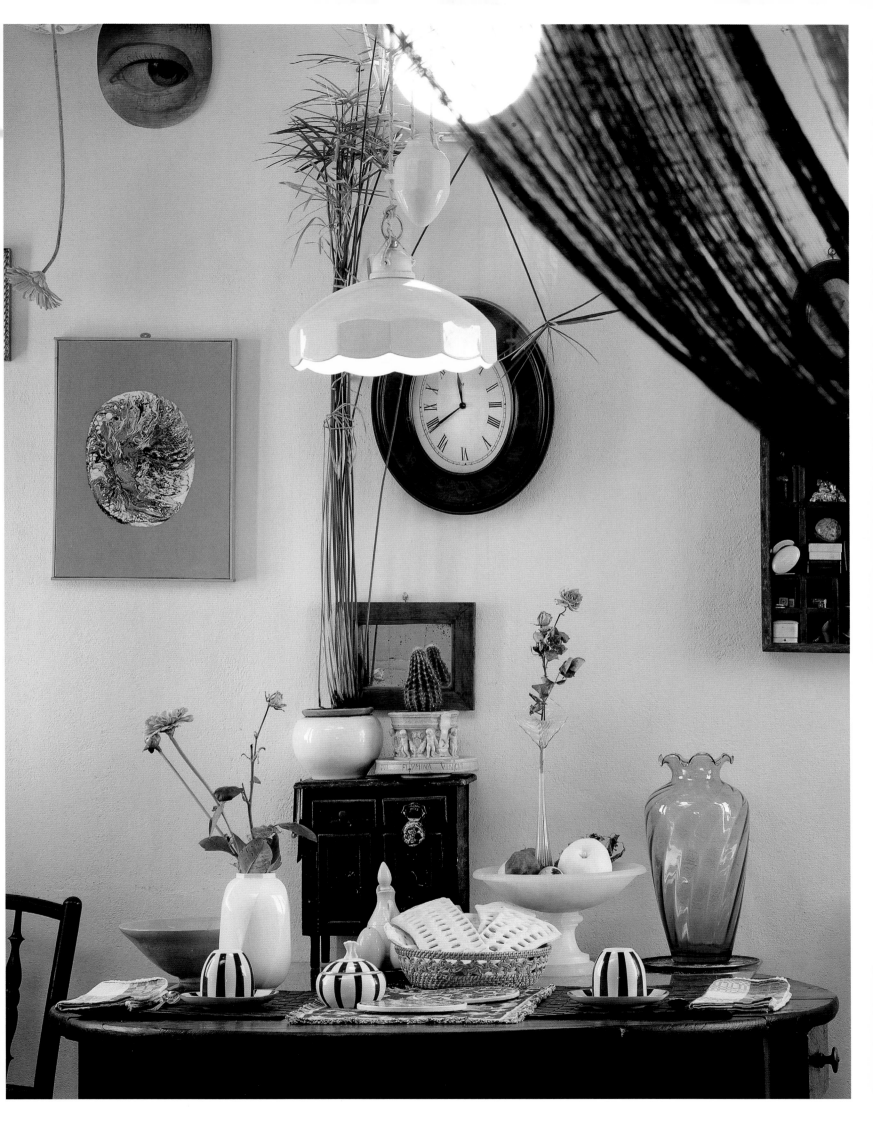

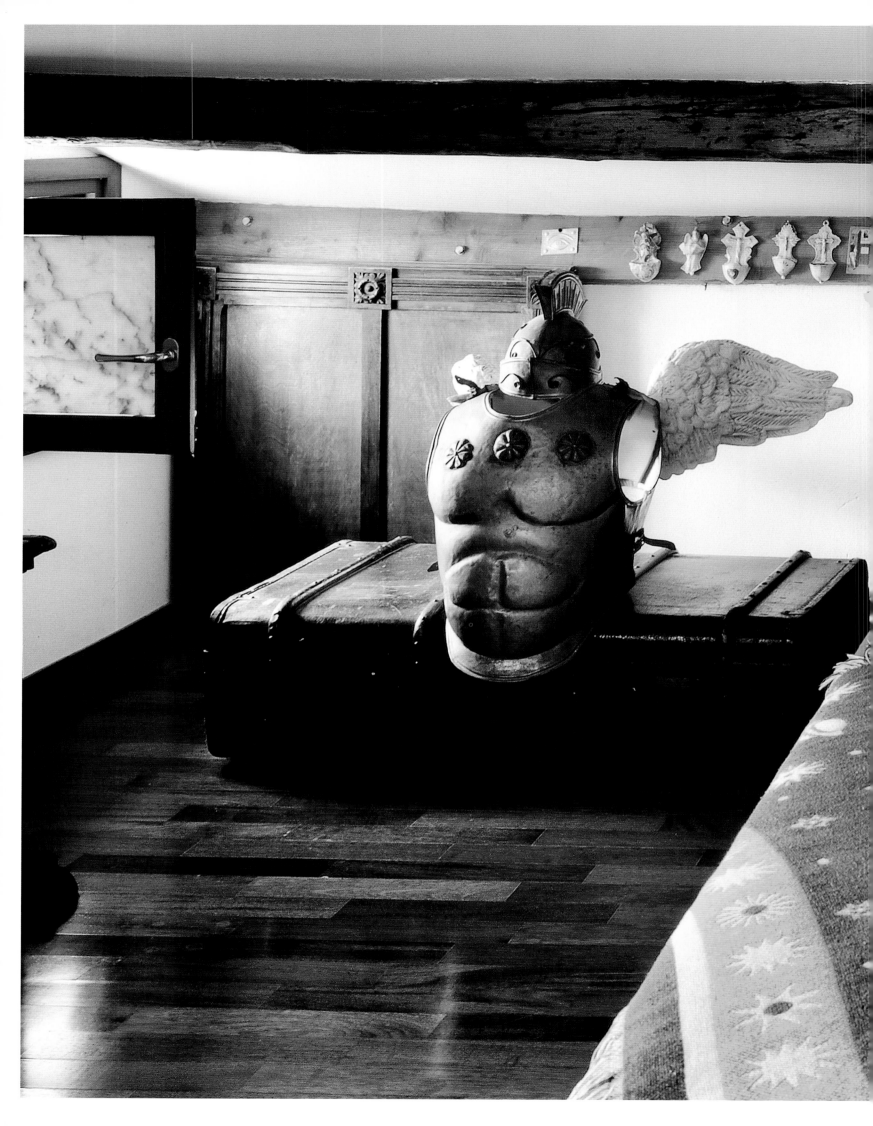

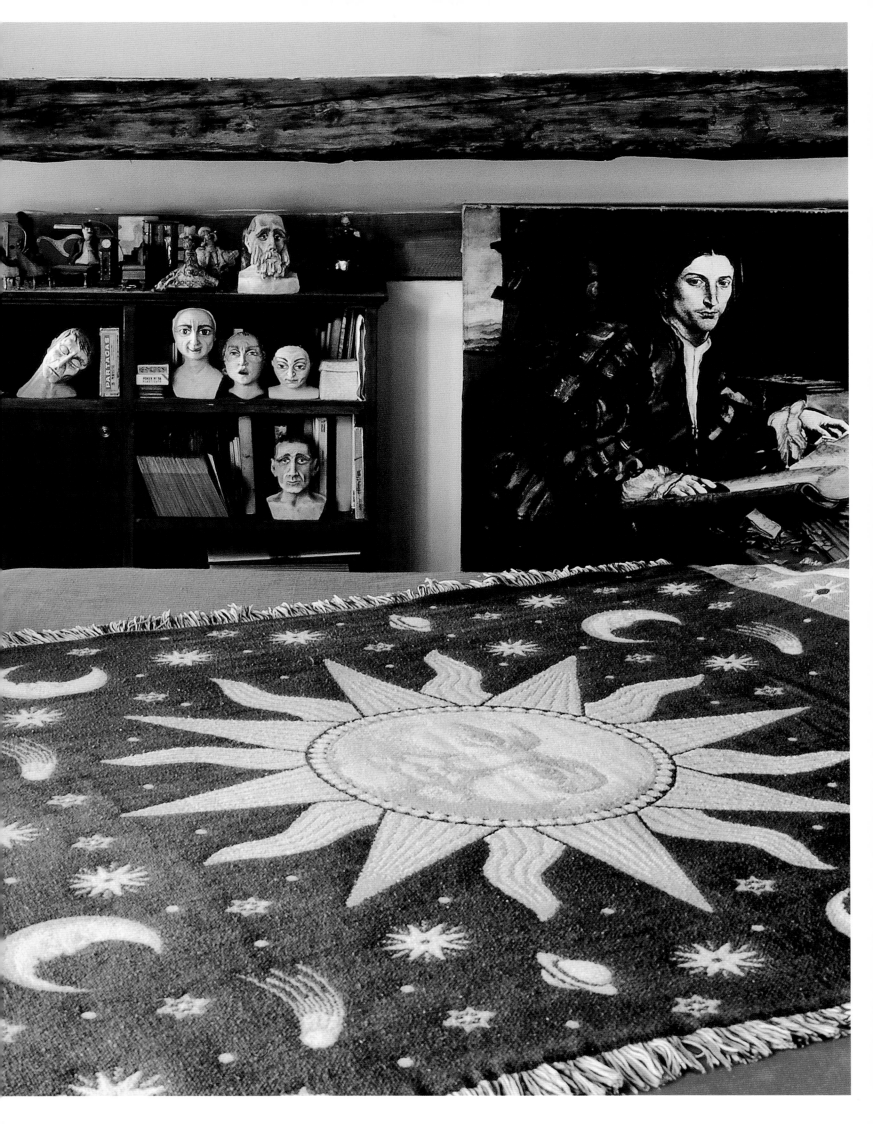

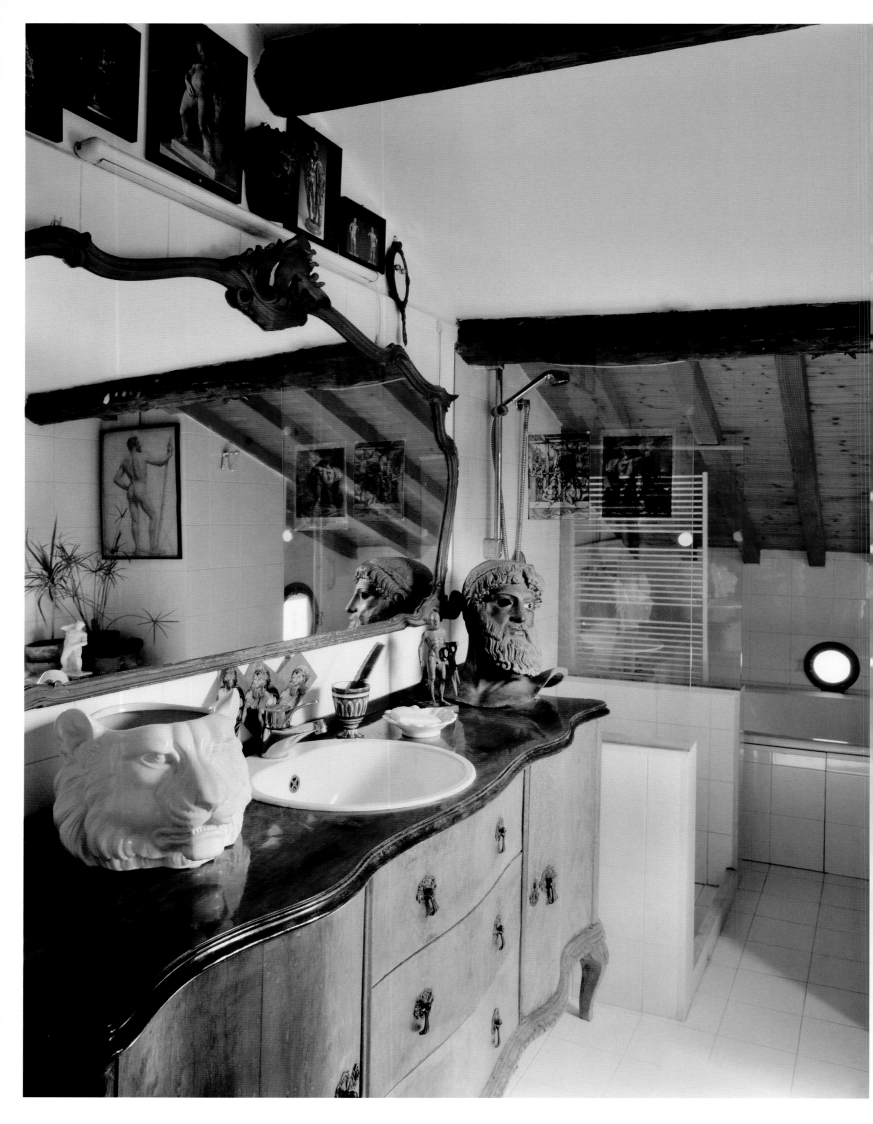

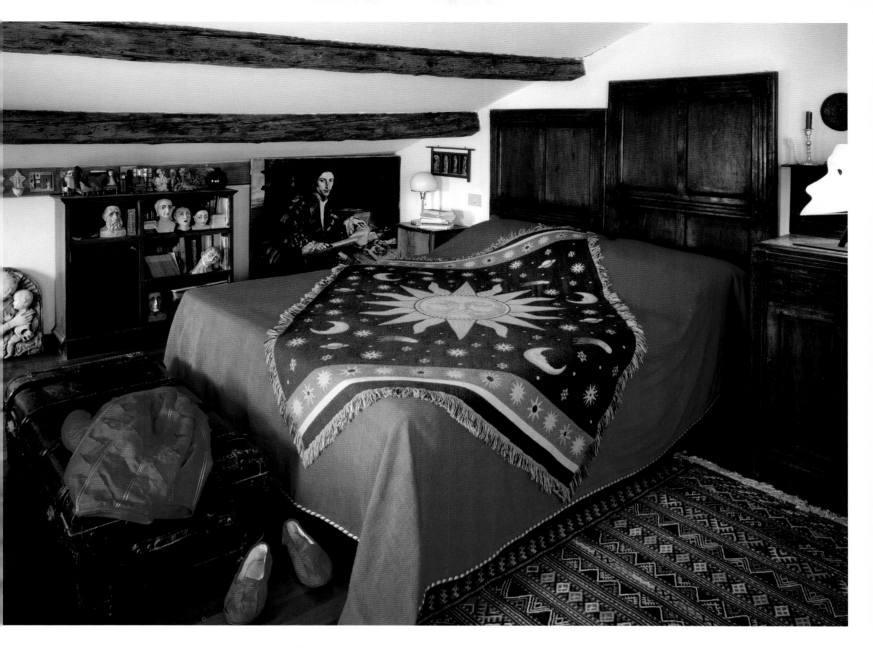

His carefully groomed beard and moustache are now white, but he hasn't lost a single ounce of his trademark energy. His sharp eye is constantly attracted to thousands of stimuli and his imagination knows no bounds—it is a vivifying font of facts, stories, experiences, and memories. His storytelling skills entrance everyone around to hear. And his house is a little bit like him: "My job has shaped every inch of it," he says. It's packed to the gills with curiosities and objects of all sorts, from innumerable places and time periods, many crafted by his own hand. The place is chock-full of conceptual pathways and secret assonances that simultaneously reflect who he is and encourage him to dive into new cultural explorations.

The house is located in the ancient Jewish ghetto in a sixteenth-century building. It has grown over the centuries to make the most of the narrow plan; more vertical space was made available thanks to a permit granted to the local Jewish community back when it was still isolated from the rest of the city. Lovato occupies the building's seventh floor, which dates back to the eighteenth century. What makes his home special is the way the rooms seem to pursue one another, literally pulling visitors into the living room, which in turn gravitates around a faux fireplace whose front is decorated with a view of Borromini's Palazzo Spada in Rome. Each room is distinguished by a particular scenographic inspiration, drawn from one of Lovato's stories recounted through the panoply of objects that inhabit it, and filtered by a latent mental alchemy that springs from the crucible of the past. The adventure begins with the room that isn't really a room—that is, the covered rooftop terrace where a collection of faces arranged amid statues and fragments of old columns looks out upon everything else. Once you get over the breathtaking view of Venice from up here, you might notice that these faces are prototypes for the gigantic Saint Francis manger scene Lovato and other artists created for

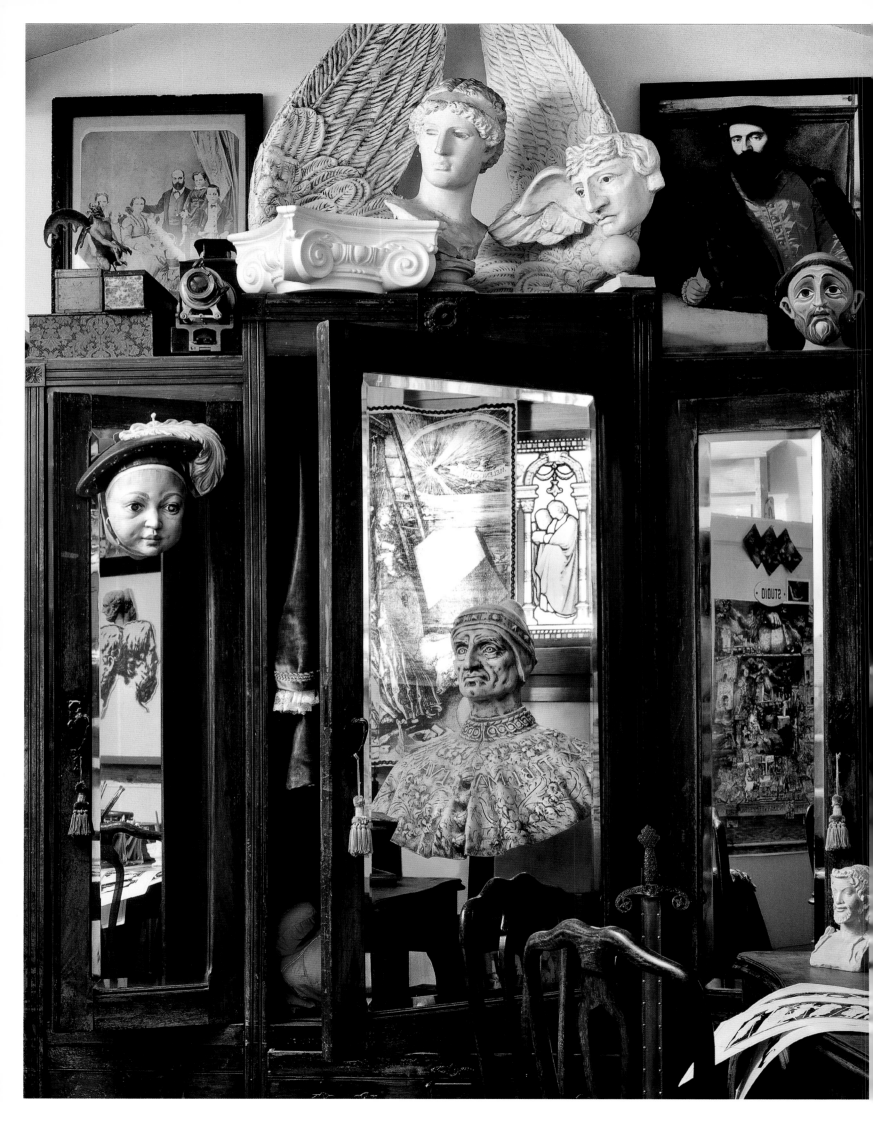

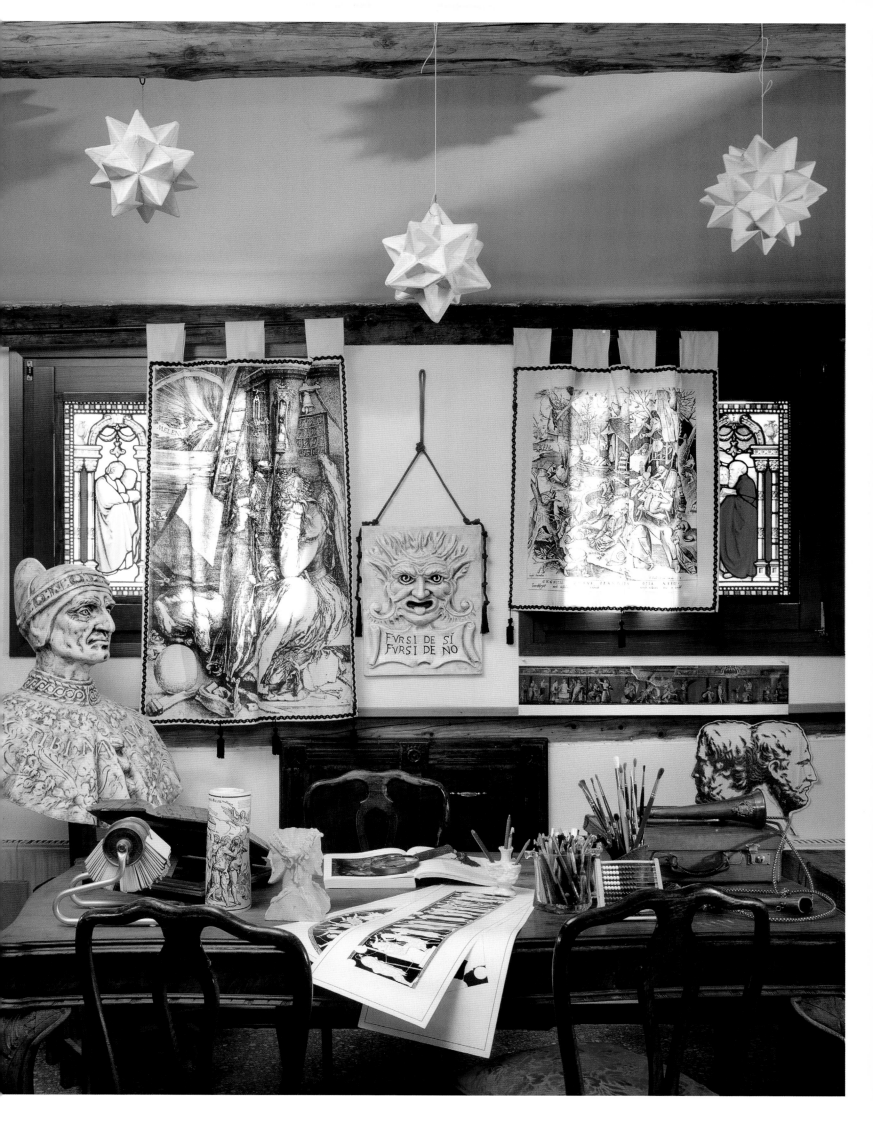

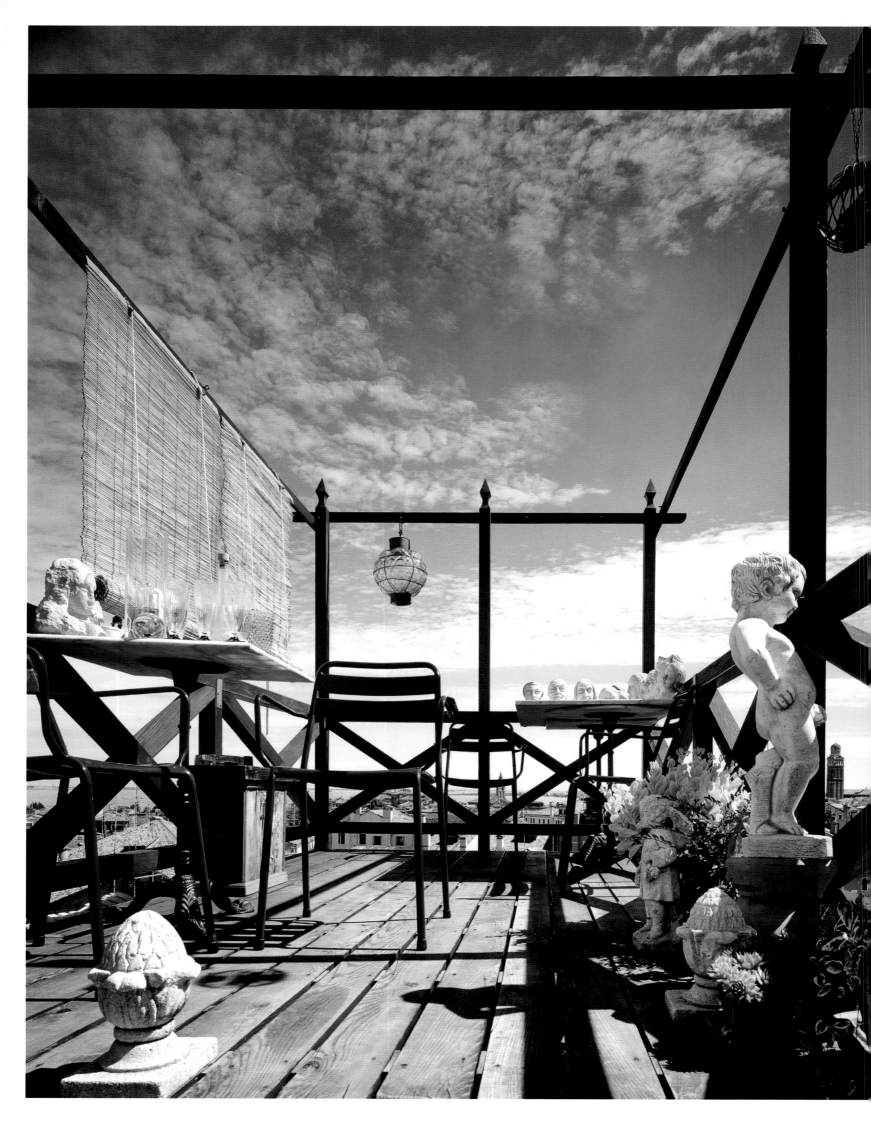

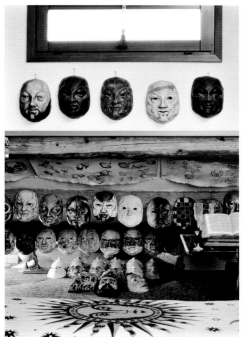

the City of Paris in 1994. The year before, the same client had commissioned him to create a Parisian Crèche, an awe-inspiring, mechanized installation covering over eighty square feet and featuring a voiceover narration by Marcello Mastroianni. Speaking of faces, it's worth noting that the attic houses a collection of papier-mâché masks, all part of Lovato's physiognomic study of King Henry VIII based on the well-known portrait completed by Hans Holbein the Younger between 1539 and 1540, when he was the official British court painter.

The small entranceway is lined with old objects, including dolls' heads, votive pictures, even a colorful theater. In the kitchen the aromas of traditional Venetian dishes blend in the air surrounding two papier-mâché masks representing Tragedy and Comedy, while the study is a deliberately entangled whirl of imagery: a monumental papier-mâché bust of Doge Loredan (despite its impressive size, it weighs a mere ten ounces) is reflected in a nineteenth-century reproduction of the windows of Chartres Cathedral made by skilled glassmakers, while a portrait of Lovato in Renaissance garb by the painter Anna Trevisan seems to converse with a Corinthian capital. The living room also features a banner designed by Giorgio Spiller—the infamous artist who partook of the 1982 carnival dressed as a phallus—a leafy Murano glass chandelier, and a stairway leading to the aforementioned rooftop terrace.

Amid this house's many marvels we mustn't forget the bedroom, which stands where the building's coal cellar once was. Its low ceiling seems to emphasize the abundant wealth of decorations: the bed is covered by an American throw with images of the sun, moon, and stars on it; at its foot stands a well-worn trunk, topped by the upper part of a sixteenth-century suit of armor with angels' wings. A nearby shelf houses a row of small heads, also preparatory sketches for the manger scene with Saint Francis.

Exploring this world is like stepping through the looking glass. The house itself is an amazing experience, as it takes you beyond your world into a cultured, visionary, ironic, eccentric realm, surrounded by the spires, steeples, and roofs that only a few of Venice's visitors are lucky enough to see. It is like going on vicarious journey wherein each detail passionately and personally touches upon a tiny fragment of the past—a past that, as the blind homogenization of the Internet continues to spread, grows more precious every day.

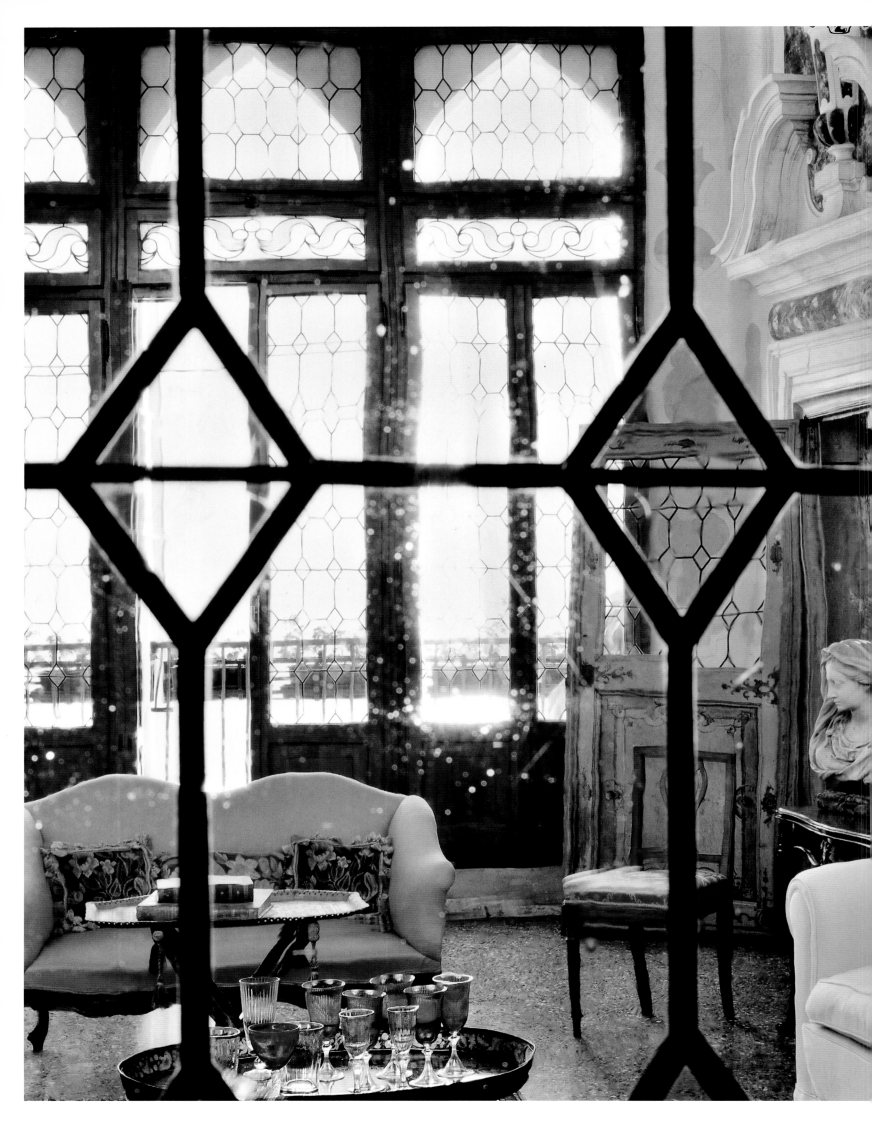

The House of Time Regained

When the anonymous, well-respected Venetian architect we shall call Ms. Maestra crossed the threshold of this house for the first time, it was as if lightning had struck. It was a perfect evening, one of the few, even in Venice. The sun was sinking slowly into the lagoon, the sky was like marble striated with purple and red, and the subtle scent of the sea swirled in the wind. Having climbed the stairs of this late-Gothic building near the Church of San Polo, she opened the door and for a moment felt a magic that seemed printed or projected on the flaking walls, as if spirits had gathered in the thick filigree of the cobwebs, indifferent to the decay of time and abandon.

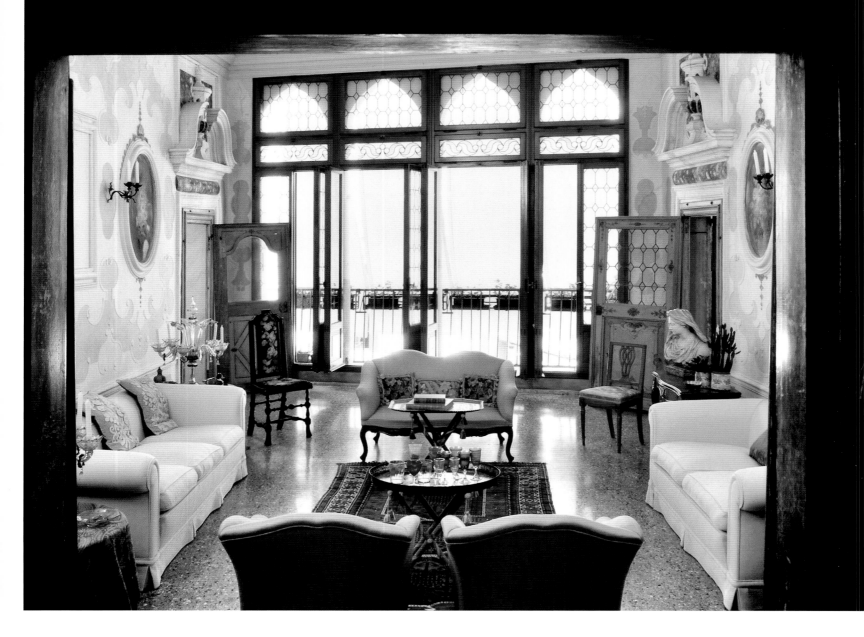

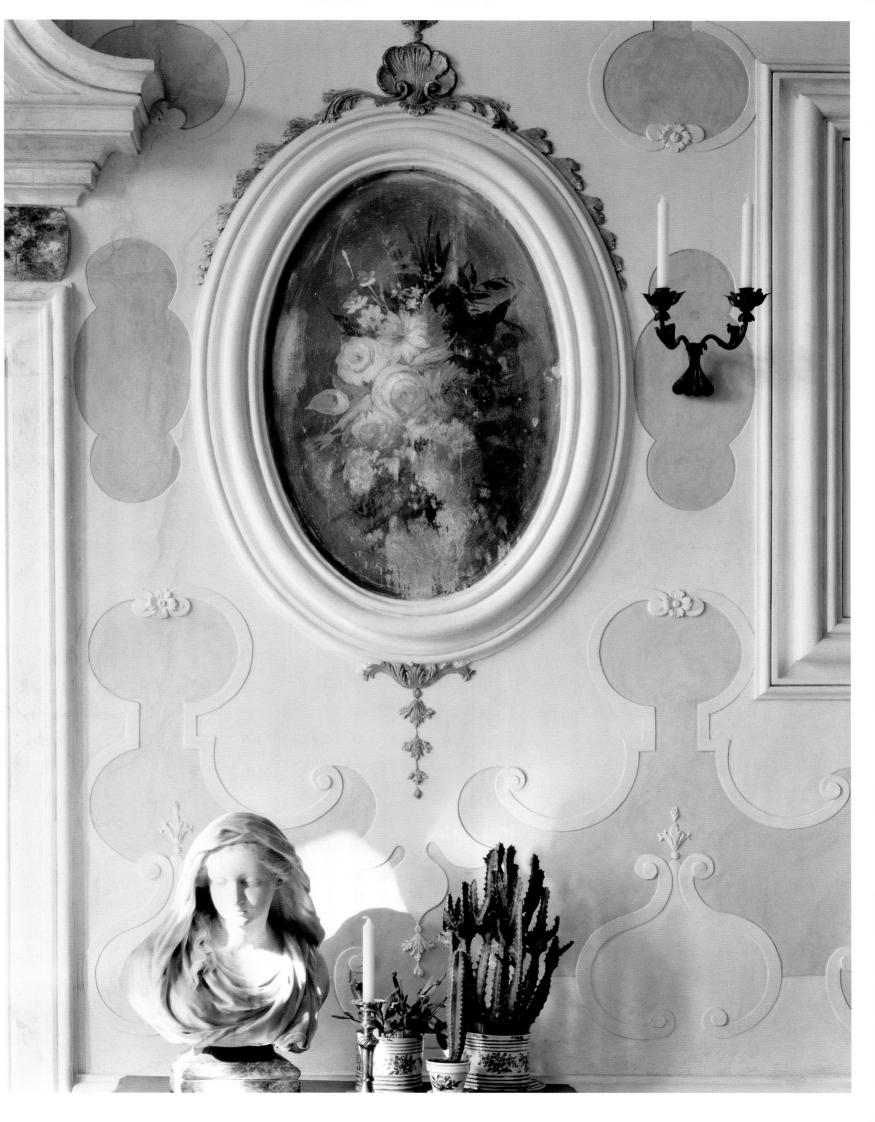

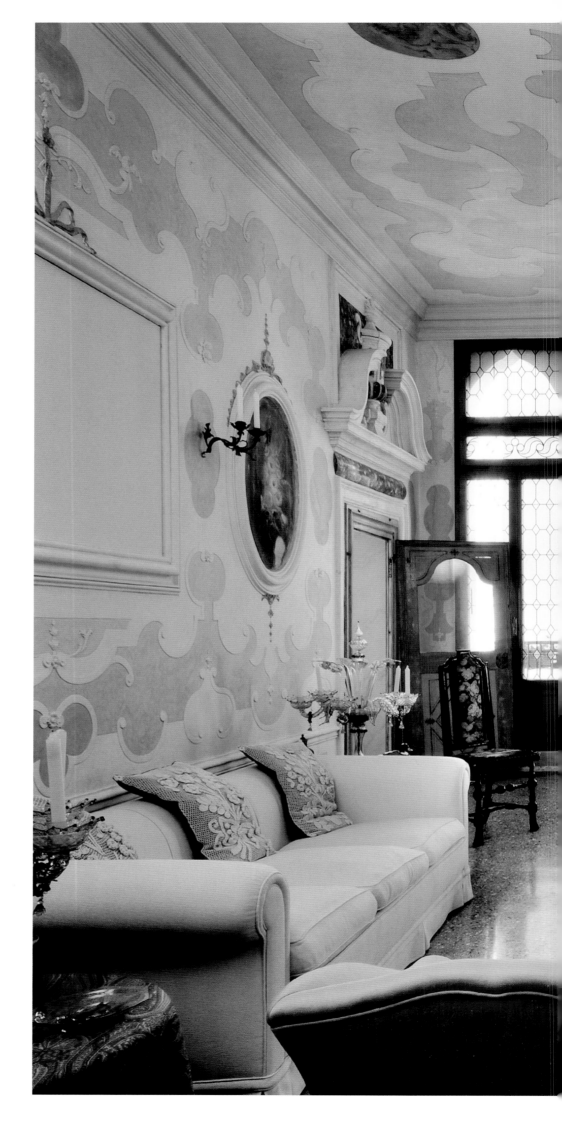

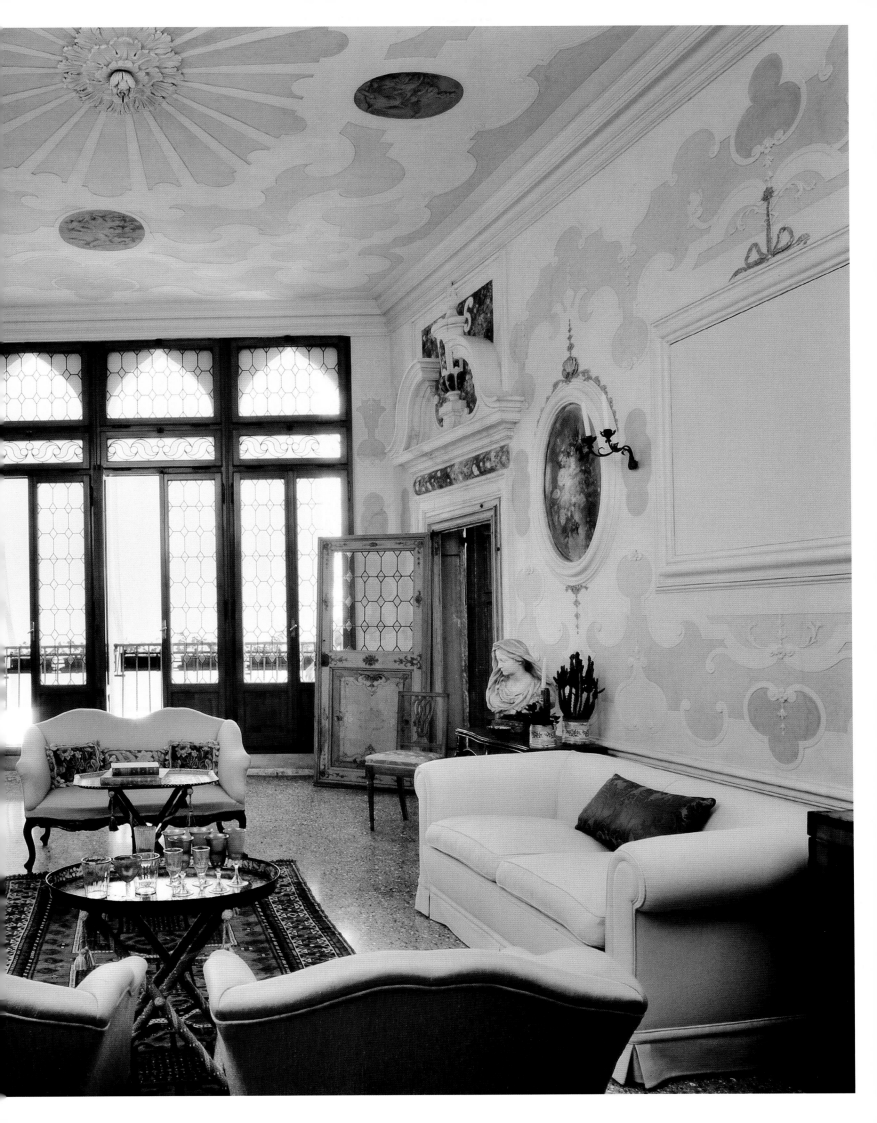

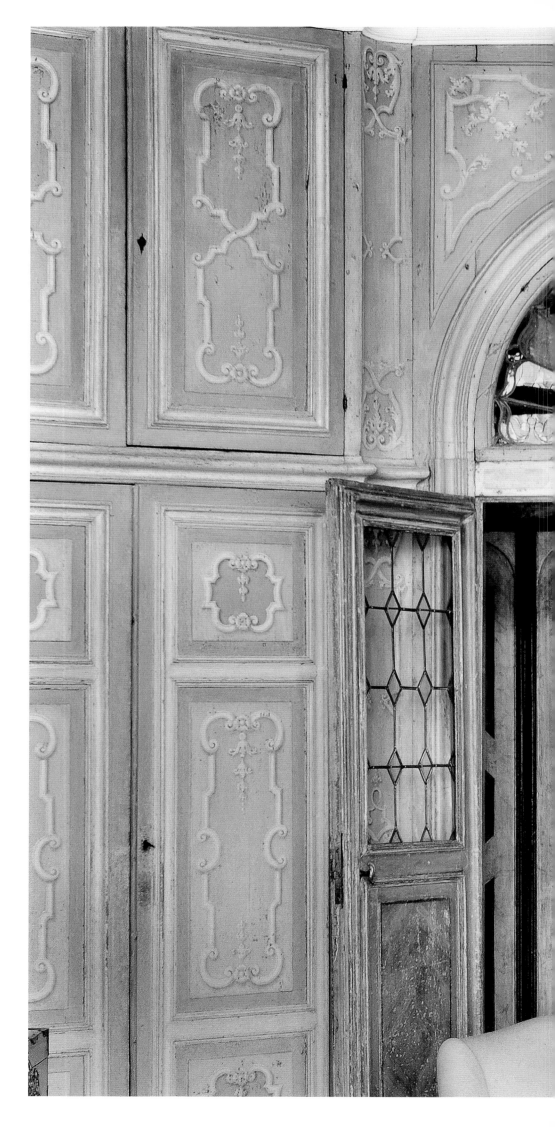

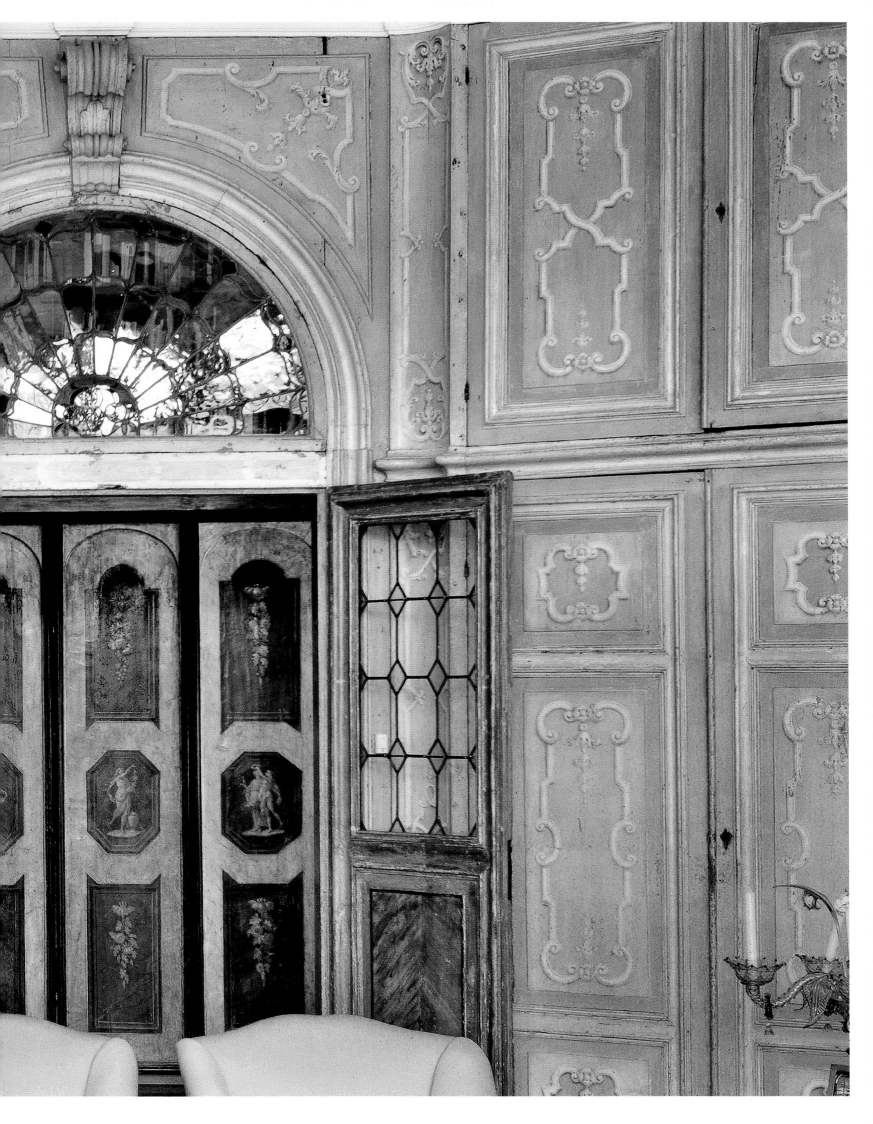

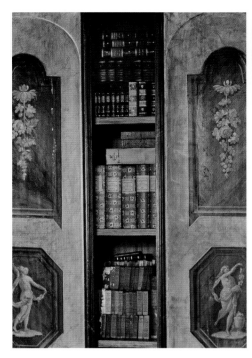

"You know, Madame Architect," said a voice from behind her, "this house has been uninhabited for years. And considering the damp climate here in Venice. . . ." But she had other things on her mind, and succumbed to strong emotions that blinded her to the many problems plaguing the apartment; there she stood, lovingly observing the fragments of decoration that peeped out here and there in the grayish, moldy, chalky paint peeling off the walls and ceilings. She was absorbing the twilight pouring in through the windows, the roofs and bell towers aglow outside in the sinking afternoon sun, and in her imagination she constructed her future home. "This is my house," she said to herself. And she bought it. Later, to anyone who asked why she had taken such a risky step, she would answer, "Because it was a challenge," making it clear that, in the ecstatic moment she experienced upon entering the house, she had already imagined what she could turn it into. After all, she is an expert in architectural restoration, and in her mind the decorative passages she had glimpsed or perhaps just imagined had come together within an overall design, like pieces of a jigsaw that had yet to be completed. The living room was the testing ground for her insight, and she began by scraping the white from the walls and ceiling, grating at the surface and rubbing every inch down. Little by little the traces became shapes, the shapes took on color and thickness, and the whole turned out to be an amazing cycle of delicate frescoes whose mythological and floral motifs featuring pink, green, and yellow watercolor decorations were set within soft frames and stucco molding. This startling harbinger of more recent postmodern hues dates back to 1750, as the owner later discovered, very much to her own surprise. Today its palette is complemented by custom sofas upholstered in pink silk and the many colors of the distinctively Venetian terrazzo flooring. Her intervention also restored the large marble tympana above the two doorways to excellent condition. Ms. Maestra brought the same sleuthlike attention to historical detail into the bedroom, where her subtractive process brought to light a carved rafter dating back to the Byzantine era. As the nineteenth-century additions were removed, a rare wallpaper, made from natural fibers and hand-painted with blue and gold arabesques, gradually resurfaced. The alcove bed gained dramatic stature when framed by a newly uncovered wooden platform and an arch bearing portraits of the home's eighteenth-century owners.

That well-pondered addition, stemming from an almost theatrical vision of the dwelling space, embodies the second nature and virtue of this home's owner-designer. If restoration

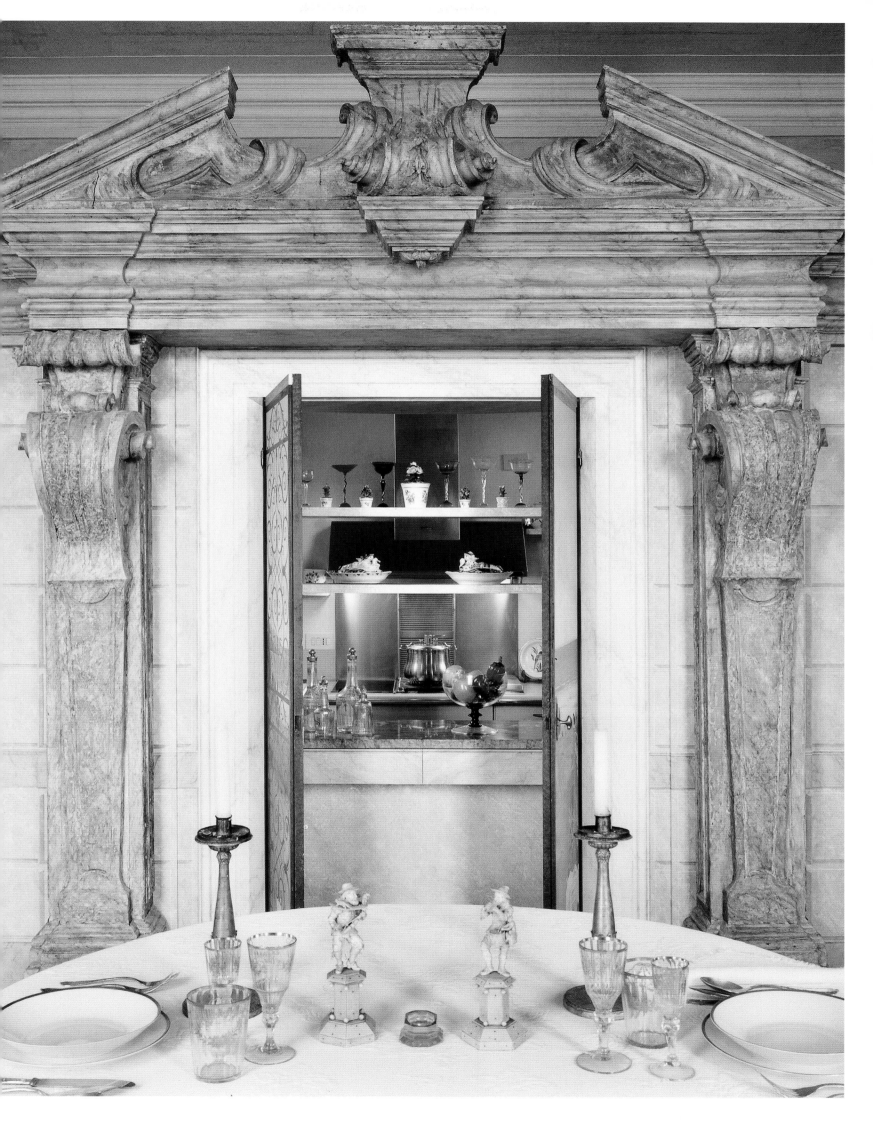

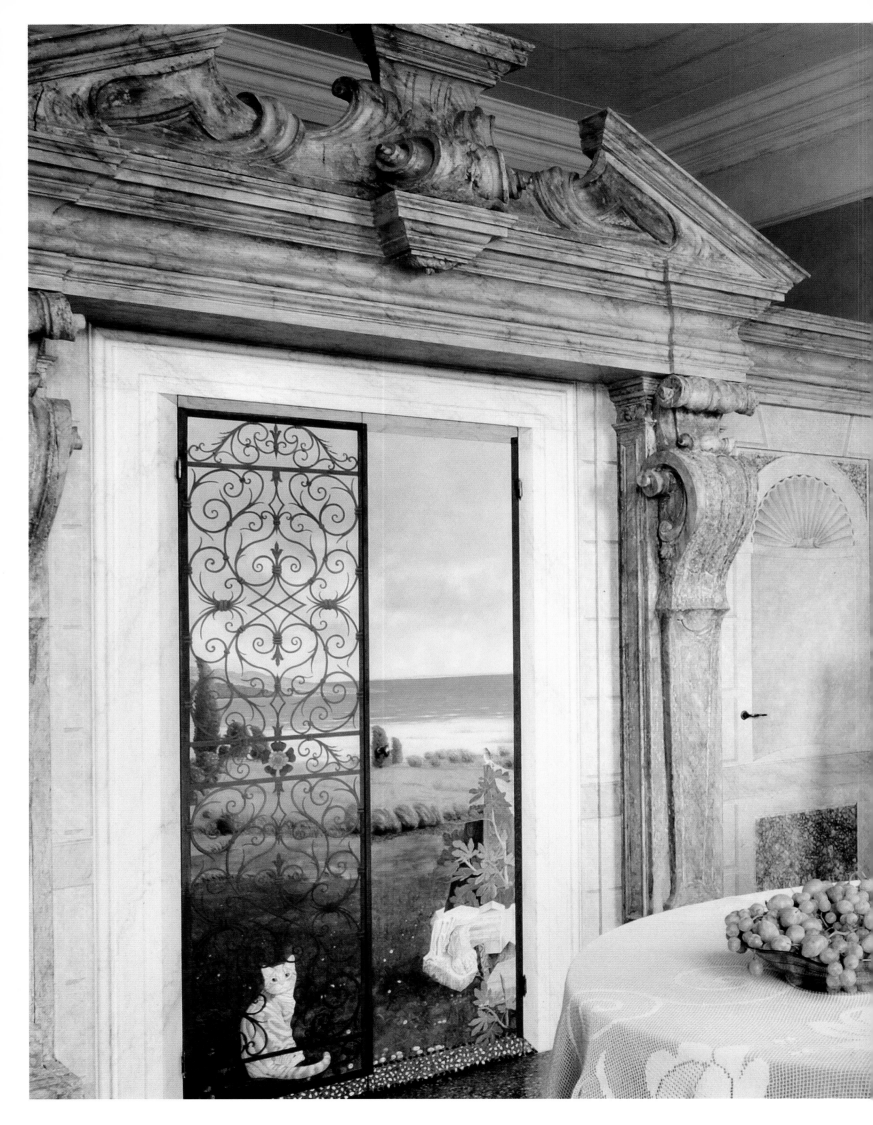

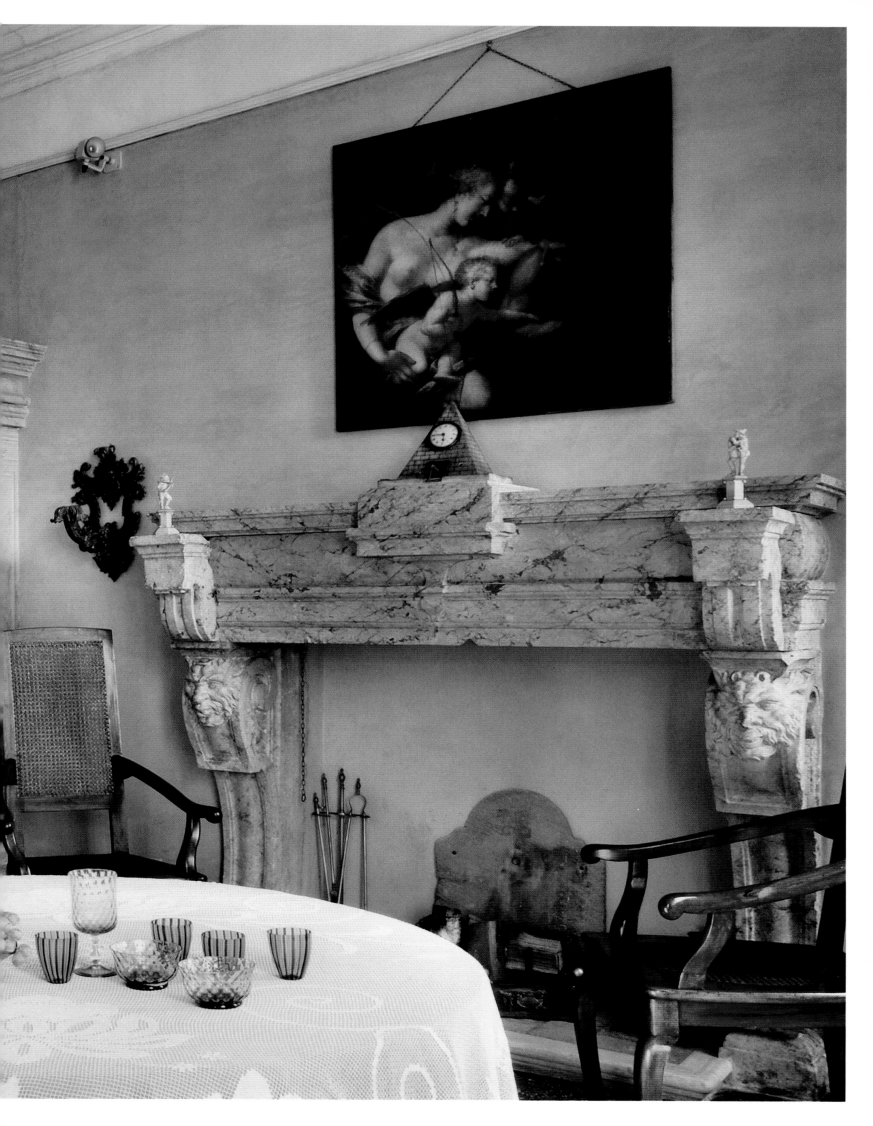

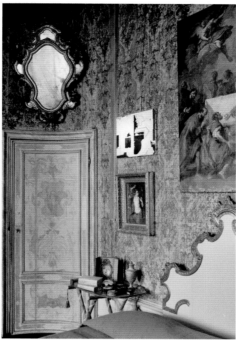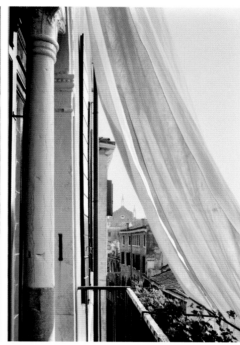

is her professional calling—she also does research and teaches—creativity is her vice, and she doesn't even keep it a secret. Such dramatic, theatrical creativity transforms every room of the house into a compelling story; it's paired with an illusionary, allusive creativity that turns everything here into a daydream, the embodiment of memory. In the bedroom this inventiveness appears as a subspecies of the theater's backstage; elsewhere it pops up as trompe l'oeil—upon entering the dining room it becomes clear that Ms. Maestra is a master of this playful art. The room is closed off by two types of iconostases marked by columns, architraves, and tympana from a deconsecrated seventeenth-century church. The architect has delicately painted these two fascinating partitions with illusionistic scenes: one side shows rusticated walls with shell-shaped niches in the center and a door painted as a faux window which, when open, reveals the kitchen; the other side also has niches, as well as a beach lined by the cypresses native to Istria and Dalmatia, the owner's birthplace and part of present-day Croatia. Even the bathroom is fertile ground for the imagination. Here nothing is bound to the original dwelling, and yet nothing is new. "I have tried," says the architect, "to mix the ancient Roman spirit with a Mannerist wit." Such historical cross-pollination has an ultramodern flavor: the rusticated walls are made of Venetian stucco, a manually worked limestone surface that recalls the appearance of marble both in its striations and its brilliance—it was also used for some of the bedroom decorations. The bath also features an arched mirror topped by an eighteenth-century "caccia acqua" mascaron, a water-spewing ornamental face originally found in an Italian-style garden.

Is this the grand home that Ms. Maestra imagined when she saw it for the first time in a state of melancholic ruin? We'll never know, but it is undeniably her own house. Its balanced and harmonious blend combines carefully recovered bits of the past with dreamy, decorative inventions. The whole forms an elegant scene characterized by eighteenth-century overtones. It would be the ideal set for one of Goldoni's comedies, and you can almost hear the voice of Sgualdo in *La casa nova* echoing through these rooms, dictating their decoration in his thick Venetian dialect: "Fenimo sta camera za che ghe semo. Questa ha da esser la camera da recever; e el paron el vol che la sia all'ordene avanti sera. Intanto che i fenisse de far la massarìa, el vol sta camera destrigada. Da bravo, sior Onofrio, fenì de dar i chiari scuri a quei sfrisi. Vu, mistro Prospero, mettè quei caenazzetti a quela porta. . . ."

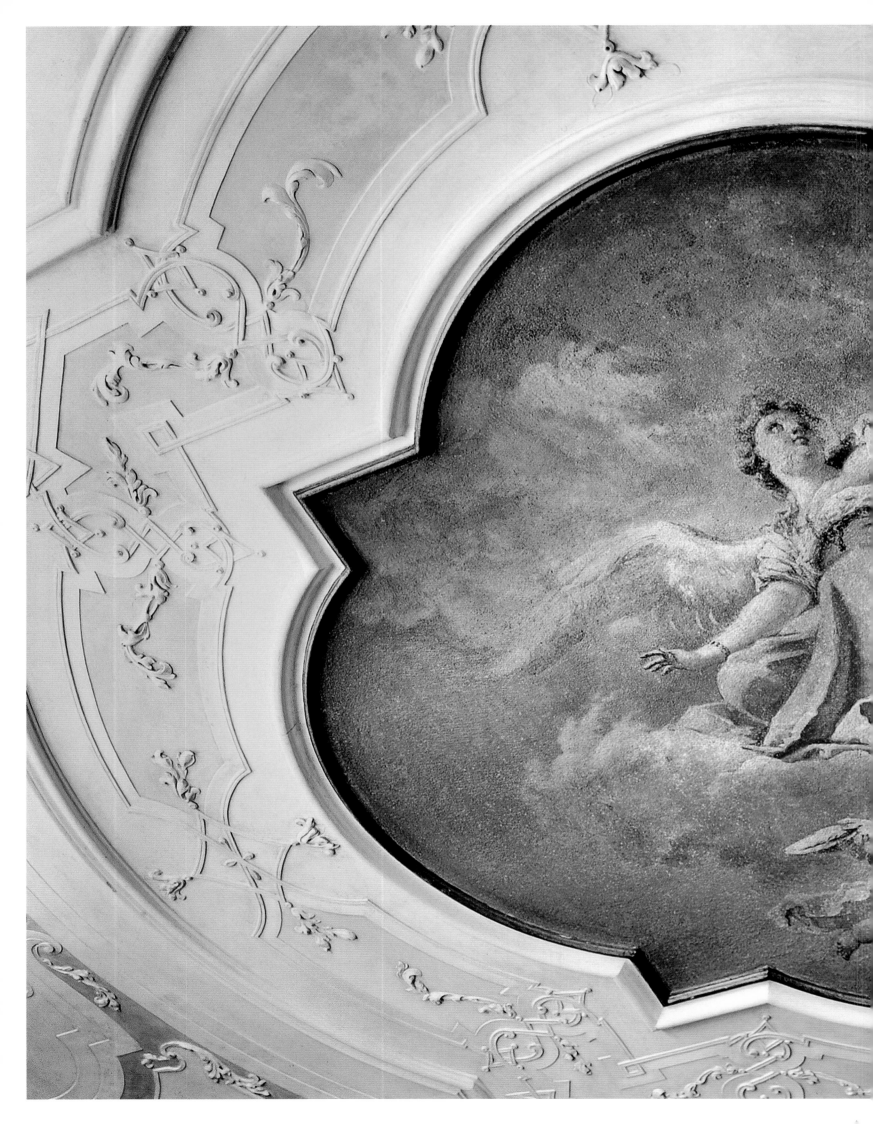

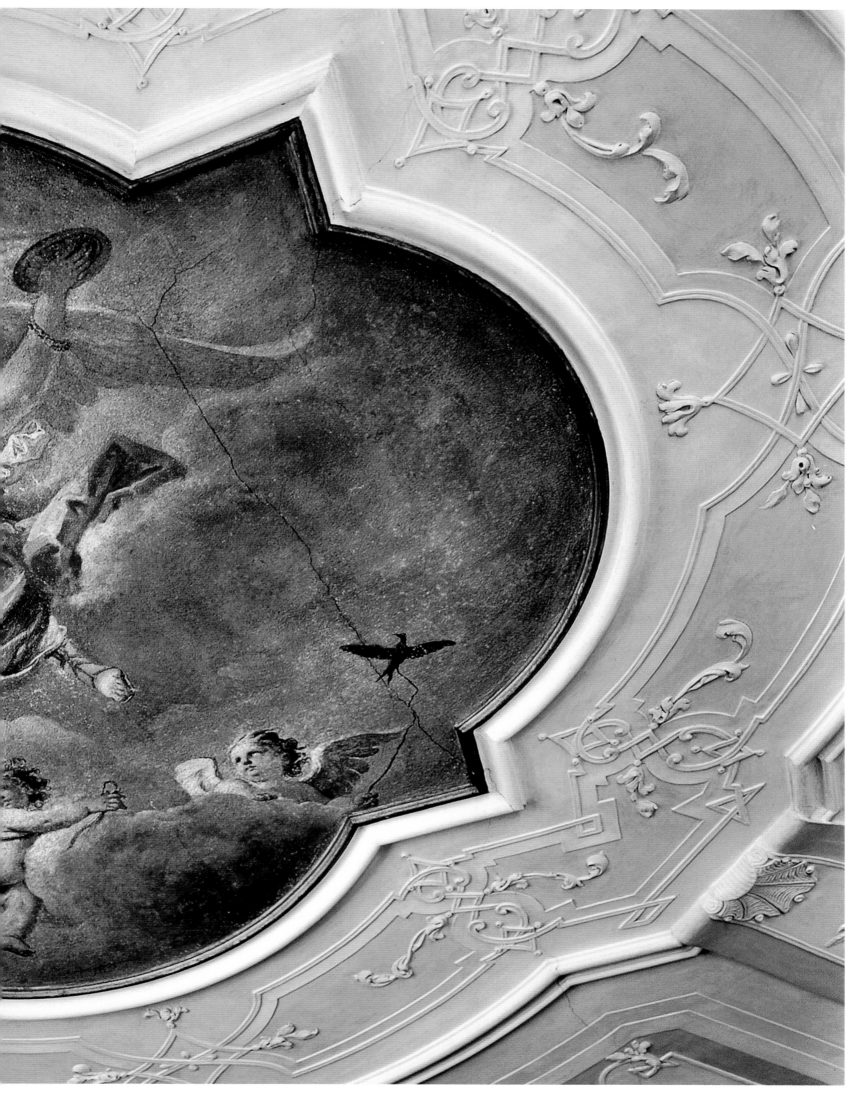

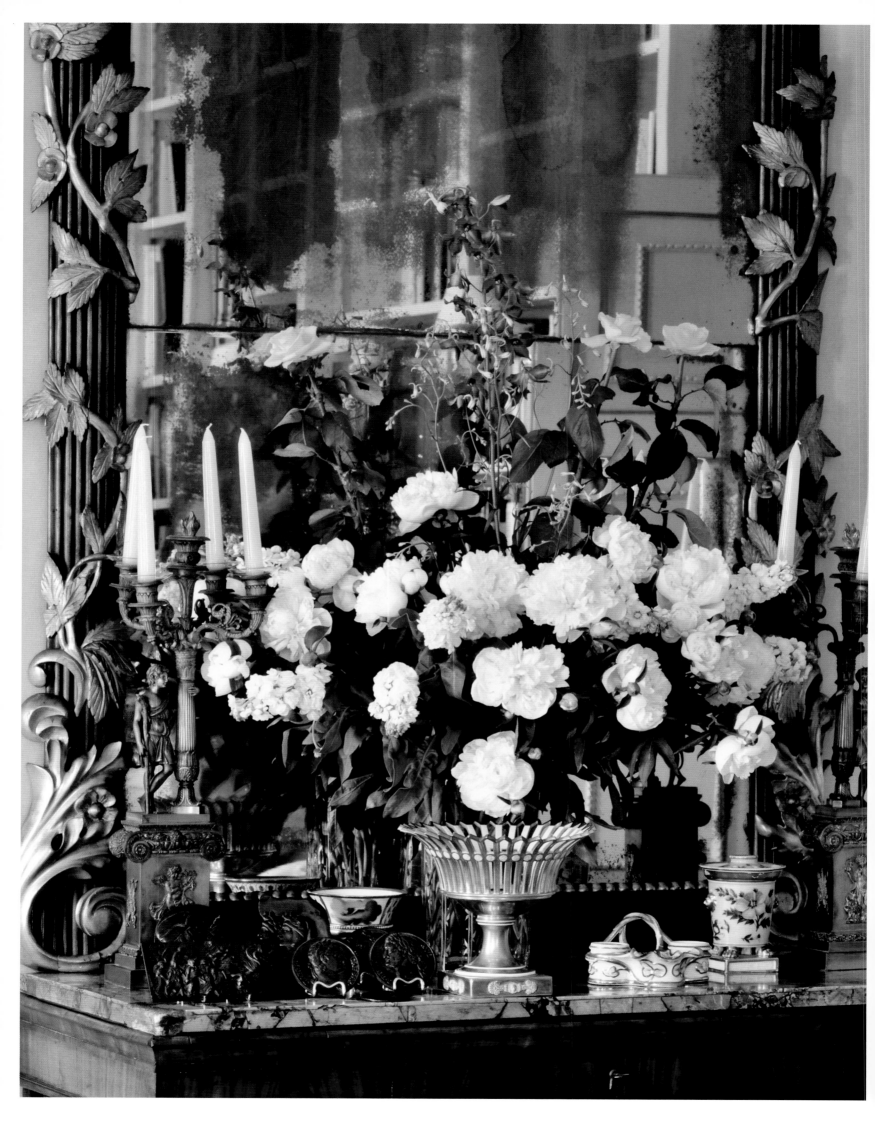

Beneath the Gaze of the *Signorine*

A page from *Senso*, the superb and tragic novella by Camillo Boito, comes back to life in the heart of Venice. Countess Serpieri, the main character, says: "Venice, which I had never seen and so longed to see, spoke more to my senses than my soul. Its monuments, whose history I did not know and whose beauty I did not understand, mattered less to me than its green waters, starry sky, silvery moon, golden sunsets, and above all the black gondola in which I would recline, abandoning myself to the most voluptuous whims of my imagination . . . In Venice I was reborn."

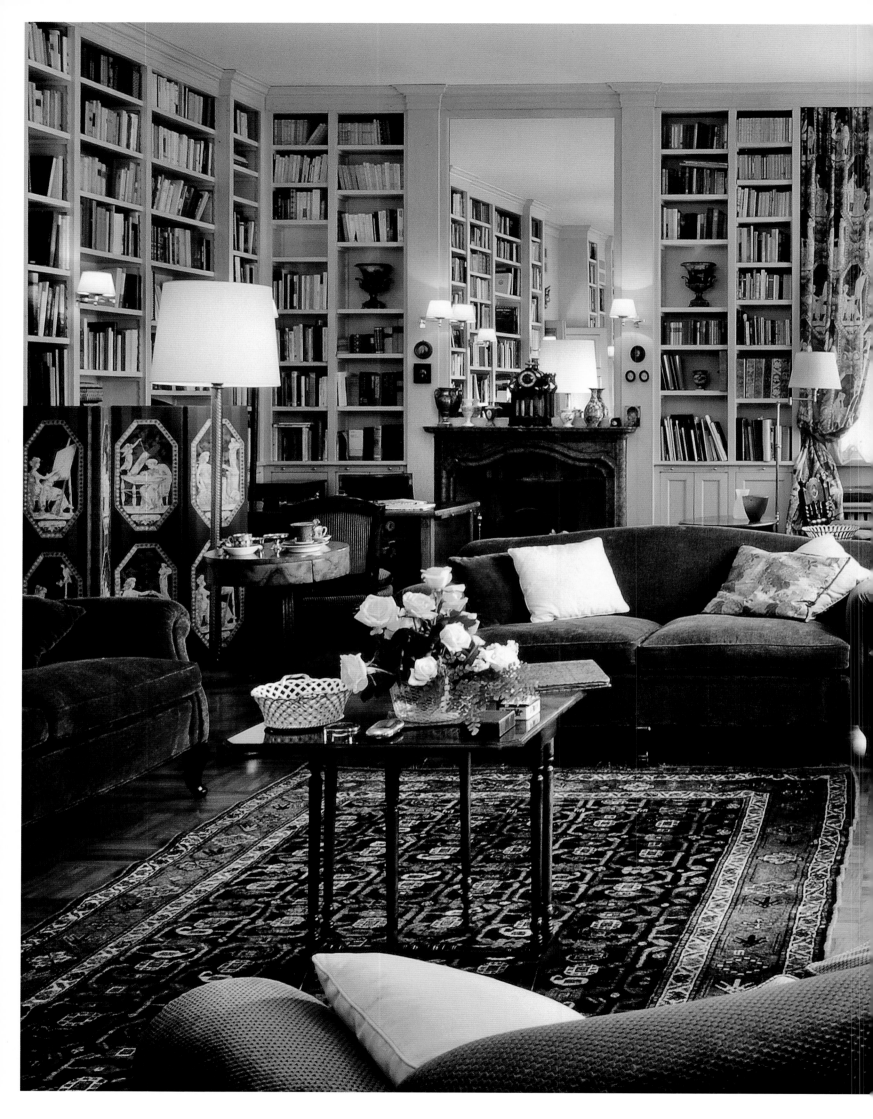

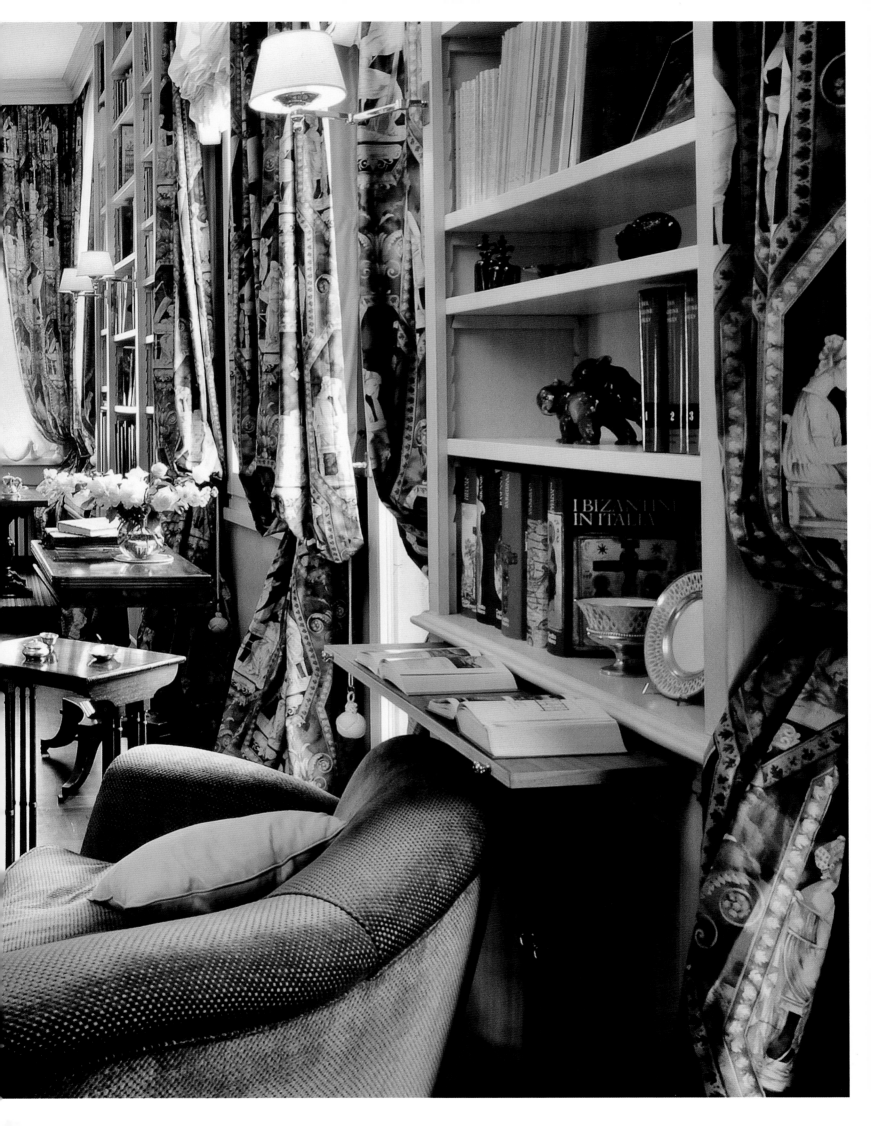

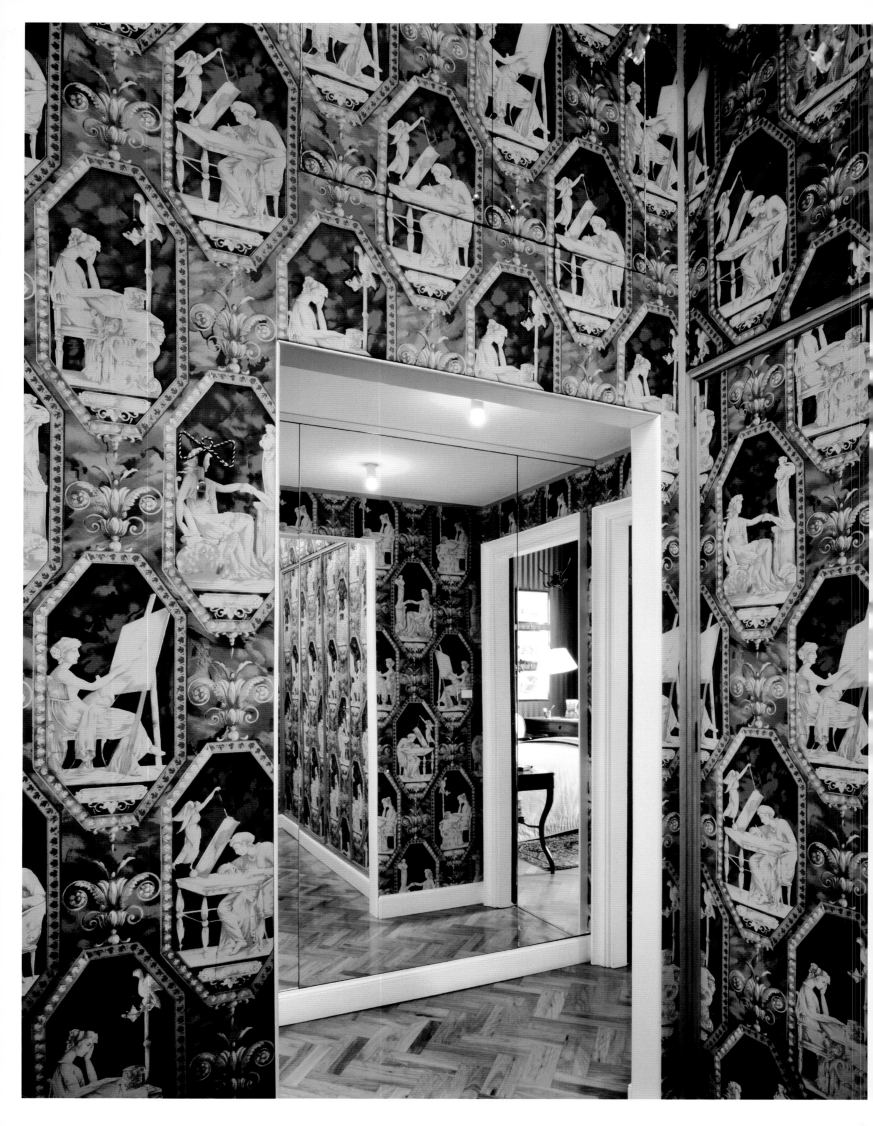

With these words echoing through our minds, we enter the house and find an atmosphere exactly like the one in Boito's masterfully written book, as well as Luchino Visconti's film version of it. It overwhelms us like the scent of seduction, with a classical aura tinged by a disquietingly sensual subtext. The interior has an essential quality, its golden ratios in sharp contrast to the flowing fabrics rhythmically draped all about. There is clearly a woman's hand at work here. Indeed, the home's owner (and interior decorator) is a renowned art scholar and essayist specialized in antiquities, and has also curated many major exhibitions. Reflecting on her home, she says: "First came the architectural remodeling. It was a challenge, but also helped established a new plan for the distribution of space: the living room, no longer a through-passage as Venice's architectural tradition often dictates, acts as a pivot around which the various functional spaces are organized. Once that transformation was complete, work began on the decoration, which I dealt with directly. I had one color in mind—blue."

This color, in many different gradations united in chromatic rhapsody, sets the decoration's true protagonists, the Rubelli textiles, apart from everything else. The living room's sofas and armchairs are upholstered in solid blue velvet of various shades; the curtains, walls, and old-fashioned screens bear neoclassical motifs, and their single panels are tied together with ribbons, instead of metal hinges, to fold and unfold more easily. The pattern on many of the curtains and wall coverings also has its own small tale to tell. Taken from a design found deep in the Rubelli archives, it depicts allegories of the arts executed in delicate lines. Each medallion features a female figure gracefully performing her creative activity: one is playing music, another is painting, still others are drawing and sculpting. Set like gems in golden yellow frames, a color repeated on the walls and ceilings as well, these young ladies—*signorine*, as the owner affectionately calls them—demurely preside over the home's highly aesthetic life.

Amid these occasionally decorative, occasionally narrative blue hues, portions of the imposing floor-to-ceiling bookcases can be seen. They house the thousands of tomes the owner has accumulated over her many years of study and research. Designed by the architect Riccardo Gaggia and built by a highly skilled Venetian artisan, they feature a fold-out ledge and adjustable-height shelves, and seamlessly frame the original fireplace in red Verona marble. The furniture is equally important: each piece has been in the family for ages, and most of them date back to the nineteenth century. The one exception is a magnificent seventeenth-century Bolognese *cassettone*, the beautifully crafted chest of drawers in the bedroom. It completes the home's richly romantic ambience, and is surrounded by paintings, porcelain, travel clocks, and other precious souvenirs reminiscent of the homes of late nineteenth- and early twentieth-century writers. This home particularly calls to mind the work of Antonio Fogazzaro, a poet and author whose family had a villa on the shore of Lake Lugano. Like some of the homes in his novels, everything here exudes female sentiment and reasoning, and history's emotional and intuitive sides prevail over the more rigid logic of function. These spaces have a subtle beauty, an almost musical harmony. Their discreet yet dramatic feel brings to mind a somewhat more masculine passage penned by Joseph Brodsky, the Russian émigré who loved Venice enough to make it his final resting place: "One day you will realize that beauty is simply a fragment of eternity that has come to our aid, it helps us live. . . . If you have beauty and nothing else, you have more or less the best thing God ever invented."

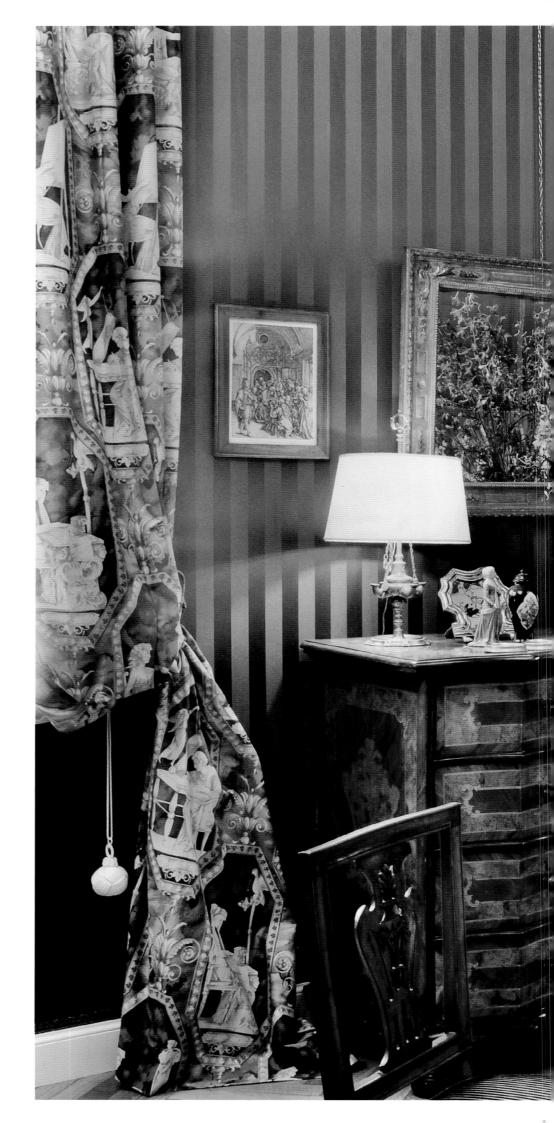

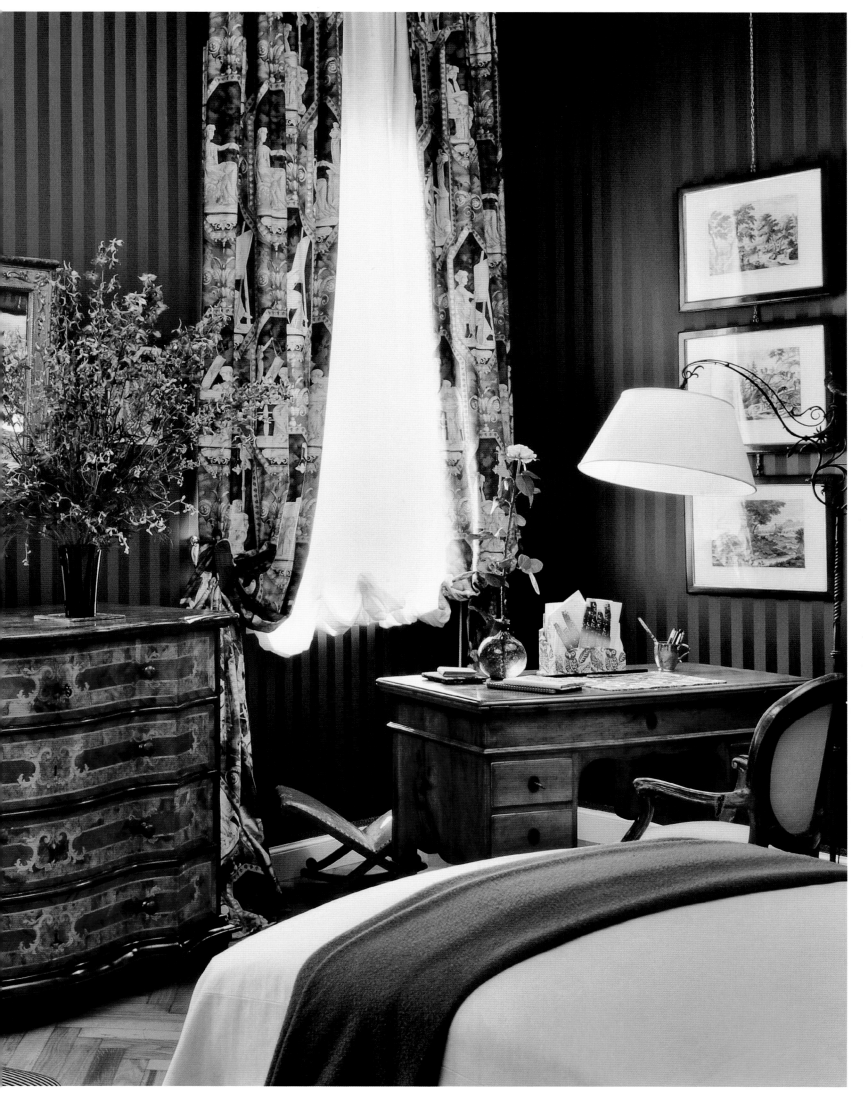

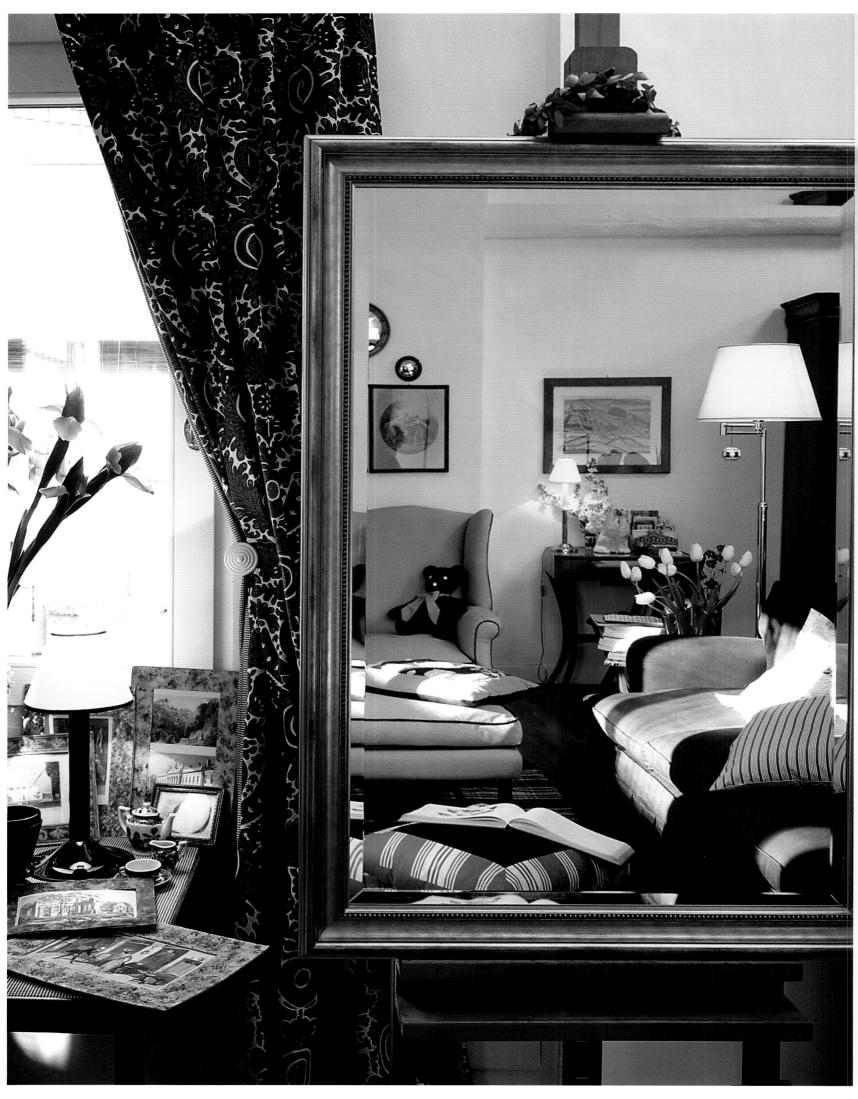

Blue and White Spaces

This Gothic palazzetto embellished by a multimullioned lancet arch originally belonged to the Pisani family, prominent members of the Venetian nobility. It's not all that easy to find if you're just strolling the calli and campielli around San Marco. Although it's a well-known and historic landmark, it is nevertheless a bit detached from everything else. It feels secretive, perhaps even "somewhat haughty," as Renaissance composer Claudio Monteverdi put it. The apartment in question can only be reached by climbing up a steep staircase. But before crossing the threshold, considering the person we are about to meet, we should probably stop a moment to talk about Venice and its colors.

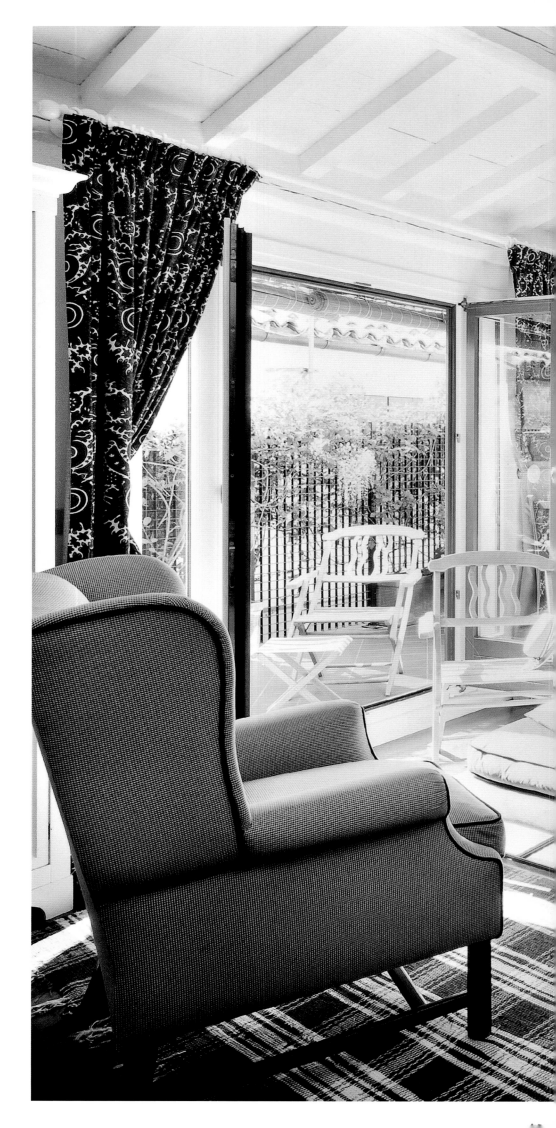

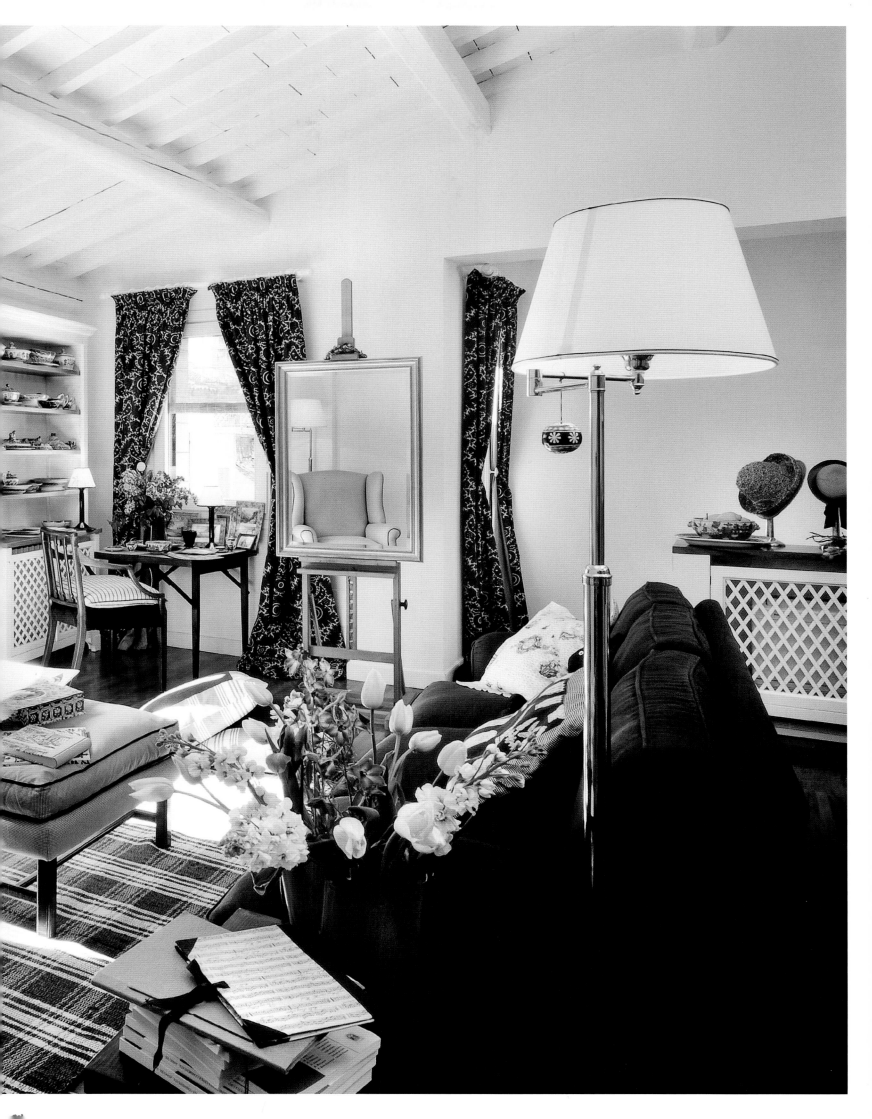

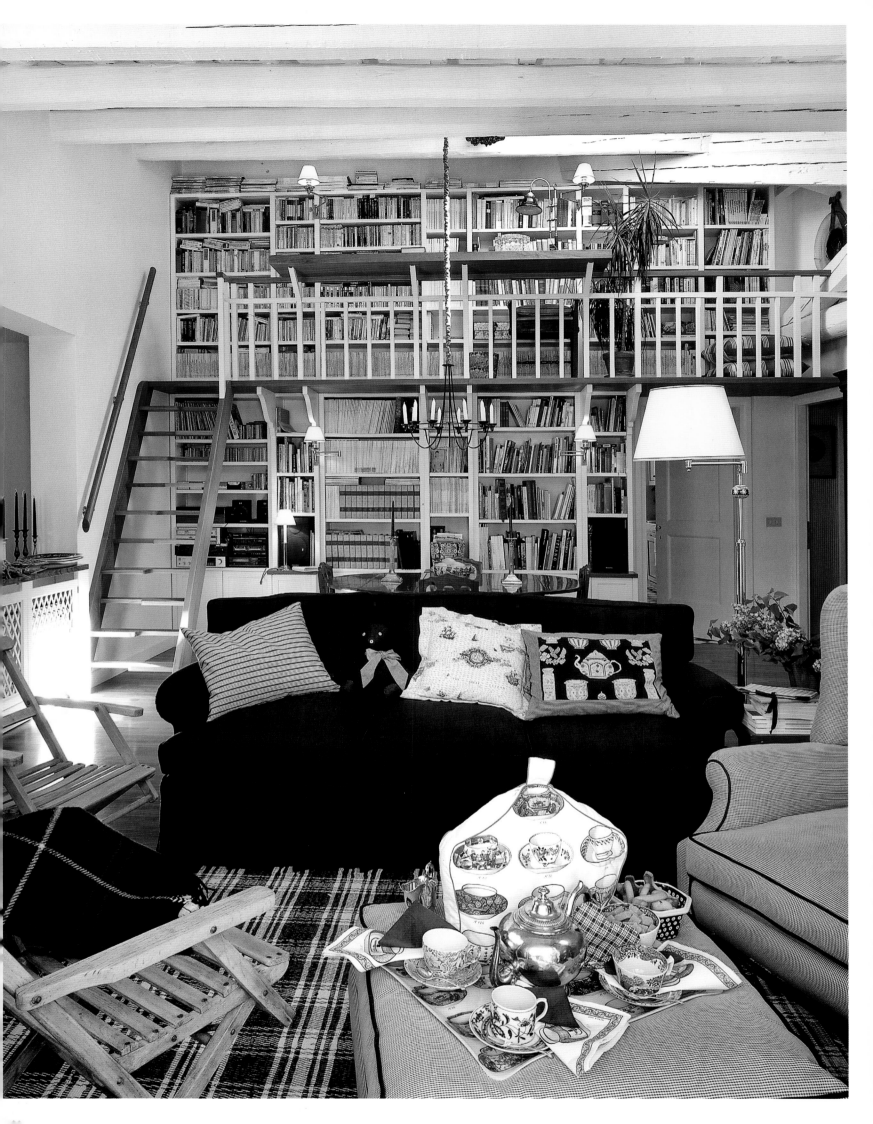

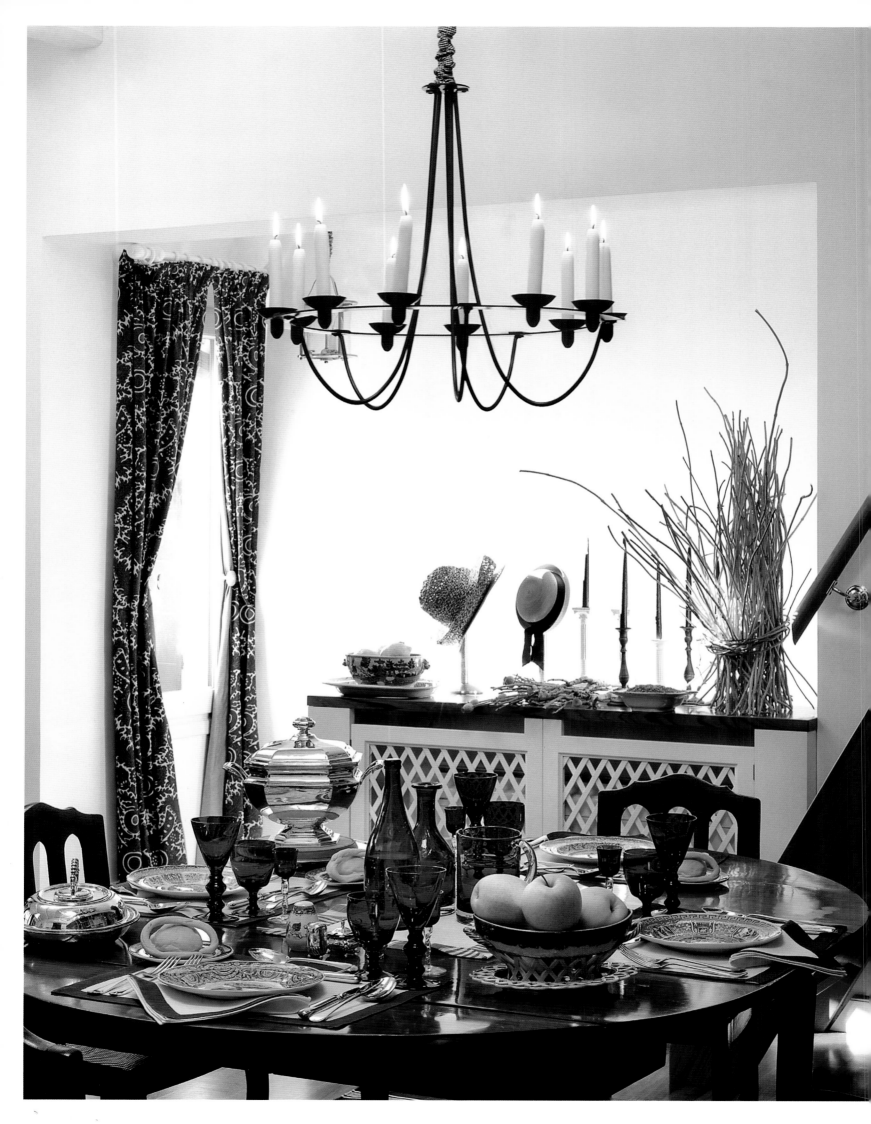

As the sixteenth-century French poet Clément Marot once said of Venice: "Its temples and its palaces are rich in gold and blue, white and black marble." And there is indeed so much color here, with so much meaning, alternately set ablaze or softened by the light that Henry James felt was the city's true soul. Light shapes the whole city: the blinding gold of Saint Mark's domes; the lagoon's turquoise waters, either rippled like the waves depicted by Francesco Guardi's brushstrokes or still and clear like Canaletto's; the vermilion reserved for Doges and senators; the singular shade of red employed by Titian, and the very different yet equally Venetian red of Giambellino's late works (blues were also his trademark); the light taupe tones of the stuccos; the glowing sumptuousness of many churches' baroque columns, painted to create the illusion of marble; and the rich, colorful brocades ennobling the city's inhabitants and homes. So many colors are so intricately woven into the city's landscape that they sometimes go unnoticed. They leap at the eye not only from the city's countless paintings, but also from its fabrics, its way of life, and in the way its public and private spaces are decorated.

The sheer power of sparingly deployed color is the first thing that strikes you when entering the home where Matilde Favaretto Rubelli lives with her family. For more than a century and a half, the name Favaretto Rubelli has been synonymous with "Venetian-style" color as applied to precious fabrics. Despite the fact that her family is one of the world's finest textile manufacturers, this home has little—if any—of their fabrics' chromatic sumptuousness. Like a harmonious chord, its dominant colors are a simple blue and white, almost Scandinavian-inspired tones that are delightfully informal, and reminiscent of a vacation home or seaside cottage. The local character isn't missing here, of course, but it can only be seen in the entrance hall, which, like a miniature boatyard, houses various types of traditional Venetian rowboats used for regattas. The apartment, built into the building's old loft space, has an atmosphere all its own. "When I saw it for the first time," says Matilde, "it had already been completely renovated, so its interior architecture had been remodeled and the faux ceilings that stifled the original trusses removed. It looked like the ideal image of tranquility and family intimacy, devoid of all ostentation, which was just what I had in mind. The decision to use only white and blue came naturally to me, as they are two colors that make you think of the sea, the sky, past memories, and the simplicity of maritime life. All the same, what really convinced me to choose this particular place to live in was the view." And the views are indeed unequaled; they are like a sought-after collection of poetic passages sublimated into images and sensations. Every window is a verse, every perspective is like a masterful painting. Hermann Hesse's observation that Venice's scent is that of its water and wet stones takes visual form here, both in the rooms and the views visible through the large windows. In the words of the poet Vincenzo Cardarelli, ". . . festive lights with a silver sheen laugh / speaking anxiously and distantly / in the cold dark air. / I gaze at them, enchanted." You can almost touch Saint Mark's bell tower from here, and with a turn of the head you can catch a glimpse of Campo Sant'Angelo. Looking beyond the canal, your eyes travel all the way to the Gothic ornamentation on Ca' Pisani, and you can easily lose yourself in the city's labyrinthine and radiant surface.

Outside the windows a visual symphony engulfs the eye, while inside simplicity reigns supreme—it's a question of decorative balance. This pared-down philosophy is visible in the bleached rafters, plain living-room furnishings, vintage blue armchair, Swedish wrought-iron chandelier, and Venetian mirror mounted on an easel so the room becomes a painting in constant motion. It reaches its peak in the bi-level white bookcase that turns the mezzanine into a study lit by the large skylight—you can never have enough books. Natural teak is used for all the floors except the kitchen and bathroom, which instead feature a checkerboard pattern of blue and white lozenge-shaped ceramic tiles. A love of the simple life pops up again in the Provençal-style kitchen with a pendant lamp made from a birdcage, and in the master

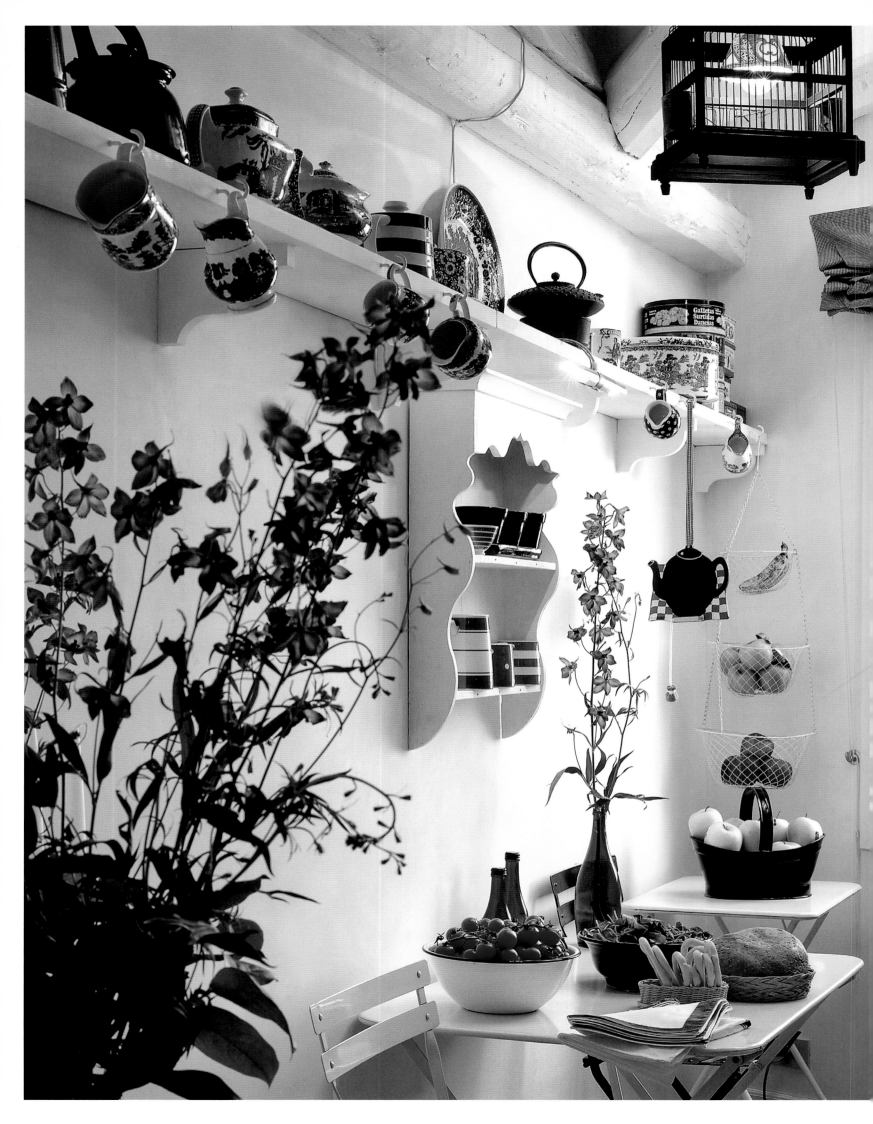

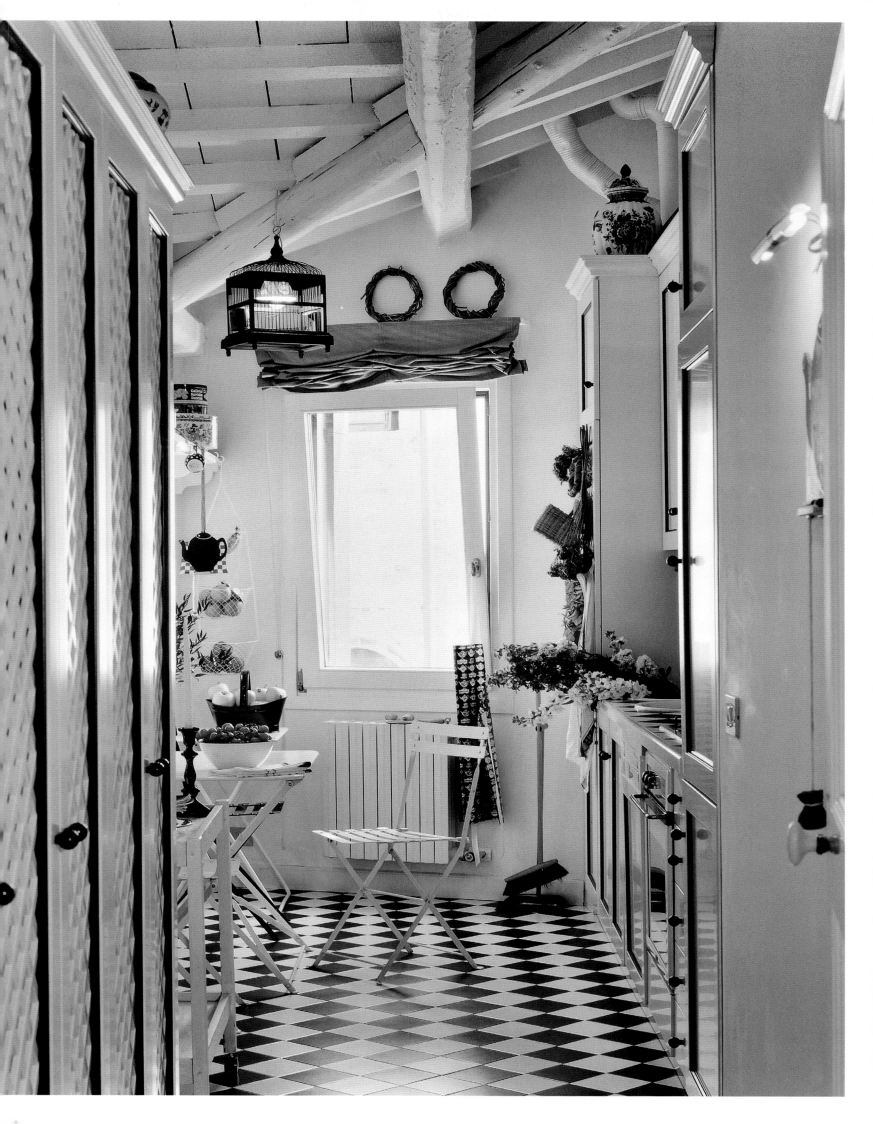

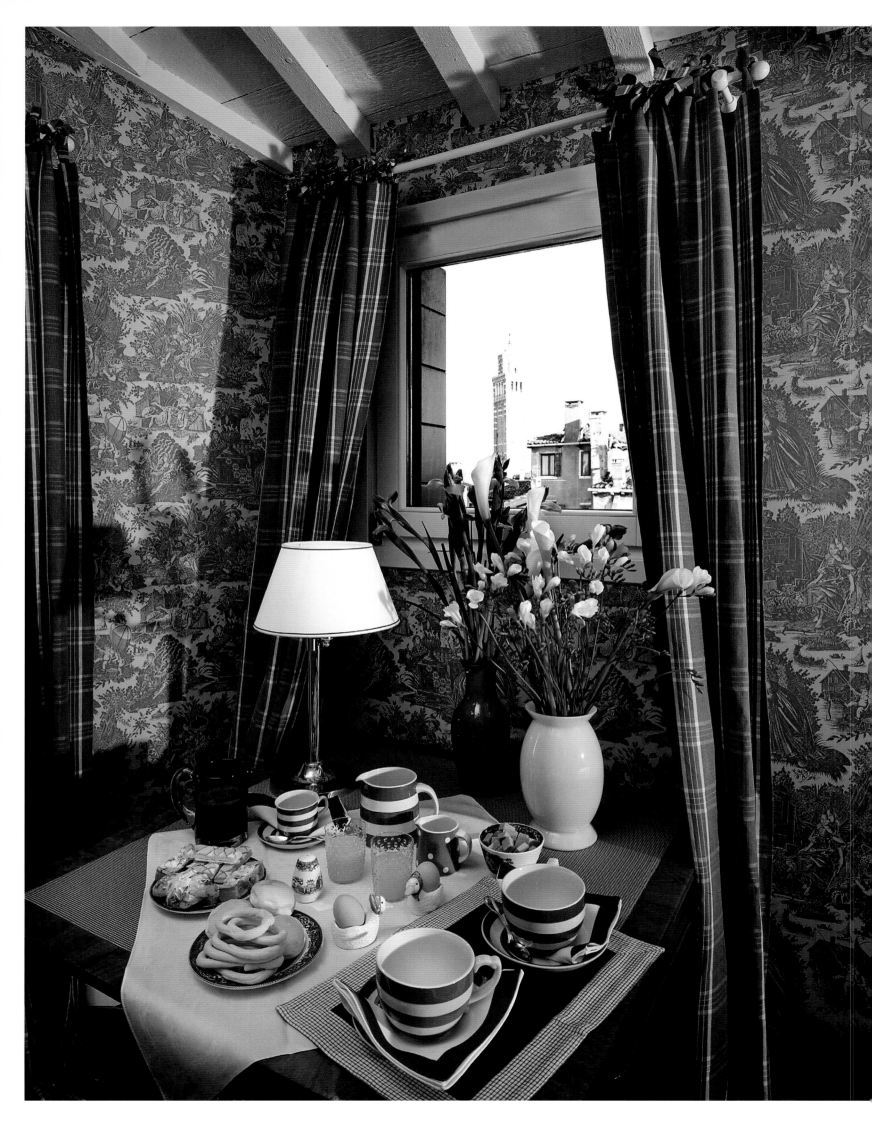

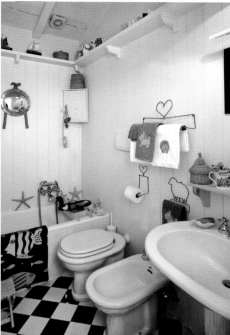

bedroom with *toile de Jouy* wall coverings and a four-poster bed designed by Matilde herself. All the fabrics, of course, were carefully selected to match the blue and white theme of the entire home.

The lady of the house is an affable woman with many passions. One in particular is antiques, and she doesn't hesitate to show it by displaying, here and there, pieces of nineteenth-century silver and a collection of blue and white Chinese porcelain, yet another tribute to these two beloved colors. "These are objects I cherish," she says, "that go well with the pieces of furniture. The only one that was in my family is the nineteenth-century wardrobe. All the others are cherry, in Louis XVI and Biedermeier styles, from the shop owned by Massimo Micheluzzi, one of Venice's finest master glassmakers." Each object is a surprise, and feels like something taken from the pages of Carlo Gozzi's irresistible fairy tales. Alongside the family they inhabit a home that, in its romantic sobriety, tucked away into a corner of Venice's unique panorama, conjures up a truly magical feeling.

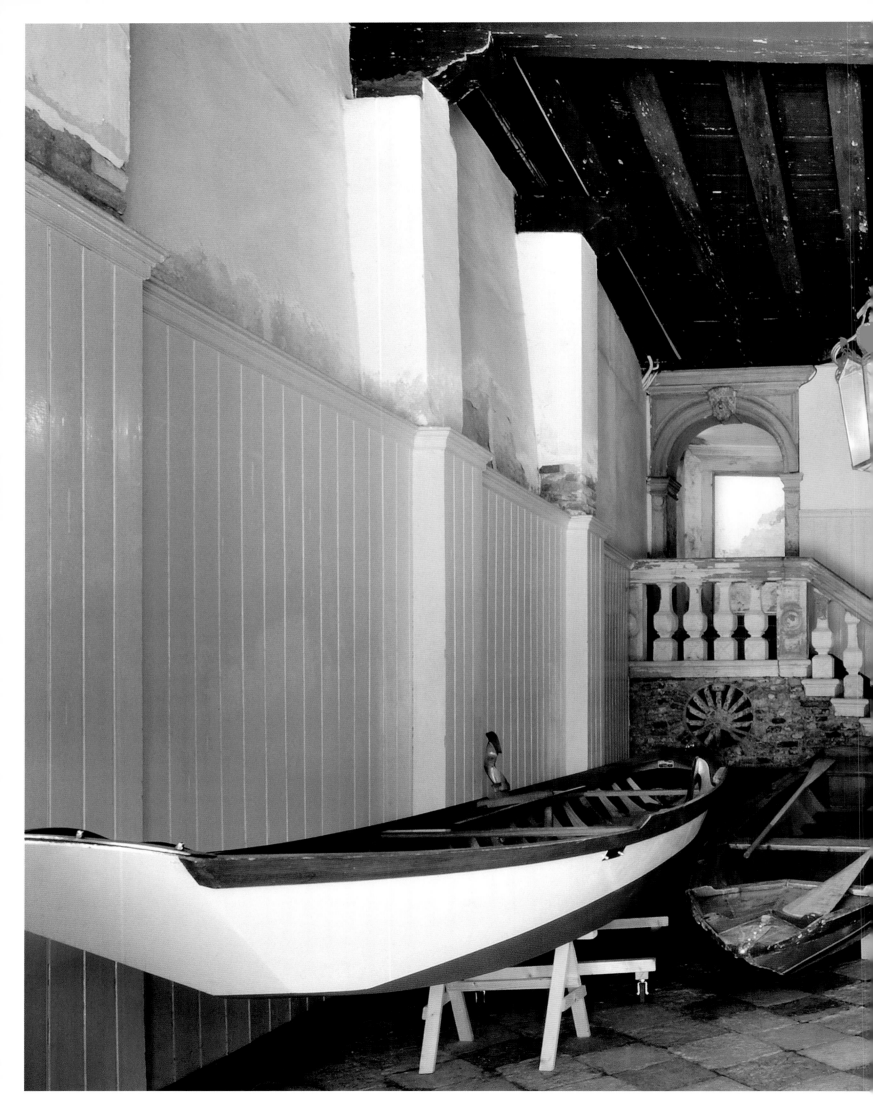

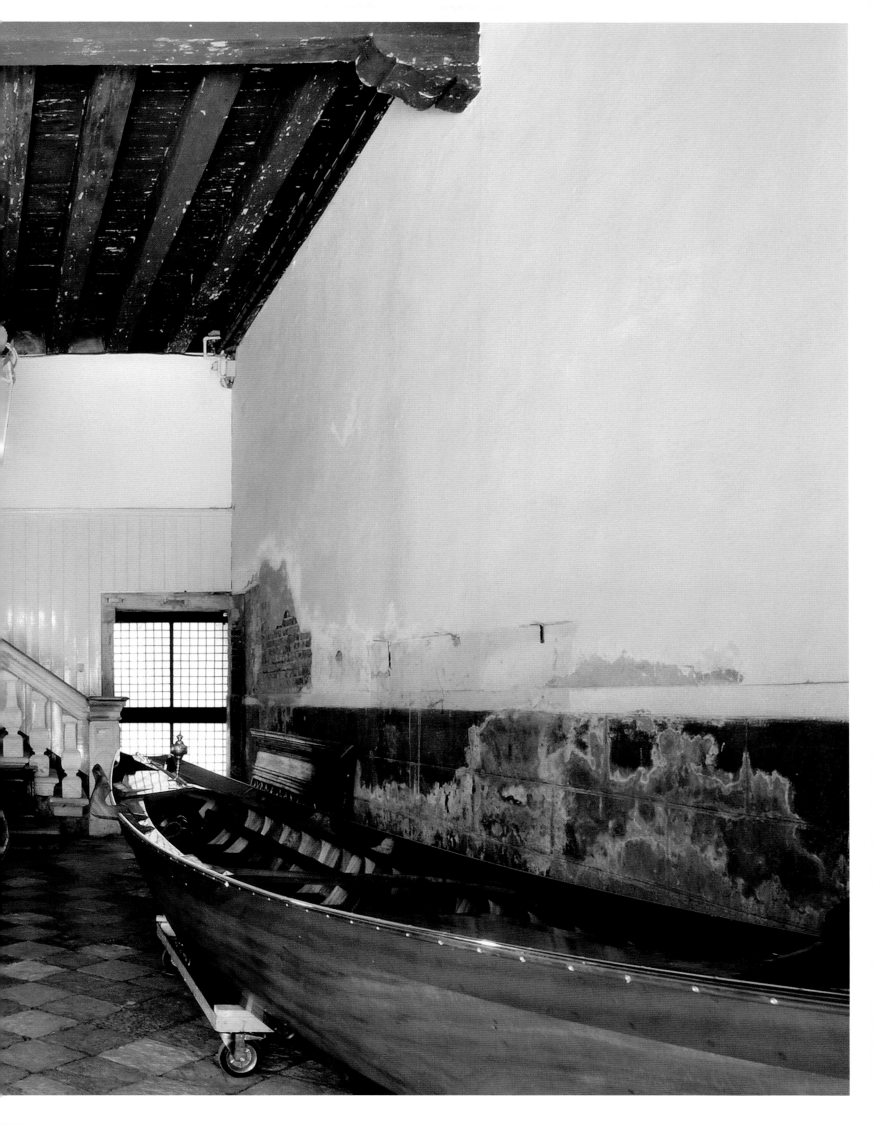

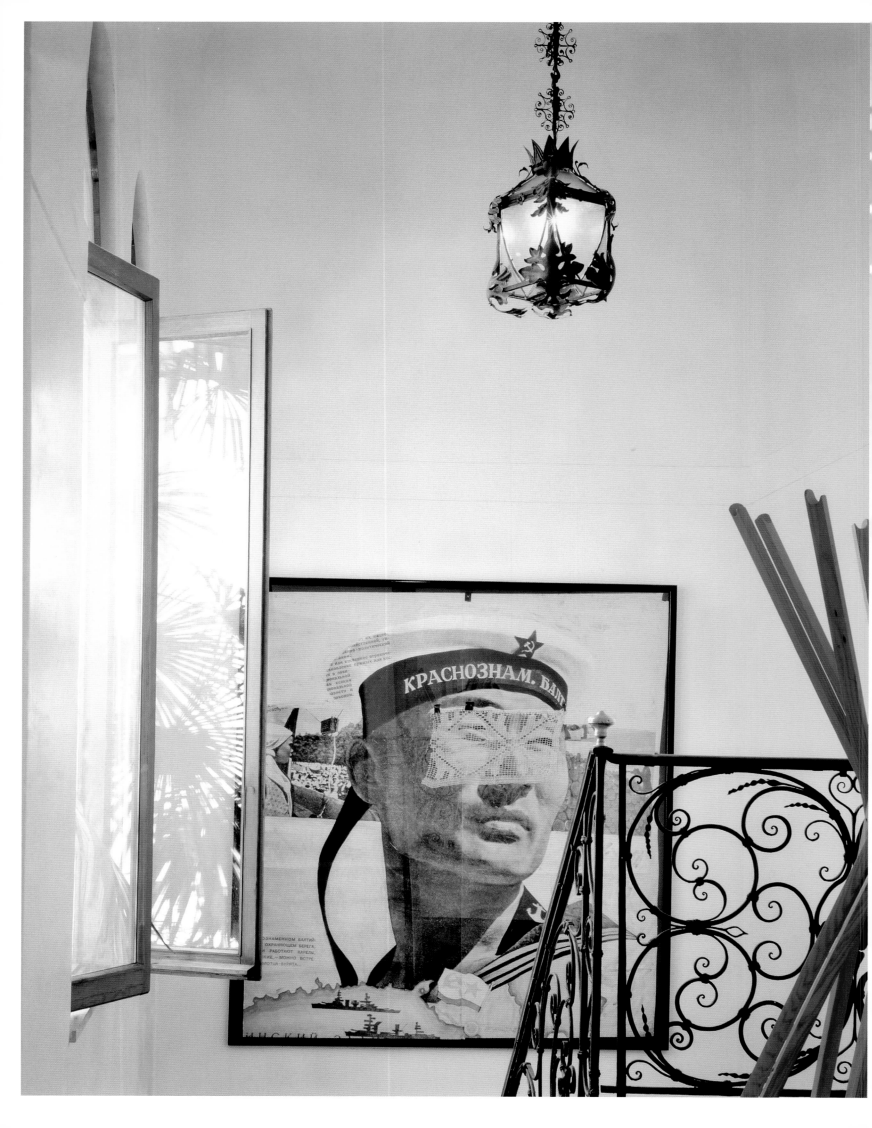

Soviet Art in the Lagoon

Few people know this, but the Soviet Union is still alive and kicking, right in the heart of Venice. It survives as an enclave outside time that outlived the fall of Communism, a group of petite heroes of the October Revolution— politicians, soldiers, ballerinas, and workers. Either plain white or colored, their faces are lit by the inspiration of their mission, their gestures are assertive, and their gazes focus on their work or look toward the future (and what a future!). They were given a warm welcome to Venice in the home of Alberto Sandretti, an entrepreneur who in his youth had entertained the idea of being able to change the world. With that ideal in mind he set off for Russia, and in 1956 he graduated from the University of Moscow.

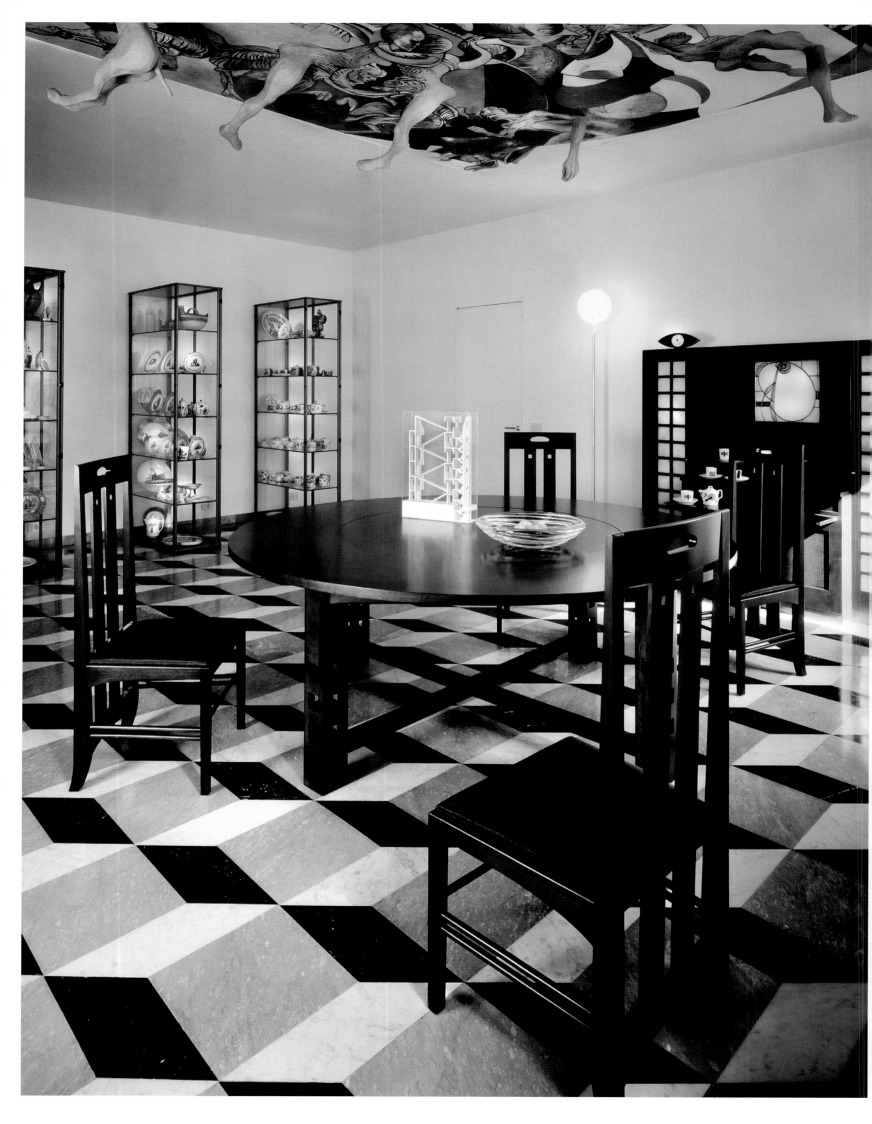

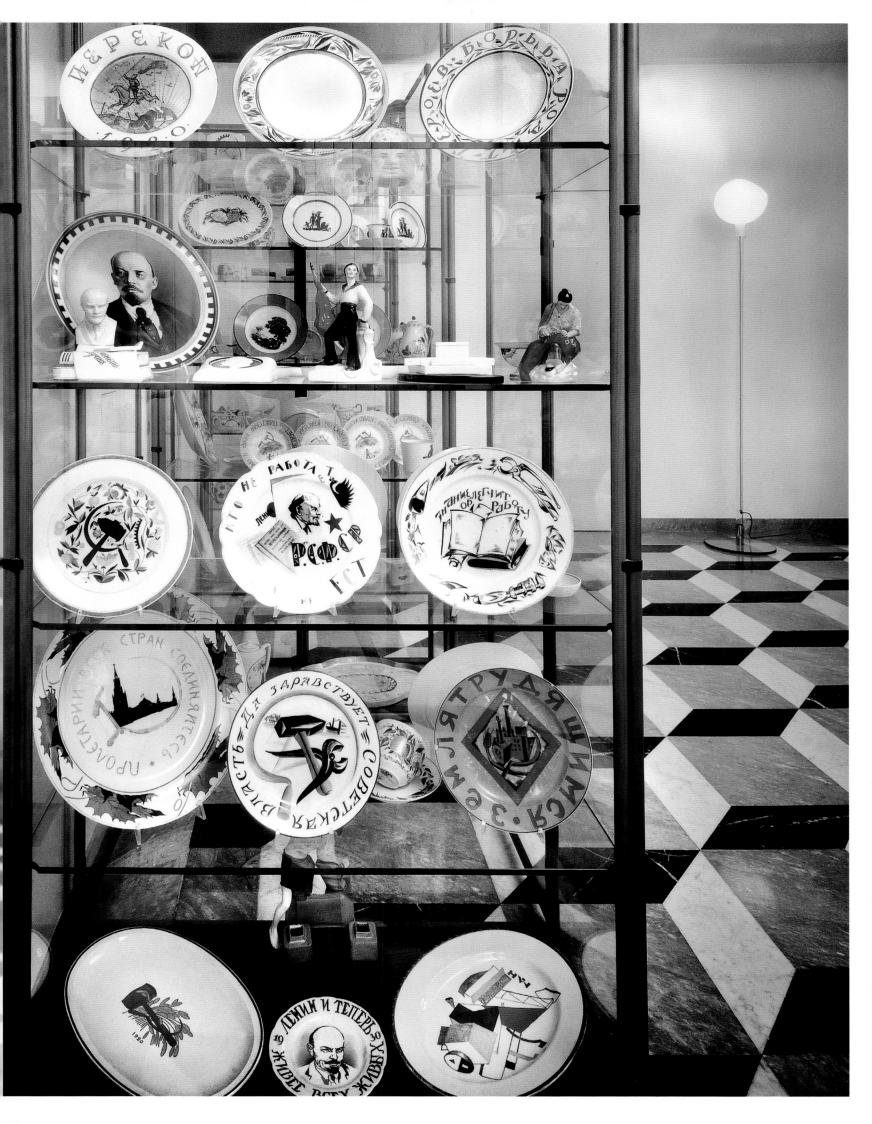

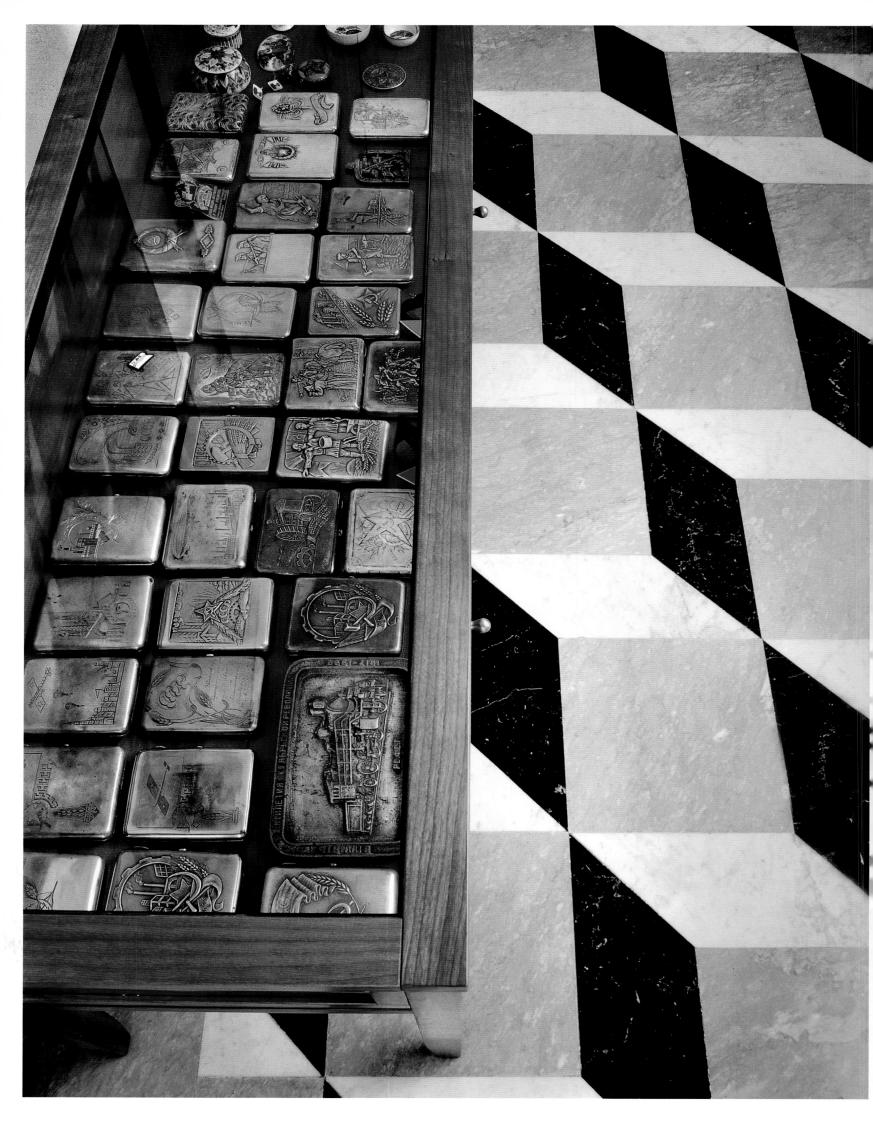

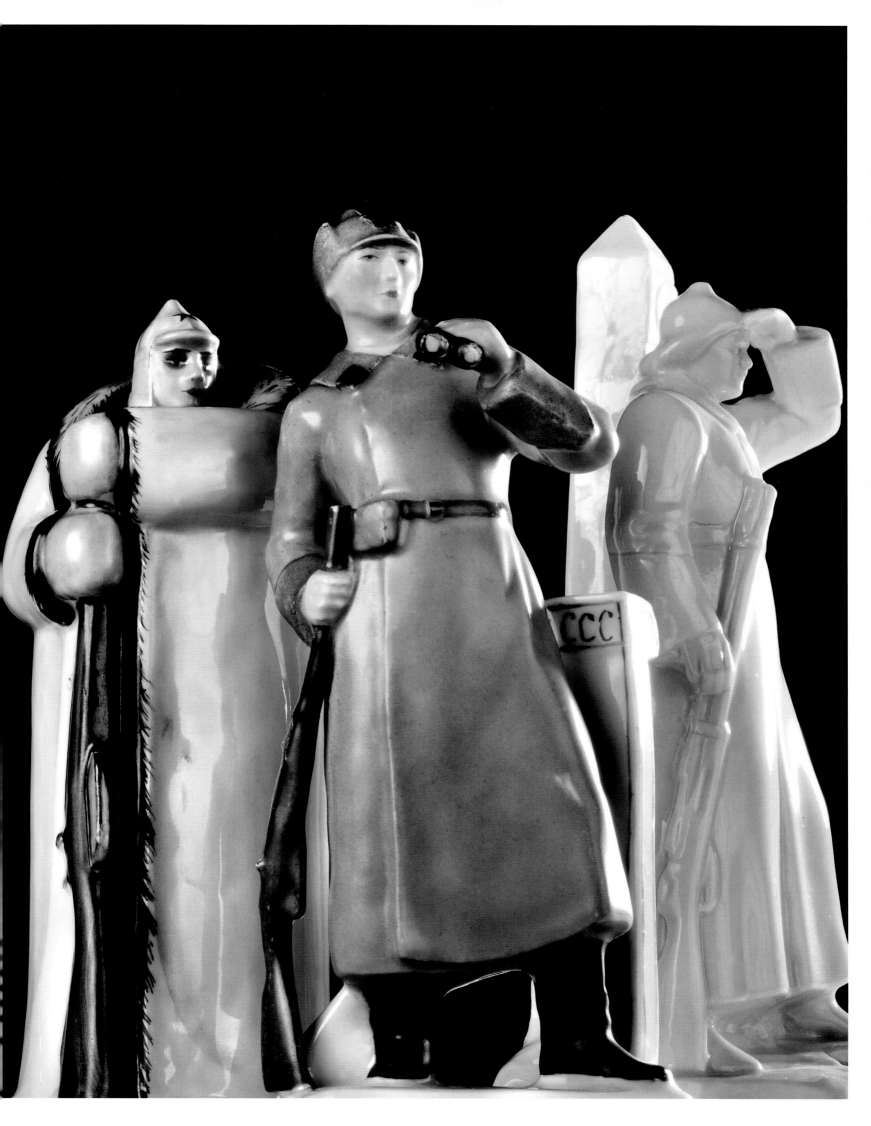

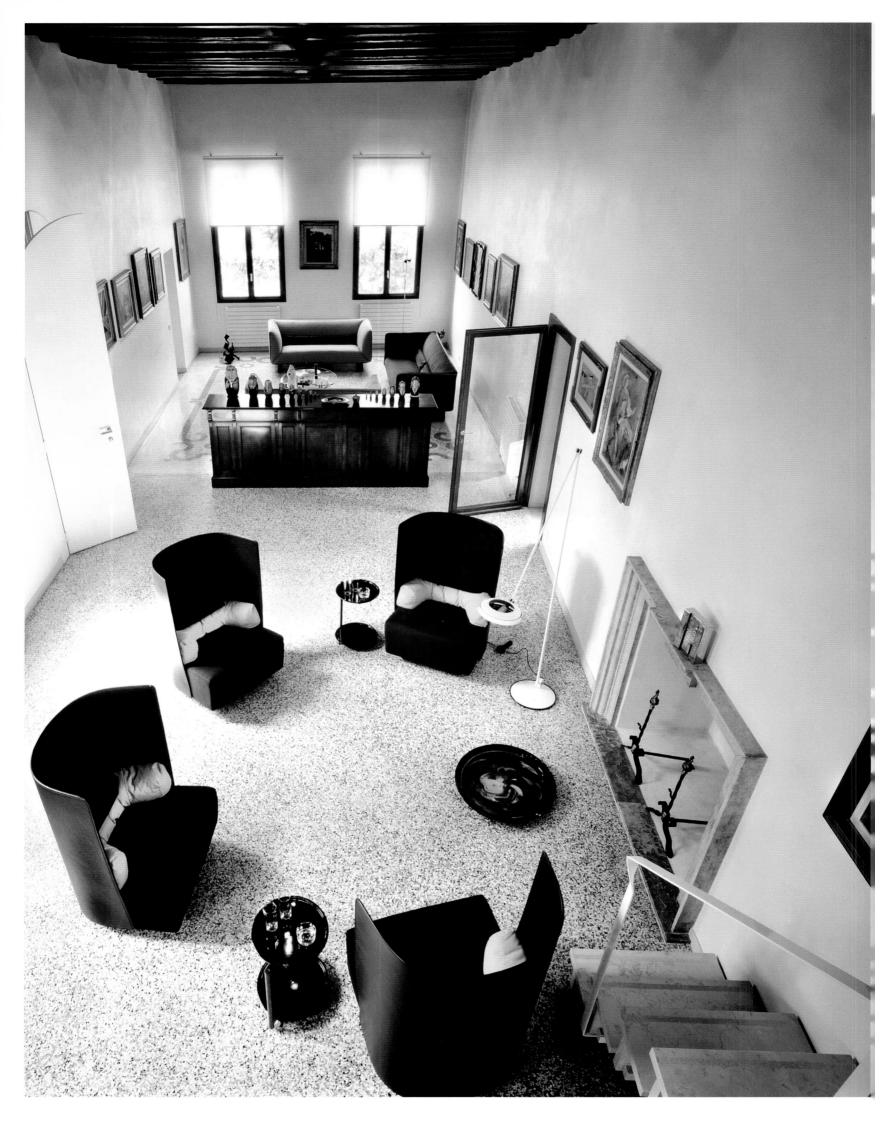

His guests are neither retired servicemen nor relics of the regime; rather, they are porcelain figurines made by the state porcelain manufactory of St. Petersburg (or shall I say Leningrad?) and by the Dimitrov and Lomonosov companies in Moscow. These hundreds of characters walk a fine line somewhere between kitsch, nostalgia, and true art. To this day Sandretti divides his time between Milan and Moscow—some have called him Russia's informal consul in Venice—and this collection has been patiently built with endearing nonchalance during his long visits to the land of the tsars. It is truly one of a kind, and includes rare pieces cast by Natalia Danko, Tigran Davtyan, Elizaveta Tripolskaya, Tamara Karsavina, Aleksander Matveev, and other artists who studied under Sergey Chekhonin, mentor of Soviet porcelain and director of the state porcelain manufactory of Leningrad. These iconic figures of Soviet anthropology were created to carry the precepts of the "Communist panacea" to every house in Russia and the entire world, and they've since become mementos of that remarkable period. Today, alongside plates and other revolutionary items, they proudly inhabit crystal display cabinets—realizing the dream of all totalitarian regimes, a glass house so easily surveilled—in the oblong living room and dining area of a Venetian home dating back to the sixteenth century.

And yet the house is not a shrine—it's anything but. There's a lot of life inside, and you can almost feel the sheer energy of intense thought, the exuberance of Sandretti's interests and those of his wife, Cristina. The home reflects their love of Venice, a city, they confide, where "as soon as you arrive you put aside your usual life and dive into a dream life. It's hard to explain exactly what it is. It's not a state of rest, nor the effect of just letting your hair down. It's a sense of happiness, of light-heartedness." The traditional feel of Venetian architecture has remained intact here: the home has almost endless ceilings and thick oak beams; its wide-open rooms fade seamlessly into the cozier adjacent spaces; some of the flooring is marble-chip terrazzo, while the rest is made of white, gray, and black lozenges forming a three-dimensional illusion; and the windows provide enchanting views of the canals and the sea. "It's a whimsical home," says Sandretti, "designed for relaxation, for parties, to spend time with friends, and do a bit of public relations as well." There is little furniture, and most pieces are contemporary design, like Zanotta's Campo armchairs, and the Interflex bed that has fourteen (yes, fourteen!) different bedcovers, including one inspired by one of Giacomo Balla's Futurist paintings. Sandretti himself chooses the one he wants, depending on his mood that day, almost as though he were

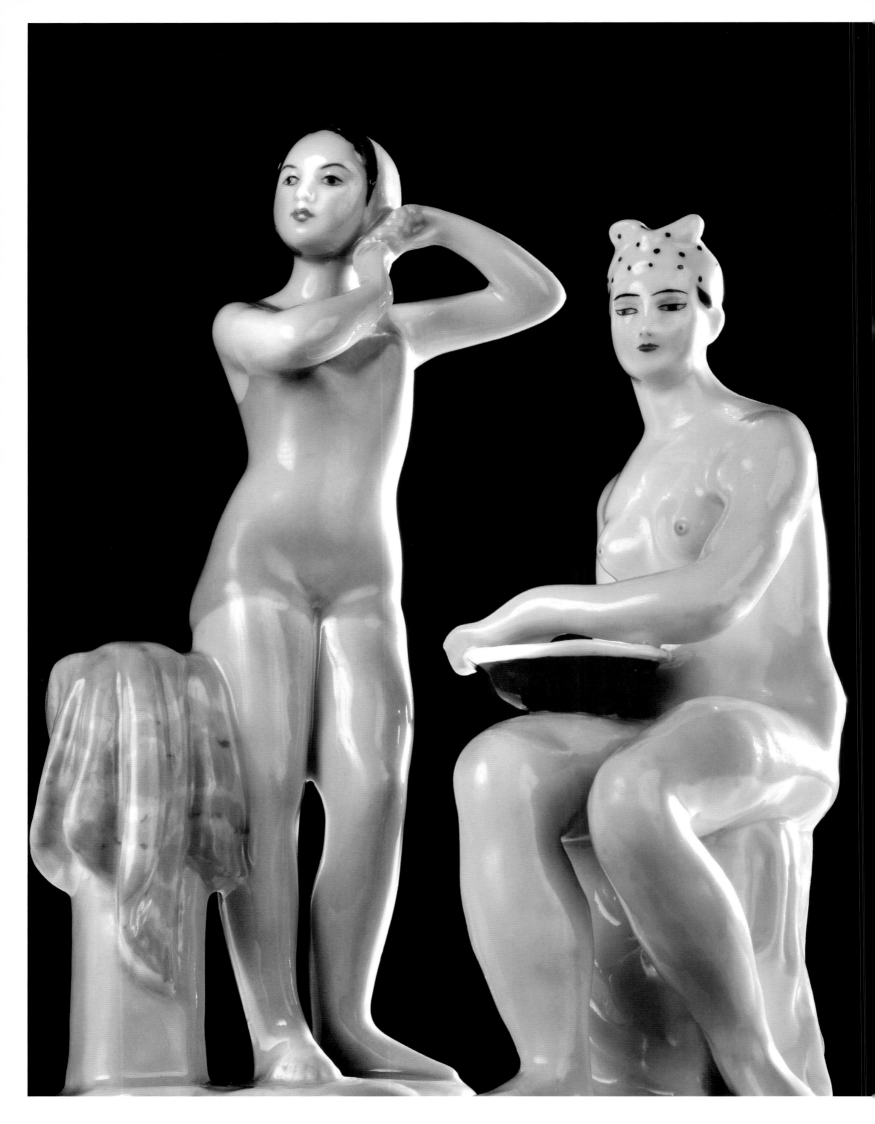

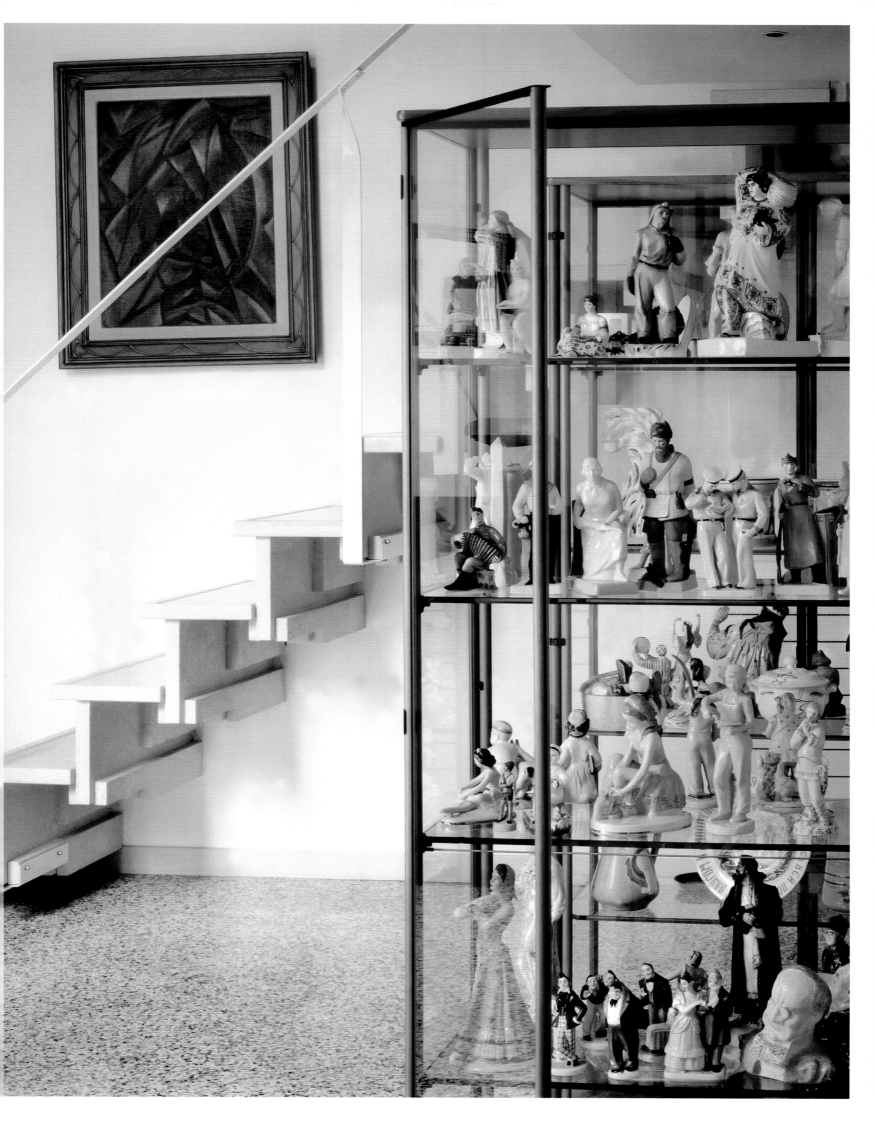

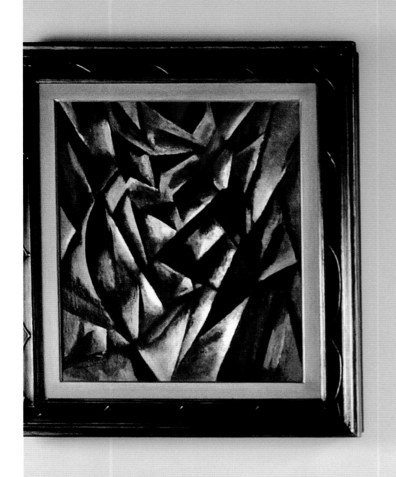

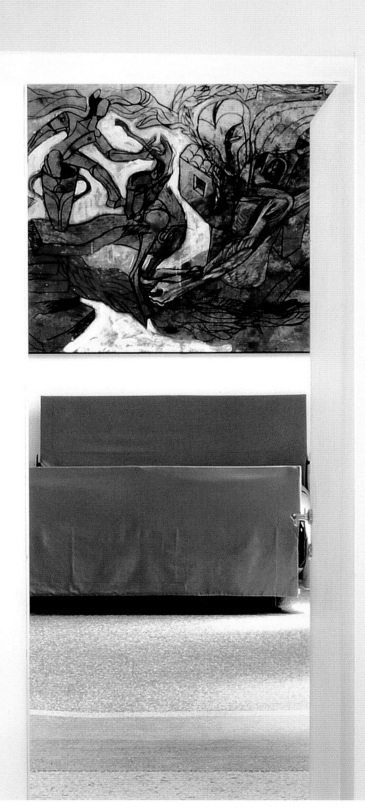
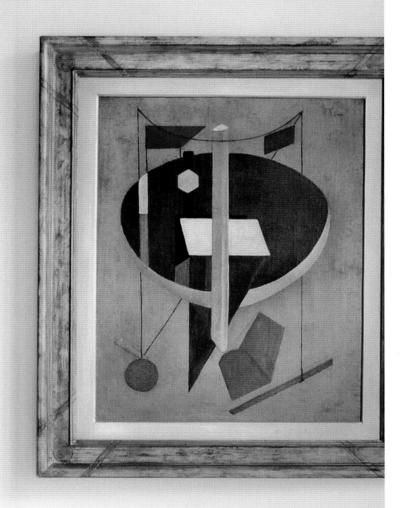

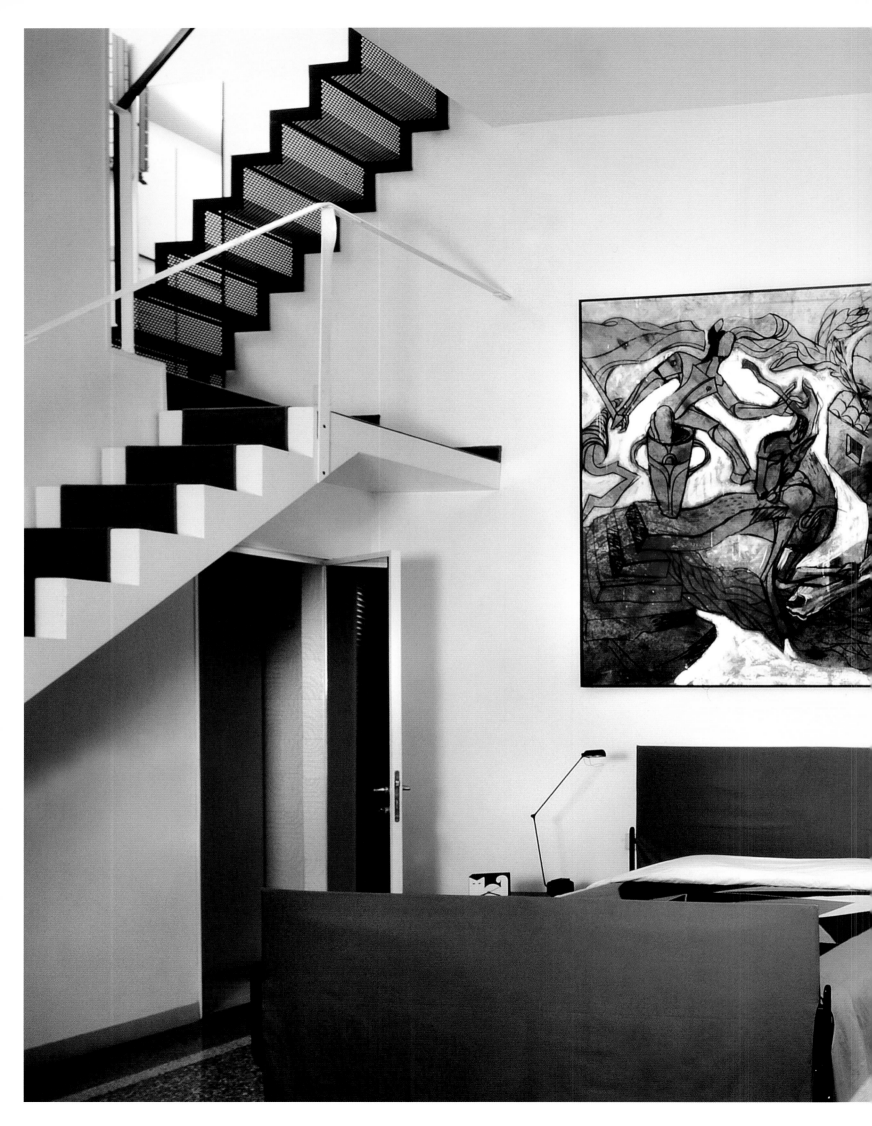

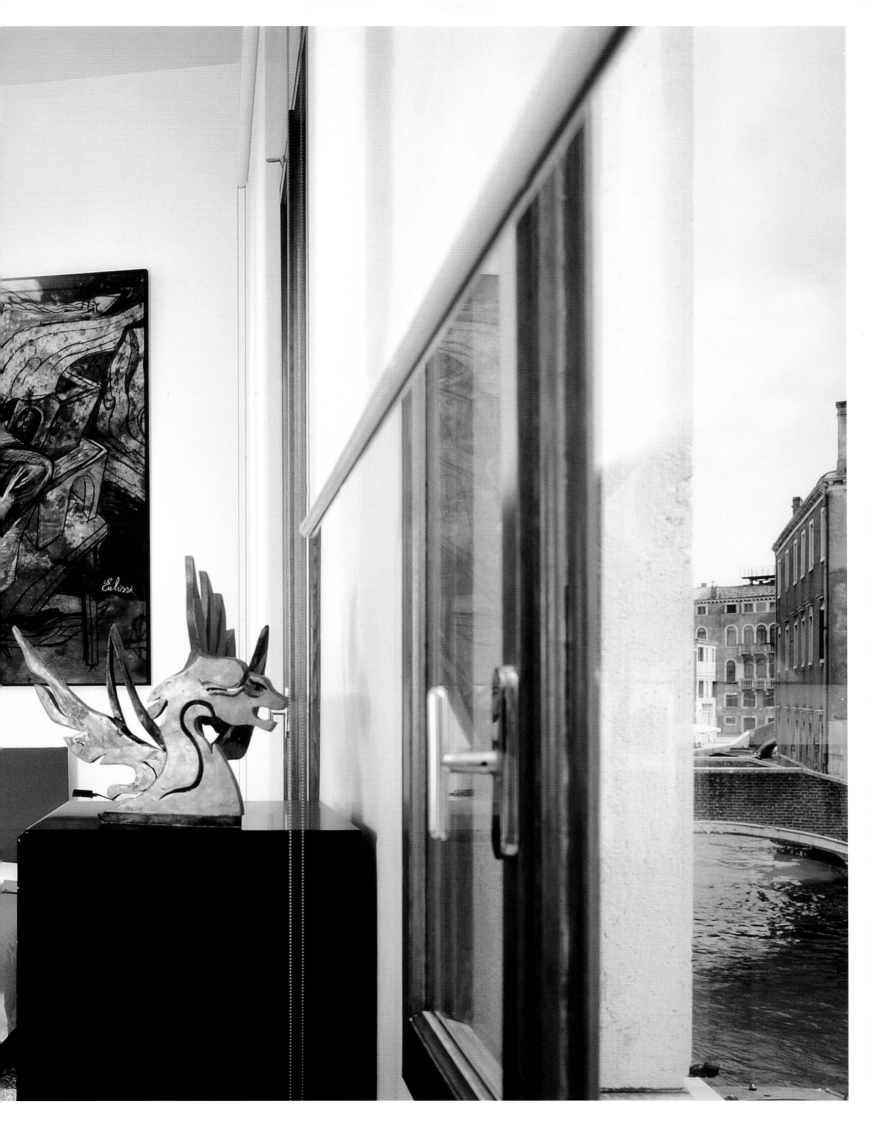

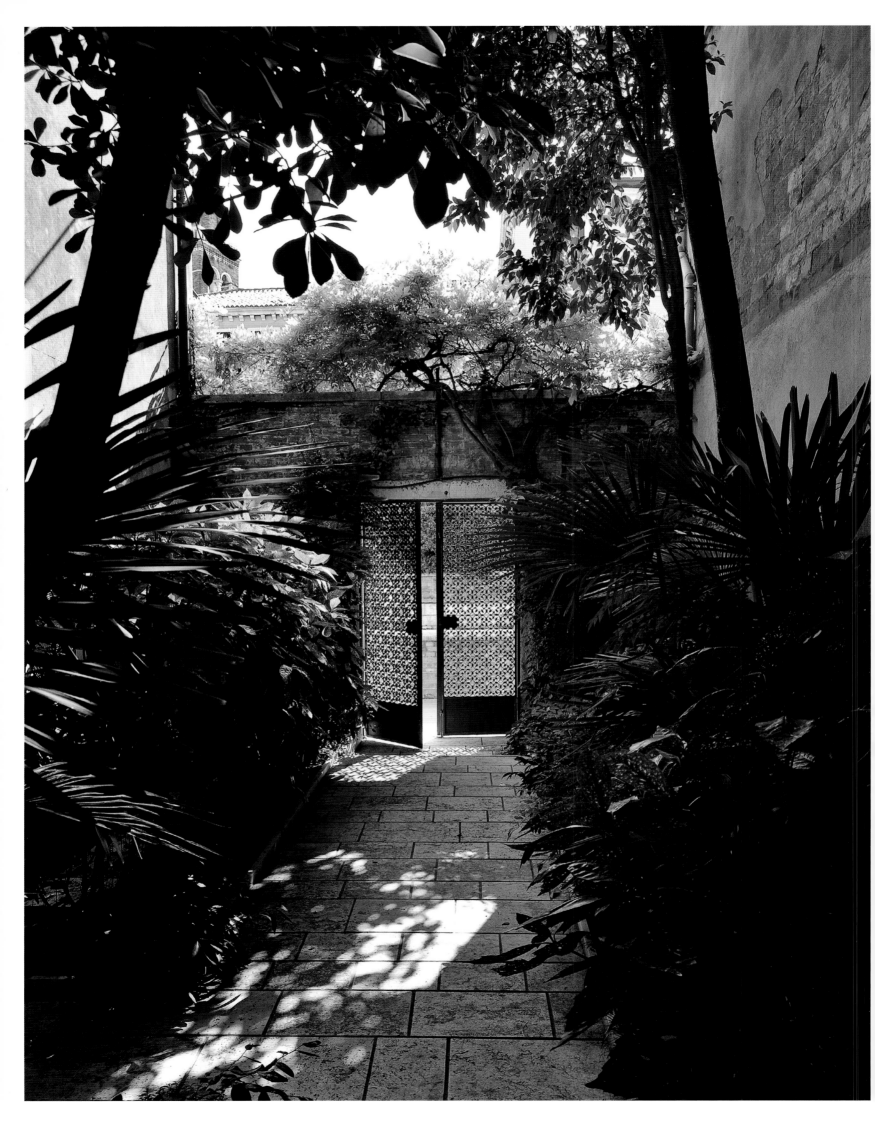

dressing a doll. There are few cumbersome objects and numerous staircases, all different, as though they were sculptures. The television has been exiled to the mezzanine because, Sandretti says, "It's like a motorcycle roaring down the street, it bothers everyone." The home has a lot of light and lots of space. He further explains: "Cristina and I wanted it that way, so there might be more room for the beautiful things to breathe."

His modest mention of beautiful things, all arranged to give the viewer a feeling of well-measured memories and emotions, refers not only to the porcelains but also to a collection of Soviet paintings from the 1920s. It includes work by abstract painters and Constructivists, exponents of a yearning for creative freedom, a scale model of the Utopia gallery designed by Moscow architect Yuri Avvakumov, and the painting *Ricordo di Guernica* (Memory of Guernica) by the Venetian artist Vincenzo Eulisse. The work of Vittorio Basaglia juts playfully from the ceiling over the dining table, in a vortex of colorful forms crossing from two into three dimensions. "When I bought it," Sandretti says, with a sardonic smile, "I had nowhere to put it. Then we bought this house, and the first thing we did was find the right ceiling for it. This was it, right where we eat. I am greatly amused by the idea that it hangs over the heads of our guests, and sometimes it even makes them a bit uncertain: you can almost hear them thinking, 'Will some leg fall into my *sarde al soar* . . . ?' That dampens their appetite, so they eat less, and my expenses aren't quite so outrageous."

This playful spirit extends beyond the house. Between it and the water lies a lush green belt with thirty-two cypresses, a precious treasure in Venice's dense urban network. Weather permitting, this garden becomes the dining room—providing a nice escape from the artwork that hangs like a sword of Damocles over their indoor dining table! This outdoor space is yet another magic aspect of the home, filled as it is with ironic provocations, a deep sense of history, and souvenirs of a bygone era that is somehow perplexingly present. Sandretti has also collected extraordinary works by Soviet dissidents, providing a stark counterpoint. Despite the home's undeniable beauty, "I don't want to spend more than three or four months of the year here," he says, with a touch of Gogolian humor. "Otherwise I, too, will turn into a museum piece. I definitely don't want that to happen; I like to go to the museum as a visitor, not as a relic!"

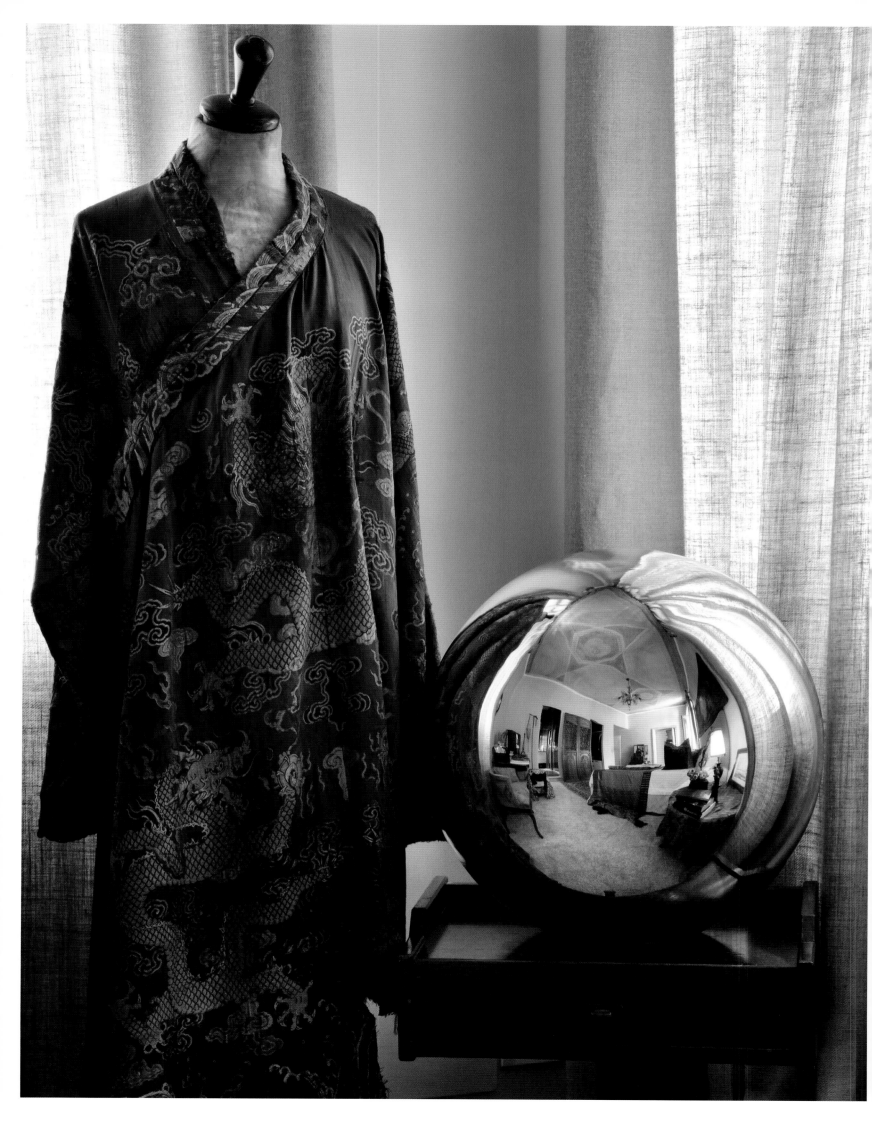

A Workshop of Fabrics

Sometimes a single characteristic is strong enough to define an entire house. This rhetorical idea of the part standing for the whole, known as synecdoche, perfectly suits the Venetian home of Gloria Beggiato. Not because it is a one-dimensional house—quite the contrary, it is full of ideas and possibilities. Instead, this idea fits because the home's interior has an overpowering presence—its fabric, and its velvets in particular. But before proceeding to explore this home, there are a couple of things worth noting about its owner.

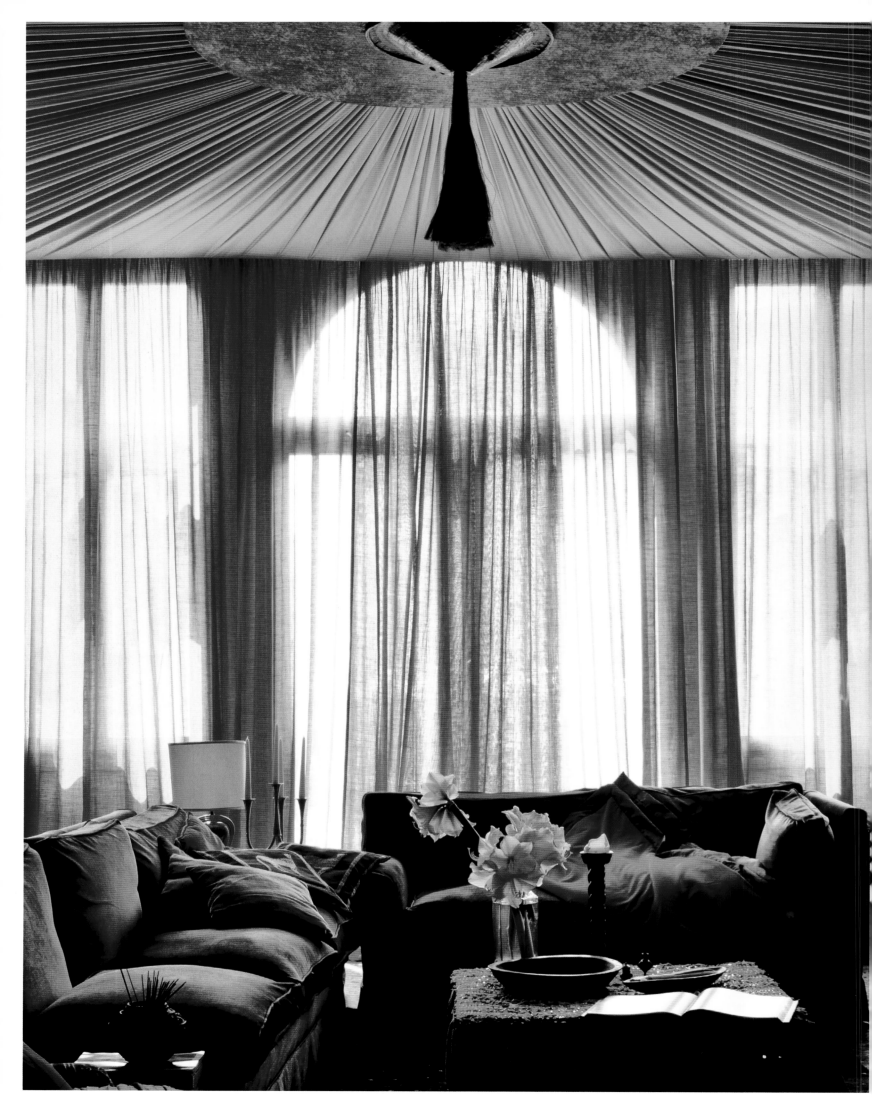

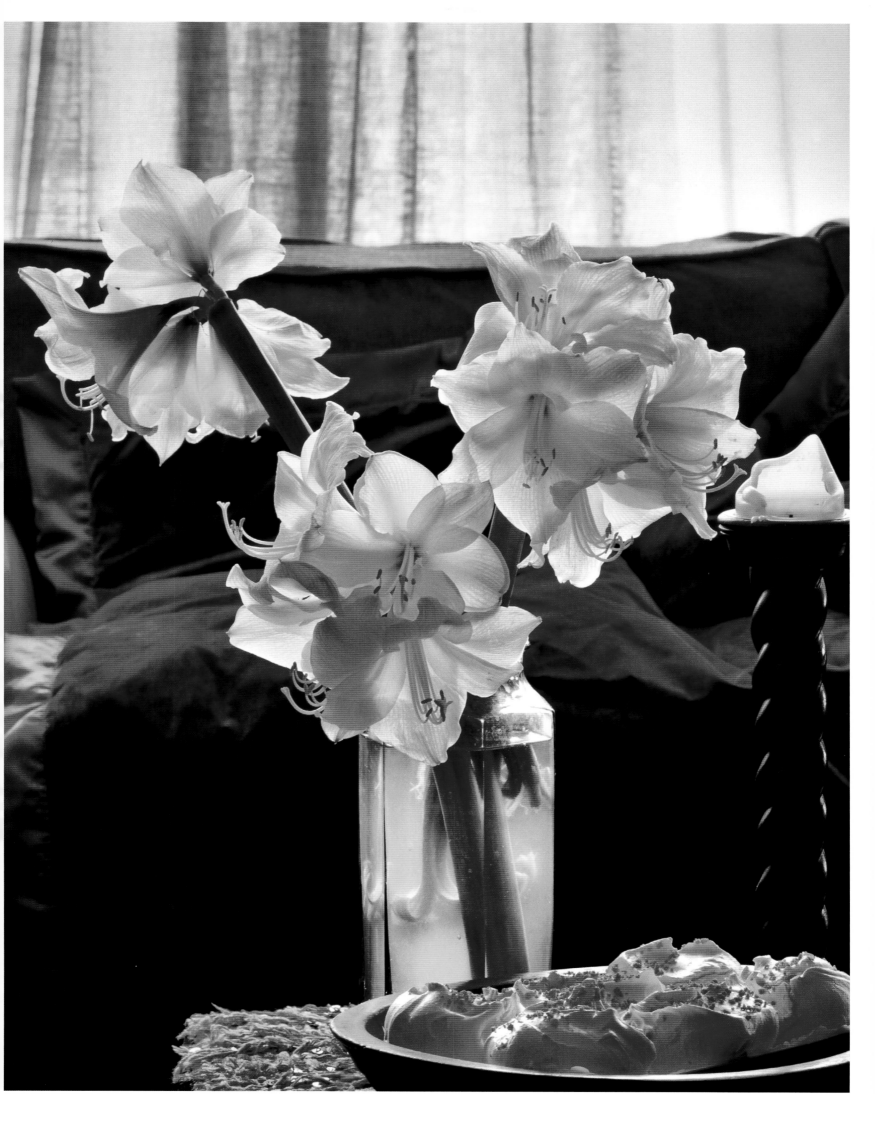

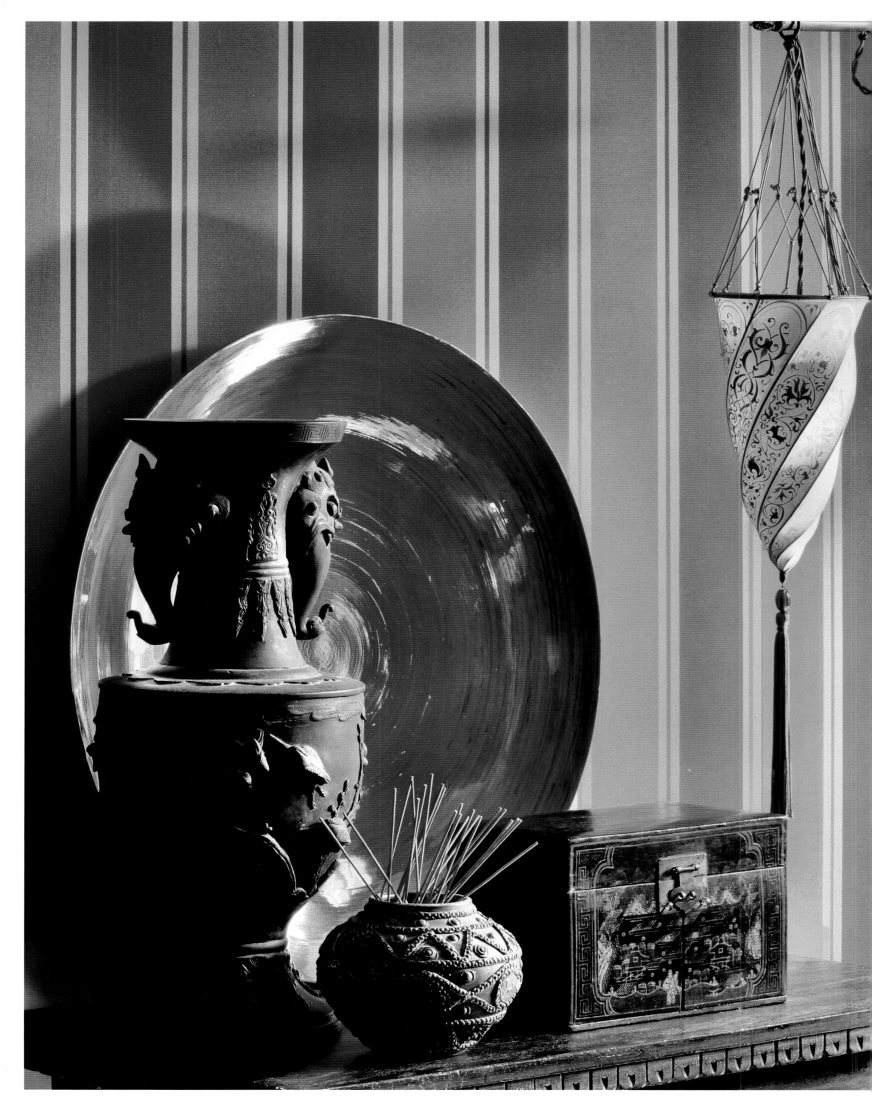

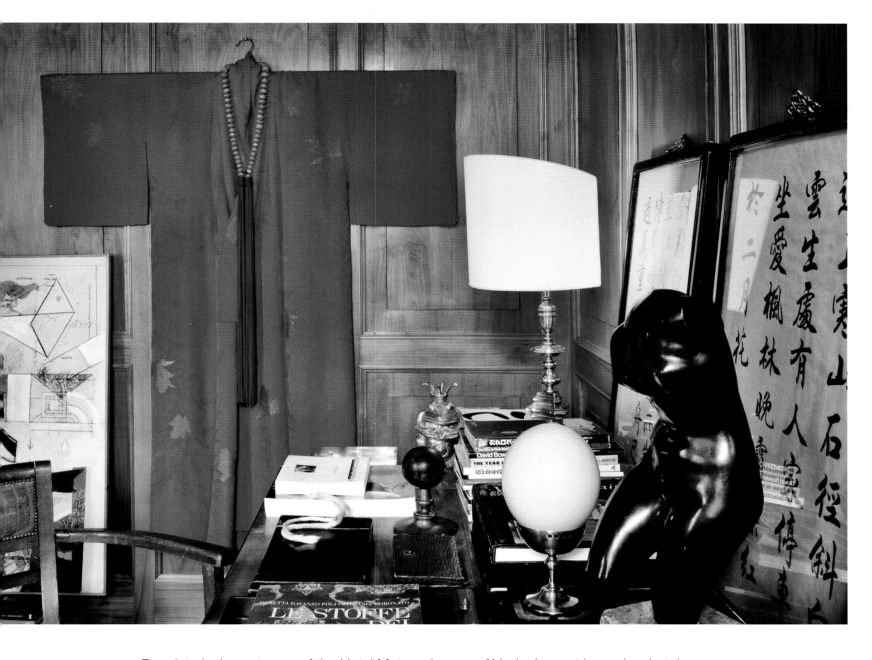

Beggiato is the *patronne* of the Hotel Metropole, one of Venice's most legendary hotels. Sigmund Freud and Marcel Proust both stayed there, and in 1901 Thomas Mann booked two of its rooms—one for himself and one for his brother. Pierluigi and Elisabeth Beggiato took ownership of it in 1968, and their daughter remodeled it in 2000 and again in 2008. Her work has enhanced its mysterious and romantic ambience—a magical touch here, a vintage detail there—all the while maintaining its literary quality. That atmosphere melds with influences from around the globe, with Asian touches, exotic flourishes, and other vivid mementos of her passion for travel. Its restaurant, the Met, earned two Michelin stars, and is one of the few in Italy to be honored by such an accomplishment. The hotel is famous for its welcoming atmosphere, its priceless position on the Riva degli Schiavoni, the wealth of services it provides, and the multisensory nature—as the specialized magazines call it—of its overall experience. The Metropole elevates hospitality to a refined art.

This is not an attempt to publicize the hotel, there's no need to; rather, it gives you an idea of Beggiato's bubbly temperament, and explains the similarly vibrant mood that breathes life into her own home. It's a family home, with lots of memories and lots of nostalgia, but also exudes a new, exuberant creativity. It's set apart by its warm, orangey hues and the intense, velvety, golden violets taken straight from Claude Monet's paintings of sunsets over the lagoon. The visitor here is also stirred by traces of a rediscovered Venetian lifestyle, such as the stuccowork above the lounge door, which emerged during a delicate restoration, the Fortuny lamps, and the views glimpsed through the fluttering filigree of the curtains. The idea of the journey is another important decorative motif. Beggiato explains: "I am a seasoned traveler, I like to bring back the feel I get for each country I visit. Each time I return to Venice I dig my purchases out

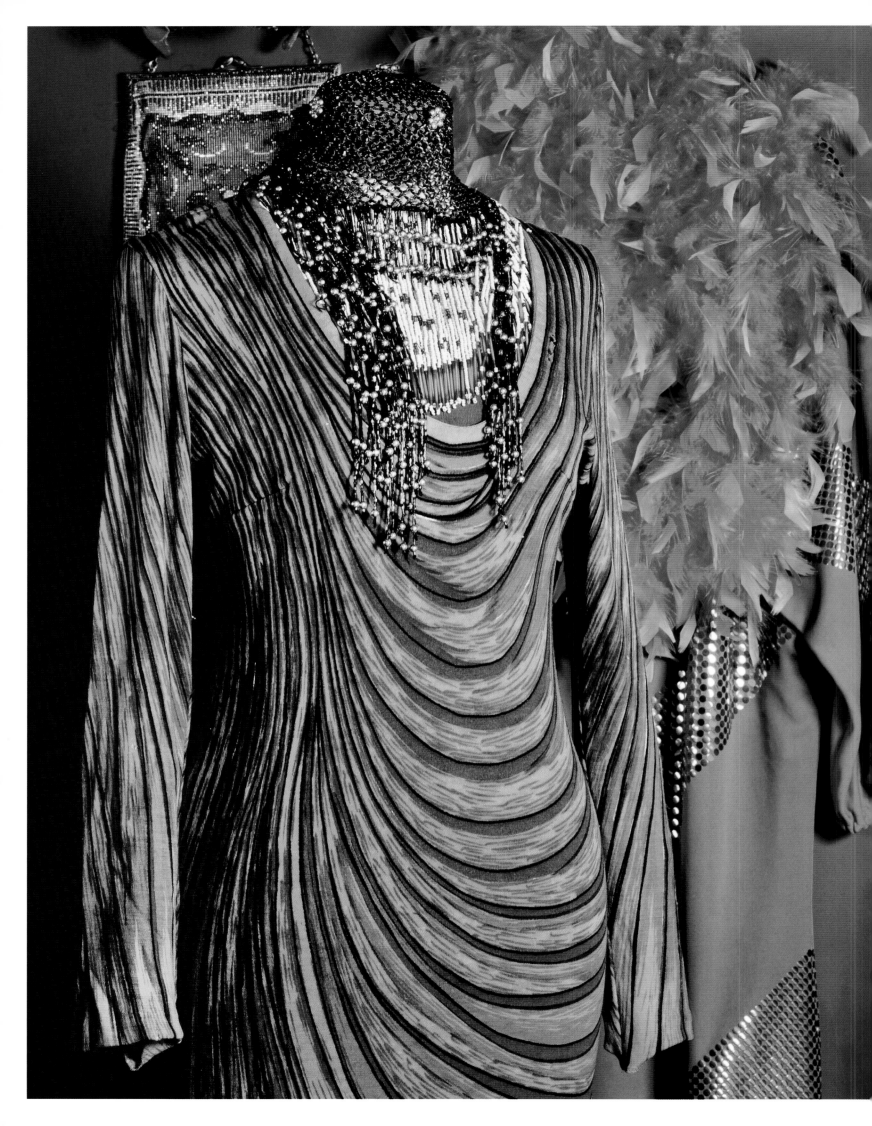

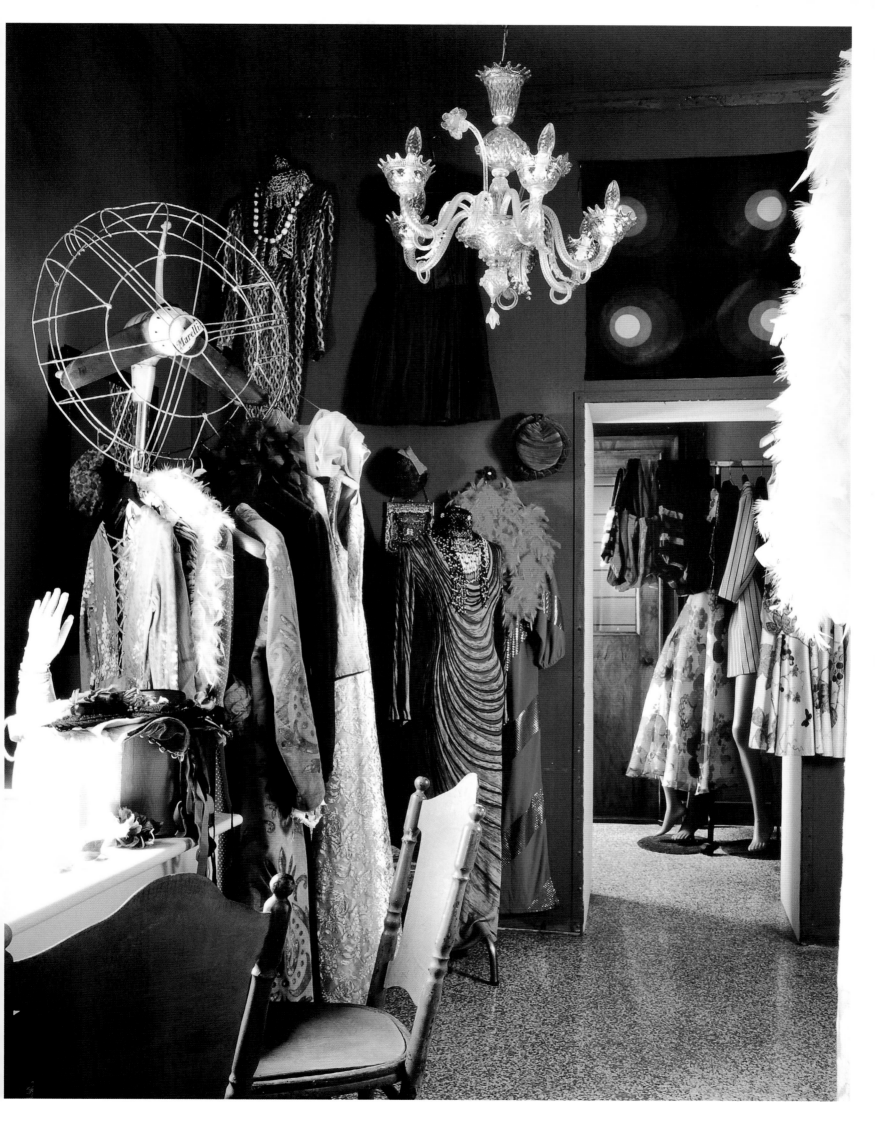

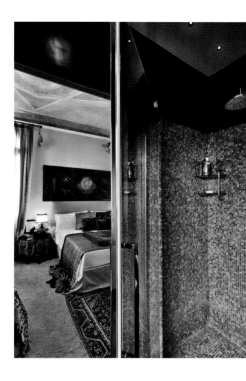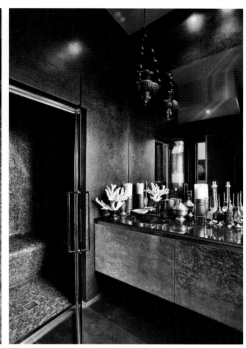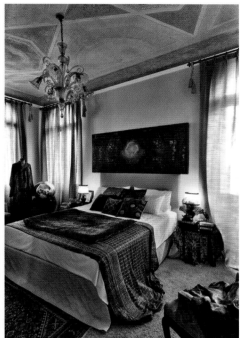

of my suitcases—although that word can't quite describe it, because one is a magnificent Moorish treasure chest—and immediately find a spot for them, as if they had been born here, and had only left the house for a moment. I often take some things to the hotel, and vice versa, to create new scenarios. I like to rearrange things, it gives meaning to my life. . . . I learned a lot about this way of inhabiting a space from the designer Giorgio Mecchia Maddalena. He has done interiors for the director Mario Monicelli, as well as actresses Monica Vitti and Anna Magnani, and has helped me put it into practice. He's a fabulous person, a psychologically perceptive architect and set designer who has understood and developed my ideas, insights, and passions."

One of her strongest passions has given her an impeccable taste for textiles, and velvet in particular. "It all started at a charity event, when I met a lady who was selling remnants of Venetian fabrics from different places. I don't know why, but I really let myself go, and ended up with a lot of material to use, of all different sizes and from various eras. I've made some of it into handbags and blankets, but mostly I've used it to embellish my home. In the living room, for example, to conceal the wear and tear of time, Mecchia Maddalena and I decided to use the velvet to disguise the ceiling: anchored to a leather shield in the middle of the plafond, the fabric radiates in pleats to the corners of the room, creating the pavilion-like effect so often seen in late nineteenth-century Orientalist paintings. And then there are the curtains. . . ."

Beggiato's exploration of textiles has only begun, and the further she goes, the greater her drive. She has even transformed part of the apartment into an atelier, so she can cultivate her passion around the clock. The atelier also houses her collections—one of shoes, complete with must-have Manolo Blahniks, and another of hats, dresses, and buttons. This is where her thousands upon thousands of ideas incubate, eventually blossoming into soulful form. And she loves to share it all with her friends, many of whom have stayed or are staying at the Metropole. "I love to have guests, but I don't invite them to lunch at my place—for that we have the delicacies of the Met Restaurant. At home I prefer to host predinner cocktail parties— there's somehow more intimacy when you're just holding a glass."

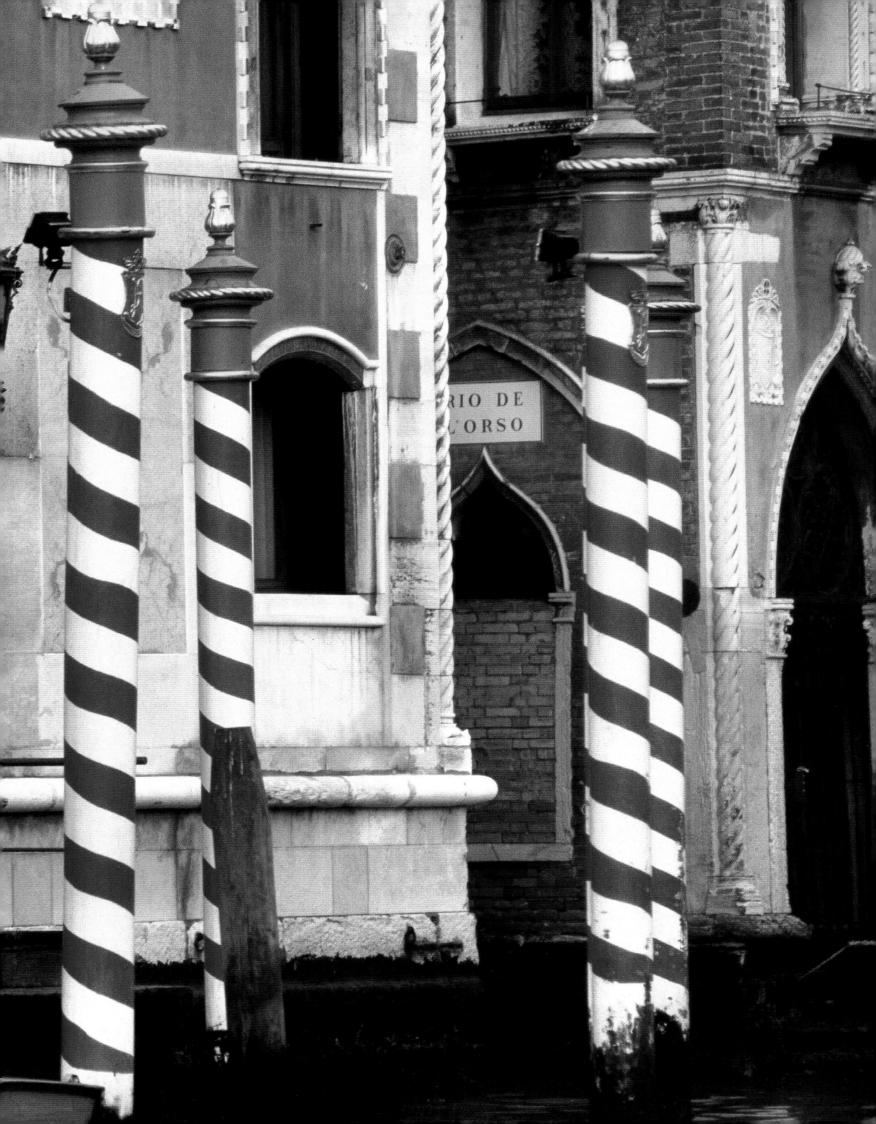

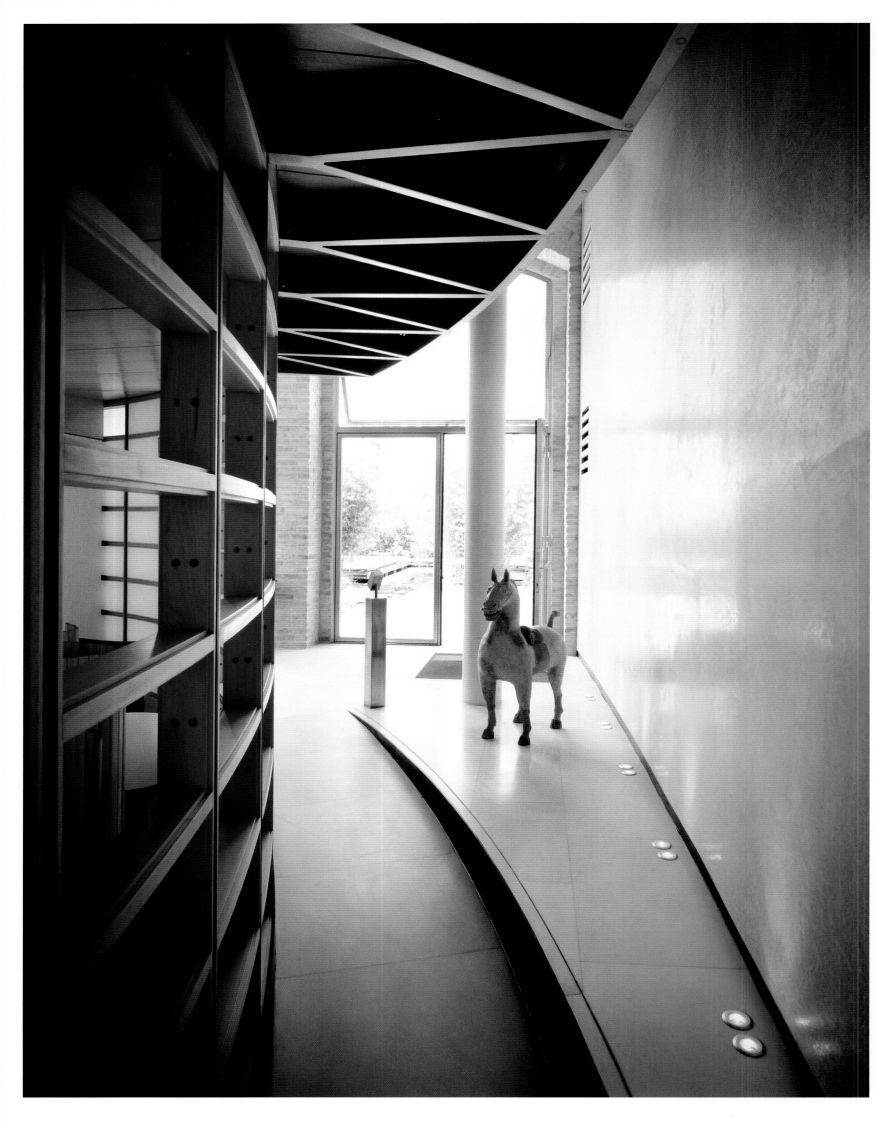

Brewery at Giudecca

The words *Venice* and *modern* would seem to be a contradiction in terms, and this holds especially true for architecture. The Serenissima was a wonderful laboratory for experiments in construction up until the eighteenth century, but in the centuries that followed, its insular inhabitants almost stopped building anything new at all, rejecting all forms and styles that weren't already part of the city's established tradition. Of course, some Modernist work—in the relative rather than absolute sense of the term—has been done since then: industrial buildings such as the "Hanseatic" Mulino Stucky; Paolo Perilli's Santa Lucia train station, designed by Virgilio Vallot and Angiolo Mazzoni; the Piazzale Roma

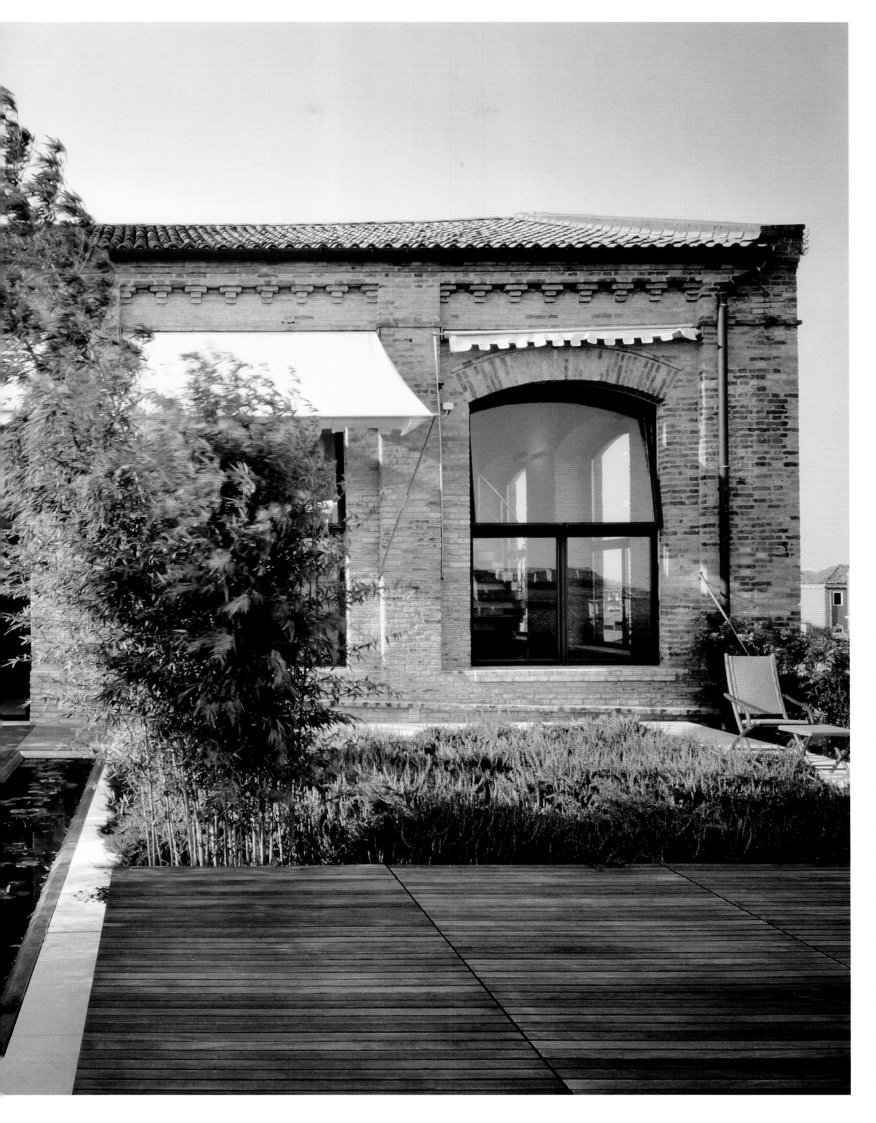

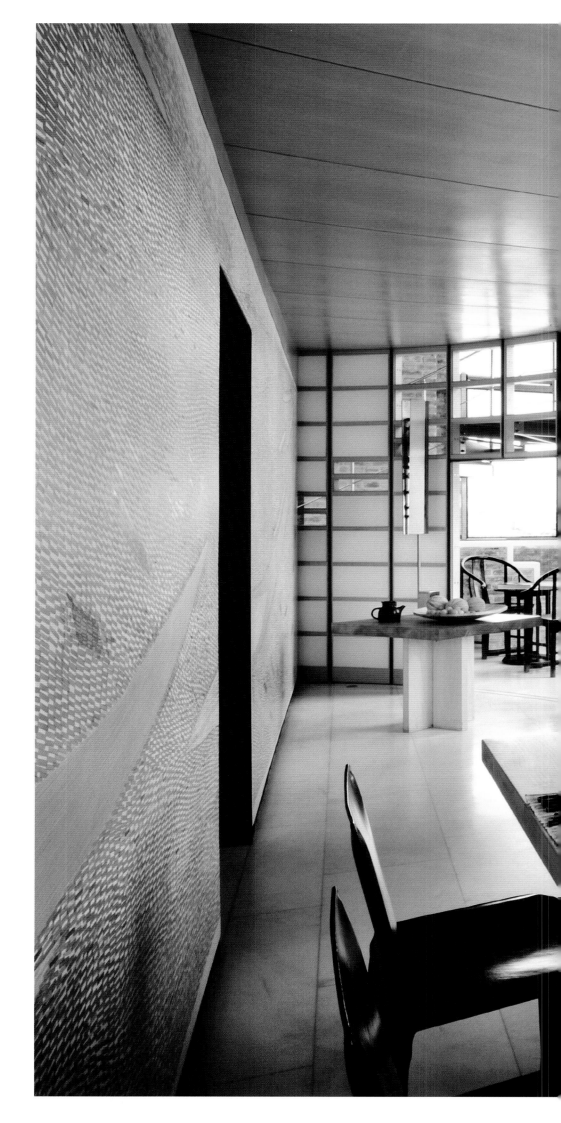

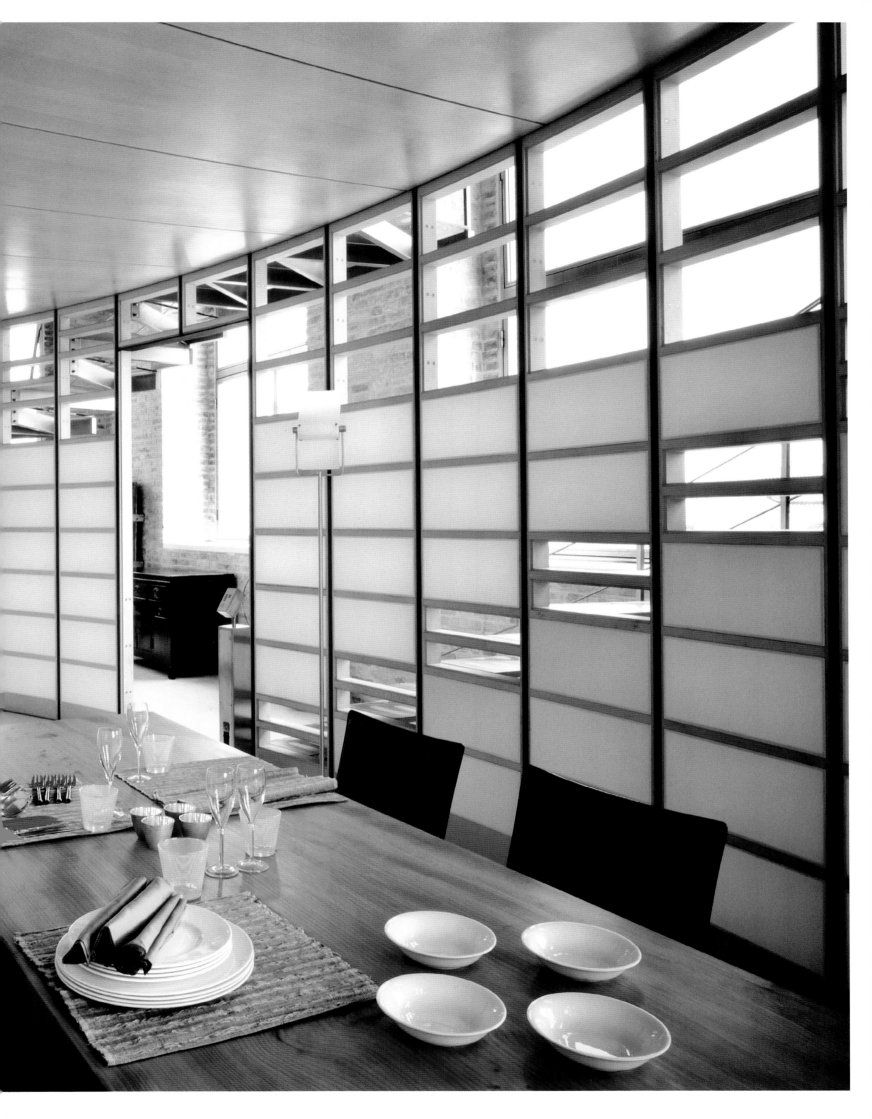

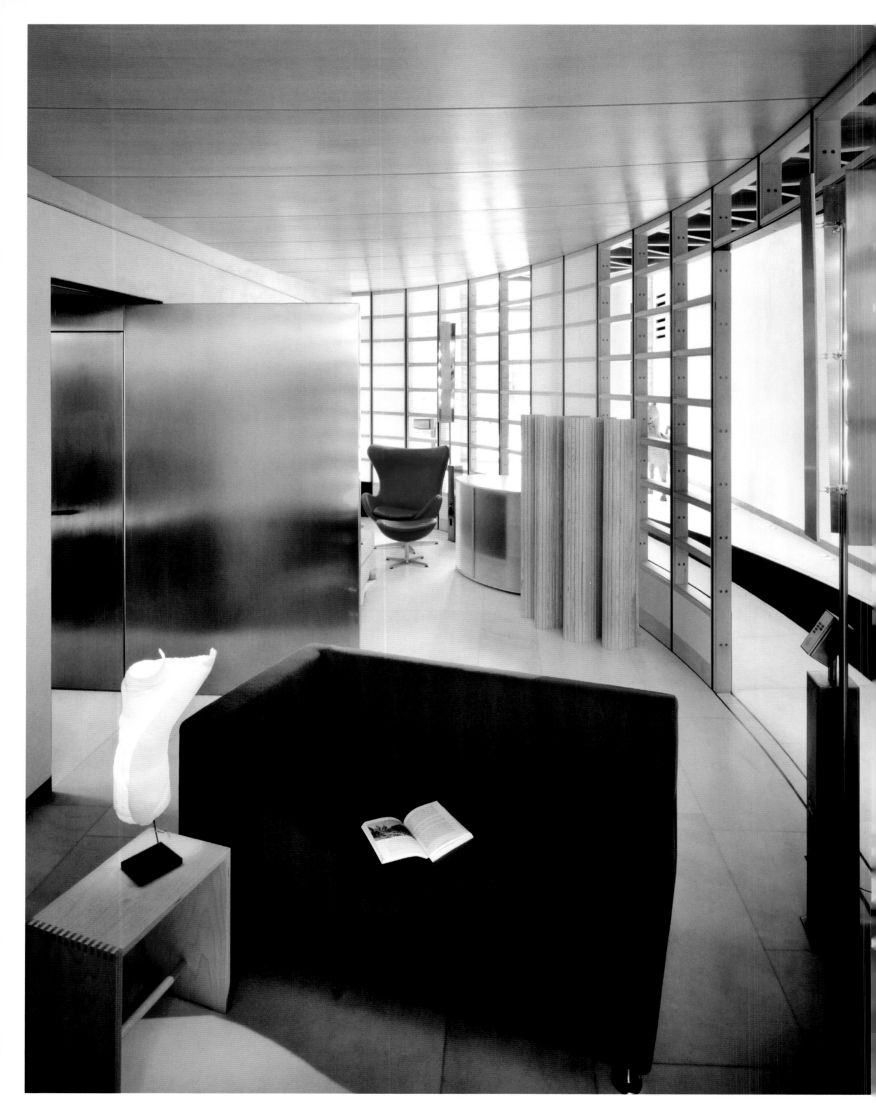

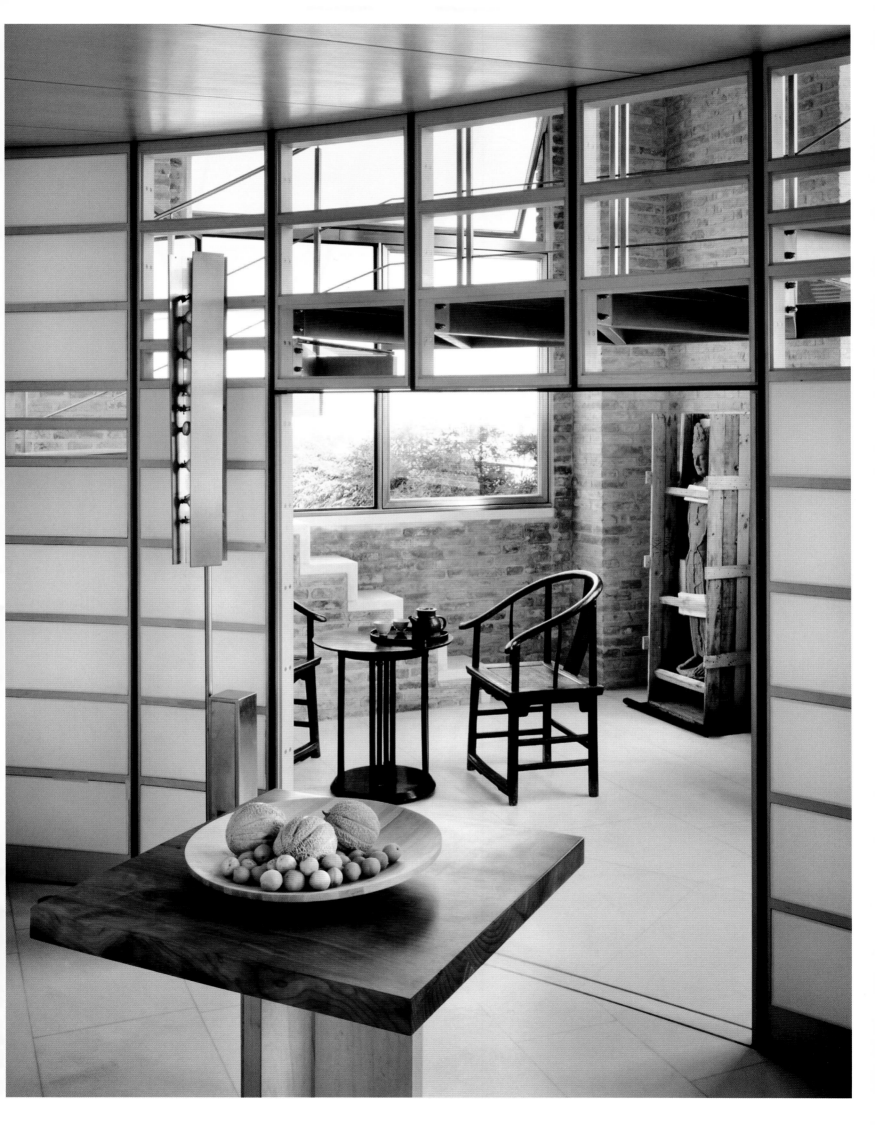

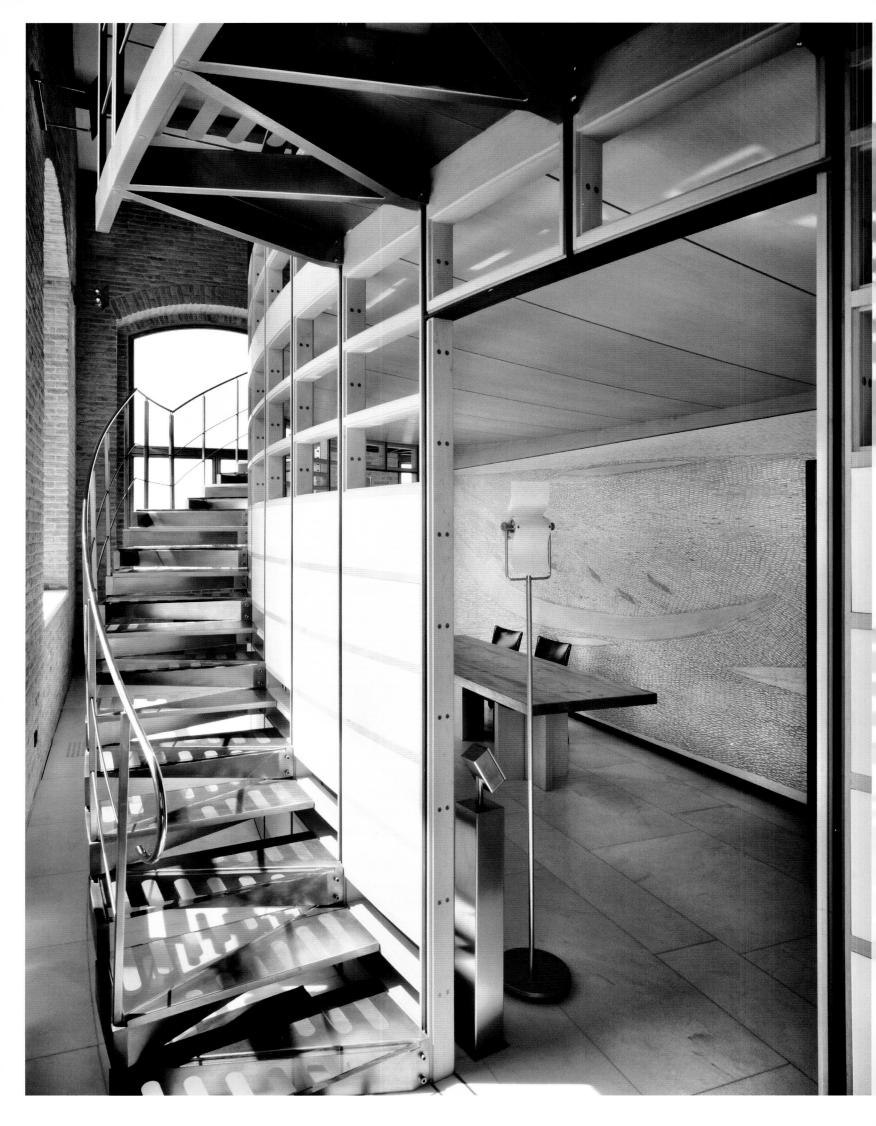

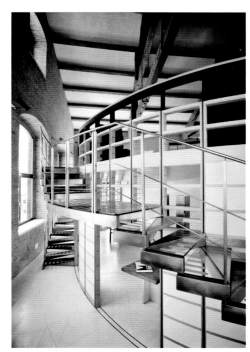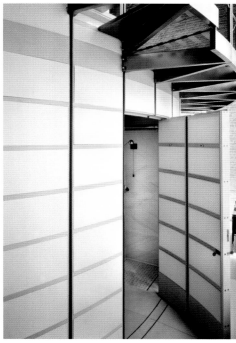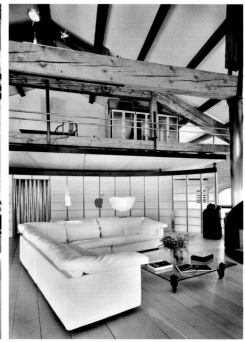

parking garage, designed by Eugenio Mozzi; Ignazio Gardella's art nouveau house in the Zattere; the new bank headquarters for the Cassa di Risparmio overlooking Campo Manin, designed by Pierluigi Nervi; Gino Valle's public housing projects on the Giudecca; and, lastly, Santiago Calatrava's glass bridge. But even these are just isolated cases, many of which the city is still hotly debating. And yet, if you observe closely, modern architecture has not been missing over the years, nor is it missing now. It has been expressed on the interior, without touching the buildings' outer skins, and is beautifully showcased in renovations, restorations, old palazzos saved from the brink of decay, refurbished apartments, and other new uses for old spaces.

The terrain for innovation and transformation has proven to be extremely fertile here in Venice, and has fostered some great architectural highlights, spanning from Carlo Scarpa's renovation of the Fondazione Querini Stampalia to Gae Aulenti's work on the Palazzo Grassi. On a lesser yet equally interesting scale, that British architect Michael Carapetian orchestrated a veritable metamorphosis of the former Dreher brewery on the Giudecca, which had been transformed once before, in the 1970s. Carapetian is both a practicing architect and university professor, so he knows a lot about interiors. In London he has designed and restructured many such spaces, and one is especially impressive; it was a dim terrace apartment, so he transformed part of each floor into a transparent skylight, so that the limited natural light flows from top to bottom. Here in Venice, instead of aiming for such straightforward functionality, he chose to play on the space's preexisting character. It used to be a brewery, and the analogy he drew is so obvious it almost always remains secret, invisible at first glance. It is the archetypal house within a house, an architectural tour de force that adapts a formerly public space to a private vision—in this case, the vision of Hans Wagner, a German businessman who is also the architect's good friend. This building was designed squarely around his practical needs.

But when you examine the project more closely, you discover a second side: the house is hoisted up atop an older, more traditional building, and almost bursts from it, surrounded by two huge terraces. Not only is it the kind of marvelous objet trouvé that more than one critic has written about, it's a readymade with a special nature, conceptually and formally linked to the context and its history. It wraps itself around space in an elliptical profile, like a beer bottle deformed by the architect's creativity. This composition, continuing the underlying

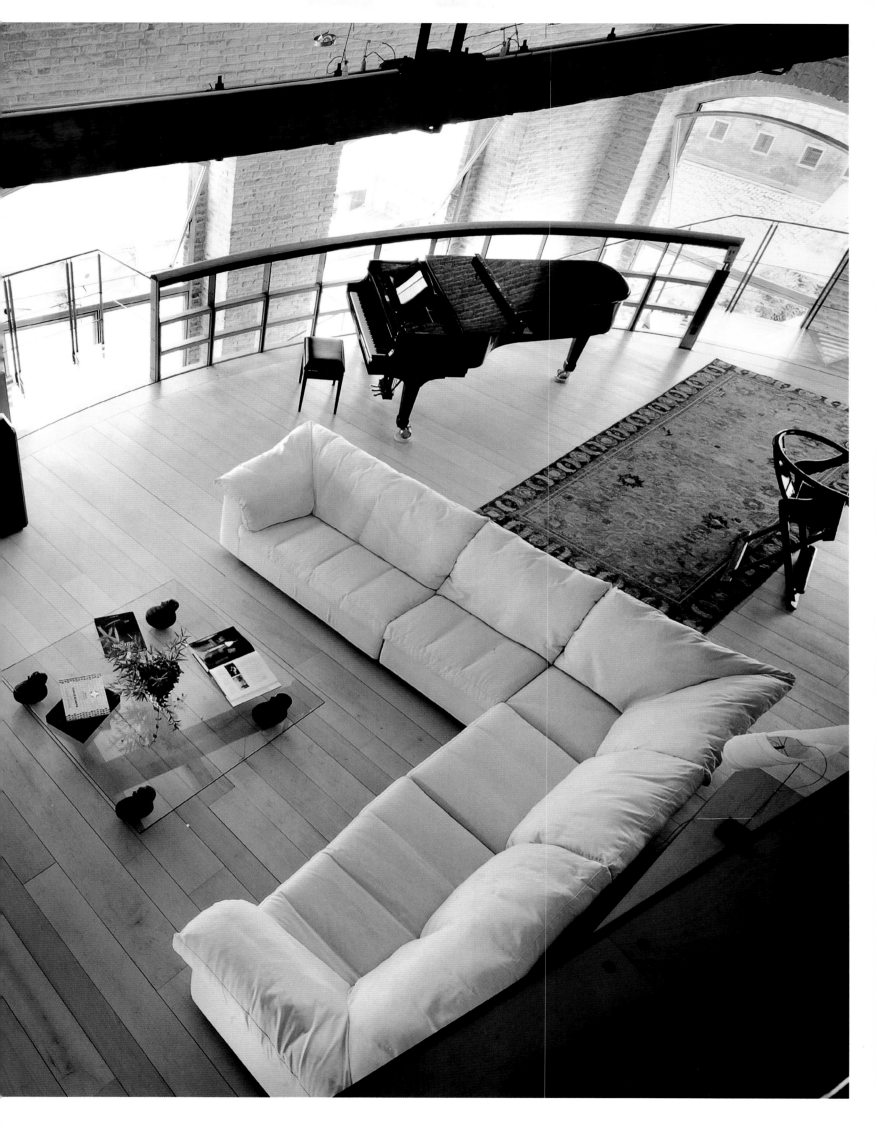

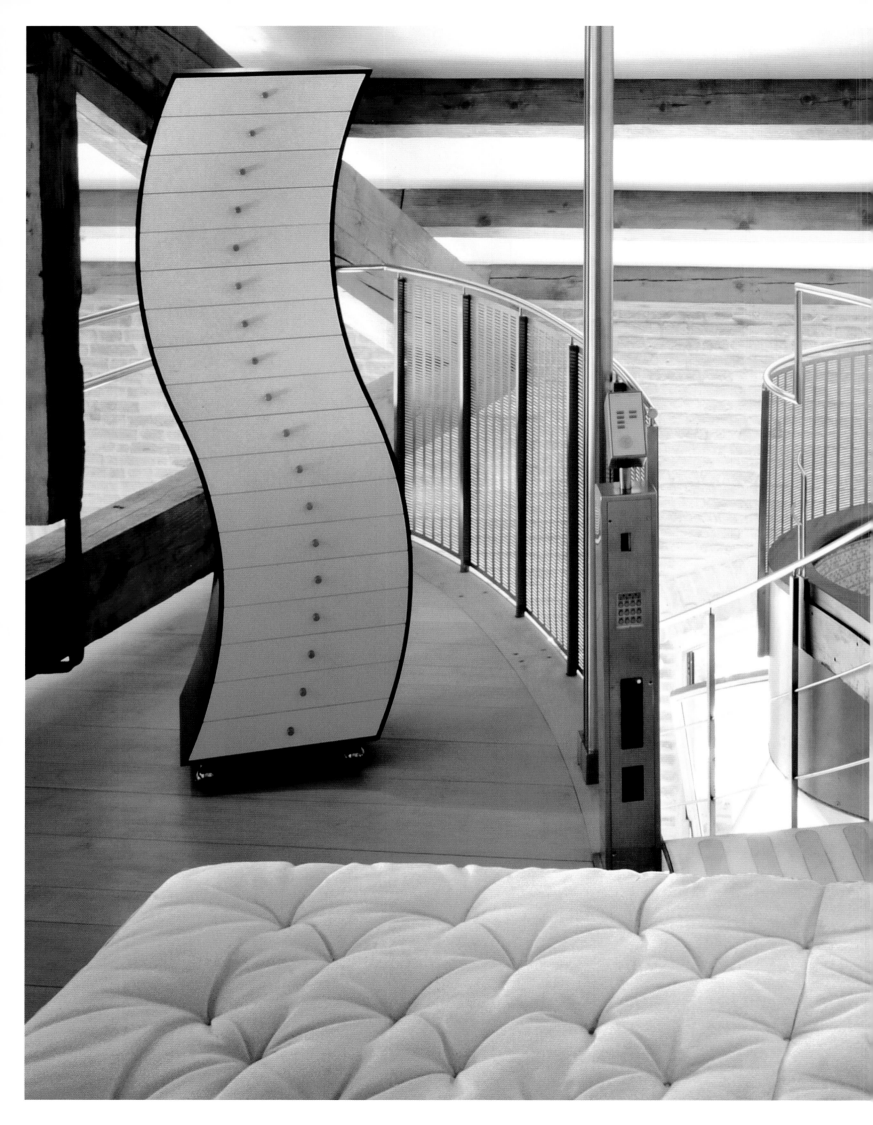

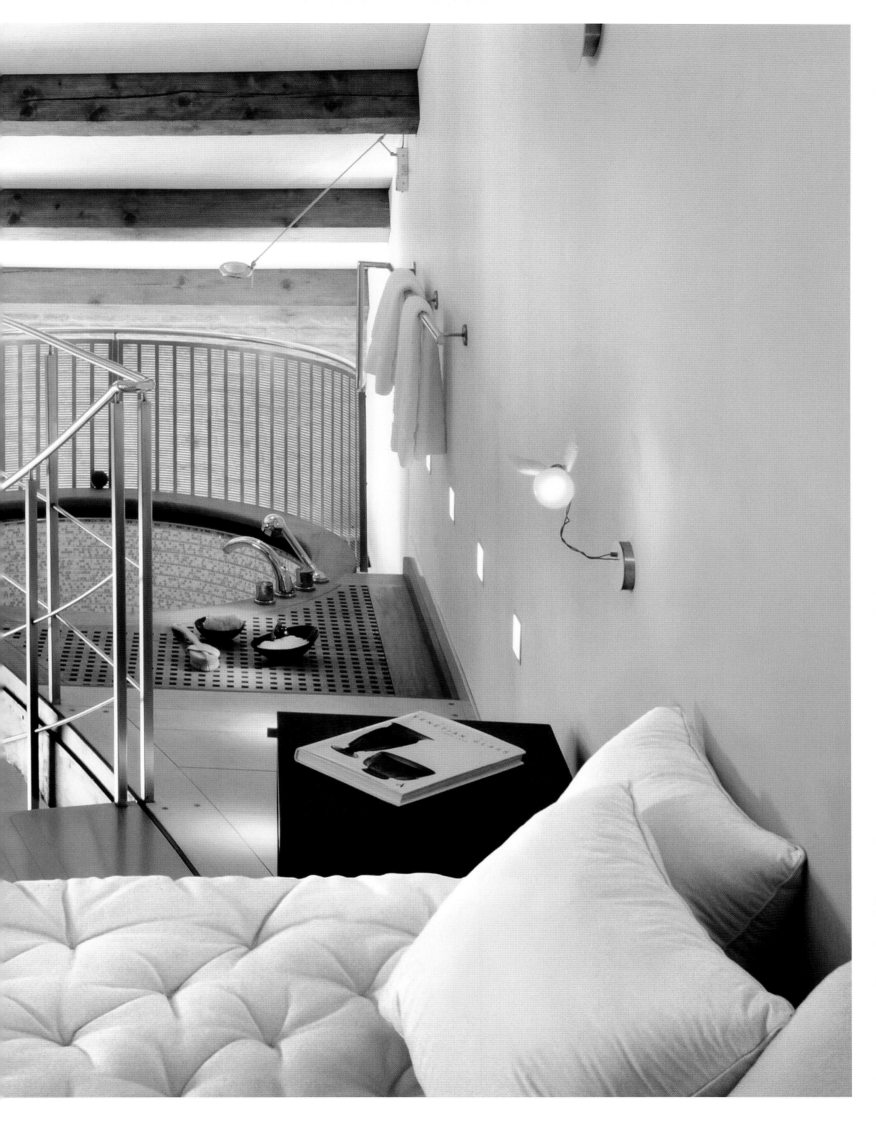

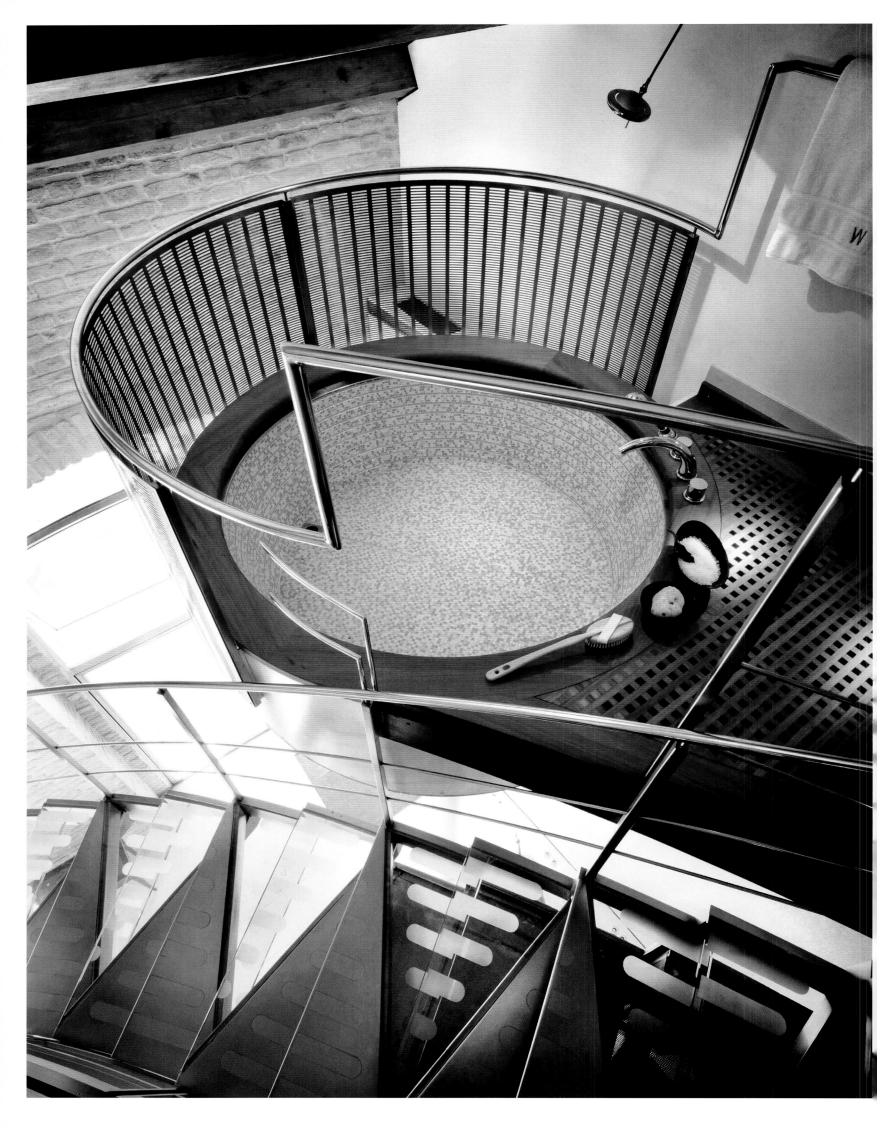

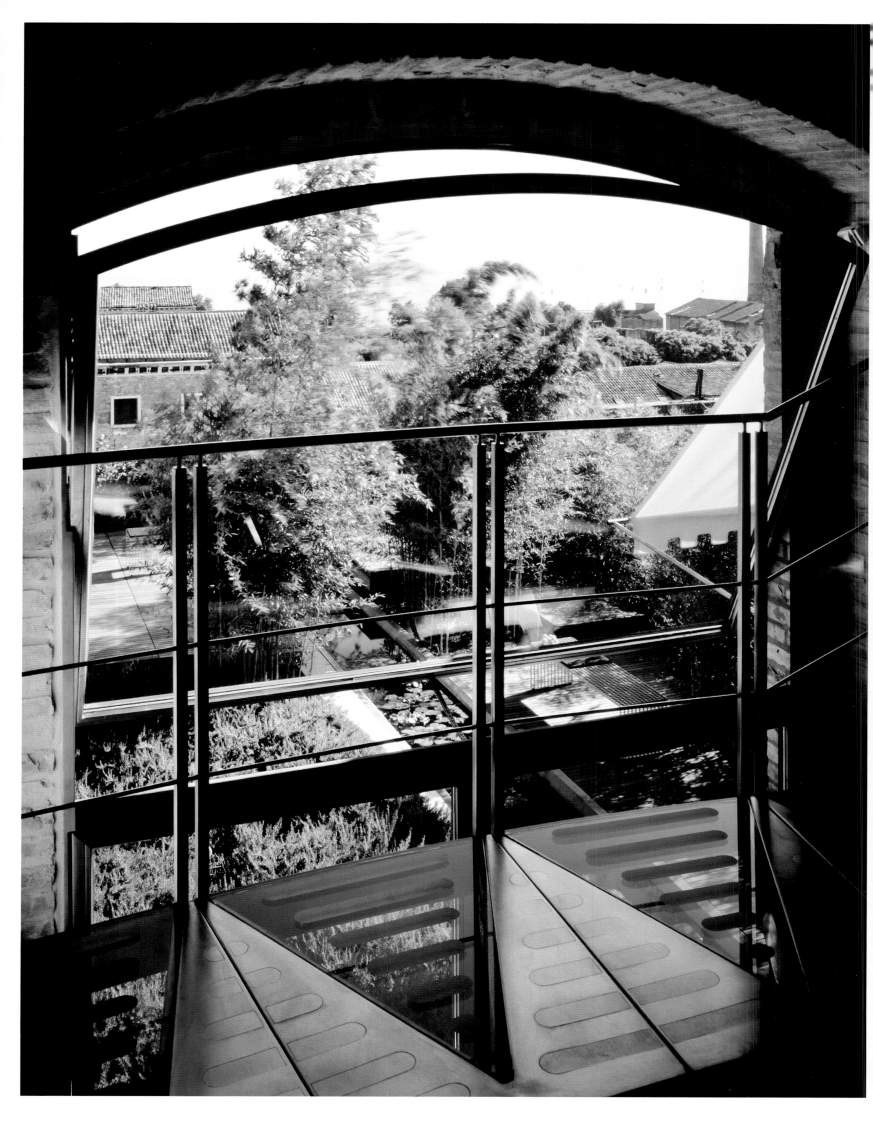

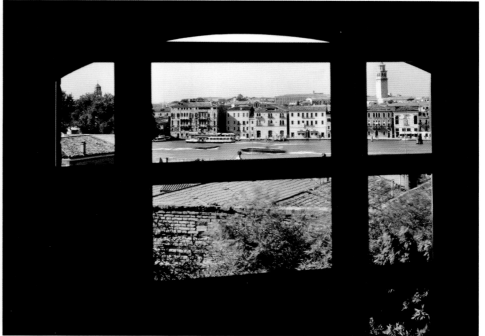

analogy, is filled with large, transparent, plate-glass windows, many of which are arched like the connection between container and spout in a beer bottle. Views of the city pour in through these windows, and outside you see the glimmering blue-green lagoon with white stripes left by motorboats, the buildings of the Zattere, the Church of Santa Maria della Salute, and the island of San Giorgio with its Palladian architecture. After taking in this scene, Carpetian did a lot of research and then got down to work.

With infinite patience his artisans restored beauty to the ordinary pattern of the surrounding wall's red bricks, and brought the roof's powerful trusses back to life. Using noble and sensual materials, such as stone and maple, as well as more technological ones, such as iron, the architect built the self-supporting structure of this "bottle," a spiraling nautilus contained by Zen bulkheads that define its axial spatiality. Inspired by the materials made to build boats, a circular stairway made of steel, wood, and glass connects the different levels. The kitchen, service area (with Luca Orsoni's beautiful mosaics), and guest rooms are located outside the tower, hidden within the brickwork. The house has little furniture and not much decoration: the airy, shimmering space of the living area is punctuated by a pure white Delta sofa by Zanotta, a table designed by Gae Aulenti for FontanaArte, and another table by Max Bill, while the lamps are by Ingo Maurer. Wagner collects Oriental rugs, so there are a number here, and because he loves music there is also a grand piano played by talented musicians he invites to give concerts at the house. A large rose-hued mural made by the London-based artist Antoni Malinowski beautifies the dining area, while the small breakfast room features furniture from the Viennese Secession. A precious Khmer statue of Buddha dating back to 220 BCE, framed by a wooden crate, takes center stage here.

The bedroom area reinforces the apartment's meandering layout, as it features the wavy Side 1 chest of drawers designed by Shiro Kuramata for Cappellini and a round bathtub. Like messages in a bottle, these spaces and their furnishings seem to pen the intimate diary of an impassioned city and its interior lifestyle—the way Venice lives between marmoreal sky and wave-wrinkled water, amid its slim steeples and rotund domes. From here the sea's music is ever present—sometimes as a lullaby, at other times stormy—and in continuous flux. The sole constant, perhaps, is the evening ritual of enjoying a local brew on the terrace.

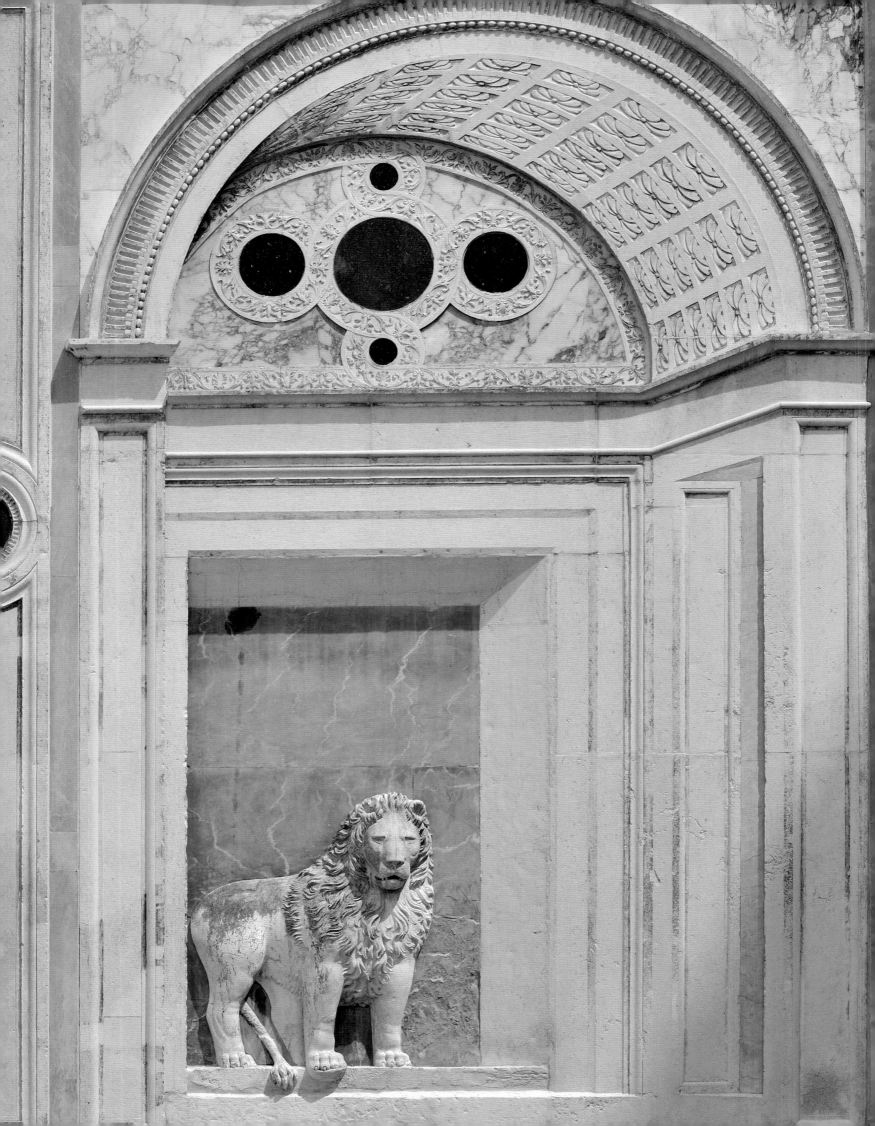

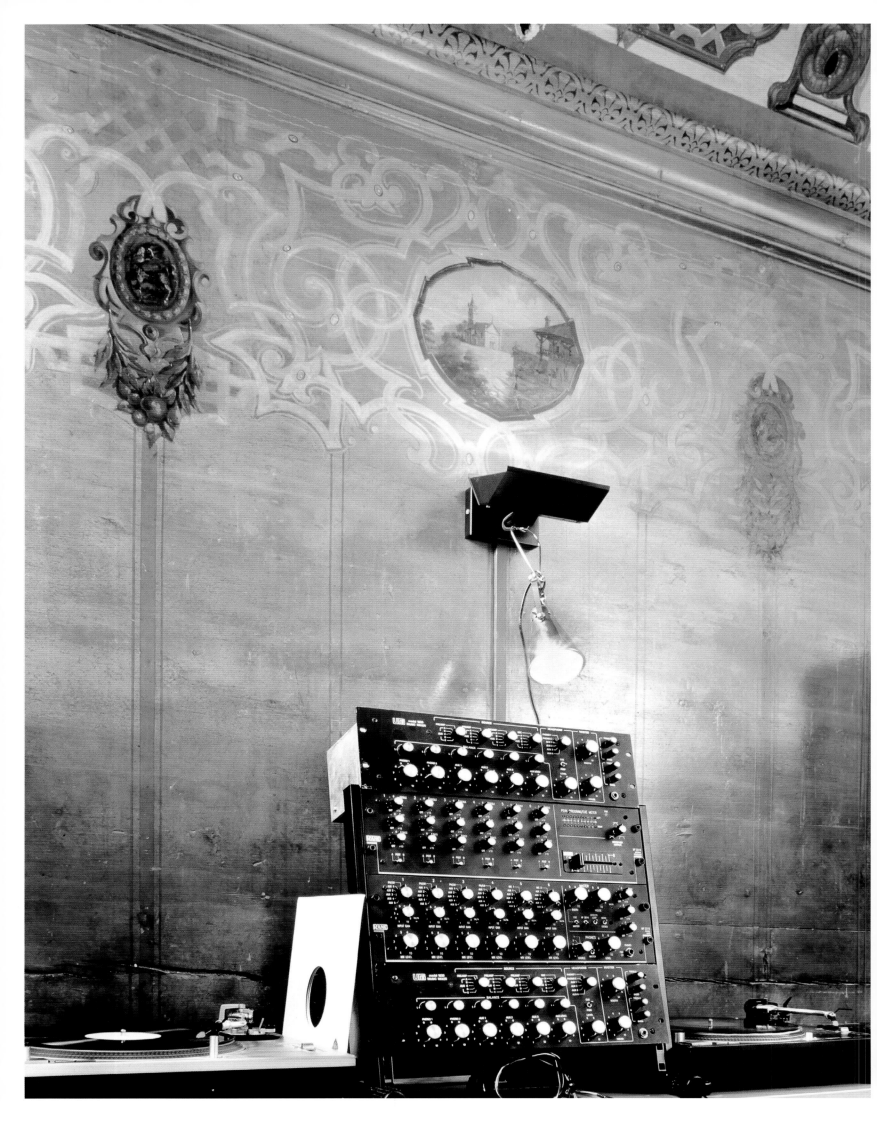

The House of Music

Present-day Venice is filled with music—it echoes, pulsates, beats, and throbs down the streets. The sound you hear today isn't the trains in the nearby station, nor is it the rhythmic puffing of the *vaporetti*, nor is it the people's Babelesque chitchat, which makes the city feel like one big, perennially partying lounge. No, this beat-driven music is something else entirely. It comes from Rio Marin, in the Santa Croce sestiere, and it's nothing like the heartrending, sensual, agonizingly erotic melody that filled the gardens of Palazzo Soranzo-Capello in Gabriele D'Annunzio's book *Fuoco*.

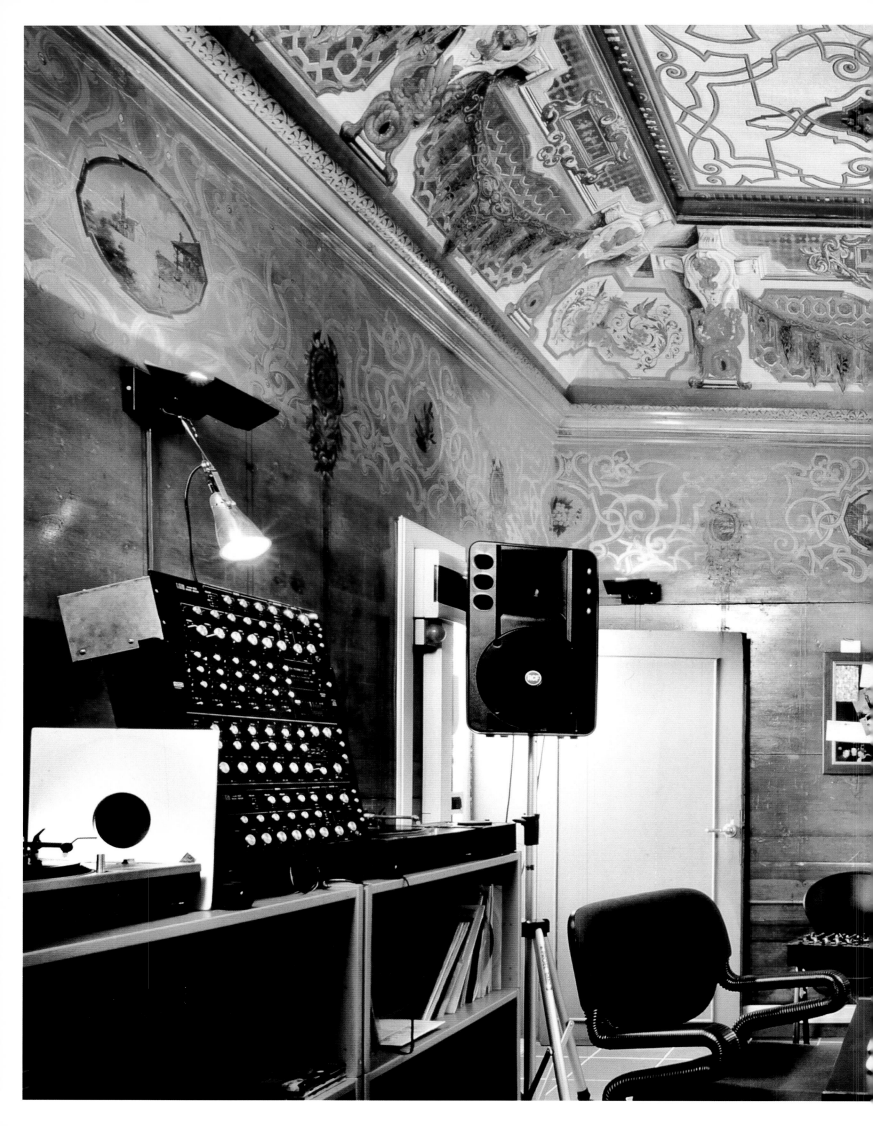

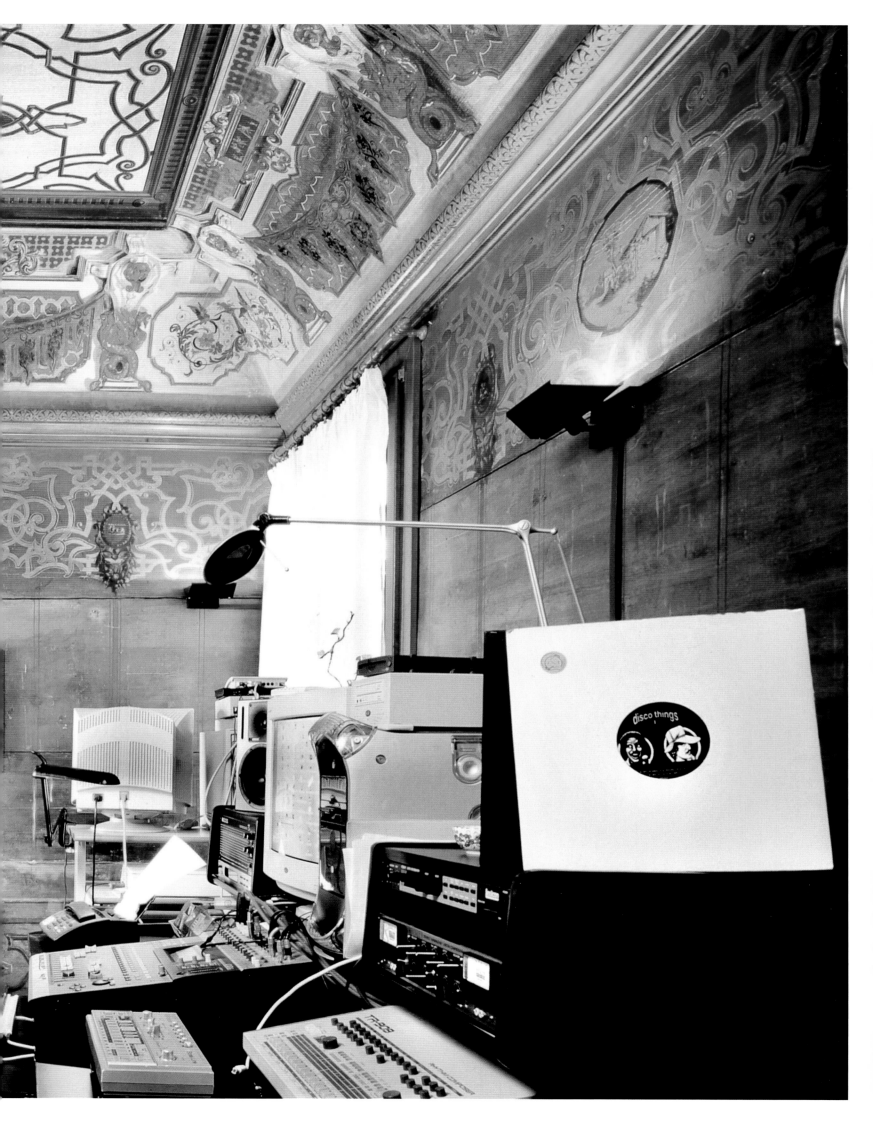

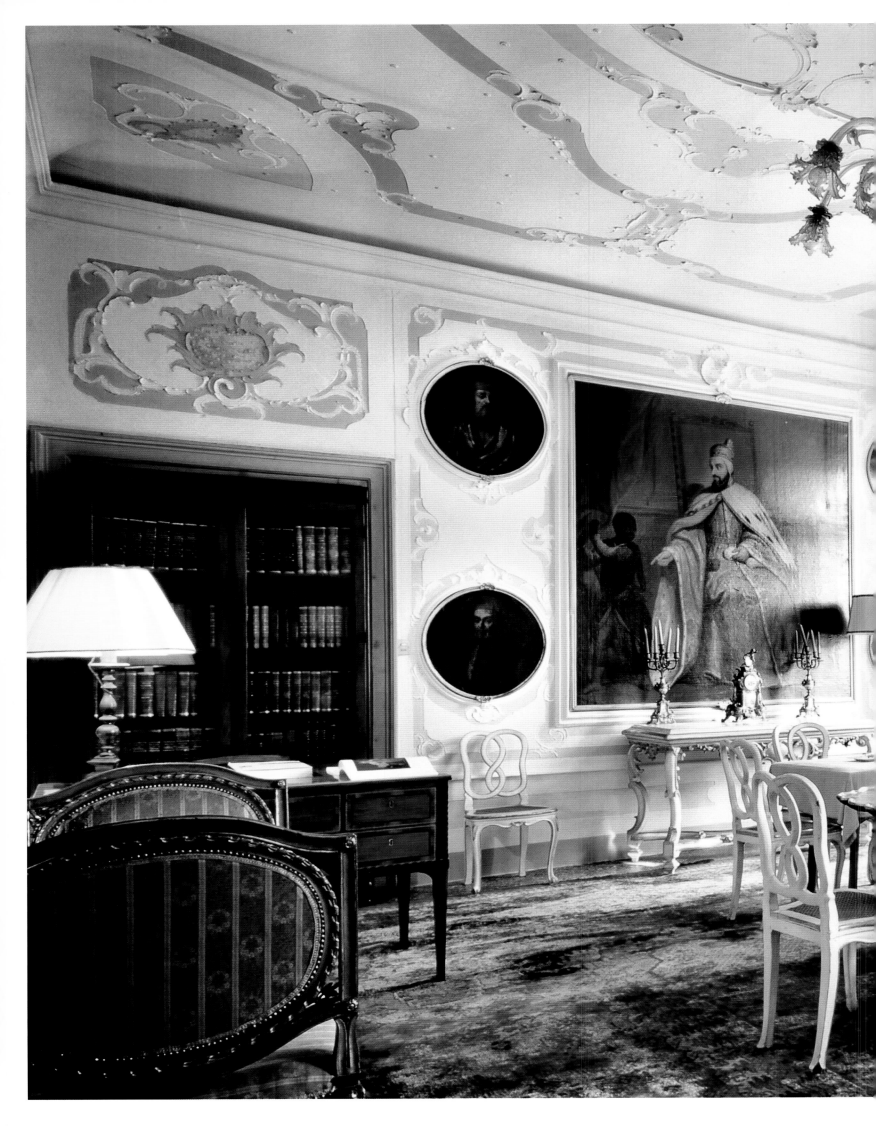

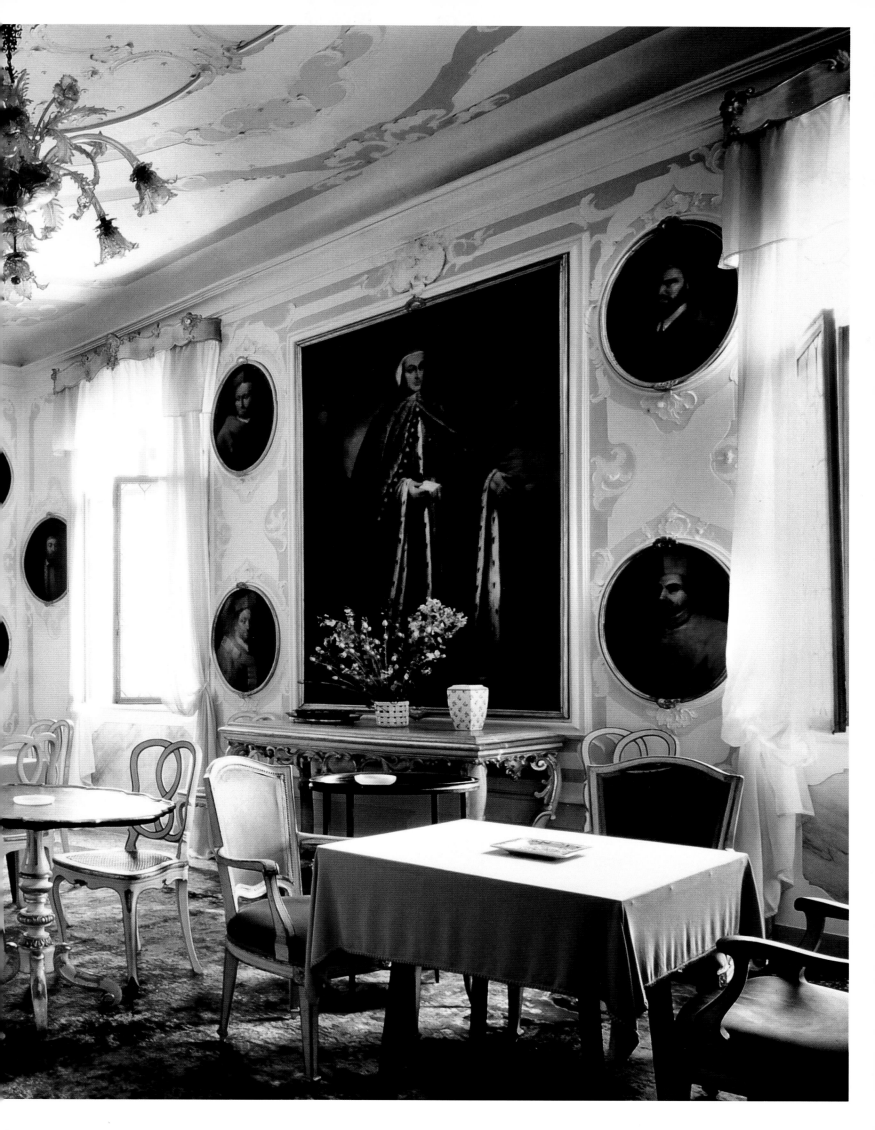

It's also not quite what Friedrich Nietzsche had in mind when he wrote that the synonym for *music* is *Venice*. This music can only be "Groovejet." Following the beat down the calli and along the banks of the canal, it's clearly coming from a large building, where an open window just barely above the waterline flickers with light. The edifice rises up heavy and shimmering, with rows of single-lancet and multimullioned windows, a single, solemn entrance, and an adjacent garden where D'Annunzio's young Foscarina experienced the feverish madness of passion. This is the unmistakable Palazzo Gradenigo, built in the seventeenth century by Domenico Margutti, who was likely following a design by his mentor, Baldassare Longhena. The glow of the window grows more intense, and the lyrics become clearer: "If this ain't love / why does it feel so good? / If this ain't love / why does it feel so good?" Then silence, then a peremptory "Are you ready?" In the yellow window frame reflected in the canal, a Mephisthophelean shape stirs over a console. Zooming in for a close-up, the shape turns, as if it had sensed our approach; the silhouetted face comes into the light, and you can make out a short beard, sharp eyes, and outstretched hands at the controls—it's none other than DJ Spiller, the genius behind "Groovejet."

Indeed, Palazzo Gradenigo is the unlikely facade disguising the laboratory where thirty-six-year-old DJ Spiller creates, mixes, and remixes his house music. For those who might not be familiar with it, it's a kind of electronic dance music greatly indebted to late 1970s disco music and funk, and borrows from many other kinds of music. "This is quite a place, don't you agree?" he asks. "The majestic portraits of my maternal ancestors, many of whom were doges, now watch over my keyboards. What an absurd pairing." Indeed, it's a bit absurd to see such a noble and highly institutional past combined with a contemporary world that is so transgressive, so Pop—and yet the contrast works really well. "Ever since 'Groovejet' exploded onto the scene—it sold two million copies, and topped the UK charts for months on end—I've had thousands of opportunities to move to other, more important cities in terms of musical production. London's just one of many, but I feel perfectly at home in Venice, so if anything I'll just 'export' my music from here. I like its atmosphere, it's detached, suspended, a bit magical. This city has a unique sentimental charm, and that's what makes this building special. Not only that, this is also where Henry James set *The Aspern Papers*; these rooms are where the drama unfolded as the main character, a literary critic, tried to take possession of the love letters his lover had exchanged with a late great poet. Even the cartoonist Sergio Staino has mentioned the building. I was raised on the amazing anecdotes my grandmother and my mother would tell me about some of the things that happened here. . . . Sometimes I wonder how much this place had to do with my current fame. A lot, I think."

Spiller is right, it's a question of genes and genius loci. His studio is actually a piece of Venetian legend transplanted into today's most cutting-edge creativity. The electronic instruments that are part of the DJ's trade cohabit in irreverent harmony with the eighteenth-century frescoed ceilings and trompe l'oeil panels. His pulsating music crosses the halls and rooms furnished with a flair for detail, envelops the precious eighteenth-century furnishings, and mingles with the portraits of the family doges, starting in the thirteenth century with Bartolomeo and Pietro Gradenigo. There is an unpredictable, ghostlike presence where you might well have expected to hear a Vivaldi minuet. But such is life—each era has its own languages, its own culture; it's only right that things change, especially if newer generations can take such pleasure in living alongside the marvelous things that the past has bequeathed. Such quirks breathe new life into this ancient city and, to quote a line from "Groovejet," "Everything's going to be fine."

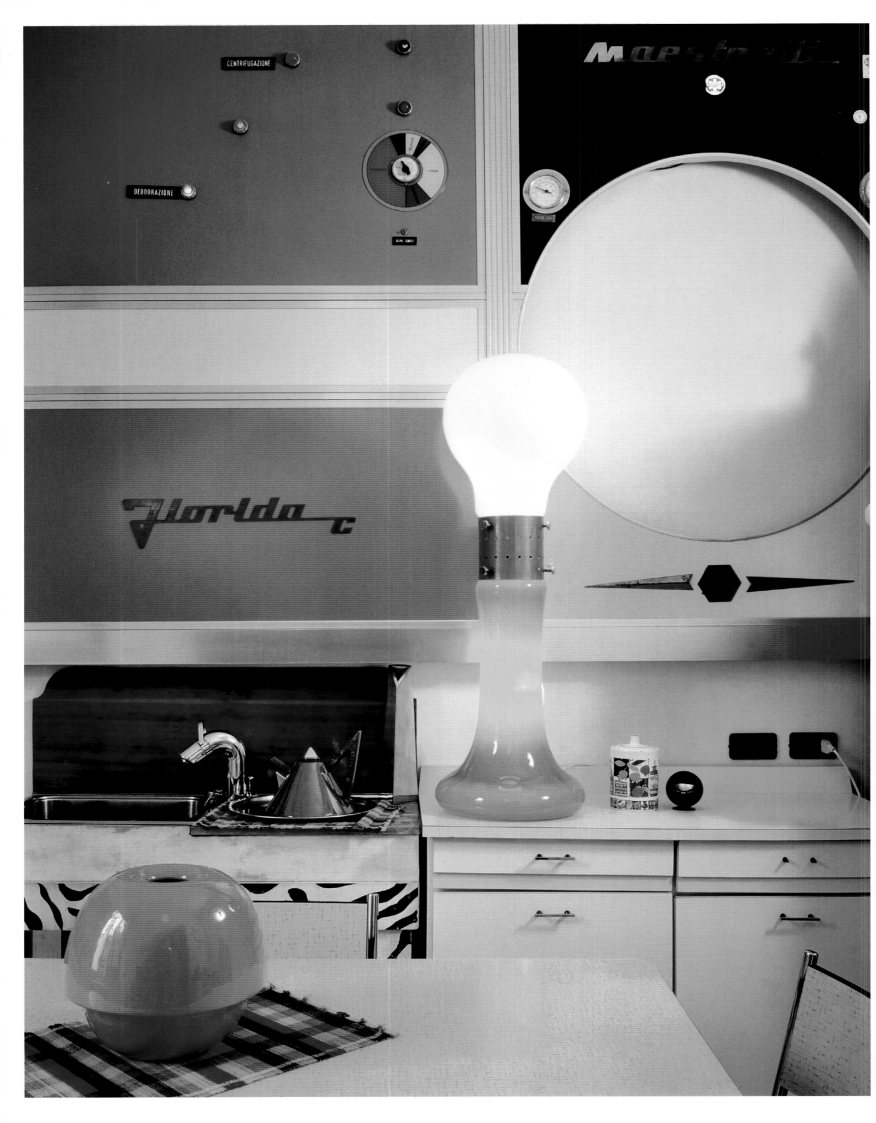

A Collector's Theater

Contamination is the password to understanding this house in the Castello sestiere. This is perhaps the only neighborhood that has managed to preserve the straightforward, down-to-earth soul of the Venetians—an asset that really is on the path to extinction. The house is a stone's throw from the Arsenale, a few steps from San Giorgio dei Greci, and lies between the Renaissance Church of San Zaccaria and the Gothic Basilica of San Zanipolo (as Saints John and Paul are referred to in the local dialect), considered the pantheon of Venice owing to the numerous doges and prominent figures buried there.

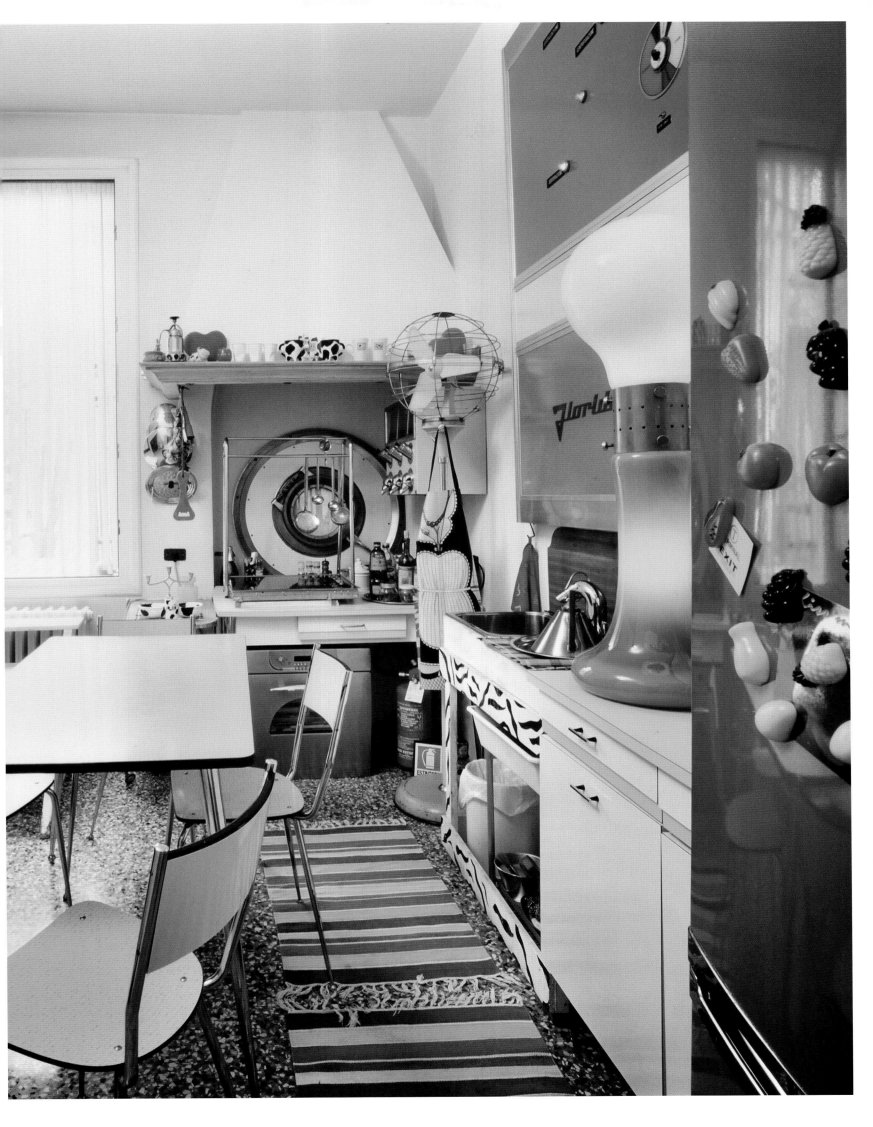

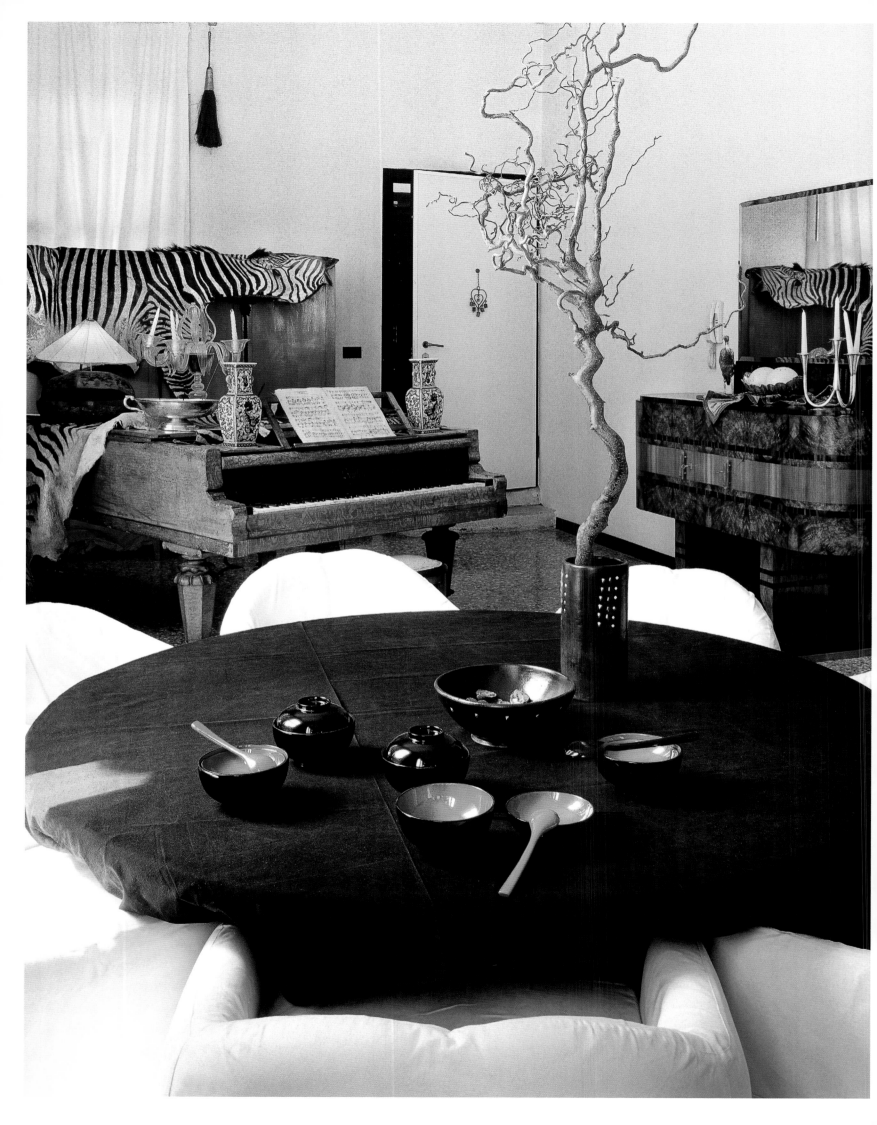

This authentic context, attested to by the souls of the famous *Serenissimi* (as the city's inhabitants are sometimes called) who've chosen it as their eternal resting place, harks back to a shimmering palimpsest of styles, and its unique blends connect the present to both the recent and distant past. Interior designers often called such combinations "contamination" in a positive way, and their power is apparent in this home's decorative pattern, while the architectural structure maintains a sovereign linearity. The owners' passions invigorate the space's nonstop hybridizations—another term in vogue among design gurus—and they collect everything from vintage clothing to Venetian boats and all sorts of relics of local customs and habits. Their pursuit is a veritable contemporary anthropology, and implies that the material culture surrounding us, evident in every corner of the home, calls for a shift in the way space is inhabited. That transformation is unquestionably achieved here, and centers on the large drawing room with its elongated shape lit up by a rhythmic sequence of windows. The other rooms radiate outward from the core: first the kitchen; then the bedroom; and finally the bathroom, a true and proper *salle de bains* with Asian-inflected details.

Every room brims over with objects that are really just the physical manifestations of thoughts, feelings, and emotions to be experienced again and again, and shared with friends. Each narrow corridor, each and every inch exudes color, material sensitivities, and cultural expressions. This home speaks the language of curiosity, and embodies an aesthetic unconsciousness in which everything has its place, and it all mingles within an ornamental flow of free associations and existential creativity. In the living and dining room armchairs from one of the Compagnia Adriatica's old cruise ships are matched with a Biedermeier piano built in Vienna by Eduard Seuffert. An art deco sideboard holds a glassware collection by Barovier & Toso, work by Seguso and Venini, and Chinese vases; the nearby wardrobe showcases silver antiques and a colorful menagerie of Murano glass animals signed by master glassmakers, such as Barbini, Poli, and Seguso.

In the bedroom a bed and a wardrobe from the 1920s—part of a furniture set that won a medal at the Éxposition des Arts Décoratifs in Paris in 1925—are placed alongside an eighteenth-century leather altar covering, Fortuny Studium lamps, ethnic cushions designed by Angela Pintaldi, a vintage 1930s table, and a priceless Capodimonte porcelain sculpture. The flow of decorative encounters continues in the kitchen, where a Pop aesthetic rules the

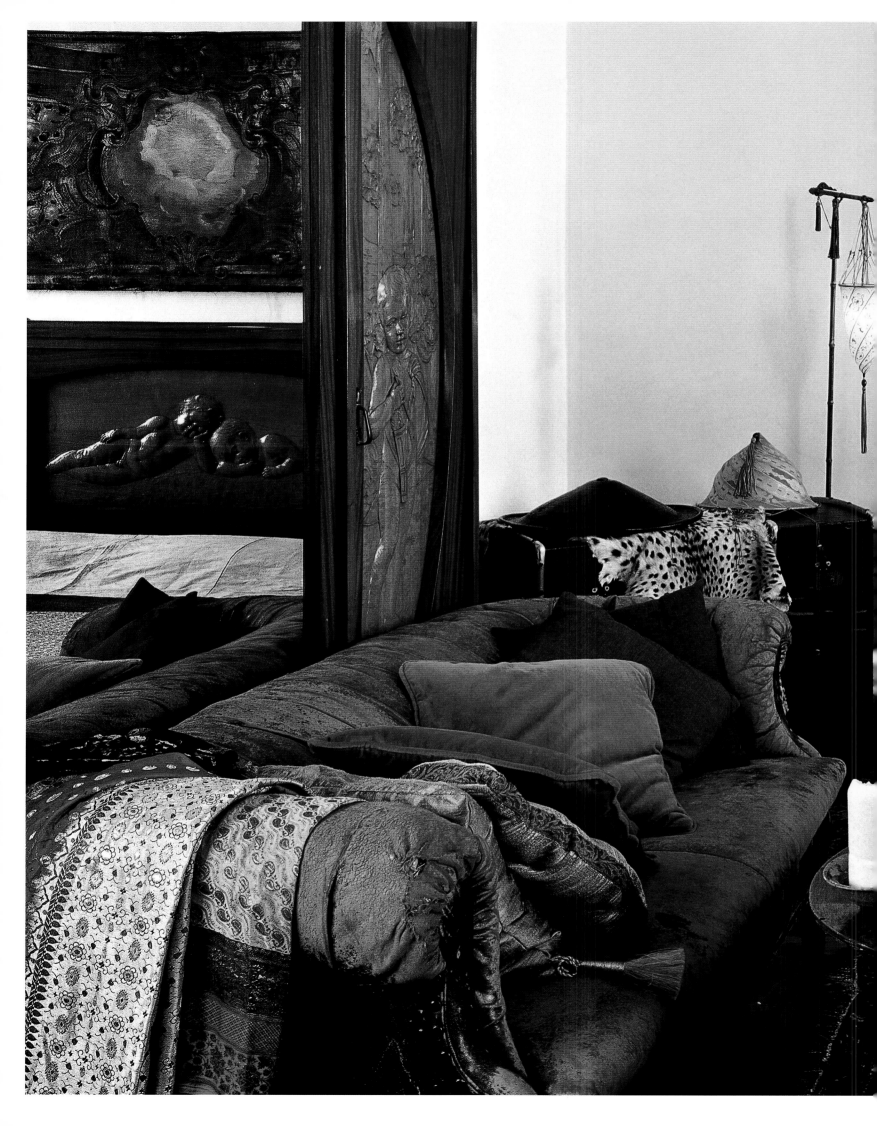

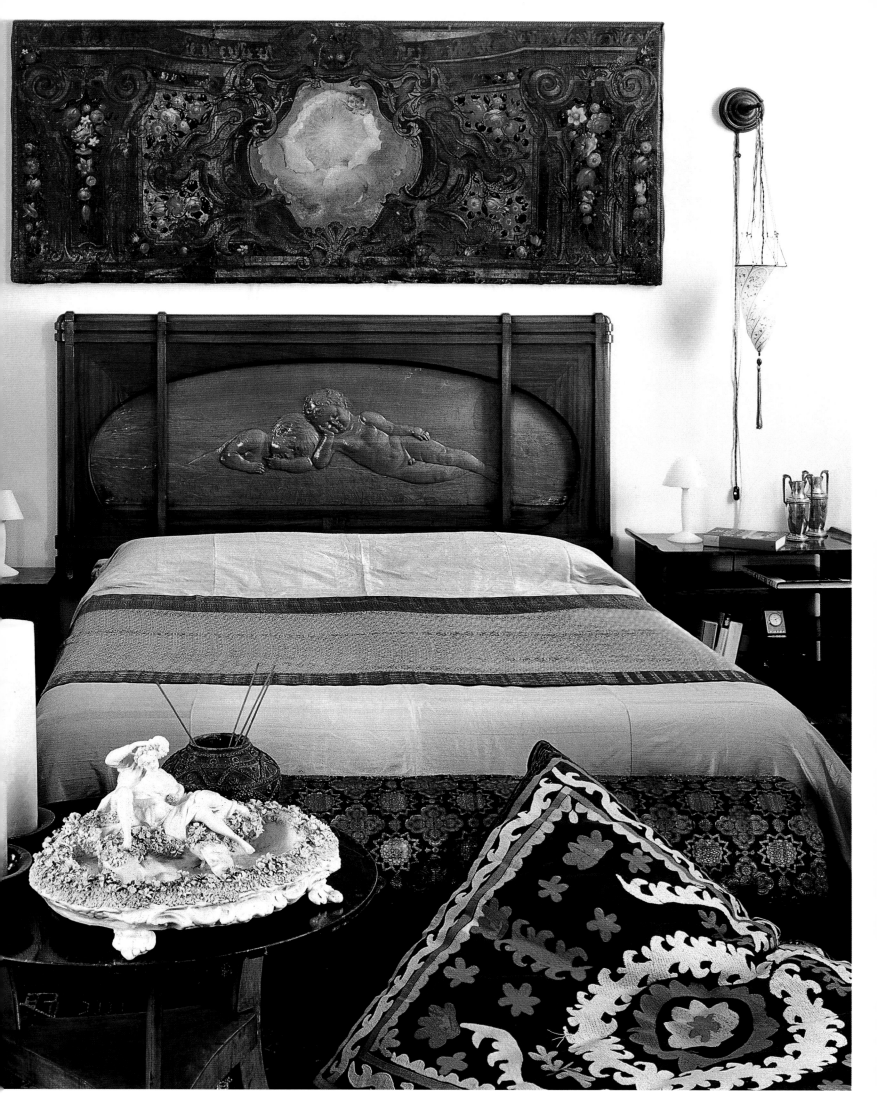

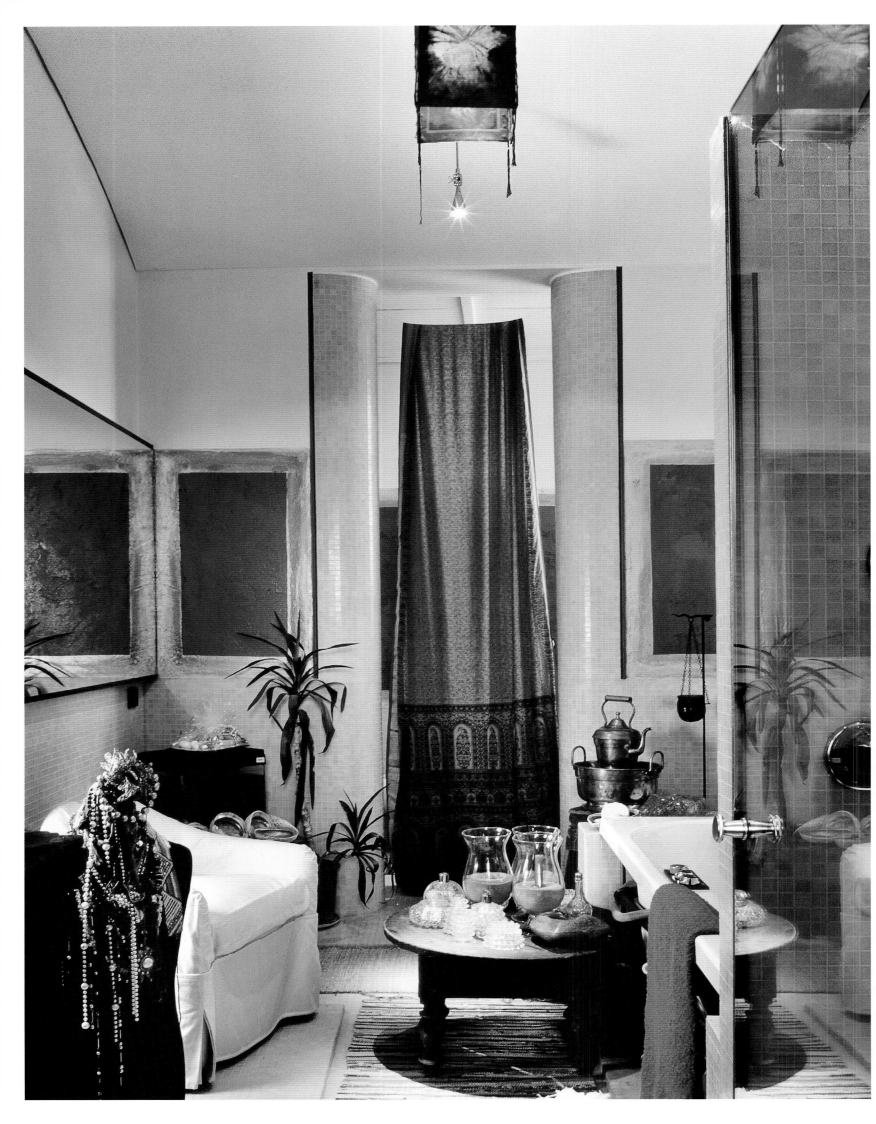

bright composition of colors and stylistic surprises: the Formica finishing from a 1960s industrial laundry machine lines the wall in yellow, blue, and red. The table, chairs, and the sideboard are also in Formica, but are slightly older, as they date back to the 1950s. A whirlwind tour of the postwar boom years includes a Cadibel mixer, a Formica chessboard—people just couldn't get enough of that material!—a radio in the shape of a Cynar bottle, a Murano chandelier, and a lot of other small objects that are somehow "in bad taste" and yet utterly appealing.

The psychological maelstrom that this dwelling stirs up begins and ends right here: as soon as you look out the window your soul is calmed by the delightful views, starting with the bell tower of San Giorgio dei Greci. Each time it tolls, it sounds as if it might come right into the kitchen to order a plate of sautéed *caparossoli*, an exquisite clam that only lives in the lagoon.

The bell tower stops, but its sound rings through my mind, telling me to organize my thoughts, asking me to give it a reason for being. I can't help but think its reason is to facilitate yet another contamination, a tacit but decisive one: this is a home whose humble objects span more than a century. It has a fin de siècle aura because it brings to mind the decorative plenitude of late nineteenth-century bourgeois mansions, but it's also modern thanks to the stylistic outcrossings reminiscent of David Hicks's unique interior designs. Above all, it is rigorously contemporary because its impetuous contamination of eras, styles, forms, colors, and materials reflects the present-day phenomenology of fine living.

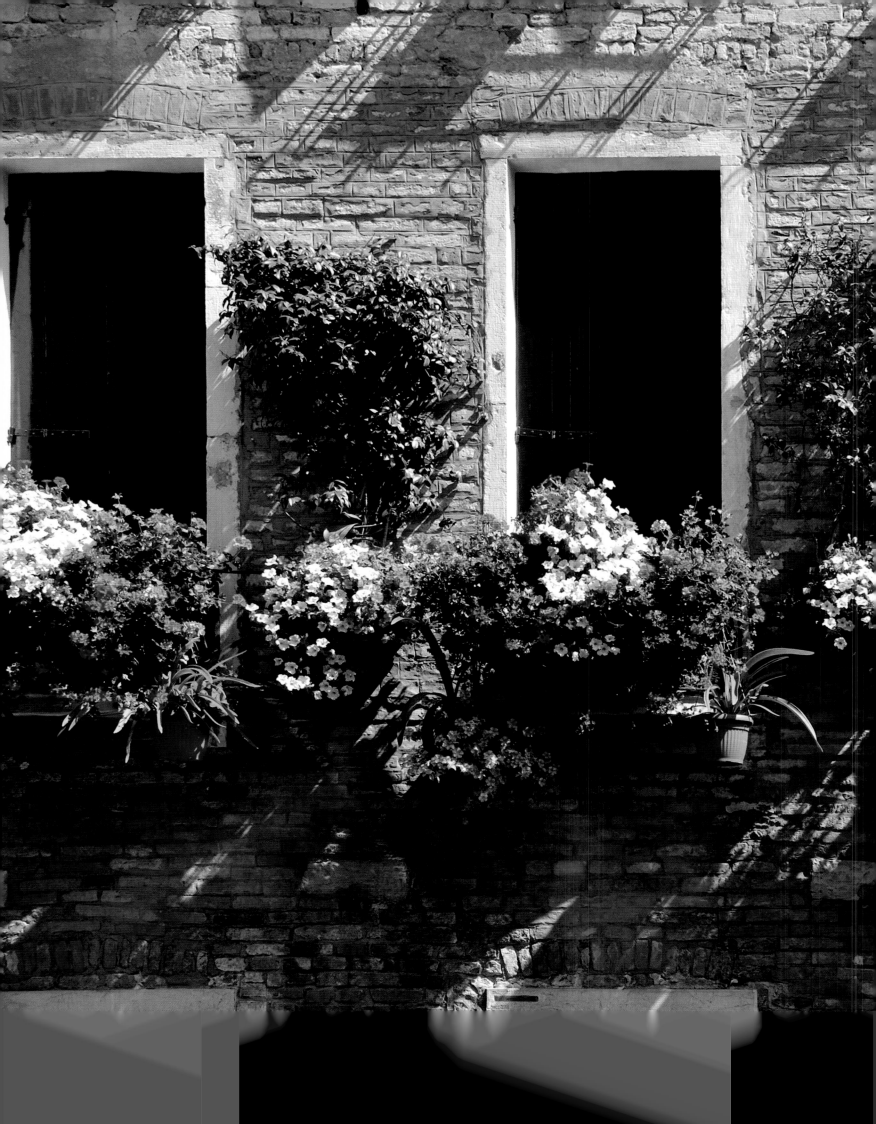

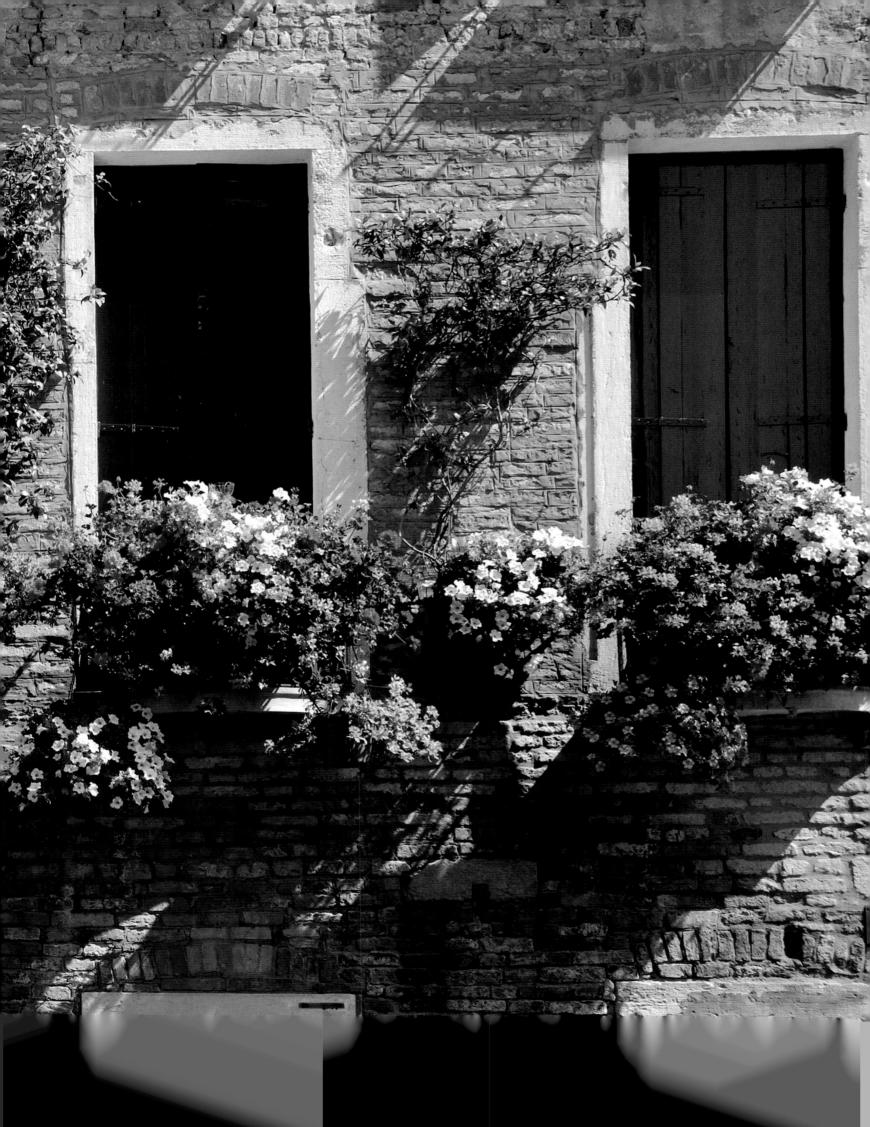

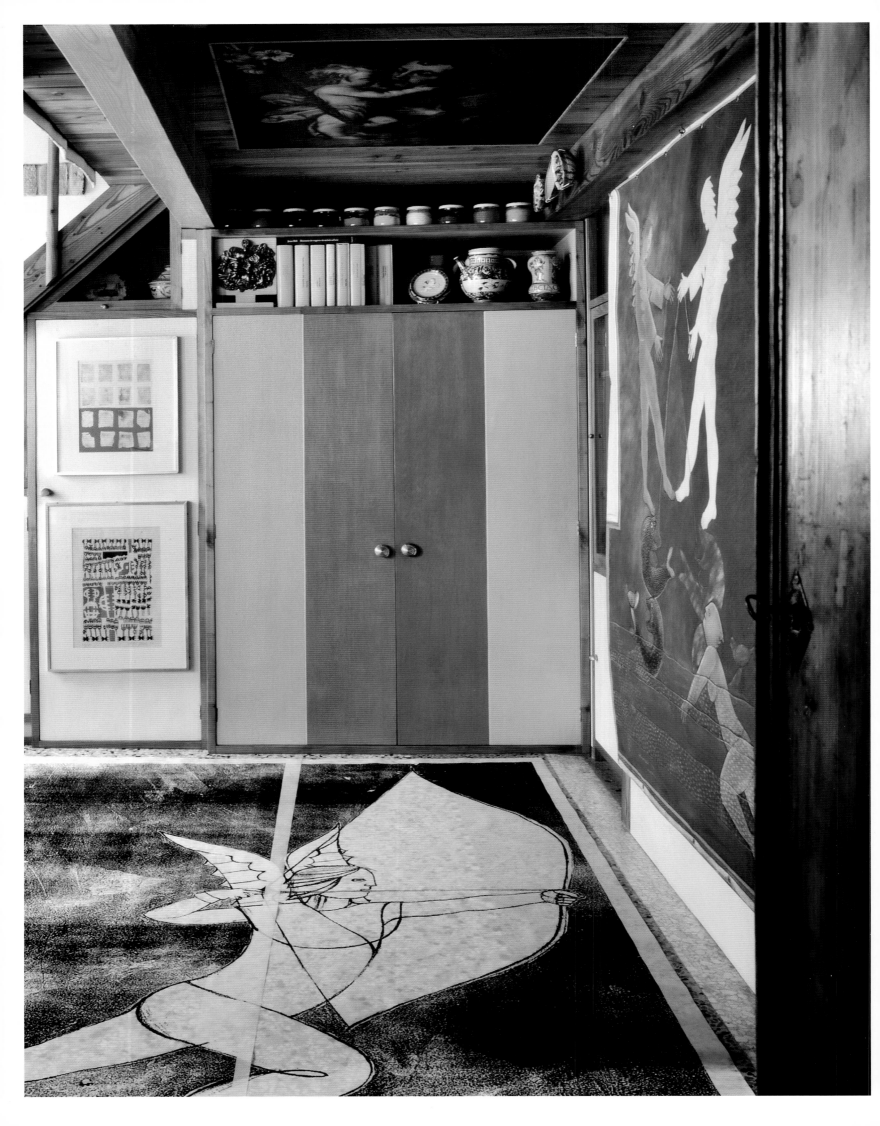

The Sky over Venice

The fact that this is an artist's live-work space can be understood at a glance. It has a creative atmosphere, a fluctuating energy, and an orderly jumble of colors. Here and there faces and bodies appear, like surreal, dreamlike presences. There is no mistaking it, especially since the artist in question, Pietro Russo, has a very personal style, a dreamy, fairy-tale flair. Much as Giacomo Balla adopted the one-word moniker Futurballa, Russo is more widely known simply as Pietrorusso.

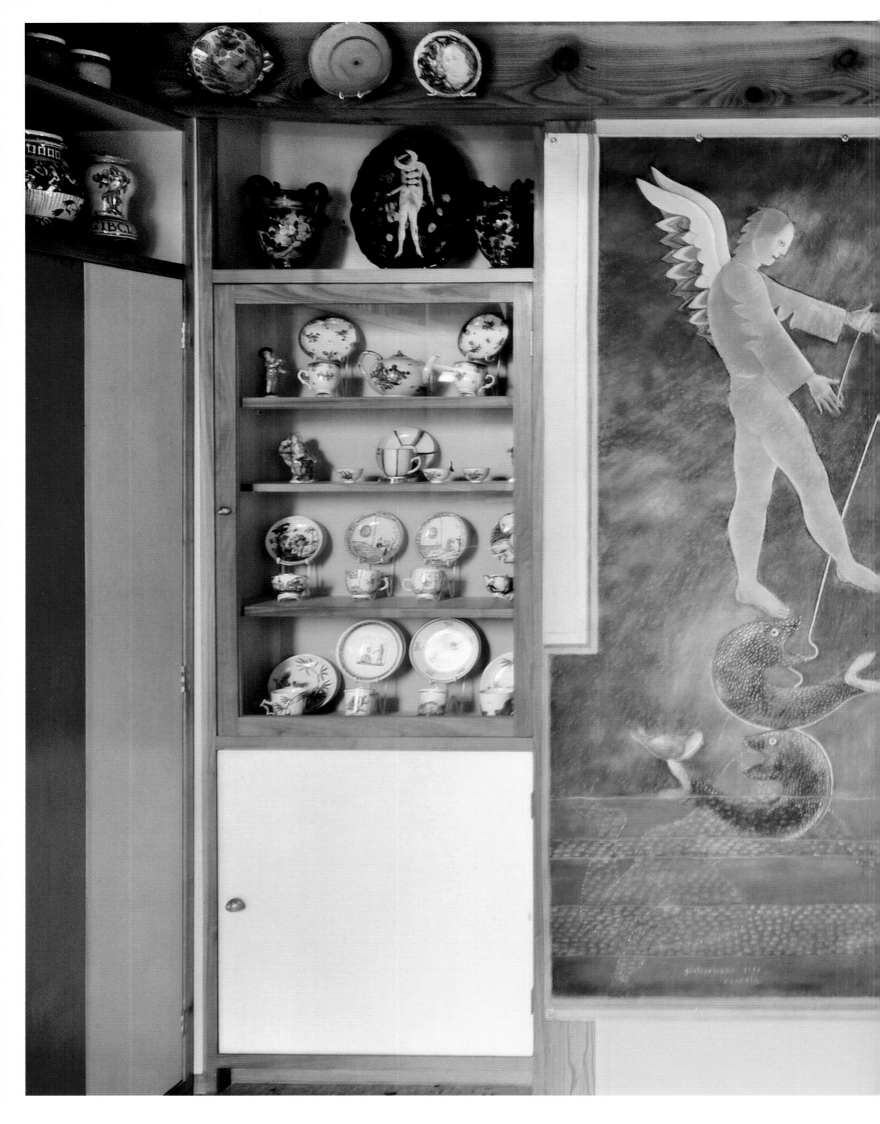

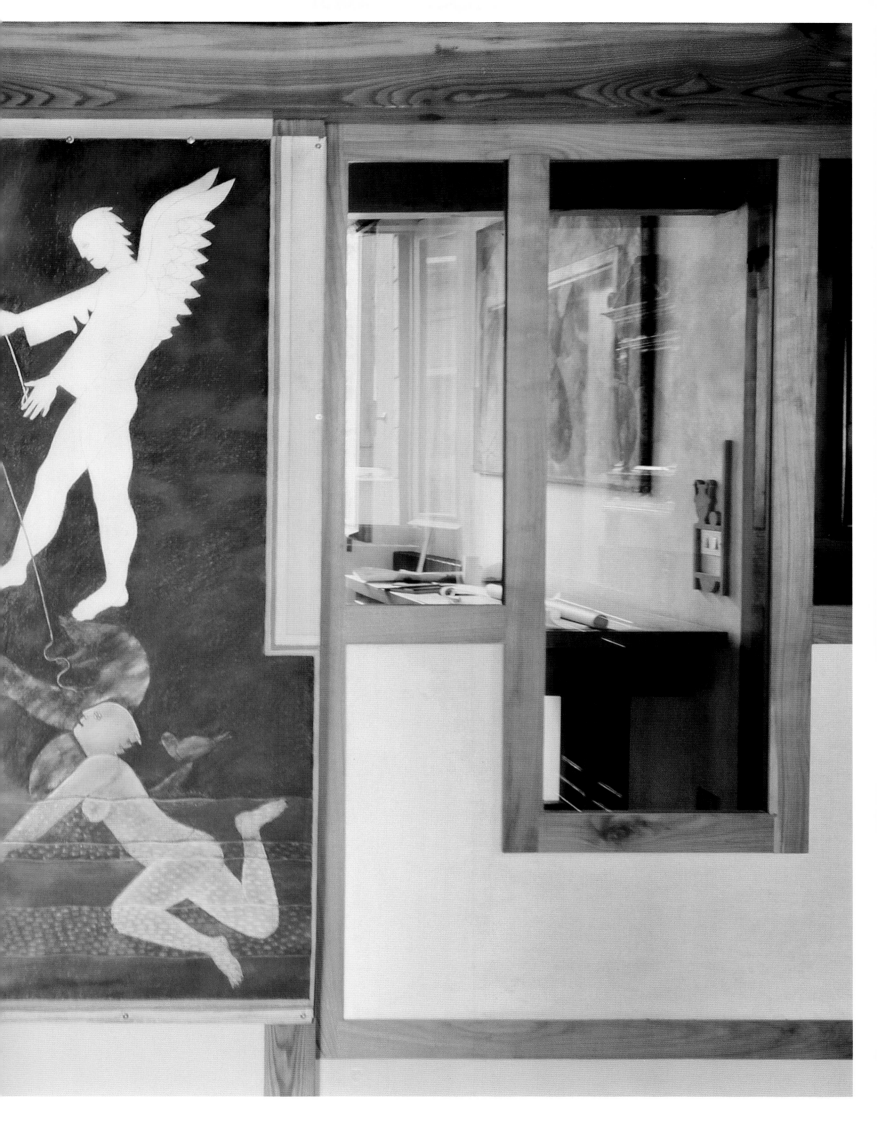

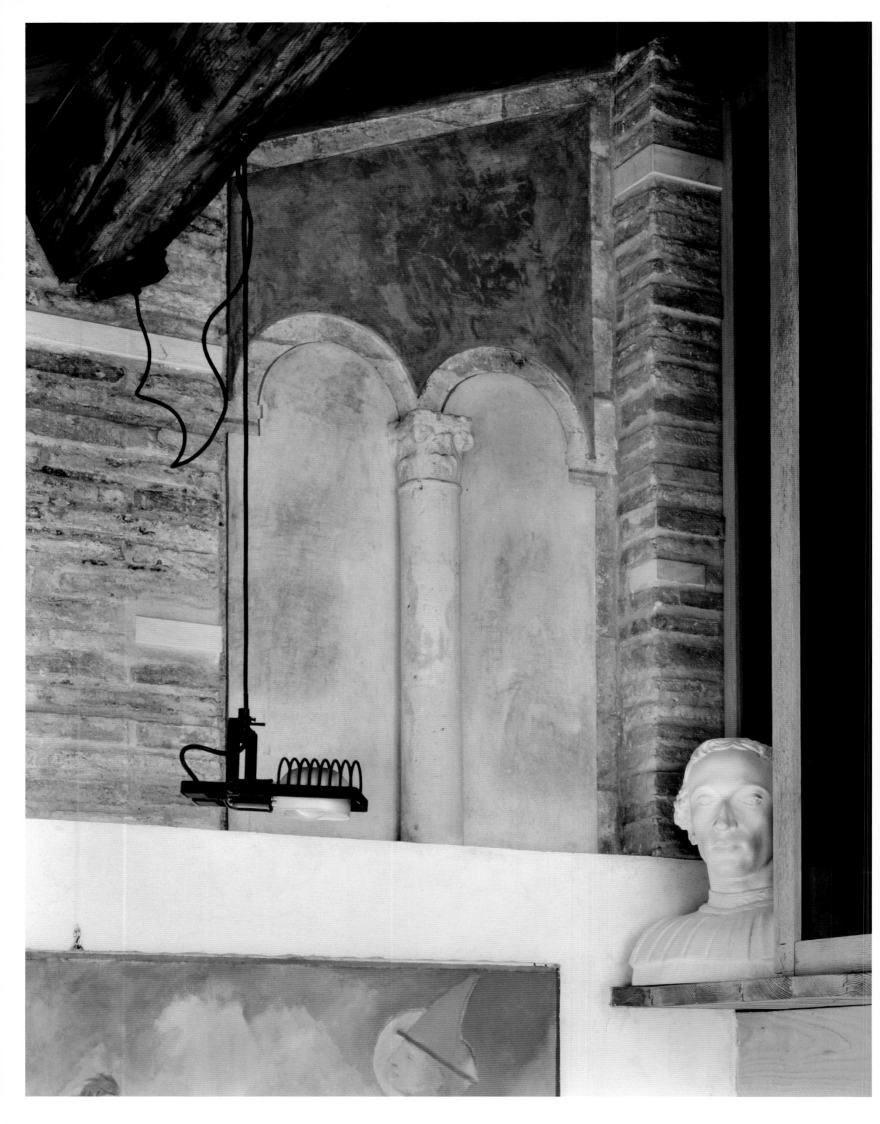

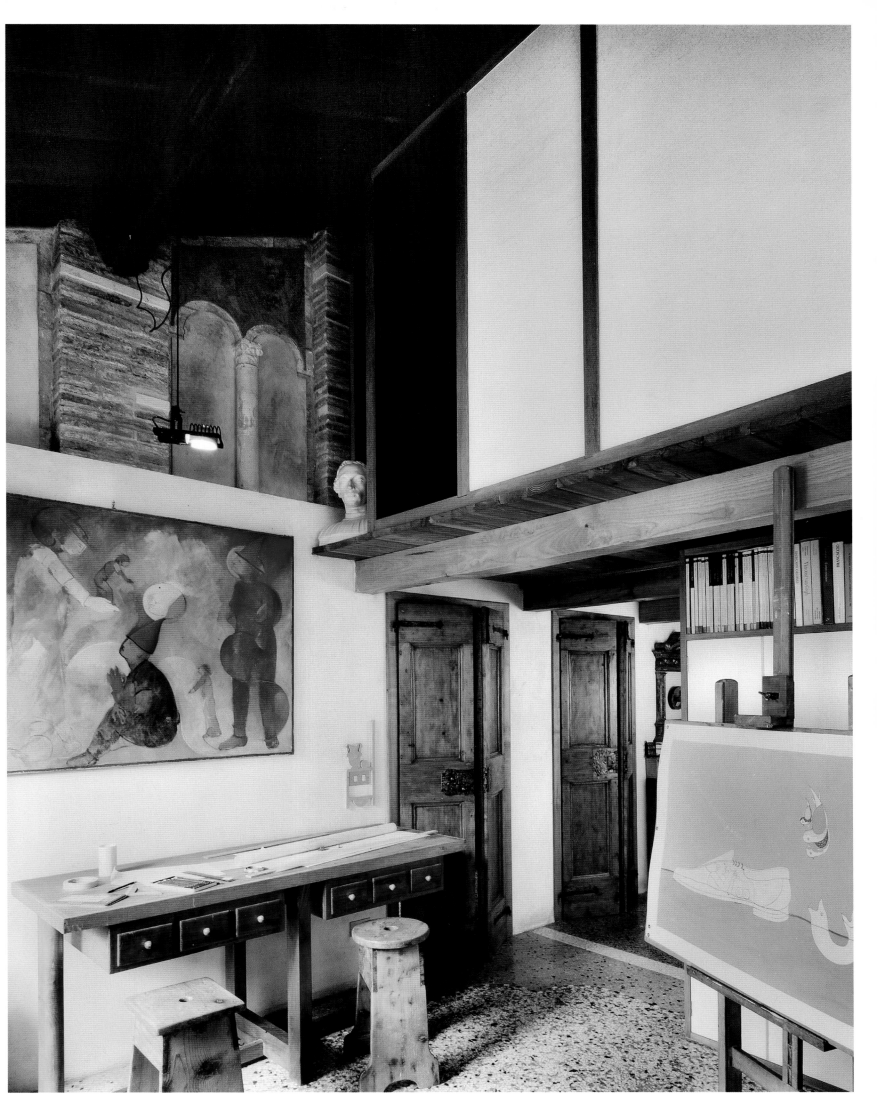

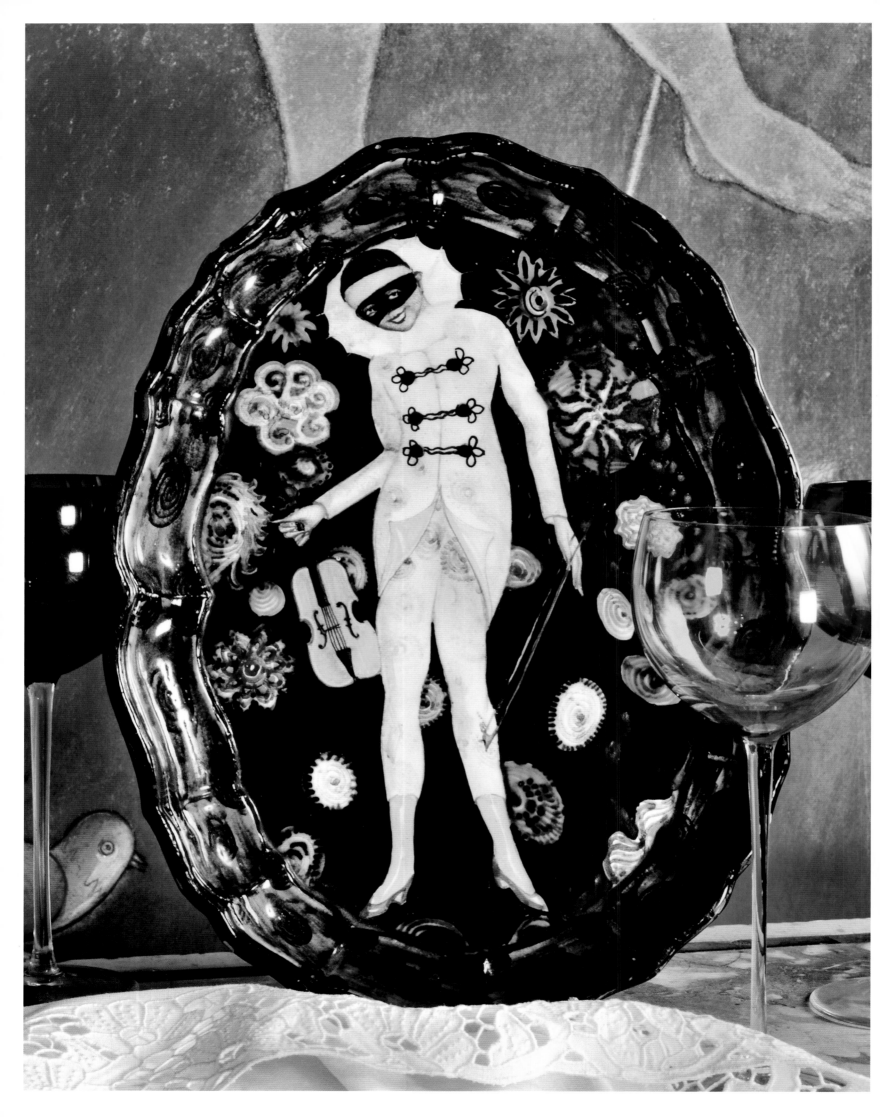

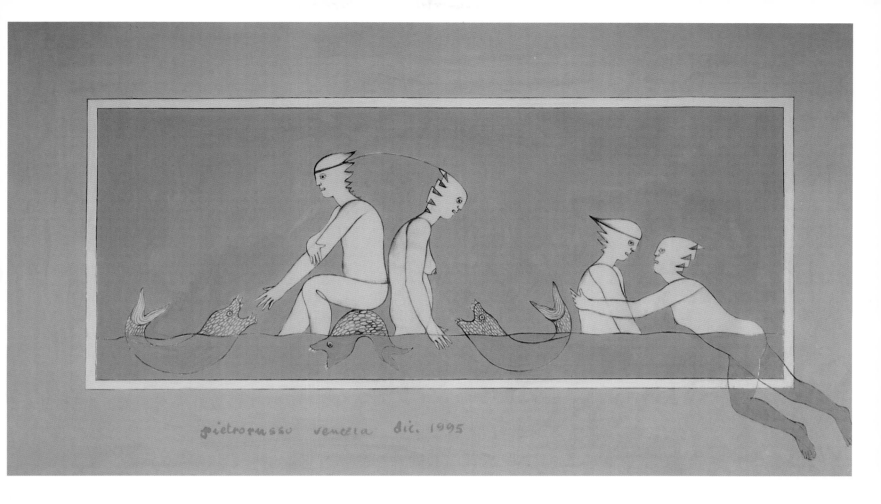

Originally from Orta di Atella, a town outside Naples, he says of himself: "As a boy, I spent hours on end at the National Archaeological Museum of Naples, just sketching. I would look at the *Doryphoros*, the *Venus Kallipygos*, the *Farnese Bull*, the *Farnese Hercules*, the *Women Playing Knucklebones*, and other masterpieces, and draw them. The clarity, serenity, awareness, and balanced composition of that subtle, mysterious, deeply human atmosphere spoke to me. My sensibility was steeped in those myths and legends. Then, in the late 1960s, I decided to live and work in Venice, so here I am, working as a painter, sculptor, and even doing openwork."

"Here" refers to a refurbished loft in an eighteenth-century palazzo overlooking Campo dei Mori, in the Cannareggio sestiere, not far from the Church of the Madonna degli Orti. It's a cozy place, full of magic, very Venetian, and undeniably bohemian. The hefty ceiling beams are in plain sight, the marble terrazzo flooring adds to the loft's flavor, and its high ceilings allowed for the creation of two complete floors—the living room, kitchen, and studio are below, the bedroom area is up above—connected by a wooden staircase. The space is cleverly divided by sliding walls, niches, internal windows, and partitions, which enable a seamless transition between communal space and more personal, private space. This home is a veritable stage of sorts, with traditional features, and if it had a voice it would speak a thick Venetian dialect. Russo's colors give it a modern and up-to-date feel, as do his characters, which move like electric currents lighting the old space up from every corner. Blues, reds, yellows . . . temperas, tapestries . . . On one wall the artist's angelic, winged archers are frozen in the act of releasing the arrow, and he's depicted them on the floor as well. Puppeteer angels seem to be fishing for fairy-tale sea creatures, and lovers take metaphysical delight in the waves, swimming among unknown fish and birds that must have escaped from some undiscovered, wondrous paradise. Divers plunge into fantastical waters, and wayfarers rest at the side of a road that is not there. Some of his work includes quotations from classical books such as *Il compendio di notizie di storia naturale*, a natural-history compendium by Georges-Louis Leclerc Buffon, laid out with stylized miniatures and in a colorful, minute alphabet.

Russo's art is like the transcription of a daydream, the expression of an unstoppable imagination fed by youthful visions in southern Italy that have matured in the northern seascapes of the Venetian lagoon. It is what makes this loft a creative world unto itself, but

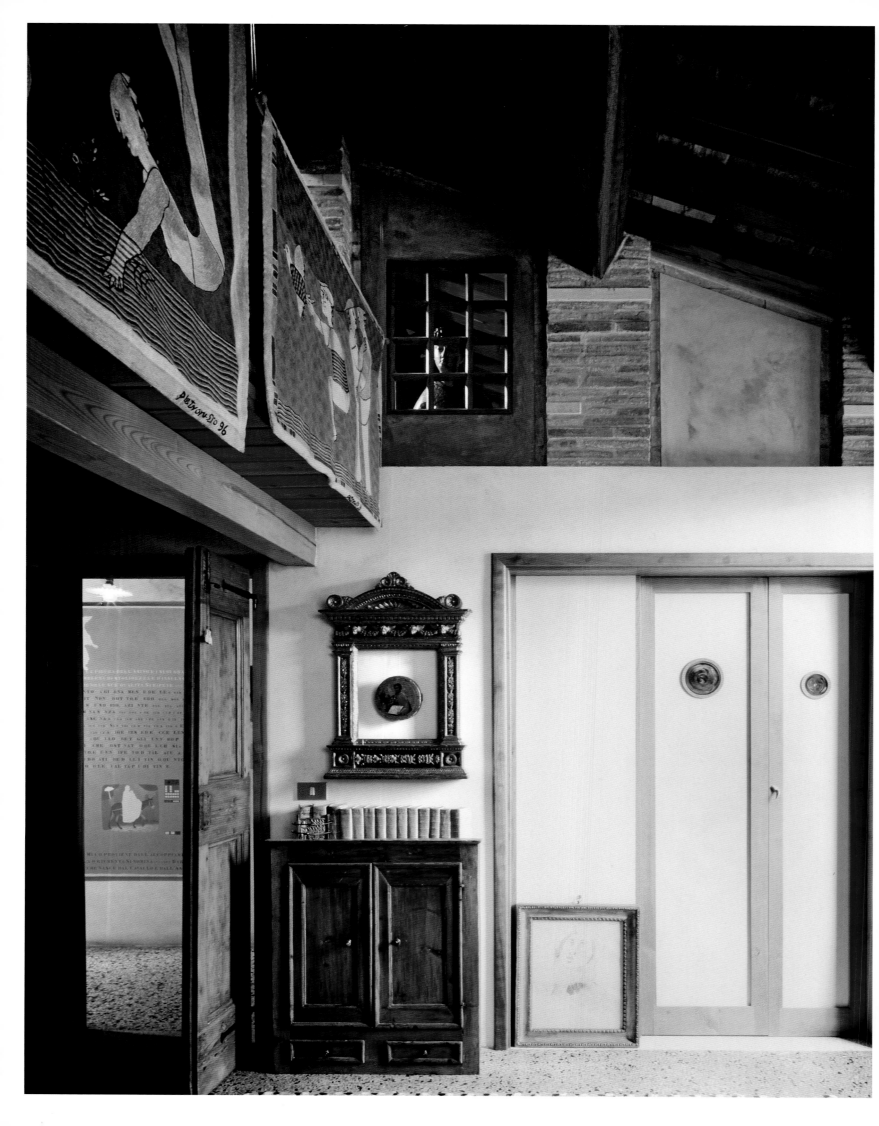

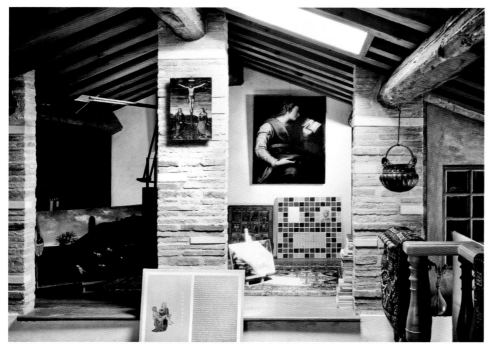
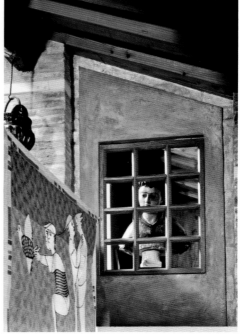

it also complements his rich accumulation of antiques arranged with a jovial nonchalance. A shortlist of the more noteworthy objects: glassware by Fulvio Bianconi, forgotten inventor of the "handkerchief vase"; a flower-shaped lampshade by Cappellini & Venini, legends of Murano glassware whose artistic director was the great Vittorio Zecchin; Murano goblets; majolica and porcelain made by the most famous Italian companies, including a Pierrot vase based on a drawing by Guido Cadorin and produced by Dolcetti; and a precious plate decorated with Hercules and the wild boar, a valuable eighteenth-century piece based on a fresco by Antonio Carracci and created by Bartolomeo Terchi; and two large sixteenth-century Venetian almoners' trays hanging in the kitchen. Then come the antique musical instruments and paintings: there is a beautiful tondo portraying a saint, set within a luxurious vintage frame; an anonymous painting of Saint Catherine of Alexandria graces another wall; and a striking Caravaggesque *Lot and his Daughters* hangs in the bedroom. The sculptures include a polychrome bust of Saint Anthony of Padua peeping out from behind a barred window, found in a farmhouse in Val d'Aosta, and a plaster cast of a bust by Mino da Fiesole, the great fifteenth-century Florentine sculptor. Situated in the mezzanine bedroom, alongside a trompe-l'oeil window with an imaginary blue sky, its stern, bright gaze watches over and protects the house, inviting us to enjoy the perfect harmony achieved by such different eras and inspirations.

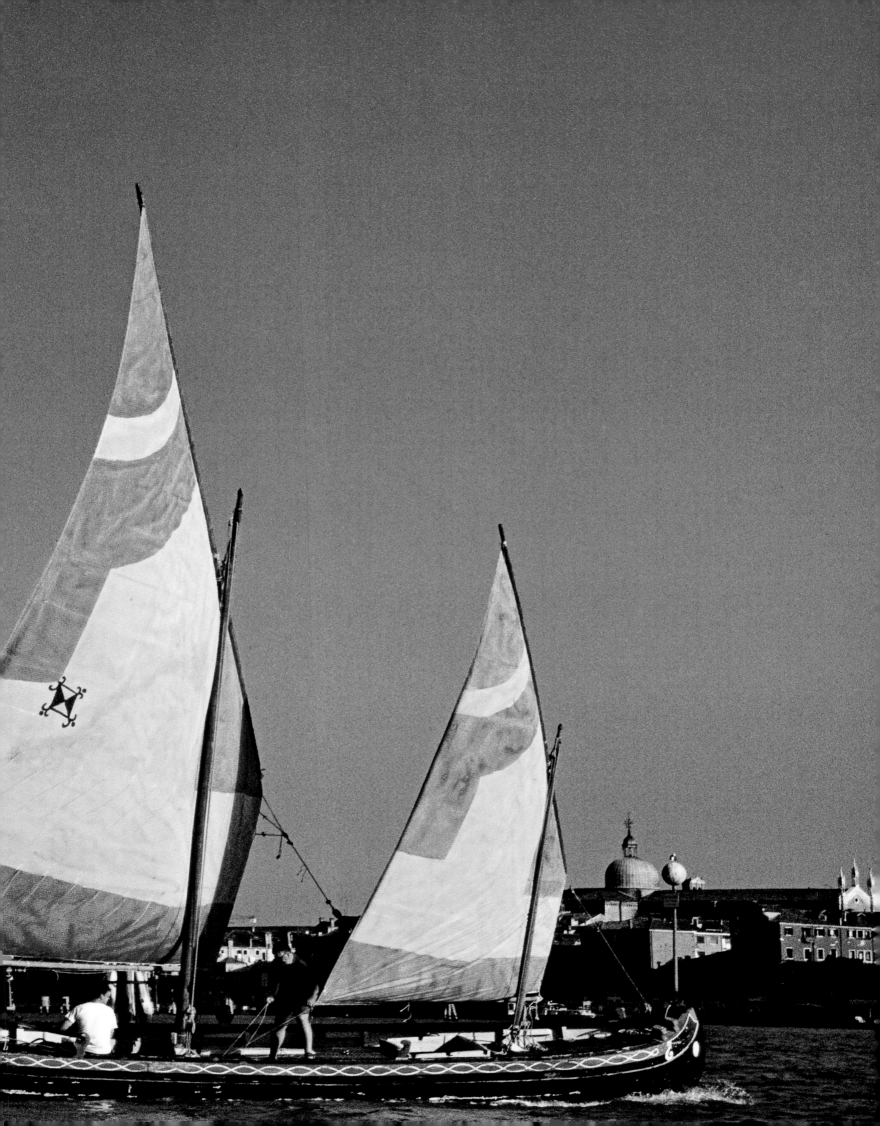

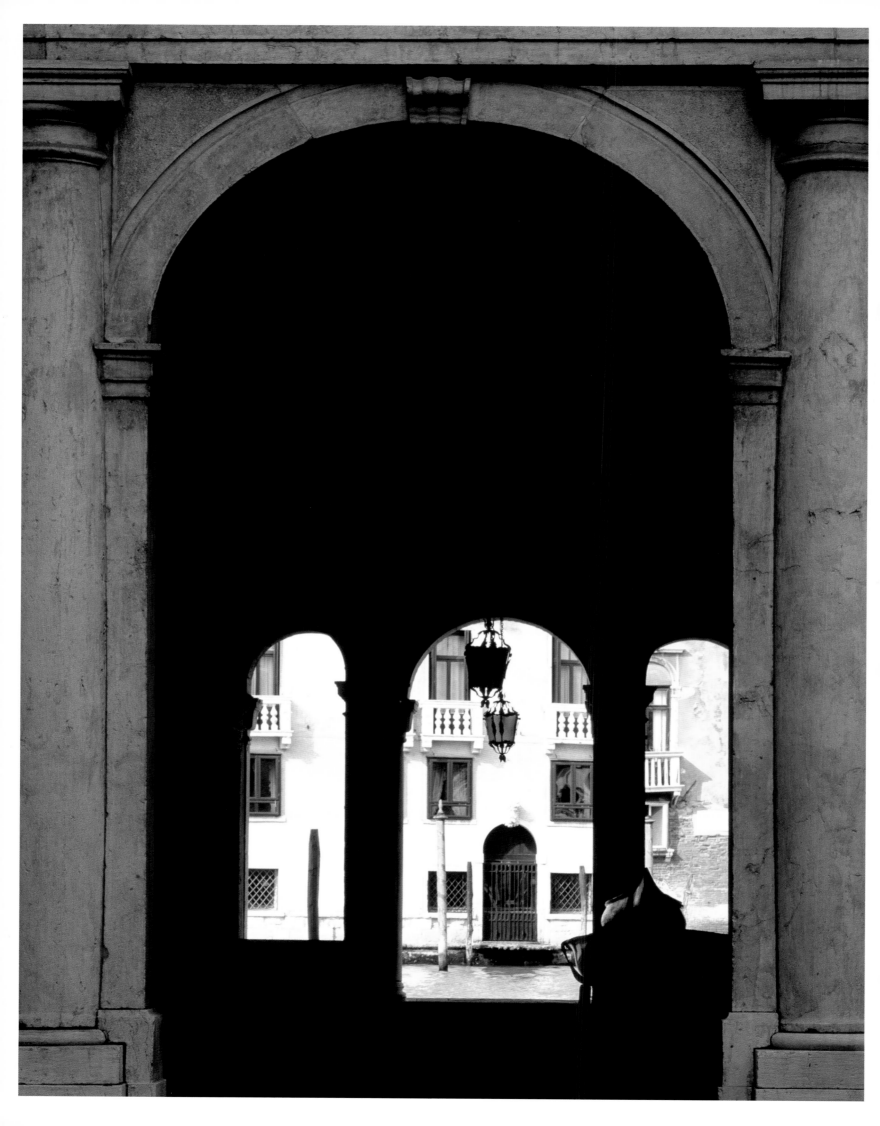

Zen and Geometry

Once upon a time there was a passageway between the *piani nobili*—the main floors—of the two buildings that make up Palazzo Balbi Valier, located in the Dorsoduro sestiere. Now, it's not that it isn't there anymore—nothing is ever destroyed in Venice—it's just been cleverly transformed into an apartment designed by Caterina Penzo. This is where Laura De Santillana lives; she's the granddaughter of Paolo Venini, legendary founder of the Venini glassworks on Murano, and the daughter of Ludovico De Santillana, who directed it for many years. She is also a renowned artist in her own right, and exhibits her work worldwide.

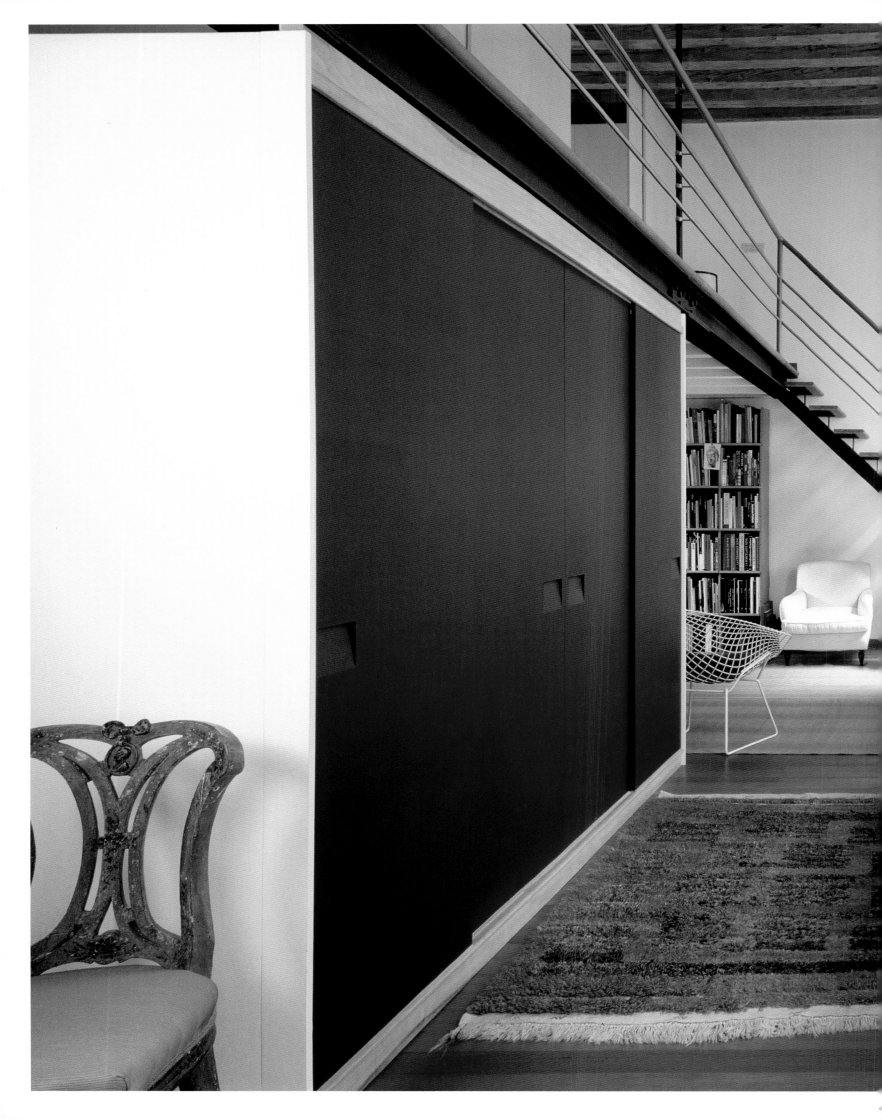

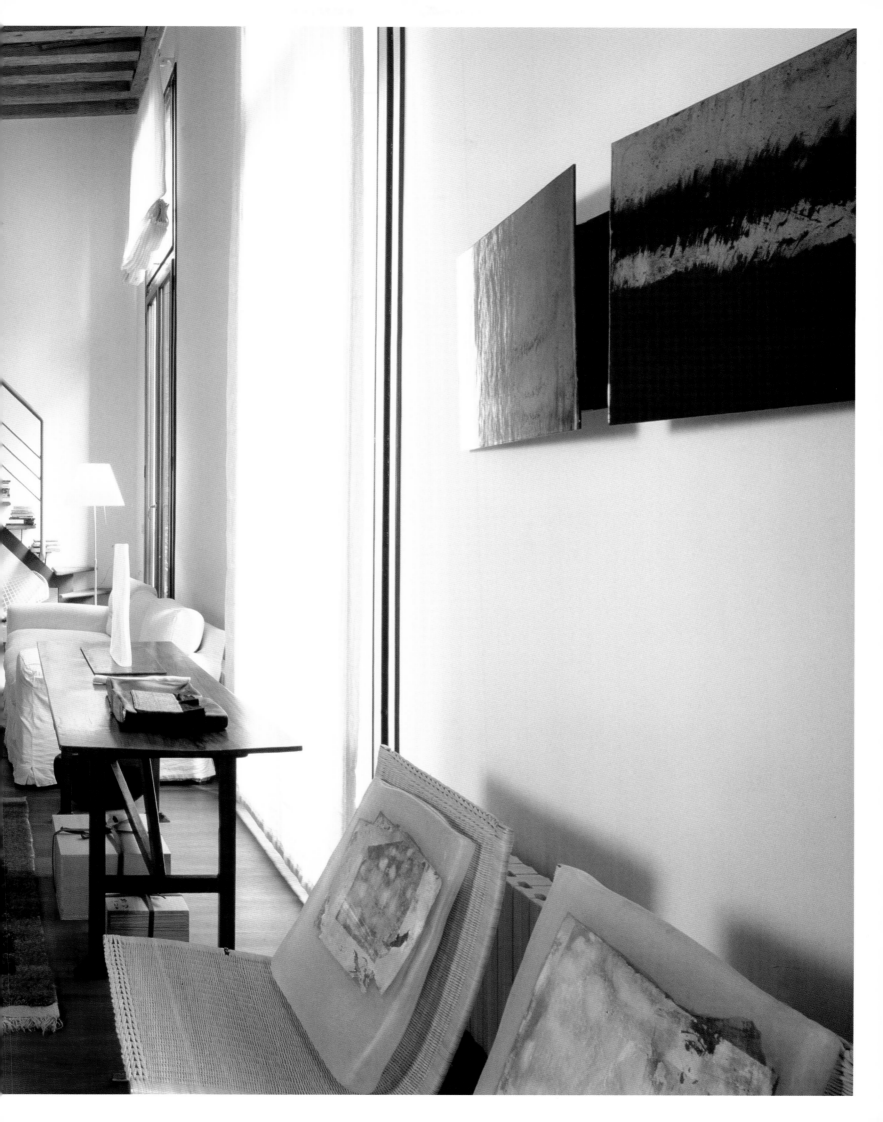

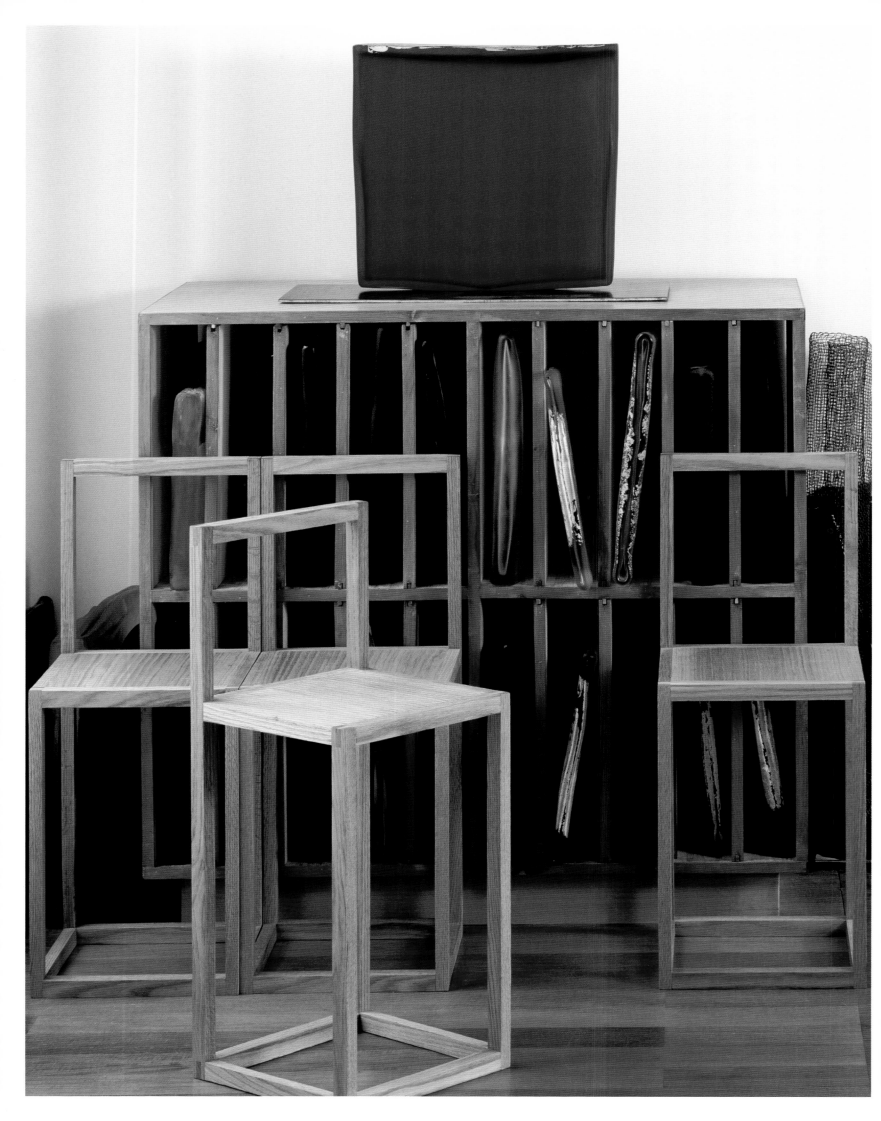

She grew up surrounded by the magnificent, glowing creativity of Murano's master glassmakers, and then studied at the School of Visual Arts in New York. After that, she explains, "I worked at Venini, so I was able to experiment and design industrial glass with Rosenthal. Now I continue my work as an artist, and it gives me a great deal of freedom and happiness." She knows everything there is to know about glass, and has reinterpreted classic glass-working techniques, pushing them to an extreme. For example, she once experimented with the blowing process, modifying the bubble formed while blowing, flattening it so as to shape it into a unique kind of visual message.

"The space inside such compressed forms," she explained during one of her recent shows in Los Angeles, "is reduced to a minimum; what remains are the skeletons of things that are consumed and unrecognizable—sequences of things, like pages torn from a book. Glass contains the soul of each and every form, and preserves it as if in a tabernacle, as if in a body."

She privileges glass because it is in her very DNA and because of her youthful experiences with it, but she also likes many other materials: bronze, with its ever-changing surfaces, as well as stone, marble, onyx, and alabaster. Such minerals have a luminosity about them, like light, and a transparency that is profoundly interior, a changing, unpredictable reactivity to light. This singular sensitivity to light brings us right back to where we started, the passageway. Its structure is hidden behind the facade of the original seventeenth-century building, and stayed hidden when it was modified halfway through the eighteenth century. Although it doesn't actually overlook the water, the building is right on the Grand Canal, not far from the Accademia, and is shielded from the city's main thoroughfare by a garden. The renovation gave the home large, double-height windows, which bathe the space in a magical, abstract illumination. This natural, vibrant, changeable light source is softened by the constant waving of the trees' leafy branches. Over time a relationship between the light and plant life evolved, and it greatly influences the emotional feel of this home. Reflecting on the renovation process, De Santillana says: "Having participated directly in the refurbishment, I developed a very special relationship with this space. I love its proximity to the garden, with a huge horse-chestnut tree that almost seems to reach into the house."

These encounters between light and the surrounding context were cultivated with a keen knowledge of colors; the palette is never too exaggerated, and centers on the light, warm tones of white surfaces and wood, all executed with a thoughtful, geometric rigor. The apartment's spaces are terse and orthogonal, and the lengthened volume of the original passageway was divided across two staggered levels, with the living area in the lower part and the sleeping area in the upper one, arranged beside an elegant walkway with sliding doors leading into the different rooms. The whole place has a very Zen spirit, like an architectural and decorative haiku wherein less means more. It's filled with serenity, and the flexible space is easily modified, by turns uniting several rooms into one larger space and then closing them off from one another when privacy is required. "It's a simple, linear home enlivened by the counterpoint of very few meaningful objects," the artist explains, adding, "I feel it's very much mine, its geometric spirit represents me. I was the one who chose the teak floor, the traditional Fusuma paper doors, my brother Alessandro's work in glass, and the boat-shaped bed from Genoa, dated to the nineteenth century just like the painting portraying a woman with a cat. And the same goes for the Harry Bertoia armchairs, the few pieces of vintage furniture, the Japanese watercolors, and above all the wooden chairs in the living room: the brilliant American theater director Bob Wilson made those chairs for *Quartet*, and then he gave them to me in exchange for one of my works!"

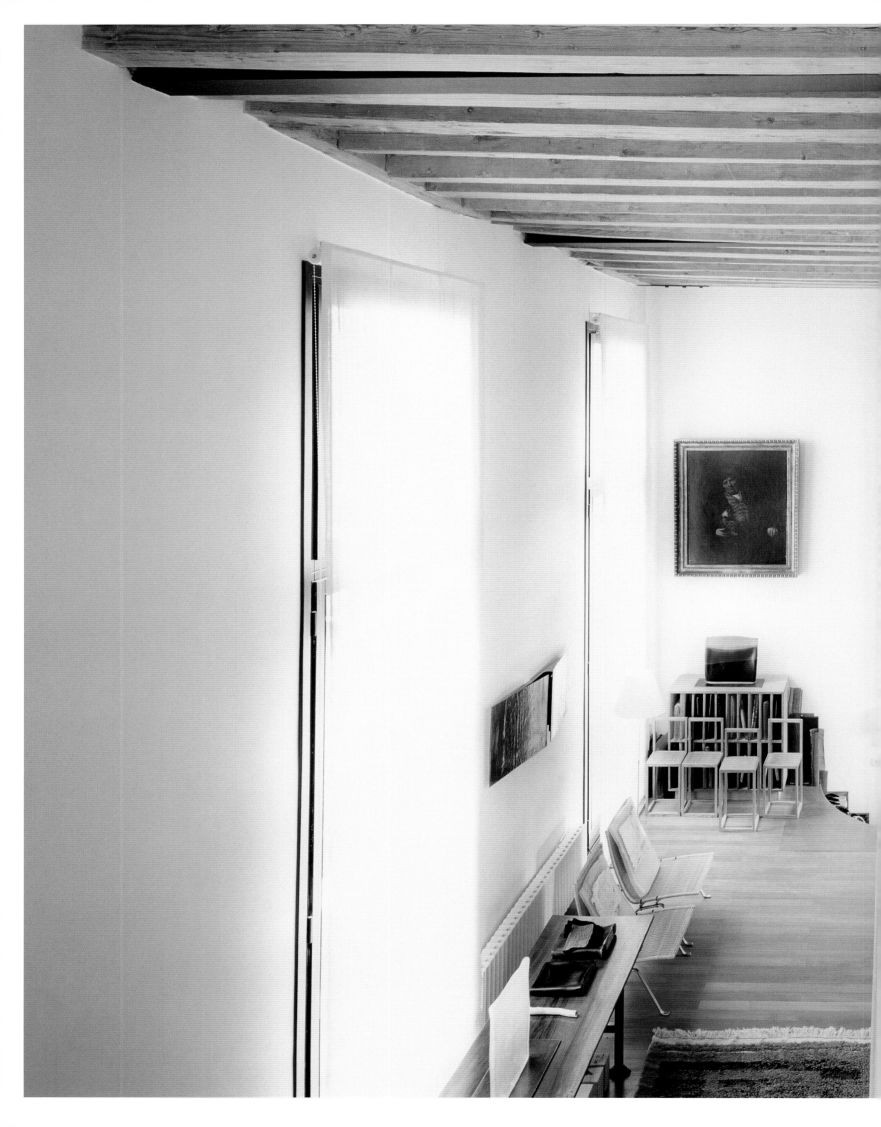

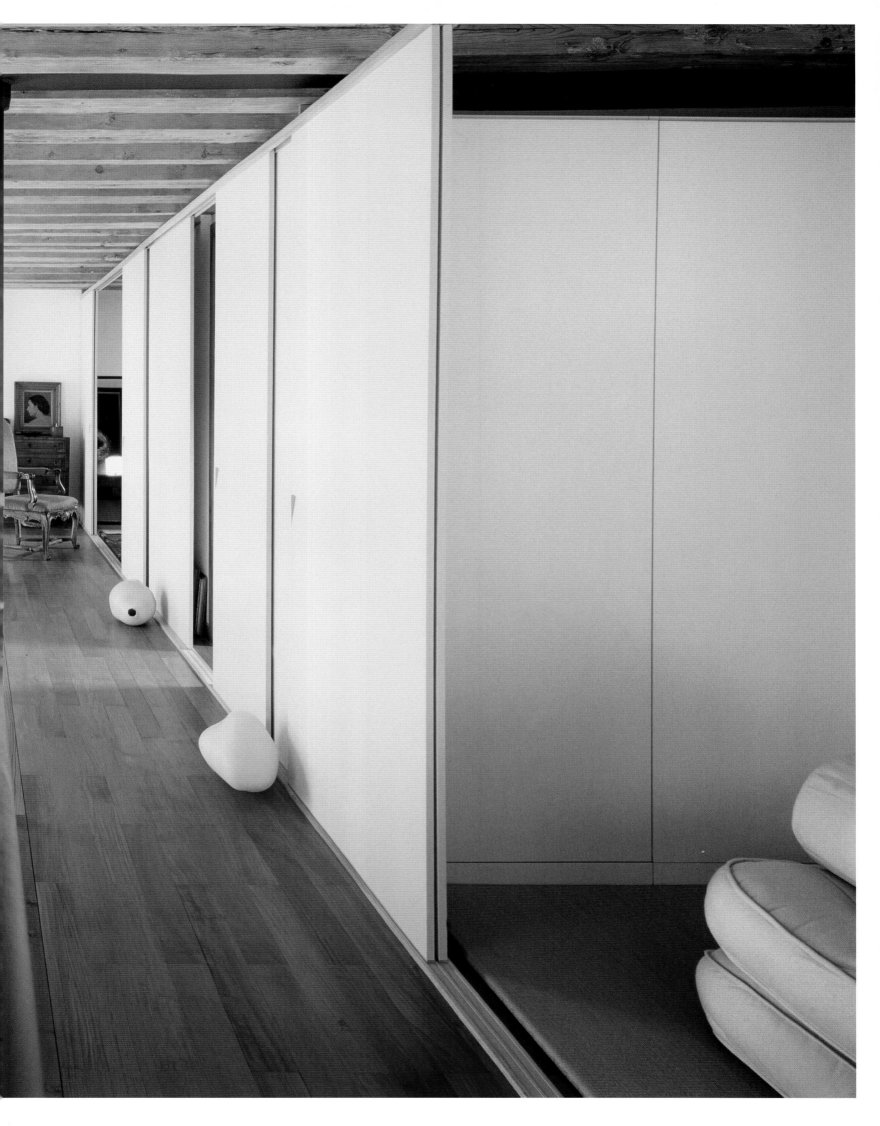

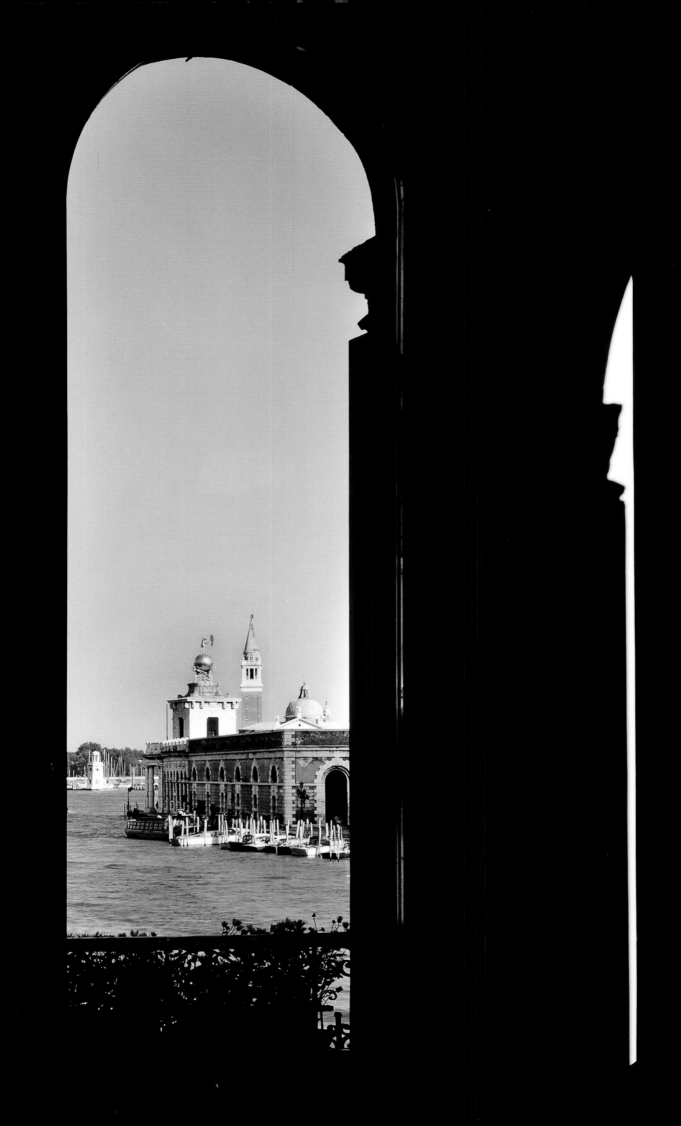

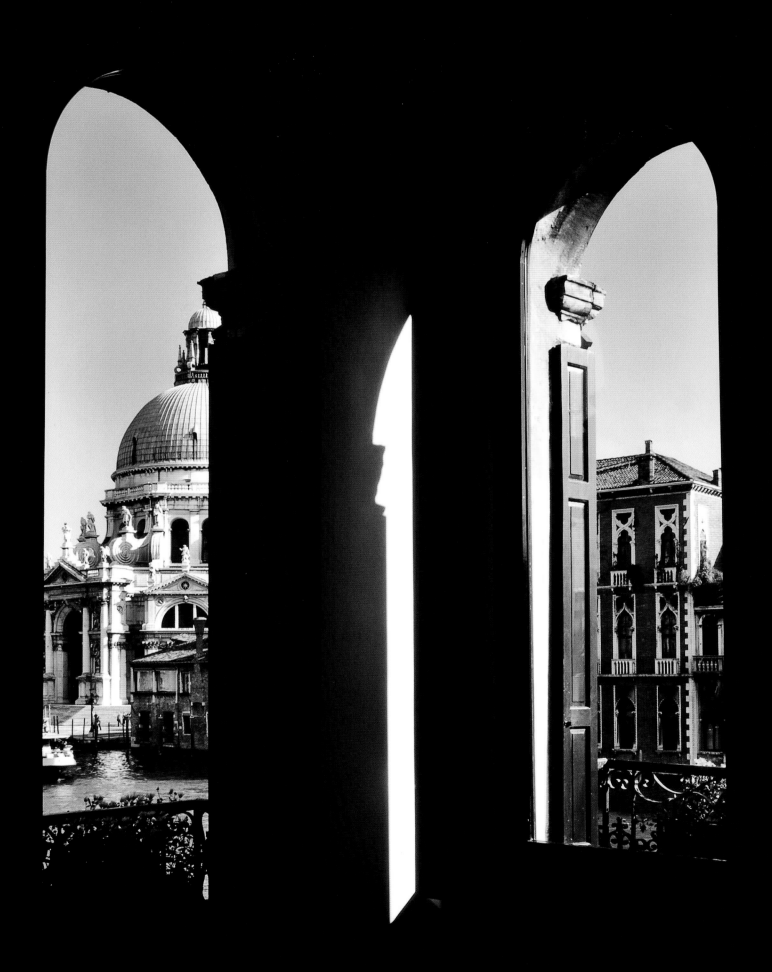

The authors wish to thank all those whose collaboration, generosity, and kindness helped to make this book possible:

Angela and Gianni Aricò, Corrado Anselmi,
Cristina Barbano, Gloria Beggiato,
Luigi Benvenuti, Mara Bertoli, Giovanni Caniato,
Michael Carapetian, Cesare Cunaccia,
Laura De Santillana, Paolo Fabris,
Irene Favaretto, Marco Friziero,
Michele Gervasuti, Giorgio Leandro,
Guerino Lovato, Giorgio Mecchia Maddalena,
Umberto Occhipinti, Raoul Pantaleo,
Gilberto Penzo, Elisabetta Pincherle,
Stefano Polizzi, Nani Prina, Matilde Rubelli,
Pietro Russo, Alberto Sandretti,
Cristiano Spiller, Giorgio Spiller, Mirella Spinella,
Giorgio Supiej, Fausta Squatriti, Matilde Terzuoli Marcello,
Anna Venini, Sandra Vigarani, Hans Wagner

Architects:
Corrado Anselmi *page 32*
Nani Prina *page 48*
Paolo Fabris *page 60*
Roberto Canovaro *page 72*
Matilde Terzuoli Marcello *page 86*
Riccardo Gaggia *page 106–135*
Giuseppe Zambon *page 138*
Giorgio Mecchia Maddalena *page 156*
Michael Carapetian, Raoul Pantaleo,
engineer Sam Price *page 168*
Caterina Penzo *page 230*

First published in the United States of America in 2012 by
Rizzoli International Publications, Inc.
300 Park Avenue South
New York, NY 10010
www.rizzoliusa.com

Originally published in Italian as *Abitare a Venezia* in 2012 by
RCS Libri S.p.A.

© 2012 RCS Libri S.p.A., Milan

Second printing, 2012
2012 2013 2014 2015 / 10 9 8 7 6 5 4 3 2

ISBN: 978-0-8478-3754-0

Library of Congress Control Number: 2011945277

Translation: Sylvia Adrian Notini
Editorial coordination: Valentina Campa
Graphic design: Simona Marzorati (K•Lab)
Layout: K•Lab, Milan
Production: Sergio Daniotti

Printed in China

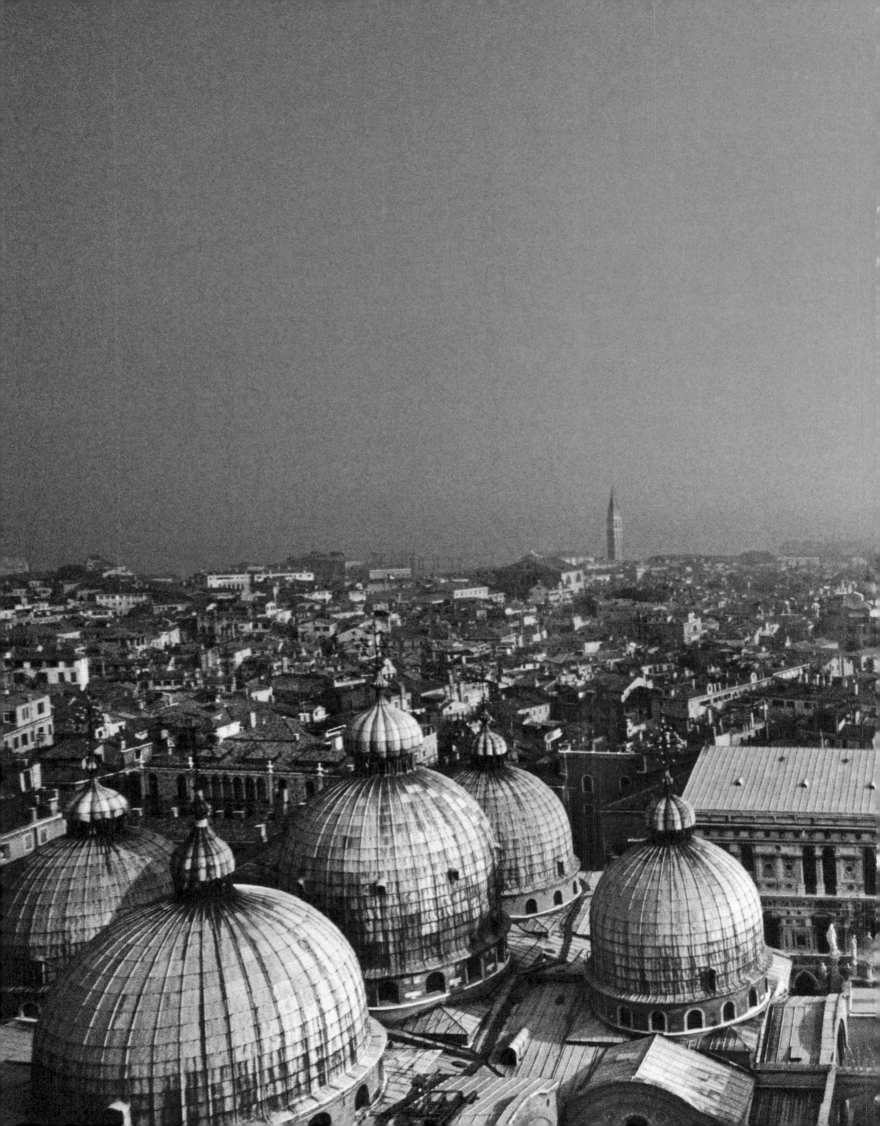